FUNDAMENTALS OF **MODERN PHOTOGRAPHY**

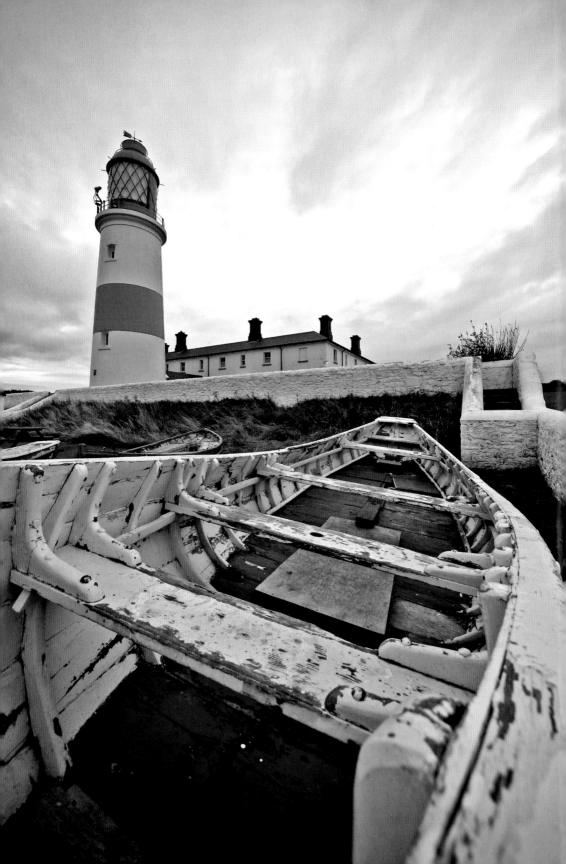

TOM ANG

FUNDAMENTALS OF **MODERN PHOTOGRAPHY**

MITCHELL BEAZLEY

This book is dedicated to the memory of
Michael Langford, who taught all of us.

FUNDAMENTALS OF **MODERN** **PHOTOGRAPHY**

TOM ANG

First published in Great Britain in 2008 by Mitchell Beazley,
an imprint of Octopus Publishing Group Limited,
2–4 Heron Quays, London E14 4JP.
A Hachette Livre UK Company
www.octopusbooks.co.uk

The publishers will be grateful for any information that will assist them in
keeping future editions up to date. Although all reasonable care has been
taken in the preparation of this book, neither the publishers nor the author
can accept any liability for any consequence arising from the use thereof, or
the information contained therein.

The author has asserted his moral rights.

ISBN 978 1 84533 231 0

A CIP catalogue record for this book is available from the British Library.

Set in Minion and Meta

Colour reproduction in China by Fine Arts
Printed and bound in China by Paramount

Commissioning Editor: Hannah Barnes-Murphy
Senior Editor: Leanne Bryan
Copy Editor: Stephanie Krahn
Proofreader: David Tombesi-Walton
Indexer: Margaret Cornell
Art Director: Tim Foster
Art Editor: Victoria Burley
Designer: Jeremy Williams
Illustrator: Patrick Mulrey
Production Manager: Peter Hunt

CONTENTS

8 Introduction

10 WHAT IS PHOTOGRAPHY?

12 What is photography?
14 The imaging process
16 Image quality
18 Digital principles
20 Workflow
22 The uses of photography
26 Eye and camera compared
28 Visual perception
30 Composition
32 Guiding the eye
34 Analysis: Composing with lines

36 FUNDAMENTALS OF LIGHT

38 Types of light source
40 Properties of light
42 The quality of light
44 Contrast
46 Basic photometry
48 Light and exposure
50 Exposure and development
52 The spectrum
54 Recording colour
56 Colour

58 THE CAMERA

60 Camera controls
62 Camera construction
64 Viewfinder cameras
66 SLR cameras
68 Electronic-viewfinder cameras
70 Medium-format cameras
72 Manual focusing
74 Autofocusing
76 How focusing systems work
78 Short shutter times
80 Long shutter times
82 How the shutter works
84 Depth of field
86 Lens aperture

88 Aperture effects
90 Digital camera features
94 Exposure measurement
96 Stabilizing the camera
98 Photography equipment

102 CAPTURING LIGHT

104 Film and sensor
106 Types of film: black and white
108 Capturing colour
110 Colour films: transparency
112 Colour films: print
114 Film formats and applications
116 Medium and large format
118 Exposure metering
120 Metering techniques
122 Digital image capture
124 Working in low light
126 Digital colour capture
128 Working with sensor formats

130 USING THE LENS

132 The photographic lens
134 Handling lenses
136 Lens specifications
138 Zoom lenses
140 Normal to wide zooms
142 Long zooms
144 Lens formulae
146 Wide-angle lenses
148 Normal lenses
150 Aberrations
152 Macro lenses
154 Medium-long focal length
156 Analysis: Working with lenses
158 Very long lenses
160 Specialist lenses
162 Image clarity
164 Optimizing lens performance
166 Light-adjusting filters
168 Special-effects and correction filters
170 Camera movements

172 Analysis: Working with movement
174 Panoramic photography
176 Photography in challenging conditions

178 MANIPULATING LIGHT
180 Principles of lighting
184 Creating the studio
186 Analysis: Working with multiple light sources
188 Light modifiers
190 Lighting set-ups
194 Actinic light and exposure
196 Portable flash
198 Using electronic flash

200 WORKING WITH COLOUR
202 Colour and vision
204 Composing with colour
206 Colour saturation
208 Colour recording
210 Reduced colour contrast
212 Analysis: Working with colour
214 Mixed lighting and mixed whites
216 Colour palettes
218 Digital colour
220 Colour management
222 Colour settings
224 Input and output

226 PROCESSING THE IMAGE
228 Processing the image
230 Black-and-white film development
232 Developers and other chemicals
234 Sensitometry
236 Colour processing
238 In-camera processing
240 Raw processing
242 Image proportions
244 File types and uses
246 Image workflow
248 Image shape
250 File size
252 Image levels
254 Controlling image tonality

256 Burning and dodging
258 Analysis: Burning and dodging
260 Colour balancing
262 Colour-to-mono conversions
264 Cloning, duplicating, healing
266 Masks and selections
268 Layers
270 Layer blend modes
274 Darkroom effects
278 Basic image sharpening
280 Adaptive sharpening

282 DIGITIZING THE IMAGE
284 From analogue to digital
286 Types of scanner
288 Scanner features
290 Scanning workflow
292 Advanced scanning
294 Image management

296 OUTPUTTING THE IMAGE
298 Principles of enlargement
300 Darkroom equipment
302 Black-and-white printing
306 Variable-contrast printing and toning
308 Colour printing methods
310 Digital output
312 Digital printing
314 Archival issues
316 Presenting your images
318 Displaying your images
320 Pictures on the web

322 REFERENCES
324 Diagnosing film and processing defects
328 Compendium of filter effects
332 Picture editing
336 Copyright FAQ
338 Glossary
344 Websites and further reading

348 Index
352 Acknowledgments

INTRODUCTION

Fundamentals of Modern Photography is the first publication to fully integrate the technical foundations of photography with both its analogue and digital practice. It combines the theoretical fundamentals of photography with their practical effects, while also fully blending film-using practice with digital photography. For today's photography is, in all respects, an almost seamless interweaving of film and digital practice: the hybrid new practices arising from the roots of past procedures and experience.

It is commonly accepted that the most stunning development in the history of photography has been its transformation by digital techniques, considered not only in the scale of change but the rapidity of transformation.

From the capture of the image, to its processing and its output, every aspect has been overturned or reinvented. Great manufacturers that once led photographic progress are now confined to history. Those clicking with film-using cameras feel in danger of extinction. Today, the makers of the greatest number of cameras are primarily in the mobile-phone or electronics business. In response to the enormous increase in the people using digital cameras, numerous books have appeared, showing how to use cameras and software, and offering advice on photographic techniques.

Unlike the majority of books on digital photography, *Fundamentals of Modern Photography* aims to help the reader to understand the fundamental operation of modern photography rather than just how to take photographs.

This book blends the classical skills, artistic appreciation, and knowledge – gained from

over 170 years of film practice – with the thrilling advances in digital technology.

The book is accessible to the beginner photographer, yet it also provides the foundations for advanced study. It is a companion reference for those studying photography in that it aims to support them as they build their experience, knowledge, and love of the subject.

The result of the union of analogue film technique with digital image capture is a new set of fundamentals of modern photography.

The photographer's command over photography will surely grow once he understands these fundamentals. With a command of the fundamentals, using a camera is transformed from a robotic button-pressing to a creative and rewarding partnership between photographer and photography.

HOW TO USE THIS BOOK

You can dip in and out anywhere in the book, and you can also start at the beginning and read it through to the end, because it is presented in a logical sequence. The tinted sections are for the more advanced or more curious photographer: you do not need to be familiar with the material to enjoy or make photographs, but the more you understand, the greater your skill and reward will be. These pages provide the fundamental knowledge of the subject on which to base your advancement through photography.

TOM ANG

What is
photography?

WHAT IS PHOTOGRAPHY?

THE IMAGING PROCESS

IMAGE QUALITY

DIGITAL PRINCIPLES

WORKFLOW

THE USES OF PHOTOGRAPHY

EYE AND CAMERA COMPARED

VISUAL PERCEPTION

COMPOSITION

GUIDING THE EYE

ANALYSIS: COMPOSING WITH LINES

WHAT IS PHOTOGRAPHY?

Many definitions of photography are possible, although none will be universally agreed. For the purpose of this book, let us define photography as "a system designed to produce photographs". And by photograph we mean "a visual recording of an event through the agency of light, using a light-sensitive material". The rest of this book devotes itself to filling out all the practical and technical details of this definition. First, we discuss some key notions.

SYSTEM

Photography is a system because many components, each designed to perform different tasks, all work together to capture an image by using light or other radiation. Each component contributes its own function to the overall task – lens to focus the light, film or sensor to record the image, and camera to hold the film or sensor. No item can create a photograph by itself, nor can it do its job if another component fails. A crucial, but often neglected, element of the system is the photographer – the agent that prepares the equipment, directing and using it to capture and record an image. Without a photographer, a camera is like a conjuror's box of tricks without the magician.

EVENT

Recording or capturing an image of an event is shaped by the complex set of circumstances that create and envelop the event being photographed. The image is, in the first instance, the light leaving the subject and reaching the film or sensor through the lens. The image and its characteristics depend on factors such as the focus, aperture, and shutter settings, and any movement of the camera or subject during exposure. Consequently, every image encapsulates not only the appearance of the subject, but all the photographic settings used, the characteristics of the equipment, as well as the decisions made by the photographer: the image of an event is therefore itself also an event.

PROCESSING

The original photographic image, when first captured or acquired, is never immediately visible, unlike, for example, an image produced by drawing or painting. It is latent or virtual and needs processing steps to be made visible. This is done through the chemical action

of developers on exposed film, or electronic and digital processing in the case of a digital image. Chemical processing is a sequence of chemical reactions that work in conditions precisely controlled by machinery and technicians to turn a strip of film into a visual record (*see* pages 228–37). In digital imaging, there are two kinds of processing: electronic

▶ **Lighthouse**
The photograph brings together a number of complex factors – the position, strength, and colour of light; the position of the subject (here, the guardian of an old lighthouse); and the camera settings. At the same time, it presents the event with tonality and colours specific to the characteristics of the camera's sensor or film.

processing and digital processing. Electronic processing takes place within the camera to convert energy from light into electrical pulses (*see* pages 122–3). These are then digitally processed by computer programs within the camera and outside – for example, on a computer.

VISUAL RECORD

The purpose of the chain of processing is to create a static and stable visible record – the print. That record is stable in that it is permanent – essentially not changing when viewed over time – and does not need any kind of viewing equipment to be visible. The beauty of a photographic print, in contrast to one on a monitor, is that we can hold it up and look at it whenever we wish. But it is a crucial property of photography that we can make numerous copies or facsimiles from one original image. Much of the power of photography as a tool for communication resides in this fact.

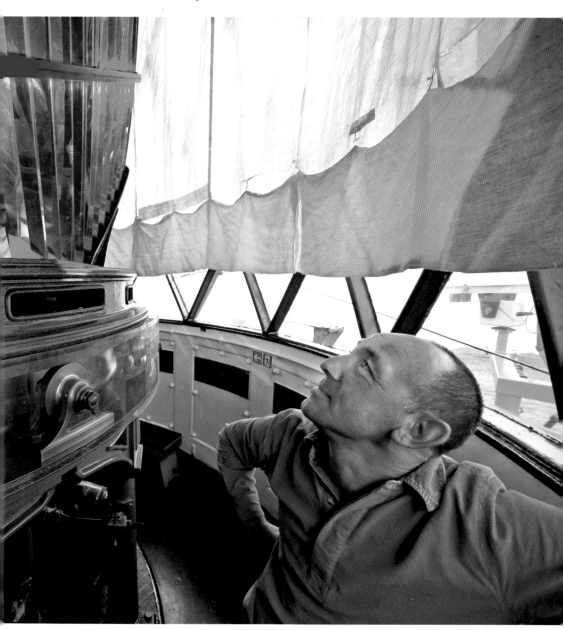

THE IMAGING PROCESS

In the first half of photography's history, the imaging process was a relatively direct chain of steps in which the sensitive material was prepared, exposed in the camera, then processed to negative, from which prints were subsequently made. The choices for variation were limited, and to take them up was often considered unorthodox or labelled as "non-standard".

THE IMAGING CHAINS: ANALOGUE

The classic photographic chain – using film processed to make prints – may be described as a purely analogue imaging chain. This means the image is created by processes in which the variations in light are registered by a proportional quantity of developed silver. In this type of imaging chain:
• Only one unique, original image can exist;
• Each step along the imaging chain results in a loss

in image quality – an inherent generational loss;
• Images can be physically damaged – often to a considerable extent – yet remain recognizable even if impaired by artifacts and a loss in quality.

THE IMAGING CHAINS: DIGITAL

Strictly speaking, no imaging chain is purely digital because every ordinary method of gathering or recording light is analogue in nature: the amount of light reaching a sensor is changed or translated (a process called transduction) into a varying amount of another effect such as electrical current. By the same token, when the image is viewed or printed, the processes involved are also analogue in nature.

That said, it is common practice to call an imaging chain "digital" if it uses scanners to digitize film-based images or uses digital cameras to capture images,

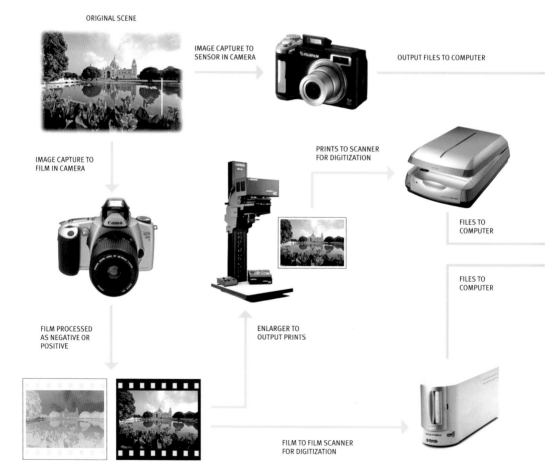

ORIGINAL SCENE

IMAGE CAPTURE TO
SENSOR IN CAMERA

OUTPUT FILES TO COMPUTER

IMAGE CAPTURE TO
FILM IN CAMERA

PRINTS TO SCANNER
FOR DIGITIZATION

FILES TO
COMPUTER

FILES TO
COMPUTER

FILM PROCESSED
AS NEGATIVE OR
POSITIVE

ENLARGER TO
OUTPUT PRINTS

FILM TO FILM SCANNER
FOR DIGITIZATION

followed by digital image manipulation for final output onto media such as CDs and DVDs.

In this type of imaging chain:

- Perfect copies of images may be repeatedly made – no generational loss is possible;
- Loss of information in one step cannot be retrieved in a subsequent step;
- Image files are very fragile and highly intolerant of errors or damage.

THE IMAGING CHAINS: HYBRID

An imaging chain is said to be hybrid when it involves components based on silver-based emulsions as well as digital technologies. Just a few years ago, many photographers went through a transitional period in which they scanned their existing work held on transparencies, prints, and negatives. The resulting files enabled corrections and improvements to be made to old images and opened the way to digital distribution to clients.

An alternative imaging chain for both professional and amateur digital photographers is to start with images from digital cameras, ending with a conversion to prints using photographic films or papers. In this, the most complicated type of imaging chain:

- The technical and creative choices available are numerous;
- The advantages of digital and analogue methods may be combined.

▼ **Pathways through photography**
This is a simplified diagram of the choices available to the modern photographer. Starting with the original scene, you can choose to record through wholly analogue processes (follow the green lines) or capture with a digital camera (follow the blue lines). The hub of the process today is the computer: inputs to it are digital (blue lines) in the form of image files. In the computer the files can be processed for printing or publishing on the internet. The outputs are more digital files, which are turned into analogue images by printers, projectors, and monitors.

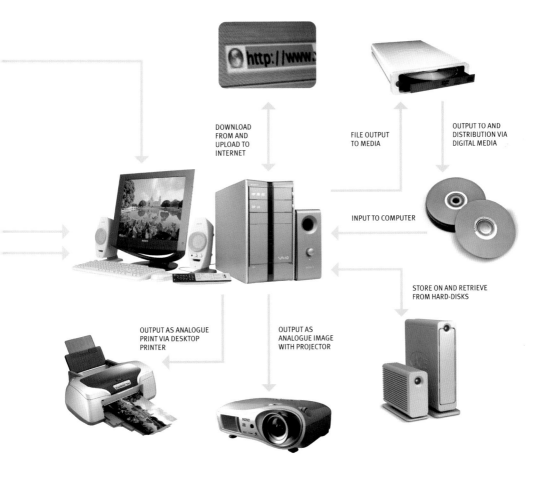

DOWNLOAD FROM AND UPLOAD TO INTERNET

FILE OUTPUT TO MEDIA

OUTPUT TO AND DISTRIBUTION VIA DIGITAL MEDIA

INPUT TO COMPUTER

STORE ON AND RETRIEVE FROM HARD-DISKS

OUTPUT AS ANALOGUE PRINT VIA DESKTOP PRINTER

OUTPUT AS ANALOGUE IMAGE WITH PROJECTOR

IMAGE QUALITY

We strive to create an image that is as exact in its likeness of the subject as possible. We can achieve an exact likeness only with a system offering perfect image quality. In practice, our systems are less than perfect, so the images are not exact reproductions. Image quality comprises a complicated set of factors, some of which are within our control while others are intrinsic to, and set by, our equipment.

SHARPNESS

Sharpness determines the amount of detail an image can convey: it requires the ability to separate two items that are very close together – resolution. At the same time, the separation of detail must be at a contrast that is visible or that can be used by the system. Sharpness is fundamentally limited by the level of correction of lens aberrations (*see* pages 150–1) and by the characteristics of the image capture, such as the quality of the film or sensor being used.

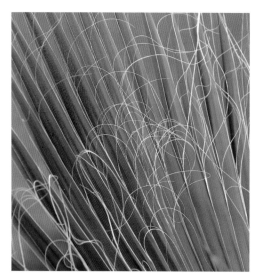

Factors such as accuracy of focus, choice of shutter speed, and aperture setting also contribute to image sharpness. There are other factors, such as mist or dust in the air, that may also limit sharpness, but these are things that are outside of our control.

COLOUR ACCURACY

While strict colour accuracy may be not preferred by viewers over vibrant, saturated colours, it remains a basic requirement. Intrinsic factors such as the colour palette of the film or the sensor's specific responses play their part, as does the colour temperature of the illuminating light (*see* pages 214–15). Other influences are the slight colour casts introduced by lenses and the tendency for saturation to be reduced by internal reflections in the lens.

When printed, the image is subject to more factors – the choice of inks, papers, and printer – that may undo any accurate colour capture. The solution is to work in a colour-managed environment (*see* pages 220–3).

TONAL ACCURACY

A tonally accurate image is one which the photographic system has correctly reproduced the variation of light in a scene. The foundation for this is accurate exposure. The tonality of the image determines the way in which the image reproduces the scale of light, from dark to bright. It can be smooth or it may be stepped; it can also change rapidly from one tone to another, or it can be gradual, with a long range of subtle changes – what matters is how well the tonality of the image matches that of the subject. Tonal accuracy is most important around the midtones.

DYNAMIC RANGE

The dynamic range of an image is the difference between the lowest and highest light levels that have been captured. In the majority of situations, the dynamic range that can be encompassed by photographic systems is much less than that of the scene. Images on paper offer a dynamic range of less than six stops – similar to a very dull, overcast day.

NOISE

Noise causes an underlying random variation in the image, independent of the subject. In film, it is caused by uneven distribution and variations in the size of film grain. In a digital image, noise causes variations in the values of individual pixels and is aggravated with high speed and long exposures and is worse in shadow areas. Noise can damage image sharpness, impairing tonal accuracy and corrupting the purity of colours.

▲ **Sharpness**
Sharpness in the optical system is needed to record the fine strands of fibre but also to display the delicate curves with true smoothness.

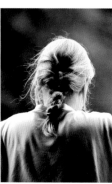

◄ **Tonal accuracy**
Tonal accuracy is essential for proper reproduction of delicate shades such as fair skin and blond hair, as on this subject. Since the dynamic range here is relatively large, it is essential to ensure the exposure is very accurate.

◄ Noise
This image was captured at ISO 1600 but was underexposed, appearing much darker than the original scene. As a result of these factors, there is a lot of noise in all but the brightly lit areas. In some cases, noise can be attractive and appear "photographic".

▼ Colour accuracy
(below left)
When reproducing artifacts, such as a precious Hungarian tapestry, for record-keeping or auction documents, colour accuracy is a requisite of the imaging system.

▼ Dynamic range
Even in very dark conditions, as this celebration of Diwali in Udaipur, India, the dynamic range can be surprisingly large – from almost zero light in the shadows, to very bright flames from the candles – making it difficult for imaging systems to capture all the information visible to the eye.

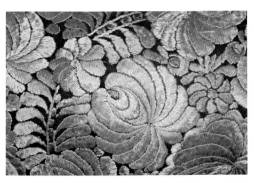

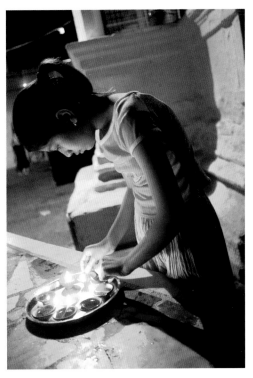

MAXIMIZING FILM-BASED IMAGE QUALITY

Photographers using film can use processes already finely tuned to maximize quality, but they can help by ensuring that they:
- Use the film speed that is appropriate for the circumstances and avoid push- or pull-processing;
- Use film balanced for the light conditions and avoid using colour-balancing filters;
- Fill the frame with the image and avoid cropping vital elements of the picture;
- Expose film as precisely as possible – avoid making exposure corrections when printing or scanning.

DIGITAL PRINCIPLES

The concepts and principles explained in this section may appear highly abstract, but they provide a foundation for an understanding of the fundamentals of modern photography. Two processes are key. The first is that of sampling – how to describe something by examining a representative portion of the whole. The second process is that of compression – the way of reducing the amount of information that is captured by either ignoring or not storing unwanted data – and the companion process of decompression needed to exploit the data. These concepts operate throughout the imaging chain, which forms the basis for the photographic workflow.

SAMPLING

The initial step of the photographic process always involves sampling – taking a small part to represent the whole. Each component of the photographic process samples in a different way, and our control over the photograph depends on our command over each type. For example, pressing the shutter button is itself sampling: you select a moment from a continuum of change to represent an entire event – whether it is a holiday or a nation at war. At the same time, the limited resolution of the recording medium ensures that we can only sample details from the subject. Higher sensor resolutions or larger film enable us to sample more of the subject to obtain greater detail.

COMPRESSION/ DECOMPRESSION

The photographic recording process always uses compression. For example, consider the reduction of a landscape onto a small piece of film or sensor chip. In order to make use of the compressed information, we need to decompress or unpack the data. From film, we decompress the data to make a print that is much bigger by using an enlarger. The brightness information in a scene is also compressed when recorded on film: the scene's luminance range is represented by a relatively small variation of opacities in the film. Another way in which compression takes place is the loss of detail that occurs when a lens projects only part of the image as sharp, and of course, all the complex data about a three-dimensional space is lost when recorded onto a two-dimensional surface.

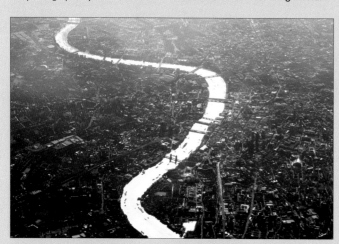

▲ **Sampling and compression**
An aerial view is a sample of an aircraft journey – an instant taken from a long flight, and only one view from an infinite number of views. It is also highly compressed. A large area of land in view is condensed into a small image.

▶ **Processing artifacts**
Artifacts introduced by the camera or photographer – such as the haloes around the house caused by excessive sharpening – are impossible to eliminate once they are ingrained in the image. The data is corrupted, and the only way to correct the situation is through retrieval of the original file, which is free of artifacts.

WORKING PRINCIPLES

Sampling and compression/ decompression are processes that are intimately tied with photography. One could say that a full command of the photographic process is a command of the precise nature of the sampling and compression that occurs with each step. For example, if the data is too compressed or sampled incorrectly, it is impossible to extract useful

information: the image may not show what we want, or the quality will be poor. If there is more data or quality than is needed, we are not working with maximum efficiency.

These thoughts lead to some fundamental working principles, and keeping these in mind as you work will help you to understand the reasons for using a certain workflow or technique.

- The information content of an image is greatest when it is first created. A image cannot be processed to increase the amount of information it contains. Image processing can improve the appearance and readability of the information you do have.
- Each step of the imaging chain introduces artifacts into the image. These arise from properties of the capture system, such as lens aberrations; those from image acquisition, such as grain; and those resulting from post-production, such as sharpening.
- Each type of artifact calls for specific corrections. Much of the work of digital photography is, in essence, artifact correction.
- Errors introduced at one stage of the imaging chain are passed down and cannot be eliminated.
- Information or data in excess of what is needed or can be handled by a system is ignored for the purposes of the output. Excess data reduces efficiency without contributing to its enhancement.

- The imaging chain is hierarchical: what can be done at one stage will depend on, and be constrained by, effects of earlier actions. You obey this principle when, for example, you change from one mode of working to another to apply a certain effect.

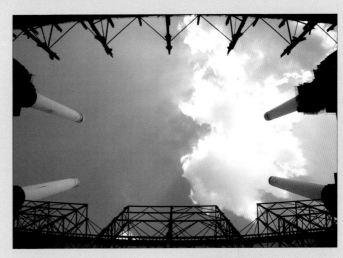

▲▼ Artifact correction
Artifacts come in many guises, and one of the most obvious is distortion. Here an extreme wide-angle view of a power station shows barrel distortion, causing the straight lines of the building to bow outwards. The defect is easily corrected using software (*left*).

◄ Colour negative (*far left*)
The colour negative looks bland and flat, with cloudy highlights and weak shadow areas. Not only is the tonal range highly compressed compared to the original scene, but colours are washed out and the hue variation is barely distinguishable.

◄ Colour print
When printed out on relatively high-contrast paper, the negative yields bright colours with subtle variations of hue and tone, as well as lively contrast. The image has been uncompressed to produce a full greyscale and range of colours.

WORKFLOW

The concept of workflow is the practical expression of the metaphor of the imaging chain. Workflow starts with settings for your various devices and computer, followed by a sequence of operations – such as that needed to output digital images – to achieve the best quality results in the most efficient way. By understanding the concept, you can make decisions that ensure your photography meets the demands that will be made of it. The aim is to save you unnecessary work, which leaves time for photography, while maintaining high image quality.

KEY POLICIES

In order to work out a workflow that suits your circumstances, bear the following points in mind:

- A decision to work with small image files will limit your choices later on. It is better to work with the largest files you can handle: mass storage in the form of hard-disk drives is relatively inexpensive.
- Quality losses sustained at an early stage, such as capture using low-quality lenses, cannot be corrected without other loss at a later stage. It is best not to compromise on quality without good reason, such as great expense.
- However, higher image quality means increased overheads, such as greater storage needs and slower processing of files.
- Greater flexibility in image processing usually entails more time spent processing images but with a pay-off of greater quality. This presents one argument for working exclusively with raw files.
- Your systems should always guarantee the integrity of the original image file. This means that either you always work on a duplicate file or, if you open an original file, that you never save changes to the original but always "save as" a new file. In addition, always keep back-up copies.

WORKING PRACTICES

Establish your priorities before starting photography: this helps you decide what kind and size of file you work with, as well as the default settings for your camera, scanner, or image-manipulation software. Review these points when deciding on your own strategies:

- Always set exposure, white balance, and focus carefully.
- If quality is primary, set the camera to save raw images.
- If convenient file handling is most important, set camera to JPEG.
- If you need to work quickly and want to avoid post-processing on the computer, optimize the

▲ **Enlargement**
This image is a section about ¹⁄₄₀ the width of the entire image: at the size printed here, the whole image would be 1.5m (5ft) wide. This is possible only because the original file is nearly 5000 pixels wide, thus able to retain skin gradations and fine detail.

▶ **Large file used small**
This image is from a 16.7-megapixel camera, producing a file 47.5MB in size. At this size of reproduction, the quality is essentially indistinguishable from an image file produced by a 3-megapixel camera.

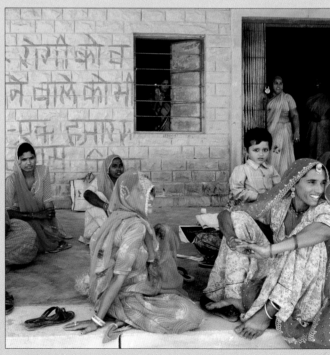

images using the camera settings. For example, you can increase saturation and sharpening, but it is likely to compromise quality.

- If you need to maintain high quality, do not apply in-camera enhancements such as contrast, saturation, or sharpness.
- If the size of the image from your camera or scanner is ample for all your needs, you can afford to work with JPEG files.
- If the size of the image from your camera or scanner is less than adequate for your needs, work with raw from the camera or TIFF from scanner. Use specialist interpolation software to increase the file size.
- Scans corrected by the scanner may look better, but the scope for further corrections can be limited (*see* pages 286–93).
- For utmost quality, carry out as many manipulations as possible in 16-bit per channel colour before converting to 8-bit for distribution.

SOFTWARE SETTINGS

A neglected aspect of workflow is the proper set-up of your most-used software. You will save yourself a lot of time and effort if you set up shortcuts for frequently used effects and corrections such as Curves or Levels in Adobe Photoshop.

COLOUR SETTINGS

Colour management (*see* pages 222–3) is vital to the photographic workflow. Inappropriate or incorrect settings will lead to inaccurate colour reproduction, particularly when images are used by a magazine publisher, for example. However, if you do not supply images to third parties such as publishers, websites, or agencies, it is possible to get by without rigorous colour management.

- For images mainly intended for print, the most commonly adopted working (not output) colour space is Adobe RGB (1998).
- For images intended for highest-quality output, including to film, use ProPhoto RGB colour space.
- For images mainly intended for use on the internet, the standard working colour space is sRGB (also known as IEC 61966–2.1:1999).
- Match the output colour space to each printer that you use; apply printer profiles as needed.
- Embed correct colour profiles in every image that you supply to third parties.
- Set your software to automatically convert colour spaces of income files so they all match your standard spaces. If you are in a work-group environment or you work for outside clients, follow an agreed policy.

▲ **White balanced** (*top*)
A properly white-balanced image shows clean whites and a wide range of colours, more or less equally represented. This image will be easy to fine-tune and tolerate a lot of manipulation.

▲ **Not white balanced** (*bottom*)
In this image, tungsten illumination was not corrected, leading to a tinted greyscale (bottom of the image). Also note that the blues have been reduced to large areas of near black, signifying loss of data.

▲ **Adobe RGB (1998) space**
This image is a photo-mechanical output of a test chart saved in Adobe RGB space. Its range of colours is limited compared to that visible in either the original test chart or the image viewed on a high-quality monitor because it has been transformed by the CMYK space (*see* page 223).

▲ **sRGB (IEC 61966–2.1) space**
This is a photo-mechanical output of a test chart saved in sRGB or IEC 61966–2.1 space. The range of colours is smaller than that visible in the original image, but more importantly, the colour range is just visibly less than that of the same image in Adobe RGB space (*see* left).

THE USES OF PHOTOGRAPHY

An extremely broad range of modern activity employs or depends on photography, exploiting its visual properties not just to record and communicate, but also to create templates for manufacture, to guide industrial processes. In fact, it is hard to think of any aspect of modern technology that does not depend in some way on photography.

We use photography for three distinctly different tasks. The first is record-making: it is used purely to record information in an objective, reliable, and reproducible way to create accurate and dependable information, as free of human interpretation as possible. Another use is as a template: patterns are recorded photographically to be used to etch plates or masks for printing road signs or fabricating circuit boards and integrated circuits.

The third use is the most familiar. It, too, is based on photography's ability to record, but we add meaning and significance, using accepted visual codes and following explicit rules, in order to communicate with the photograph. We will look at a few examples of the range of modern photography.

SCIENTIFIC PHOTOGRAPHY

Scientists use photography to record tracks in bubble chambers for nuclear research, to measure buildings and aerial views using photogrammetric techniques, to monitor the progress of experiments and the movements of groups of animals.

Photography's ability to record with dimensional and objective accuracy is often exploited. Measurements of photographs enable scientists to calculate dimensions without exposing themselves to radiation, for example, and in the convenience of the laboratory. Photographs speed up surveys immeasurably: when measuring the wingspan of birds caught for surveys, a photograph can record colorations at the same time.

SURVEILLANCE

In the current era, many photographs are not captured by people but by machines – robots or remotely controlled cameras. These include not only security cameras monitoring private and public spaces – from shops and banks to building entrances – but also speed cameras, satellites orbiting the earth, and cameras on military robotic aircraft.

INDUSTRIAL

Photography is vital for many industries – for example, the masks used to create microprocessors use an ultra-high-precision camera. Everything that uses a mask in its fabrication – from T-shirts to street signs to drinks containers – is likely to use a photographic step at one stage.

Mass printing of books and magazines using lithographic processes, such as those relying on the water-repellent properties of oil-based inks, are essentially photographic in nature. Photography is also used in quality-control processes, the monitoring often automated with image analysis software.

FORENSIC AND MEDICAL

Photographs of evidence at a crime scene or accident record the position and exact conditions with a precision that is widely accepted as objective and

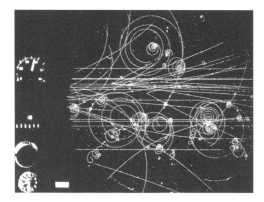

▲ **Sub-atomic photography**
Sub-atomic events were recorded using special liquid chambers in which the particles, moving at nearly the speed of light, leave tracks that can be photographed, resulting in remarkably beautiful images of immense scientific value. This image dates from the 1970s.

▼ **Documenting and measuring**
The simple device of including ruler measures and controlled colour patches can greatly increase the objective and documentary value of a record. These snail shells are immediately given a scale and a way of checking colour accuracy.

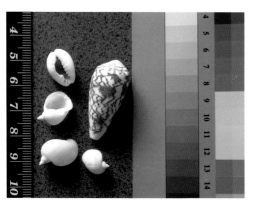

dependable. It is forensic evidence – useful for legal processes and generally accepted in a court of law. Photography often provides the only permanent record of the scene of an accident – for example, before the debris is cleared away to reopen a road.

Photography in medicine is important for record-keeping, teaching, and diagnosis. The ability to transmit images by satellite phone or internet is widely used by aid agencies to enable specialists who aren't at the scene to advise on care in the field. In this situation, image-making uses not only visible wavelengths of light but a wide range of emissions, from X-rays – a central pillar of medical diagnosis – to ultrasound and nuclear decay, to examine deep body tissues without invasive surgery.

COMMERCIAL

Photography is widely used to document progress, goods, and conditions across numerous commercial enterprises. For instance, a photograph of a group of gas meters allows many readings to be recorded at the same time. Cameras can be linked to a GPS (Global Positioning System) so that pictures can be automatically tagged with locations for things such as surveying land use and studies of environmental impact. Cameras are essential for providing records of anything from warehouse bonds to recording the look of new products for possible purchase. Photography is also a key tool of industrial espionage – the copying of new designs to make pirate copies, for instance – proving its ability to record a great deal of information in an instant.

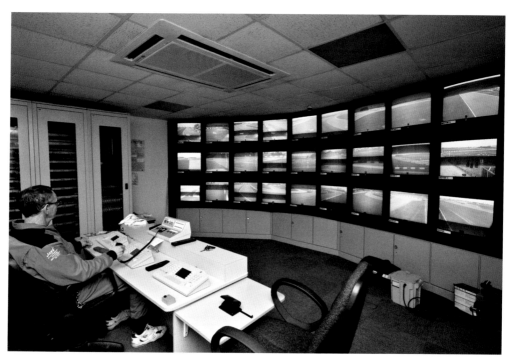

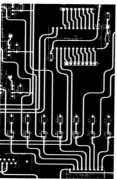

◄ Industrial
Ultra-precise masks are drawn in large scale then reduced photographically to actual size. This varies from the circuit-board mask shown, where lines are 1mm (0.04in) wide, to microprocessors whose lines are a few microns wide.

▶ Medical
A photographic record of a patient's skin is the most concise, cost-effective way to monitor their health over a long period of time.

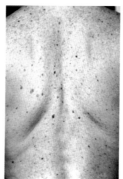

▲ Surveillance
Remotely controlled robotic cameras enable a single watchman to monitor a large area – in this case, the racing track at Silverstone, England – while simultaneously keeping a record of all events.

AMATEUR

In this category of use, photography is motivated by the need to document – the first baby, life's milestones, and holidays – plus the sheer enjoyment or fun of photography as an activity. Photography is therefore also an end in itself, in which pleasurable attention to technical and artistic quality often far exceeds what is necessary for mere recording of events or scenes.

Amateur photography is vital to the photographic industry as the main engine driving innovation, keeping prices low and manufacturers competitive. For instance, amateurs adopted digital photography far more readily than professionals, and it is their enthusiasm that has brought professional quality down in price. Amateur photographers also take far more pictures than professionals do, making up the majority of the hundreds of millions of images taken each year worldwide.

PROFESSIONAL

Once the domain of a handful of elite, professional photography is now open to anyone able to afford a prosumer camera and willing to make the necessary effort. Prosumer cameras are designed for amateur photographers but are able to produce professional-quality images.

At one end of the spectrum are the traditional sources of income for professionals: advertising for products and a way of life, and editorial photography for magazines and enterprises needing pictures for reports and promotions.

▼ **Landsat 7 – 18.12.2002**
This image of Lake Chad, which lies at the edge of the Sahara Desert, is part of a disheartening series of images showing this body of fresh water shrinking when the rivers flowing into it dried to a trickle.

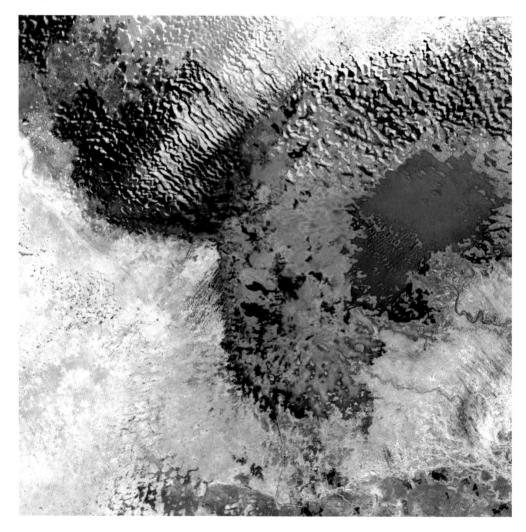

There is still demand, but competition for work is now stronger than ever. Traditional sources – private commissions such as formal portraits, weddings, and other events – have been severely reduced for professional photographers because amateurs can easily access high-quality equipment and do the job themselves.

Nonetheless, the range of possible sources of income has also grown enormously, since photographic illustrations are mandatory for many publications, however modest – from the local newsletter to the club website. And there are opportunities for the keen photographer working for smaller businesses who can neither afford nor need full professional services.

New sources have also emerged: amateurs can advertise and sell their images to the world at minimal cost through through picture libraries.

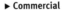

◄ Record for copy
An image of a wall hanging can capture an enormous amount of detailed information that can be enlarged to life-size for copying purposes.

► Commercial
This ruined property in Tuscany, Italy, has been photographed not only for posterity but to provide information for developers, backers, and architects in preparation for renovation.

◄ Amateur cat
The cat is already among the most documented of all animals, so there is seldom a pressing need for the highest image quality. But there is also little enjoyment in not trying to obtain the best possible image of family pets.

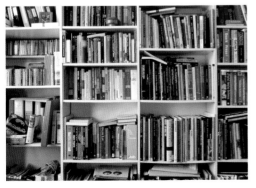

▲ Microstock
A search for "red" brings up 25,000 images on what is a relatively small website. These images are available for as little as $1, which buys unlimited usage in time or territory.

◄ Professional
An image of a private library with crammed bookshelves is hardly very professional, but it has earned the photographer a modest sum from people willing to pay for its use.

EYE AND CAMERA COMPARED

We use the term "human eye" in two ways. The primary meaning refers to the organ of sight itself, its anatomy and characteristics. The other meaning is shorthand for the way the eye functions: how it works together with the brain to enable vision, the operation of seeing. In photography, the human eye is not only what you see with to photograph, it also serves as a model for the photographic process. And most importantly, it is the standard by which photographs are judged: an image's colour fidelity, detail (resolution), and tonal qualities are all judged against the performance of our own eyes.

THE ORGAN OF SIGHT

The optics of an eye consists of the front cornea, lens, and aqueous humour in between: these lie at a fixed distance from the back of the eye. As a result, focusing takes place not by moving the lens forwards or backwards, as in a camera, but by changing the shape of the lens through the squeezing action of muscles surrounding the lens. This alters the lens's curvature to accommodate for different viewing distances.

At the back of the eye is the light-sensitive "capture surface", the retina. It consists of the cone cells, which register colour but need high light levels, and the rod cells, which work in low light but have little or no colour discrimination.

Because it lies on the inside of the spherical eyeball, the eye's capture surface is curved in two dimensions – in contrast to the flat capture surface used in cameras.

ADAPTING TO BRIGHTNESS

The amount of light entering both systems is controlled in similar ways: by varying the size of the iris or pupil. However, the eye adapts to levels of brightness in two distinct ways. Normally, the eyes' pupils change their shape dynamically to let in more or less light according to outside conditions. And when the eye searches into a dark area, the iris opens up to admit more light, while a brighter area within the scene may cause the iris to close down a little. This adaptability enables the eye to work in scenes with a very broad luminance range.

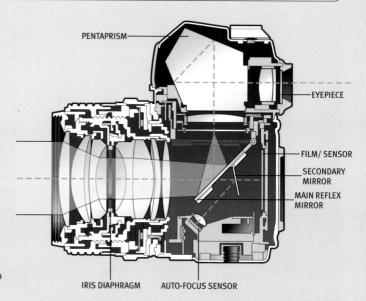

PENTAPRISM

EYEPIECE

FILM/ SENSOR

SECONDARY MIRROR

MAIN REFLEX MIRROR

IRIS DIAPHRAGM AUTO-FOCUS SENSOR

▲ SLR camera
The light path in cameras, such as a single-lens reflex, involves multiple reflections and inversions. As a result of these, the instrument is bulky and complex with many fine adjustments needed to ensure the accuracy of alignment of all parts.

▼ Human eye
In contrast to the camera, the human eye is optically the simplest possible and highly flexible. It also works for an amazingly long time. But the parts are extremely fragile and need constant upkeep to maintain their condition.

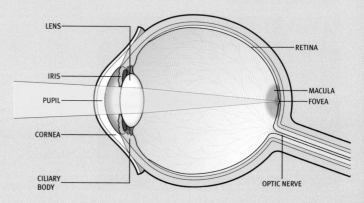

LENS

RETINA

IRIS

MACULA
FOVEA

PUPIL

CORNEA

CILIARY BODY

OPTIC NERVE

In darker conditions – light levels at o.1cdm² (candelas per square metre) – the retina supplements the wide-open pupil by bringing the rod cells into operation; this takes several seconds. It has the effect of increasing the retina's sensitivity. However, that is obtained at the cost of losing colour as well as a reduced ability to discriminate detail.

As a result, the eye can work in different circumstances over extremely differing luminances – ranging from moonlit nights to equatorial middays.

SEEING DETAIL

The retina covers about 65 percent of the interior surface of the eye. One set of sensors – the rods (about 120 million, two microns wide) – works at low light levels and is relatively insensitive to colour. The other set – the cones (about seven million, six microns across) – works in brighter conditions.

Unlike photographic surfaces over which capture is uniformly distributed, the light-sensitive area in the eye is functionally very uneven: colour and detail perception is concentrated into a small area – directly facing the back of the lens – called the macula, into which the majority of cone cells are packed. The centre of the macula, is called the fovea, which is densely packed with only cone cells. As a

▲ **Dark priority**
A brilliant shaft of sunlight picks out the hair and white blouse: the camera exposes this correctly but at the expense of leaving the unlit part almost black. To the eyes, the shadow area is not black.

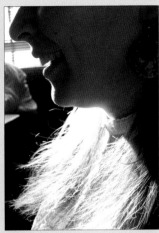

▲ **Light priority**
An exposure that brings the unlit areas to a level similar to that seen at the time has the side-effect of making the sunlit area far too bright, with loss of detail, tonal nuance, and colour.

result, the most detailed vision covers not more than 2° of the field of view. In normal vision the fovea scans the scene, applying some six million sensors (from each eye) to small portions of the scene to build up a detailed picture.

The process is not like digital scanning, since the result of human vision is not a single, coherent image. But normal vision is like looking at tiny portions of a scene using a 12-megapixel camera.

SEEING COLOURS

In good light, the human eye can distinguish at least 10,000 colours at a given brightness, and over different brightness levels many thousands more colours may be added.

The eye is most sensitive to greens and least sensitive to blues. Our perception of colour depends on light levels, with reduced ability in dark conditions. However, cameras can see the colours perfectly well at any lighting level, provided exposure is sufficient. This is why images captured in dark conditions can appear surprisingly full of colour, which we were unable to see at the time. A small proportion of the population suffers from colour blindness, which is commonly a reduced ability to see red-green colours. This may be as a result of a number of causes, one of which is a lack of certain types of retinal cells.

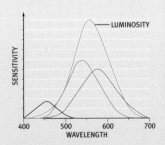

▲ **Colour sensitivity**
This diagram shows sensitivity to violet-blue is very low (it is magnified 10 times to display on the graph), while sensitivity to reds and especially greens is much higher. As a result, the perception of luminosity is a combination of red and green, and brightness sensitivity peaks in green.

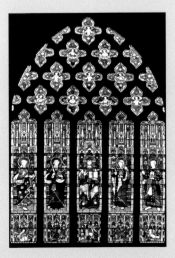

◄ **Colour recording**
Photographs can capture several thousand colours, at best to give an acceptable representation of a complicated subject such as stained-glass windows. But the camera cannot capture the subtle dark and very bright colours that the eye can distinguish with ease.

VISUAL PERCEPTION

▲ **Branches in dark**
In the dark, very small differences in luminance are detectable. During the day, the variation in luminance visible here would be swamped by light and would be completely invisible – to both the eye and camera.

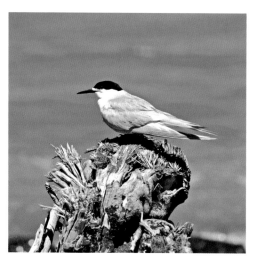

▲ **New Zealand tern**
The eye has evolved to maximize depth of field, with constantly adjusting focus. In photography, only one (sometimes extremely narrow) space can be in focus, producing blur effects unknown before the advent of photography.

Photography's view of the world is very similar to ours because we designed it that way. However, differences remain. It is useful to appreciate the way our visual mechanisms work, because what we see may not be what we record in our photographs.

WEBER-FECHNER LAW
Fundamental to our experience of photography is the way we respond to changing levels of light. The amount of extra light needed to make a dim source appear doubly bright is much less than the extra light needed to make a bright source appear brighter.

In fact, although a physical stimulation increases logarithmically in strength, the sensation increases only arithmetically. These two statements make up the Weber-Fechner Law. In practice, the law tells us to expect that the minuscule changes visible to us at low light levels are difficult to record.

FOCUS AND DEPTH OF FIELD
The eyes adjust continuously to changes in the subject: you adjust focus to ensure that the point of attention is sharp, allowing all else to fall out of focus. In photography, one single focus setting must be settled on before you make the shot. On the other hand, depth of field in the human vision is not as easily controlled and manipulated as it is in cameras.

LIGHT AND COLOUR ADAPTATION
The eye's ability to adapt to varying light levels was discussed previously (*see* pages 26–7). This means the eye continuously adjusts its sensitivity to suit the prevalent light level. Perhaps of more practical consequence is the eye's ability to adapt to large brightness differences in a scene in a way only the most advanced photographic systems can match. As a result, we need to take precautions to control the dynamic range by using, for example, fill-in flash (*see* pages 196–7) and adjusting highlight and shadows.

The eye also adapts to the colour of the illuminating light, automatically compensating to render highlights as white as possible. This has been emulated by photography only in its digital era, in the form of automatic white balance. Before, films had to be matched to a nominal standard light to ensure correct colour reproduction (*see* page 217).

THREE DIMENSIONS
Normal sight sees the world from two separate viewpoints that are fused to give a sense of three dimensions – depth, as well as height and width. With normal photography, the sense of depth is collapsed onto one flat surface. To compensate, we exploit visual markers and compositional tricks to create a sense of

▲ **Urban scene**
This image shows a building site. One viewer may wonder if it is safe to be in the area at night or worry that demolition has released pollutants into the air, while to another viewer the dark clouds may suggest an imminent storm. To the photographer, the scene shows urban ruin with contrasting colours – rural green, dark sky, and bright foreground. All are examples of the image's intertextuality.

▶ **Mirrors**
There are numerous cues that this image is of something three-dimensional – from the converging parallels to overlapping elements, curved mirrors, and the same-sized objects appearing smaller with distance. Yet the image is still two-dimensional.

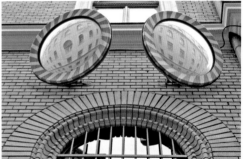

depth in the image. It could be said that much of our inventiveness and effort in creating compositions are devoted to overcoming photography's weakness in the third dimension.

INTERTEXTUALITY

For the camera, only the light that enters the lens is captured on the image. Our experience of the image takes in everything around it – including the design, where we view it, and how we view it, as well as text or images that accompany it. Your consumption of the image will also be coloured or modulated by your memories, likes and dislikes, and prejudices, as well as emotions stirred up by the image. This adds a cultural or contextual dimension to the visual experience and its interpretation, and may be referred to as the image's intertextuality.

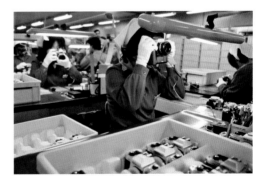

▲ **Nikon factory**
To the observer, the lighting in this camera factory is pure, neutral white, but colour film balanced for daylight has recorded a strong green tint arising from the fluorescent lamps. The photographer must constantly be on guard that what his or her eyes see may not be what the capture surface records.

COMPOSITION

Composition is a key skill of photography: it is the skilful control of the disposition of elements within the picture frame for expressive effect. "Disposition of elements" suggests that you have to work with what you find. This has a most important consequence for practical photography outside the studio, and often even within the studio: picture composition comes primarily from indirect changes – from the choice of camera position.

PERSPECTIVE AND POSITION

The perspective of an image is the way in which three-dimensional objects with depth are rendered onto a flat, two-dimensional surface. The process is performed by the lens in such a way that more distant objects are rendered smaller than near objects, and parallel lines appear to converge on the horizon. This means that the perspective of any image depends only on the photographer's (or camera's) position.

Therefore, perspective cannot be changed by lens setting. We may refer to a "long-focal-length perspective". This is shorthand for viewing the subject from a great distance using a telephoto lens in order to make objects appear to be similar in size and near to each other (see pages 142–3).

A "wide-angle perspective" of the same scene means, in contrast, viewing it from a reduced distance, which tends to exaggerate differences in size as well as the relative distances of objects (see pages 146–7). The beauty of perspective control is that it is free: all you have to do is walk around, close to and further from the subject, to find a viewpoint that gives a visually effective perspective.

▼ **Children dancing**
The activities during Independence Day celebrations in Tashkent, Uzbekistan, are organized in the image by a framework of people defining the far distance to contrast the close-up perspective.

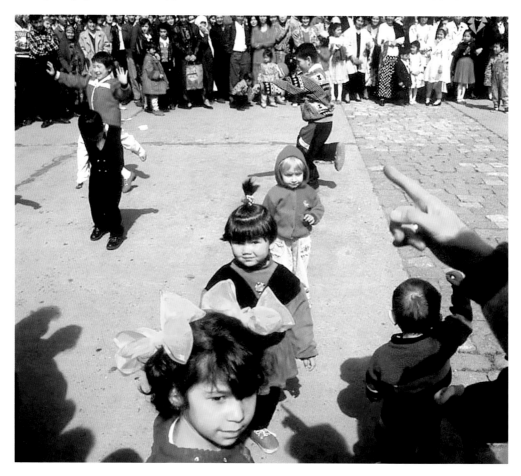

PROPORTIONS

There are two ways to control the proportions of a composition. We can vary the shape of the image canvas by using anything from a square shape to a tall or wide thin one – even a rounded frame.

Square frames offer a feeling of stability and the most neutral effect. Rectangular frames of between 1.3:1 (4:3) and 1.5:1 (6:4) are the most popular, while those of greater aspect ratio such as 16:9 or 16:7 can be effective for landscapes. We also control the proportions of the composition through the placement of key elements within the image.

The composition of an image can convey broad notions according to the placement of the main subject and the resulting proportions of the space around it, as follows.

- Subject placed centrally: an image divided into two equal halves suggests stability, solidity;
- Subject placed one third of the way into the image: image space divided into unequal one-third and two-third portions may suggest dynamic equilibrium;
- Subject placed at Golden Ratio (see below) may suggest balanced, elegant proportion;
- Subject placed very close to the edge or cut into by the frame may suggest instability, vitality, or an imminent sudden change.

▶ Golden Ratio

The Golden Section is the foundation for the Rule of Thirds. This says that if you divide up a picture into thirds and line up major elements with the sections, the resulting composition will appear pleasing. The Golden Ratio is one that is seen in nature and has been recognized since ancient times as giving satisfyingly balanced compositions. It is the ratio where the longer section divided by the shorter section is the same as the total length divided by the longer section; it equals approximately 1.618. The Rule of Thirds ratio is approximately 1:1.667.

This image shows how the key element of the image was placed precisely but instinctively at the junction of the Golden Section lines – there were no guides in the viewfinder.

◀▲ Perspective and viewpoint
A viewpoint at ground level tends to overlap compositional elements, which may lead to compositional confusion unless care is taken to give each element its own space and function. Viewpoints higher than normal tend to separate compositional elements, reducing distance cues from overlap. A normal or long focal length tends to equalize the size of objects.

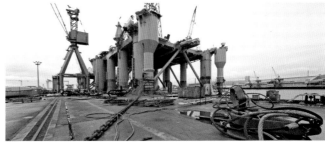

◀▲ Vertical or horizontal
The massive structure of an oil rig demands to be placed centrally. Located off-centre, the image would look lop-sided unless balanced by an object that, if not equally massive, at least offers equal visual weight. The wide, narrow format is ideal for concentrating the viewer's attention on the centre of the image – cropping off unnecessary foreground and sky – making it ideal for wide views. It is easily created by cropping the top and bottom off a suitably composed image.

GUIDING THE EYE

The big question is, how do we know when a composition works? How can we be sure that someone viewing the image will think the elements are skilfully arranged and that they will convey our intentions effectively? Practical experience shows that much depends on how cleverly and successfully we succeed in guiding the viewer's eye around the image.

For this, the key element is the shape of the picture within the frame; and this in turn depends on how we structure the picture space. These may be said to be the "achromatic" features – those defined solely by line, light, and shade. Another element altogether enters when we work with colours (*see* pages 202–3).

SHAPING THE IMAGE

Strong shapes are characteristic of effective photographs. The distinct and easily recognizable shape of a face or human body is one of the reasons why portraiture and nude photography is so rewarding: the subjects guarantee strong shapes.

With other material, you may have to wait for shapes to form – birds wheeling in the sky, sheep in a field – or, if working on a landscape view, move around until you see a strong shape emerge. Shapes that can be reduced to simple forms – a square, diamond, or circle – tend to be the most effective.

▼ **Implied space**
This image relies entirely on implied spatial relationships and implied movements for its atmosphere and energy. The figure just entering into the frame swings his camera forward, following the progress of the bicycle and tuk-tuk. At the same time, the shadows and the line of the road impel further movement into the picture.

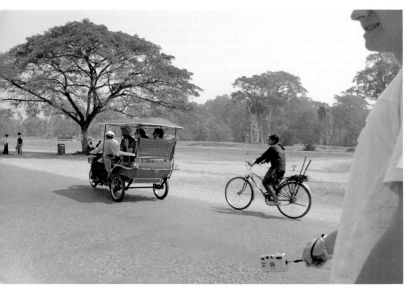

▲ **Shapeless**
There is some dynamism and balance between the shapes, lines, shadows, and light in this picture, but there is no focus, no resting place for the eye. It is a composition, but is it an effective one?

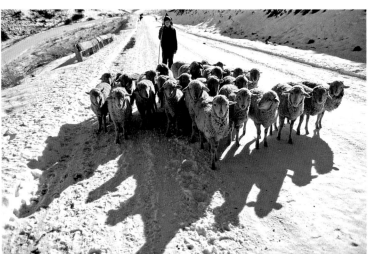

◄ **Sheep shape**
A small herd of sheep huddle together in freezing temperatures in Kazakhstan. For a moment their shadows are organized in a visually coherent way, offering a strong shape that complements the road receding behind them.

▶ **Implied space**
In this shot, taken in Morocco, the man on the bike appears nearest not only because he is larger than the other four men; he is also central. His movement complements the implied movements of the other men, all of which suggest space, organized within a geometric framework.

▼ **Confusing overlap**
Strong shapes such as the cow's head and the man's arm and face are separated by overlapping. By cutting off every element, the photographer introduces a sense of chaos and rapid change in this picture taken in India.

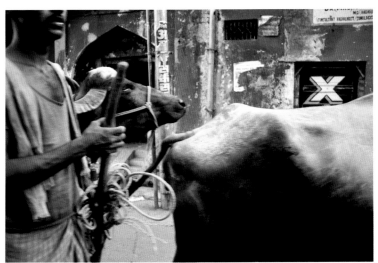

▼ **Framing composition**
This archway of a ruined tower in China frames another distant tower. Without the framing device – and the curved movement it suggests – the image of the tower would be without shape and a dull composition.

Another way to shape the image is to create a frame, using, for example, a doorway or branches of a tree. The frame offers a reference against which less strongly shaped subjects can relate. The practice of darkening – or vignetting – the corners of the image is another way to shape the image. The darkening helps emphasize the central portion of the image, guiding the viewer's eye away from the periphery and to the heart of the image.

• Practise half-closing your eye when you examine a scene – it helps to reduce the detail and reveal the overall shape.
• Shapes on location are often easier to find if you are able to look down on the scene.

STRUCTURING THE SPACE

The magic of picture composition is in convincing the viewer that the scene before them is three-dimensional, with distance that enters into the picture as well as height and width. For the illusion to work, we have to structure the picture space in a convincing way, employing all our knowledge of visual perception.

We use converging parallel lines to suggest distance, we overlap objects to show which are nearer, we use variations in scale to give perspective, but above all, we try to draw the viewer into the space. One method is to invite the viewer to roam around the image by offering a lot of things to look at, and at the same time gently guiding the eye to a focal point. A road that winds into the distance offers a visual narrative, as does a spiral staircase or a meandering river.

It is satisfying for the viewer to be taken on this guided tour of the image as you offer what amounts to a narrative or visual story within the one image. There is a start – the initial visual impulse to look at the image; then a middle – the exploration or "guided tour" of the picture; and the finish – a satisfying finale, perhaps understanding what the photograph is about or being left with intriguing questions.

• The most rewarding movements are usually the simplest – a diagonal across the image or a spiral from the edge to the centre, for example.
• A good test of a structure is to turn the image upside down; if you can still see the "movement", it is a strong and well-composed photograph.

A field of bright colour attracts the eye, but the repeated pattern of flags also draws attention to other parts of the image.

ANALYSIS: COMPOSING WITH LINES

Lines fulfil many roles in photographs. Not only do individual lines delineate or outline shapes, functionally related lines group together to suggest another level of information. This is about the structure of the space: sets of lines we know to be parallel in nature but that converge in the picture signify spatial depth. Other lines lead the viewer's attention from one part of the scene to another. Yet other lines divide the picture space into compartments, corresponding to differing perspectives and scale. In this image, different lines interact to give rhythm, convey space, and imply movement to create a visually rich experience.

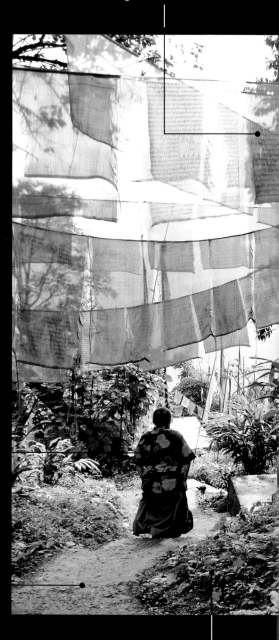

A figure walks towards the centre of the image, travelling left to right – a natural reading direction for many viewers – leading the eye into the rest of the composition. The lively colour contrast of her dress is a visual bonus.

The footpath, with its weak converging parallels, not only leads the eye into the picture, it offers a point of human interest: it is important to reward the viewer's cooperation in exploring an image.

Rich and soft textures of the vegetation offer a welcome contrast the complexity of line and quasi-regular patterns.

A strong vertical line located near the Golden Section divides the image into two, each with its own perspective, with space receding at different scales.

Contrasting elements – bright colours and lively details – are framed by the dark wall whose lines lead the eye strongly to the right, while the detail is in another direction, leading to visual tension.

The repeating elements of the same size – the prayer wheels – and the converging parallels work together to indicate depth and receding distance.

Fundamentals
of light

TYPES OF LIGHT SOURCE

PROPERTIES OF LIGHT

THE QUALITY OF LIGHT

CONTRAST

BASIC PHOTOMETRY

LIGHT AND EXPOSURE

EXPOSURE AND DEVELOPMENT

THE SPECTRUM

RECORDING COLOUR

COLOUR

TYPES OF LIGHT SOURCE

TYPES OF LIGHT

HMI lamp housing
HMI housings are roughly half the size of tungsten-halogen lamps with the same output, but they can be more than double the price.

Studio flash
A unit suitable for a small studio is shown here: without reflector in place, showing the flash-tube wrapped around the base of the modelling light, which is used to indicate the effect of the flash.

Tungsten lamp housing
Housings for tungsten lamps may be inexpensive but deliver uneven light. They are compact but can become very hot.

Modern photographers are fortunate because they can choose from a wide range of light sources that suit different tasks – from lighting buildings to jewellery, from pets to crowds – and fit different budgets. The choice of light source may be stylistic, technical, or simply practical. The main consideration may be power, but the quality, level of control, and colour are also important. We consider the basic choice here; see also Manipulating Light (*see* pages 178–99) for details on manipulating light sources.

SUN

Light from the sun is the most powerful source we have, but it is highly variable and, in most places in the world, thoroughly unreliable. It is also often unpredictable in quality, while its colour temperature varies throughout the day and sometimes very rapidly. It can be the hardest, most contrasty light, but it can also be the softest. It is misleading to refer to the colour temperature of daylight as if it were constant – it can be very blue but also almost red. An accepted compromise figure is 5600 K. Despite all of that, sunlight is free, available worldwide, and does not require electrical supplies.

FLASH

Electronic flash, which works by using a spark to excite gas in a tube to emit light, is universally available on compact cameras and is even found on phone cameras. It is highly portable but relatively weak and is only effective over very short distances. It requires

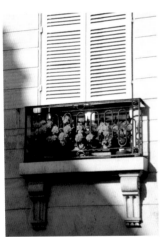

▲ **Balcony – sunny morning**
On a sunny morning the light is bright and harsh, giving hard shadows and desaturating the colours, while the overall tint is on the blue side of neutral.

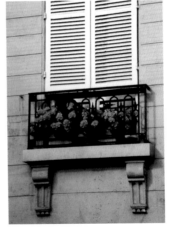

▲ **Balcony – overcast**
When the sun is blocked by clouds, shadows disappear and the lighting is flat with an overall cool tint, while colours appear more rich than in full light.

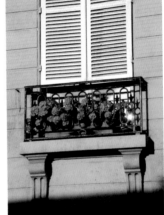

▲ **Balcony – evening**
In contrast to the morning and overcast images, evening light is luscious and warm, bringing out shadows but giving the overall scene a golden tint.

electricity, and power requirements multiply with the square of the increase in light. For example, if you want double the light, you need to supply at least four times more power. Flash can stop fast action, but it is difficult to tell in advance what the effect of the lighting will be except in studio conditions, using modelling lights. Its colour temperature is very stable and can be tuned to nominal daylight of 5600 K.

TUNGSTEN HALOGEN

Incandescent lights, which work by heating a wire in a glass bulb full of gas, are capable of providing very

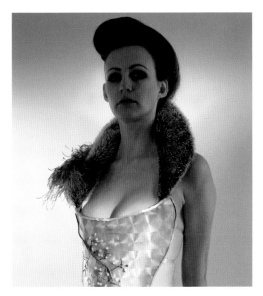

bright light, but they use a great deal of electricity and give off a lot of heat. The colour temperature of these lamps is relatively stable short term but drifts over time and is set to different standards – from about 3000 K to 3600 K – according to use, whether in theatre, film, or a photography studio. It is the easiest to set up because its effect can be continually monitored.

HMI

Hydrargyrum medium-arc iodide (HMI) lamps work by causing an arc or continuous spark across electrodes in a glass bulb containing mercury iodide. They produce a continuous light correlated to about 5600 K and are more efficient than incandescent lamps. However, they require sophisticated electronic ballasts to ensure a steady light output, and this makes them costly and relatively bulky. Their efficient daylight means they are popular for underwater photography.

LIGHT SOURCES AND SCANNING BACKS

Digital scanning backs, used in large-format cameras and, indeed, any scanning device, make stern demands on the stability of lighting. The slightest flickering will register as irregular scan lines, and any waxing or waning of illumination during scanning will also register as graduated scans. As a result, neither instantaneous sources, such as flash, nor flickering sources, such as fluorescent or discharge lamps, can be used. Lighting for scanning backs requires heavy ballasts – electrical systems that stabilize the flow of current to within very narrow limits.

▲ **Tungsten light in use – corset**
Subtle effects involving overlapping shadows, mixed lighting, and translucence demanded by the art director were far easier to create using tungsten than if flash had been used.

▶ **On-location lighting**
Continuous sources are best for lighting animate subjects on location, since you can continuously monitor lighting effects and make adjustments immediately.

PROPERTIES OF LIGHT

Photography is essentially a partnership with light that works with, and exploits, its every property. A sound understanding of the basic properties of light will serve you well. We use light in differing ways. Our camera lenses collect and project light from the scene. This use of light does not change its nature in any way, but it does direct and bend it. We use light to create images. The light must then be captured: this involves making use of its energetic nature, either to create an electric current or to cause chemical changes.

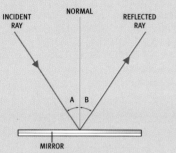

CONCAVE MIRROR

INCIDENT RAY · NORMAL · REFLECTED RAY · A · B · MIRROR

▲▼ **Reflections and virtual images**
Light reflects off a surface in such a way that the angle of the incoming light equals that of the reflected light. We see the object from the reflected ray, which appears to come from behind the surface, as shown in the diagram (*above right*) and the image (*below*). This is a virtual image, but light has been collected by the camera lens then projected as a real image onto the capture surface.

IMAGE FORMATION

Optical systems can create two kinds of image: the virtual and the real. A virtual image is one that cannot be projected onto a surface, so it cannot be directly captured. The most common example is the image seen in a mirror; another example is the enlarged image seen in a magnifying glass held close to an object. You also see virtual images in the optical viewfinders of compact range-finder and autofocus cameras.

A real image, in contrast, can be caught or projected onto a surface such as ground glass or a focusing screen, or onto light-sensitive surfaces. The images projected by camera lenses are real, as are all images captured on film or sensor. Only real images can be directly captured photographically (*see also* pages 144–5).

REFRACTION

Light waves travel from a source in a medium, such as air, until they hit the boundary with another medium, such as water or glass. As the waves travel from material of one density to another, they change direction. Where the new medium is denser than air, it effectively slows the part of the wave that first enters the medium, thus turning the light.

This phenomenon is refraction. The refractive index is a measure of how much the medium bends light. Air has a refractive index of 1.000292, water is about 1.33, glass is 1.5 or more.

Photographic lenses use refraction to bend light using glass of different refractive indexes and shapes in order to form an image.

▶ ▼ Refraction – building
A building seen through very uneven glass shows the effect of refraction on the wavefront of light. Because each part of the incoming image has been bent by different amounts, the result is a highly distorted image.

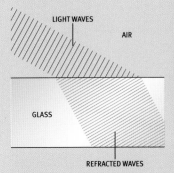

LIGHT WAVES

AIR

GLASS

REFRACTED WAVES

Refraction also takes place at the sensor, where micro-lenses collect incoming light to focus it onto the individual photosites.

REFLECTION

When light hits certain materials that it cannot penetrate, it does not refract but bounces off the surface. This is the phenomenon of reflection. In air, light can travel in a straight line, but when it hits glass, metal, or another solid object, it is forced to reverse its direction. In fact, even when it hits a medium that transmits light, a certain amount of reflection takes place; we know this from seeing reflections in glass and water.

This loss of light is a serious problem where many glass elements are used to construct a camera lens. Modern designs can use more than a dozen different elements, representing over 20 air/glass surfaces, all of which cause reflections that lead to a darker image. In order to combat this, manufacturers apply coatings to the glass surfaces that have the effect of smoothing the suddenness of the transition from glass to air, which reduces reflective losses.

Lenses can be made that use reflection to create an image – so-called mirror lenses, which were commonly used in astronomy. In photography, the majority of mirror lenses are catadioptric, which means they use a combination of refraction and reflection to form an image (*see* page 150). Catadioptric lenses produce a characteristic halo-shaped blur, which limits their usefulness.

▶ Catadioptric image
The image created by a catadioptric lens – which uses both reflection and refraction to project a real image – produces characteristic ring-shaped out-of-focus highlights, as well as distorting the outlines of out-of-focus objects.

MAXIMIZING FILM-BASED IMAGE QUALITY

Diffraction in light occurs when light waves interfere with each other. In photography, these effects are rarely used to create images, although certain lenses use diffractive optical elements. In contrast, diffraction is universally encountered as it sets a limit to the performance of a lens, particularly at very small apertures, where it causes a loss of contrast and resolution. This is why it is not good practice to set the smallest apertures; even if there is a gain in depth of field (*see* pages 84–5), the reduction in image quality is not desirable. Diffraction also limits the smallest apertures that can be usefully set on very small lenses such as those used in compact digital cameras.

THE QUALITY OF LIGHT

In photography we are concerned not only with the amount of light to photograph by, but also with its quality. We need to work with the way the illumination reveals the shape and textures of our subject. If the way your subject is illuminated does not support what you want to say or show – harsh contrast for a wedding portrait, for instance – then it is of little use, however ample the available light.

On the other hand, if the light gives us the exact effect we wish to see, we will struggle to make the most of it, even if there is very little light to work with. To this extent, then, the quality of light comes before its quantity (*see* pages 46–7). We describe light by its hardness or softness, its colour, and its direction. In this section we deal only with the achromatic qualities of light – those that do not depend on colour (for which *see* pages 52–3).

HARDNESS AND SOFTNESS

The ability of light to shape and sculpt three-dimensional subjects varies with its hardness. Hard light reaches the subject almost entirely from one direction. The lit areas are very bright, but unlit areas are dark with razor-sharp shadows – typically it is light from the sun on a clear day. Soft or low-contrast light is diffused: light reaches the subject from many directions at once. All parts of the subject are similar in brightness, resulting in soft shadows; typically it is light from an overcast day.

▼ Mixed light
Many photographs combine hard and soft light in the same image. Here most of the image is in the shade, but the direct sunlight on the man's sleeve and hands enlivens and directs attention to the action depicted.

▲ Hard and soft light
In full sun (*top*), shadows are crisp and so are details in the buildings – all contribute to give the overall sense of a sharper image. With the sky overcast and sun obscured (*above*), the lighting is soft: shadows are blurred or barely visible and textures are not revealed, so overall the image appears soft.

APPLYING QUALITIES OF LIGHT

No light is perfect for all tasks; this table offers a guide for applying different qualities of light.

TYPE OF LIGHT	USEFUL FOR	USE WITH CARE WITH
Hard light	Showing relief Graphic shapes Travel	Portraits Shiny subjects
Medium-hard/soft	Dramatic portraits Nature Showing strong colours	
Soft	Copying documents Plants and flowers Portraits and fashion	Architecture Travel

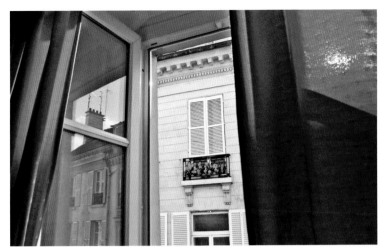

▲ Reflection fills – red curtains
The sun is shining behind the building visible in the window, so it should be in deep shade. Instead it is bright because light reflecting from nearby buildings is filling in the shadows so it appears almost light.

▼ Light from front – girl
This woman is fully lit from the front (catchlights from the windows are visible in her eyes), so textures are suppressed and the outlines of classic beauty dominate.

◀ Light from side – earring
Direct sun on the jewellery brings out all the brilliance as well as casting hard shadows on the face. By using a black background, the harsh quality of the light is minimized.

▲ Light from back – exhibition
The lighting on the person at an exhibition is from above and behind, giving highlights to the hair but not providing a flattering light on the face.

DIRECTION

Light is directional if it casts a significant shadow. The relationship between light and shadow makes understanding direction of light fundamental to photographic technique.

- **Light from one side** of the subject (and camera) tends to bring out shape and texture. On portraits, it throws a shadow of the nose across the face. The more oblique the angle of the light to the surface of the subject, the longer the shadows and greater the effect of three-dimensional relief.
- **Light from in front** of the subject – behind the camera – hides texture and needs large-scale shapes or other contrast to define subject contours. Strong light behind the camera – for example, at sunset – can cast a shadow of the photographer into the scene.
- **Light from behind** the subject – in front of the camera – tends to bring out the overall outline of the subject. It may pick out highlights in, for example, hair, but it throws the front of the subject into shadow. Such light may also cause flare in the lens.

REFLECTIONS AND FILLS

The surroundings may have an important influence on the lighting of your subject, since they may pick up stray light and reflect it back. Light-coloured walls or curtains, windows, and metallic surfaces may be out of the picture, but the light they reflect may be significant. As a result, for example, hard light on a face that is near a white wall may look relatively soft because the wall reflects light into the shadow areas, filling them with light (*see also* pages 180–3).

CONTRAST

The word contrast is one of the most overworked terms in photography. In the context of lighting, it refers to the subject luminance range. This is the difference between the amount of light flowing from the darkest area of pictorial interest, and the amount of light flowing from the brightest area. Contrast in this context is measured in stops, signifying the difference in exposure stops between the brightest highlight with detail and the darkest shadow with detail. A scene with high contrast is one with a large luminance range – a range of about 10 stops. A low-contrast image has a relatively narrow luminance range of about three stops.

SUBJECT LUMINANCE RANGE

What you do in response to the subject luminance range depends on the photograph you are taking. For example, the scene may be flooded by direct sunlight, with deep shadows from trees and buildings: the

contrast appears to be very high. But if you are using a wide-angle lens that takes in much of the scene, all the bright and dark elements are relatively small. They are small enough for the scene to affect the film or sensor like a contrasty image.

What matters is the brightness of visually important areas. This means that if you do not need details in the shadows and you are prepared to let them go black, then you need work only with the bright areas, and these may encompass only a small luminance range.

One important consequence is that different exposures of the same subject may yield acceptable results, but acceptable for different reasons. Overexposure may reveal details in shadows, while underexposure delivers saturated colours against black.

With a narrow luminance range or low contrast – as encountered on an overcast day, or indoor scenes that don't have any natural light – you are working with a limited range of acceptable variants. Such

▲ **Low contrast**
This scene of shadows cast by a setting sun is about midtone subtleties: it will not tolerate exposure error, since an image that is too dark will fill the shadows, and one that is too light will remove the deft highlight colours.

◄ **Average contrast**
This brilliantly sunny day offers a wide range of luminance, from the white stonework to the shadows in the trees. However, the overall image is only average contrast because, in this wide-angle view, there are no areas of high contrast that dominate the image.

▶ **Overexposure and underexposure**

An overexposed image, seen in this simulation (right), shows up the skin tones and details of the people, also emphasizing the sunny day, by draining the water of colour. Despite being overexposed, it is acceptable. An underexposed image (far right) brings out the symmetries of shape and rhythmic lines and realizes the colours in the water. It offers a strikingly different interpretation of the scene compared to the other exposure. Neither image is "correct"; it is a matter of personal opinion.

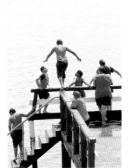
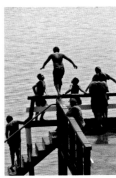

scenes require an accurate exposure because the majority of the scene will need to be rendered as midtone. Overexposure results in a pale-looking image, and underexposure yields muddy pictures.

Contrary to common opinion, it is easier to obtain a usable image from high-contrast scenes than when working in low-contrast situations, because it is easier to deliver an acceptable image in scenes with a wide luminance range.

SPECULAR HIGHLIGHTS

Images of light sources in reflections – such as the sun reflecting off metal, or lamps reflecting off a car's bodywork – are specular highlights. They register as 100 per cent white. In fact, they are technically super-white, brighter than 100 per cent, but that is not recorded in either film or digital cameras. If they were included in calculating the luminance range of a scene, the scene would come out very high contrast, so these must be ignored by metering systems or when making manual measurements.

▲ **Skin tone**

The standard against which correct contrast is measured is skin tone. The light levels are high, but the skin tones show that tonally the image is well within normal contrast.

▲ **Specular highlights**

The reflections of the sun in the ripples of water are impossible to reduce from pure white. In effect, we can ignore them, which makes this an image of limited tonal range – it has only mid-greys and light greys.

▲ **Specular highlights darkened**

Even with the buildings made black, the specular highlights in the water remain. They appear reduced because grey tones next to them have been made dark. The true specular highlights are still white.

BASIC PHOTOMETRY

How we measure visible light is fundamental to photography. The science of photometry is concerned with how much light is emitted from a source of light, such as a flash unit, and how much light is reflected off of a surface. The technical terms and definitions of different units of measurement are tricky to understand, but the essential point is that an elementary grasp of photometry helps you to understand the nature of light and its interactions with photographic systems. All measurements are based on a fundamental unit, the candela, which measures the luminous intensity of a source.

BRIGHTNESS OF A SOURCE

Light, like electricity or mechanical force, is a form of energy that can be used to do work. The brightness of a particular light source will vary depending on how much light it emits and the size of the area over which it emits the light. This is known as its luminous intensity and is measured by the candela. In photography we use units derived from the candela.

▼ **Brightness**
The lights reflected in this red corridor become light source, so the walls appear to be the source of light. The very bright light in the background is blue but overexposure has made it appear white.

Light is emitted from a source in all directions unless it is limited by shades or guided by lenses. In practice, we can consider a cone of light, with the tip being at the source.

The amount of light emitted by a light source into a cone of light is called its luminous flux and is measured by the lumen. This unit is also used to describe lighting equipment.

In photography, what matters is the brightness of light sources visible in a scene, relative to the overall brightness.

The flame of a candle in a darkened room can appear to be very bright, while a street lamp turned on during the day appears weak. Another important factor is that photographic capture limits the absolute luminous flux or intensity that is registered or captured: once a highlight is bright white, it cannot be any whiter (unlike in some types of video capture).

LIGHTNESS

Lightness is the perception of how much light appears to be reflected – not emitted – from a surface. This is called luminance and is essentially what we measure when we take exposure readings. Its unit is the nit (candela per square

▼ Bright white
The sun has burned the highlights to white; it is far brighter than is registered in any image – the luminous flux from the sun is capped or limited by the photographic process. If that did not happen, we would have great problems balancing very bright areas with dark areas.

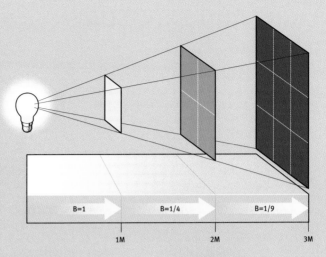

B=1 B=1/4 B=1/9

1M 2M 3M

metre). A typical laptop screen emits about 200 nits.

Our discernment of shape, texture, and form all depend on being able to distinguish variations in lightness. Note that there is no reference to the colour of the light: form can be seen in black and white. The ability to distinguish different shades of lightness varies with the overall brightness. Subtle differences in lightness of a print easily perceived in bright light are invisible in dim light.

INVERSE SQUARE LAW
The amount of light falling on a surface from a light source is called its illuminance. Suppose we measure the illuminance on a card held at a certain distance from a light source, then hold it further away. As the same amount of light is spread over a larger area, we can expect the illuminance to be less the further away the card is held. In fact, the amount of light (illuminance on the card) falls with the square of the distance: this is the Inverse Square Law.

Strictly, it applies only to small sources of radiation emitting evenly in all directions. In practice, we use it to calculate flash lighting (*see* page 196) and exposure correction for long lens extensions (*see* page 153).

▲ Inverse Square Law
This diagram illustrates how a surface illuminated by a source of light is much brighter the nearer it is to the source. When we move the surface away, its area is four times greater when the distance is doubled, and it is nine times greater when the distance is tripled, so the same amount of light has to be spread over the square of the distance between light source and surface.

▼ Lightness
The same quantity of light is falling on the scene, but some parts are darker because of shadows caused by obstructions to the light, and some are darker simply because they reflect light weakly. Other parts are very bright because they reflect light strongly. The totality of these variations creates a map of varying luminance – the picture.

◄ Light fall-off
A powerful flash unit was used to light an avenue of trees at night. The closest trees are more brightly lit than the more distant ones and, despite its power, the flash is unable to light beyond the fourth tree.

LIGHT AND EXPOSURE

The relationship between light and exposure is perhaps the most fundamental in all photography. For most desirable results, we need to match the brightness of a scene (luminance) with an appropriate exposure in a consistent and accurate way. This will help to ensure the subsequent processing steps can work at their optimum.

LIGHT METERING

Our eyes are unreliable for measuring because they adapt to changing light conditions. Exposure meters relate the measured luminance to shutter time and aperture for a given film or sensor speed. The vast majority of meters are built into the camera: the reading is transferred directly to the electronics controlling the camera. In digital cameras, the sensor itself may double as a metering device. It is good practice to remember the correct camera settings for a variety of circumstances to monitor a meter's readings, in case it develops a fault.

FILM OR SENSOR SPEED

All exposure meters must be set up with the speed of the film or sensor being used. In almost all modern film cameras, the film speed is automatically set when the film cassette is loaded; otherwise you need to set it manually using the film-speed dial. In digital cameras,

setting the sensor speed will set the internal camera meter. The ISO ratings for film and sensor are equivalent. Note that the ISO speed relates to standardized processing of film, so if you vary the processing, the ISO setting may vary too.

Higher-speed film leads to more grain, greater fog levels, and higher contrast. In colour film, colours are also lowered in saturation. In digital capture, higher settings result in more noise, which indirectly reduces the quality of sharpness and colour, and also increases the size of compressed files.

RECIPROCITY

A range of combinations of shutter time and aperture setting will give essentially the same exposure to the capture surface. If you reduce shutter time, you need to increase the aperture by an equivalent amount, and if you increase shutter time, you need to reduce aperture, also by an equivalent amount, usually expressed as a stop – a doubling or halving of exposure – or fraction of a stop.

For example, if we start with an aperture setting of $f/2$ and shutter time of 1/500sec and we reduce the aperture setting by two stops to $f/4$, we need to increase the shutter setting also by two stops – to 1/125sec. A camera exposure of $f/1.4$ at 1/1000sec is the same as $f/32$ at ½ sec.

▲ **DX coding on film canisters**
The DX coding for film speed on 35mm film canisters is given by varying the patterns of black paint and metallic squares. Inside the camera, these make contact with circuitry which sets the exposure meter. From left, the patterns denote ISO 400, ISO 200, ISO 100.

◄ **Light metering**
To the eye, the sunflowers looked as they do in the image, while the sky appears blue. But objectively, the sky was very bright and is therefore rendered near-white in this image. To give the sky its blue colour, we would need to underexpose the image, taking the shadow areas into black.

▲ High film speed
A 400 per cent enlargement from an ISO 400 35mm colour transparency film shows how grain interferes with the rendering of detail. But this pattern is quite tight and the grains are all of similar size, which helps to render tones smoothly.

▲ Low film speed
A 400 per cent enlargement from an ISO 100 35mm colour transparency film reveals fine grain that does not seriously impair the rendering of detail. Highlight areas, such as the central seagull, are relatively clear of grain.

▲ Sensor noise
A 500 per cent enlargement from an 8-megapixel image from a sensor set to ISO 800 shows a high level of noise. There are random coloured pixels, and areas that should be black, such as the shadows, are full of lighter pixels.

▲ Reciprocity – long exposure
A long exposure – half a second in this image – calls for a small aperture. While we gain depth of field – much of the tree is sharp and the distant house is also relatively sharp – there is also more time for the leaves to move during exposure, which causes motion blur.

▲ Reciprocity – short exposure
An exposure that is very short – 1/1000sec in this case – stops the blurring of the leaves by freezing them in one position, but the lens aperture must be wide open to allow as much light in as possible, causing a loss in depth of field: part of the tree is sharp, but the house is slightly blurred.

EXPOSURE AND DEVELOPMENT

Exposure – the relationship between camera settings and the subject luminance at the time the image is captured – is the foundation for image quality, because it determines tonal fidelity. Functionally, the correct exposure is the one that, after chemical or digital processing, gives the result desired by the photographer. For the majority of purposes, although not all, this is an image that has a full range of high, mid, and low tones.

OVEREXPOSURE AND UNDEREXPOSURE

Overexposure means that the capture surface receives too much light: this causes colour transparency or digital images (positive-working processes) to look too light. Negative film becomes too dense after processing. Underexposure is the opposite: insufficient light reaches the capture surface, causing images from positive-working systems to look too dark, while negative film processes give insufficiently dense negatives. However, film and digital processing can partially compensate for exposure errors.

ZONE SYSTEM

The Zone System was originally invented by Ansel Adams to describe the relationship between scene luminance range, camera exposure, and the development of black-and-white film for the final print. Essentially, exposure for a certain scene's luminance range is matched to a known film, with development adjusted to match the scene for the print result that was desired.

In theory, each frame of film capturing each type of scene – with low-contrast, average, or high-contrast lighting – received its appropriate bespoke processing. Slight "pulling", or reduced development, produces lower contrast in negatives to suit high-contrast scenes. Conversely, slight "push", or increased development, produces higher-contrast negatives, compensating for low-contrast scenes. Obviously, the system is ideal when individual sheets of film are processed or where lighting conditions prevail throughout a roll of film. Interestingly, in the digital era, we are back to the individual processing of frames.

▲ **Underexposed original**
This image is deeply underexposed in the shadows – with hardly any detail visible – but the sunlit path is badly overexposed, with large highlight areas.

▶ **Doorway highlights reduced** *(above right)*
In contrast with retrieving shadow detail, attempts to reduce highlights and extract colour for the path and plants still leaves them bright white, completely lacking in detail: the highlights are burned out.

▶ **Doorway shadows opened**
Using image manipulation software to extract detail from the shadows is quite successful – pictures on the wall on the right and details of the slats to the left are clearly revealed, with good colour reproduction.

In the Zone System, exposure determination is based on the division of a scene into 10 zones of exposure – from black to white. The key tones are III, shadows with detail and texture, and VII, highlights with detail and texture. Between these tones lie the crucial middle tones that carry much of the image's visual burden.

In practice, you first make bracketing exposures starting with the meter-indicated exposure. Make one exposure at one-stop steps (over and under to cover a range of five stops) of a subject with normal contrast. Include an unexposed frame. Note the location of the key zones III and VII in the scene. Following this, you will process the film following standard procedures, then make a print from the negative with the lowest density (least exposure) that gives a good result. From this you will be able to determine the film's effective speed and whether the indicated exposure setting is the correct exposure. For more on film development, *see* pages 230–1; for printing, *see* pages 302–4.

▼ Zones in a scene

In this image, of a temple in Bhutan, there is a full range of tones from bright white (the stupa in the sun) to deepest shadow (under the rafters of the roof). Taken together, the dark and white tones would average out to a midtone grey.

ZONE SYSTEM

	Zone 0	Pure black on printing paper; no texture or detail.
	Zone I	Slight tonality but no texture.
	Zone II	First suggestion of texture but no detail: deep shadows.
	Zone III	Dark grey but with texture and detail: dark shadow.
	Zone IV	Dark grey with texture and detail: dark or shadowed skin.
	Zone V	Middle grey, green grass, tanned skin, grey card.
	Zone VI	Full-texture light grey: pale skins, pale-coloured walls in shadow.
	Zone VII	Very light skin: textured but losing detail.
	Zone VIII	Nearly white; just textured, no detail: highlight in light faces.
	Zone IX	Glaring white, no texture: specular highlights.

THE SPECTRUM

Visible light ranges over a tiny part of the electromagnetic spectrum of radiation that takes in gamma rays through to radio waves. Normal photography is devoted to the portion of the electromagnetic spectrum that we can see, recording the different wavelengths of light as different colours. However, photographic systems may also be affected by other, invisible, parts of the spectrum. These are the infrared rays that extend beyond red and the ultraviolet (UV) rays that extend beyond violet. X-rays may also affect light-sensitive systems such as film.

BASIS OF COLOUR

Light is a radiation – a form of energy that travels in straight lines, spreading out as it goes. It varies in energy and wavelength, and this is detected by our eyes and photographic systems as colour. Colour names such as blue and orange are based on our perception of the hue of light, which is based on its wavelength. Light with shorter wavelengths are seen as violets and blues, those with longer wavelengths appear yellow or red, and in between we see greens.

The range of visible wavelengths extends only from about 400 nanometres (nm) to 700nm. All of our rich visual experience is concentrated into this tiny stretch of electromagnetic radiation.

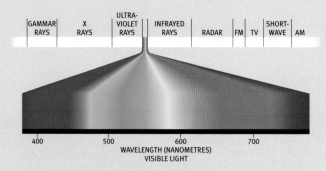

GAMMAR RAYS	X RAYS	ULTRA-VIOLET RAYS	INFRAYED RAYS	RADAR	FM	TV	SHORT-WAVE	AM

400 500 600 700
WAVELENGTH (NANOMETRES)
VISIBLE LIGHT

▲ **Electromagnetic spectrum**
This diagram shows the full spectrum of electromagnetic radiation – from radio wave to gamma radiation – and illustrates how the wavelength of the radiation is very large with radio waves and sub-atomic with gamma radiation. The visible spectrum occupies a tiny fraction of the whole spectrum.

INFRARED

We cannot see infrared but we feel it as heat, such as the warmth from a light. Near infrared wavelengths can be recorded photographically. In fact, the majority of sensors are so sensitive to infrared that a filter is needed to prevent infrared radiation from interfering with the image capture. Failure to protect CCDs adequately from infrared can cause image artifacts. Colour and black-and-white film can be sensitized to respond to infrared, characteristically rendering skies dark due to their lack of infrared, while greens, such as leaves and grass, register as white because they strongly reflect infrared.

ULTRAVIOLET

Light of very short wavelengths – ultraviolet (UV) – impacts on photography in largely undesirable ways. At high altitude and in low latitudes, the typically high levels of UV cast a haze over images. This is because normal photographic lenses will pass UV light through

◄ **Infrared**
The scene had a flawless blue sky, bright grass in the foreground, and the cathedral of Montmartre, Paris, in full sun. An infrared image shows grasses as almost white and skin as very pale, since both are rich in infrared, with a sky nearly black from its deficiency of infrared.

them but are not able to focus them, which results in the overall blur. It is possible to design lenses that focus UV but they are very expensive. It is easier to prevent UV from entering the lens by using a UV filter, which is, in fact, a minus-UV filter in that it passes visible light but stops UV.

A skylight filter – pale pink – is very effective against UV, but it has a side-effect of interacting with blue to produce a magenta cast.

In addition, UV can cause overexposure, particularly in black-and-white film. This is seen in skies that look blue to the eye but are too light in the print. This is because silver halides are most sensitive to UV light.

ACTINICITY

Sensitive materials react differently to some wavelengths than to others, and indeed may not respond at all to certain wavelengths. For silver-based materials, selective sensitivity to wavelength is called actinicity. Actinic light exposes silver-halide film. Highly actinic light, such as blues (short wavelength), produces greater densities on film than light of low actinicity, such as reds (long wavelengths). With sensors, on the other hand, sensitivities tend to be higher for longer wavelengths. As a result, the effective speed of a sensitive material varies according to the overall colour of the illuminating light.

▼ **No skylight filter**
This scene is well rendered under a UV filter with accurate colours and neutral greys, such as the tin roof, to the right.

▼ **With skylight filter**
In the same scene simulated to show the effect of a skylight filter being used, the very light red interacts with the blue to give a magenta cast in the tin roof, but the reeds are perhaps shown more accurately.

▲ **Ultraviolet in mountain scene**
High in the mountains of Tajikistan, UV levels are very high. Even with filtration to remove UV, the distant peaks – colourful to the eye – appear pallid and bluish.

▲ **Normal black and white**
A black-and-white image of this landscape leaves a beautiful blue sky too pale, needing much darkroom work to correct, because blue looks darker to the human eye than to film.

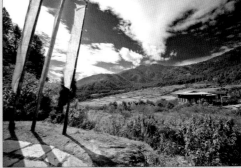

▲ **Reduced-blue black and white**
By using an orange filter, the blues are considerably darker, allowing the shape of the clouds to be clearly visible and improving tonal values in the foreground.

RECORDING COLOUR

There are three main ways to record colour in photography. We can use positive-working colour transparency film, negative-working colour print film, or we can capture digitally. The factors you need to ensure accurate recording are common to them all, namely: colour balance, colour palette, exposure matching, and exposure duration.

COLOUR BALANCE

White balance is the foundation of accurate colour: neutral tones should be free of colour cast, because they provide the reference colour for the other hues in an image. In film, this is achieved by balancing reproduction to an assumed illuminating colour – that of daylight or various incandescent sources. Colour transparency is relatively intolerant of light sources that do not match standard illuminants, but colour print is more tolerant because adjustments can be made at the printing stage.

In digital capture, highlights are examined for colour cast; if found, it is digitally neutralized by shifting all colours by the amount of the cast. This can be done automatically or by the photographer offering a neutral target to the camera.

COLOUR PALETTE

Every type of film, as well as digital camera, gives emphasis to some hues while recording others more weakly. This behaviour determines the colour palette of the system. Your choice of colour film or digital camera also determines colour palettes of your images. Some digital cameras allow you to set different colour rendering, such as low contrast or high saturation. It is best to match the type of palette to the intended use.

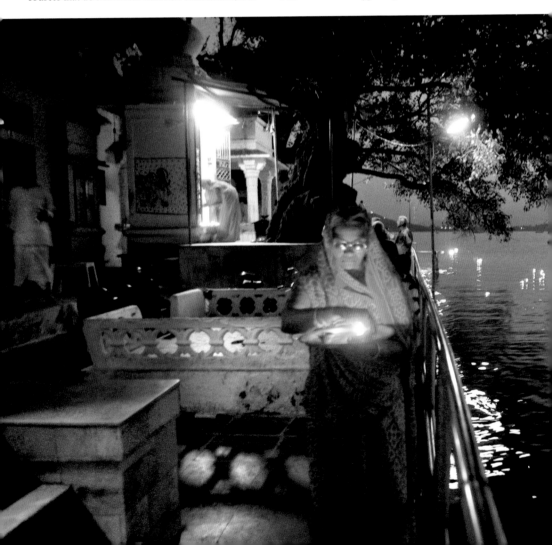

Here are some broad suggestions:
- Technical, product shots: neutral, mid saturation, mid contrast.
- Portraits: warm, mid, or low saturation; low contrast.
- Landscapes: warm, mid, or high saturation; mid contrast.
- Industrial, commercial: neutral to warm, high saturation, high contrast.
- Editorial, travel: warm, mid, or high saturation; mid to high contrast.

MATCHING EXPOSURE TO COLOUR

An exposure that is correct for one colour may not be ideal for another; this is a problem if both are present in the image. For example, if you're taking pictures in the garden, pale pink roses may appear too light when dark green leaves are properly exposed, but the leaves become too dark if the exposure is tuned to flowers. For critical applications such as fashion catalogues, it is advisable to make tests first. *See* the table, above right.

EXPOSURE COMPENSATION FOR HUE

Alter the exposure by stop indicated:

Purples	+2/3 to +1	Reds	0
Blues	+1/2 to +2/3	Oranges	−1/2 to +2/3
Greens	+1/3 to +1/2	Yellows	−1/2 to +2/3

WORKING IN LOW LIGHT

There are two separate issues to deal with when working in low light. Firstly, when our eyes adapt to low light, there is much loss of colour discrimination: images of scenes that looked devoid of colour at night record with full colours.

The other issue concerns colour films: with long exposures, the colour balance changes. For critical uses, add a filter to correct. With digital photography, long exposures increase noise but generally don't disturb colour balance.

◄ Low light
In the dark of Udaipur, the eye could not distinguish the subtle green, blue, and purple shades that are apparent in this digital image, exposed at a sensitivity of ISO 1600.

► Colour palette
For architectural interiors and other technical images, a neutral rendering with mid saturation is most appropriate. In this image, a neutralizing of the yellow tungsten lighting has made the natural light look bluish.

▼ Exposure matching
An exposure that is correct for the light green leaves renders the red flowers a little too dark. A different camera or film may give a different balance.

COLOUR

One of the miracles of photography is that the millions of different hues we see can be simulated by combinations of just three or four colours. While physics measures the wavelength of light to determine its hue, photography analyses a hue into its colour components or channels. Some systems use the additive primaries (*see* page 203) of red, green, and blue; others use the subtractive primaries of cyan, magenta, and yellow (*see* page 219). By varying the proportions of the primary colours we can record a full range of hues. In colour film, hues are usually recorded by varying amounts of subtractive primary dyes. By contrast, digital recording of hues encodes numerical values of additive primaries.

BIT DEPTH

In digital photography, the resolution of colours – how well we can discriminate between subtly different hues – depends on the bit depths at which the colour is recorded. Greater bit depths allow a greater range of tones and colours to be encoded. One bit represents the black and white of line art – with no tones in between. Eight bits can represent 256 grey tones and is the standard bit depth for colour channels in digital images.

We measure each of the three channels – red, green, and blue – using eight bits. For example, the red channel is represented by a range of tones from the strongest to the weakest in 256 steps, which provides a gradient or ramp that appears continuous to the eye.

In this scheme, a value of 255 stands for the strongest colour, 0 for the weakest. Remember that colours are combined additively (*see* page 203) in the digital image: when the strongest colours combine this produces a pale colour – and when all three channels combine, the result is white. The three 8-bit channels yield a total of 24 bits, which allows us to code or name over 16 million colours. This is the minimum required for full-colour reproduction.

While bit depth measures the number of names available to identify each tone, the actual number of tones available to a system is likely to be fewer, and the tones in a typical image will be far fewer (*see* table, right). Bit depths greater than 24 offer billions of codes and are used by scanners and advanced digital cameras, but not all the names are used to identify colours (there aren't that many). Rather, the names are used to help reduce errors at the extreme ends of the tonal range, as these are prone to sampling noise and miscalibration.

This point also shows that hue discrimination also depends on the equipment and image processing being used: higher-quality scanners or cameras, and those with more powerful processors, can handle the larger amounts of data needed for the finest hue resolution, whereas lower-quality ones cannot.

BIT DEPTH AND TONES

This table shows the number of different tones that can be coded by different bit depths. The bit depths most often encountered are 1, 8, and 24.

1 bit (2^1)	=	two tones
2 bits (2^2)	=	four tones
3 bits (2^3)	=	eight tones
4 bits (2^4)	=	16 tones
8 bits (2^8)	=	256 tones
16 bits (2^{16})	=	65,536 tones
24 bits (2^{24})	=	16,777,216 tones

◀ **Bit depth**
The image on the far left has been reproduced from only eight levels of colour, or three bits per channel. It shows that surprisingly little colour information is needed to make an acceptable image. The companion image (*left*) offers a full range of colours across the spectrum – from blues, through greens and yellows, to red. Here it is shown with full 24-bit colour. At first glance, the difference between the two images is not obvious.

◄ 1-bit
With only one bit, coding only "on" or "off", we can register either black or white. The main shape of the subject is just visible, but there are no tonal variations. The colour spectrum records a black area where the darkest colours lie – the blues.

◄ 2-bit
A small increase in bit depth gives us a lot more tonal information compared to the 1-bit image to the left. The increase helps to show the subject outlines clearly. The colour spectrum is rendered into grey tones, but notice that pale colours – azure to yellow through greens – are not distinguished.

◄ 1-bit grey ramp
A grey ramp shows that a colour spectrum is recorded only as pure black and white.

◄ 2-bit grey ramp
The distribution of the four different tones represents the colour spectrum.

◄ 4-bit
A 4-bit greyscale image shows good tonality at first glance, but variations are not smooth. The increase in bit depth also gives us much more resolution into greys of the colours of the spectrum.

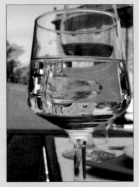

◄ 4-bit colour
The colour version of a 4-bit image gives only 12 levels of colour in each channel and confirms the deductions from viewing the 4-bit spectrum: there is a good rendition of colours, although subtleties are missing in the sky. Also there is insufficient data to tolerate any manipulation.

◄ 4-bit grey ramp
Sixteen grey tones – the start of a smooth reproduction of different colours.

◄ 4-bit colour ramp
With 12 levels of colour per channel, it is a full spectrum without gradations.

◄ 24-bit colour
This shows the full-colour version: due to losses in colour reproduction on the printed page, this image with 256 levels per channel will not look very different from the image with only 12 levels per channel, but it will be much more robust under manipulation.

◄ 24-bit colour ramp
Shows good fidelity, a wide range of colours, and no visible gaps in coloration.

MAXIMIZING FILM-BASED IMAGE QUALITY

This table compares the approximate range of different colours available to different systems operating at their best. The human eye can resolve a total of between eight and ten million colours over a range of conditions. Notice the large gap between analogue and digital methods. *See also* colour management (page 220).

Colour monitor	3,000,000–6,000,000
Colour transparency	2,000,000–4,000,000
Colour print	1,000,000–2,000,000
Digital colour proof	5,000–10,000
Printing-press coated stock	2,000–4,000
Printing-press newsprint	1,000–2,000

The camera

CAMERA CONTROLS

CAMERA CONSTRUCTION

VIEWFINDER CAMERAS

SLR CAMERAS

ELECTRONIC-VIEWFINDER CAMERAS

MEDIUM-FORMAT CAMERAS

MANUAL FOCUSING

AUTOFOCUSING

HOW FOCUSING SYSTEMS WORK

SHORT SHUTTER TIMES

LONG SHUTTER TIMES

HOW THE SHUTTER WORKS

DEPTH OF FIELD

LENS APERTURE

APERTURE EFFECTS

DIGITAL CAMERA FEATURES

EXPOSURE MEASUREMENT

STABILIZING THE CAMERA

PHOTOGRAPHY EQUIPMENT

CAMERA CONTROLS

There is a large range of camera types available, and they all share certain basic controls, whether they are film-using or digital. The most basic will have, at least, a way to control when light reaches the capture surface – the shutter button or equivalent. Next, there are ways to control the exposure – how much light reaches the capture surface. These are the controls for the aperture and the shutter. Lenses that do not need focusing are limited in scope, so to increase the camera's versatility

we need ways to focus the lens. As modern cameras grew in sophistication, the number of controls grew rapidly. The quality, logic, and design of controls – the interface between photographer and camera – are important to the functionality of the camera.

FILM CAMERAS

Being derived from wholly mechanical forebears, film cameras generally use dials and buttons to control the

Motor-driven film camera
Modern film-based cameras make extensive use of buttons and dials for settings. Controls are easily and always available, with minimal reliance on electronic displays. As a result, film-based cameras can usually be used without reference to printed instructions.

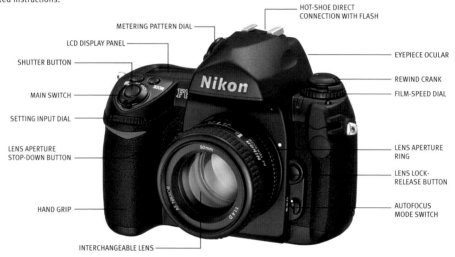

HOT-SHOE DIRECT CONNECTION WITH FLASH
METERING PATTERN DIAL
LCD DISPLAY PANEL
SHUTTER BUTTON
MAIN SWITCH
SETTING INPUT DIAL
LENS APERTURE STOP-DOWN BUTTON
HAND GRIP
INTERCHANGEABLE LENS
EYEPIECE OCULAR
REWIND CRANK
FILM-SPEED DIAL
LENS APERTURE RING
LENS LOCK-RELEASE BUTTON
AUTOFOCUS MODE SWITCH

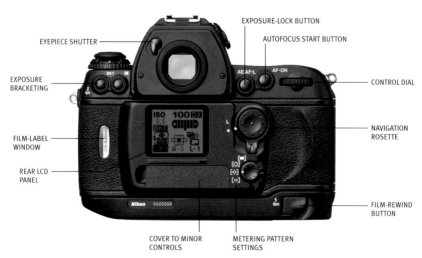

EXPOSURE-LOCK BUTTON
EYEPIECE SHUTTER
AUTOFOCUS START BUTTON
EXPOSURE BRACKETING
FILM-LABEL WINDOW
REAR LCD PANEL
CONTROL DIAL
NAVIGATION ROSETTE
FILM-REWIND BUTTON
COVER TO MINOR CONTROLS
METERING PATTERN SETTINGS

camera. Exposure controls such as shutter time and aperture are almost universally set by turning a dial. Controls specific to film-handling, such as wind-on and rewind, may have their own controls.

Some options – such as autoexposure, autofocus, and bracketing – may be set by a combination of pressing a button and turning a dial to select from a displayed menu. This type of interface was first seen in cameras controlled by microprocessors. It is clearly the forerunner of digital camera controls in which a central display is used to set or control nearly all camera operations.

DIGITAL CAMERAS

Apart from the shutter button, there may be little left on modern cameras from the traditional designs. The majority of operational options are obtained by selecting from menus and using push buttons or switches on the camera. It is often necessary to consult the instruction manual in order to find the minor controls. Functions that are used frequently, such as access to the menu, reviewing the pictures, and adjusting the zoom, will have their own button. But even these may serve different functions depending on the camera's operational state.

Digital point-and-shoot camera
Modern digital cameras offer relatively few external controls, but numerous options are available through menus displayed electronically. While this enables great versatility to be built into the camera at low cost, the access to the menus and their options can be less convenient than if accessed by buttons and dials. However, there is no standard way to organize the options, so it is usually necessary to consult the instruction manual to learn how to use the minor or obscure controls.

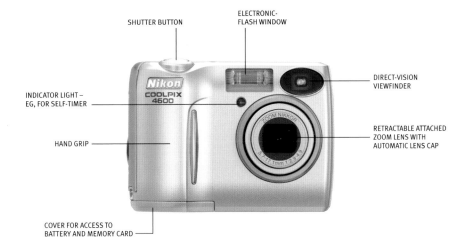

SHUTTER BUTTON

ELECTRONIC-FLASH WINDOW

DIRECT-VISION VIEWFINDER

INDICATOR LIGHT – EG, FOR SELF-TIMER

RETRACTABLE ATTACHED ZOOM LENS WITH AUTOMATIC LENS CAP

HAND GRIP

COVER FOR ACCESS TO BATTERY AND MEMORY CARD

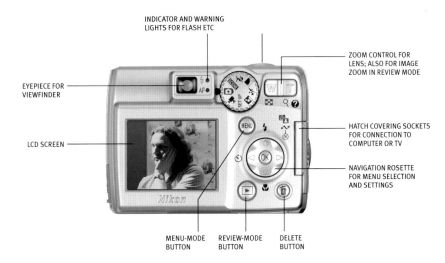

INDICATOR AND WARNING LIGHTS FOR FLASH ETC

ZOOM CONTROL FOR LENS; ALSO FOR IMAGE ZOOM IN REVIEW MODE

EYEPIECE FOR VIEWFINDER

HATCH COVERING SOCKETS FOR CONNECTION TO COMPUTER OR TV

LCD SCREEN

NAVIGATION ROSETTE FOR MENU SELECTION AND SETTINGS

MENU-MODE BUTTON

REVIEW-MODE BUTTON

DELETE BUTTON

CAMERA CONSTRUCTION

Modern cameras have evolved a very long way from their original form. Their predecessor is the *camera obscura,* described as early as the 1300s by the Chinese philosopher Zhao Youqin. In the mid-1800s cameras were essentially wooden boxes – Henry Fox Talbot's camera was called "Henry's mousetrap" by his wife. Today's cameras, in contrast, consist of precision parts so delicate they have to be assembled by robots. And the compact bodies are designed so there is no wasted space. Nonetheless, cameras from all periods of history share the same fundamental features.

OPEN-BOX ALLOY CASTING

HOLES IN FRAME REDUCE WEIGHT

▲ **Panasonic L1 shell**
The skeleton of a modern digital camera, the Panasonic L1, shows that a substantial structure is needed to protect the internal components.

INTERNAL STRUCTURE

Modern cameras are best considered as two boxes, one inside the other. The central box is the heart of the camera, carrying the capture surface – film or light sensor – on one side and holding the lens opposite. This box is crucial for positioning, with the utmost precision, key components such as the lens and sensor or film, mirror mechanism (if present), and autofocus components. In consequence, it is engineered to an extremely high level, in both strength and precise construction. It should be able to withstand vibration and changes in its dimensions from distortion or temperature. It must also be light-tight – not only keeping light out but able to absorb light reflected from the light receptor or other parts in order to prevent internal reflections (the surface of sensors is very reflective).

The outer box encloses the inner box to make it lightproof. It also carries the controls such as the dials, buttons, and displays. The space between the two boxes contains the processor, power supply, memory, and circuitry that connects them together. In film cameras, the space also carries the film and transport mechanisms, shutter, and exposure metering systems. There are many variants possible – for example, the shutter on some digital cameras is electronic and built into the sensor.

EXTERNAL FEATURES

An important part of the design is the junction between the interior and the exterior of the camera.

USE OF A MIRROR SETS THE MINIMUM SIZE OF THE INNER BOX

BUILT-IN FLASH IN RAISED POSITION

▲ **Canon 350D cutaway**
The assembled Canon 350D, here in cutaway diagram form, shows the snug fit of all the components, with hardly any unused space. Central to the success of this line of cameras is the very wide lens throat, which gives flexibility to the lens design. The on-camera flash is raised.

▼ **Canon 350D back**
Seen from the back, the Canon 350D cutaway shows that all the space that would have been taken up by film is occupied by electronic components, including the digital "film" – the memory card, shown in black on the right.

MEMORY CARD

If these are carefully sealed, the camera can be made relatively dust- and damp-proof.

The exterior should be designed to be easy to use. Controls need to be a size that can be handled, with space between them so that using one does not collide with another, and space is needed to be able to hold the camera – the smallest model may not be the easiest to use.

OUTER PANELS PROTECT INTERNAL CIRCUITS

MANY COMPONENTS INTERCONNECTED

SONY

Cyber-shot

CIRCUITRY TIGHTLY PACKED THROUGHOUT

▶ **Sony Cyber-shot F828**
Plastic is used extensively in modern cameras to form the exterior. Plastic is lightweight and easily formed to make complicated parts, but it isn't as sturdy as metal.

PINHOLE CAMERA

A pinhole camera is a *camera obscura* in miniature: a small hole on the front lets in light, which projects an inverted image on the opposite side. The pinhole camera is the ancestor of the earliest cameras, but its basic structure – a light-tight box – survives in the monorail camera and modern compact digital cameras.

Images are typically unsharp due to chromatic and astigmatic aberrations, with a very wide angle of view possible, infinite depth of field, and marked light fall-off.

A larger hole lets in more light, so exposures may be shorter, but image quality suffers. There is an optimum diameter of hole for focal length (the distance between the hole and the film) depending on the wavelength (*see* table, right).

At any rate, the pinhole should be made as cleanly as possible, for example, with a laser, and in the thinnest metal. Image quality may improve if, when using film, it is placed with a slight outward (away from the hole) curve.

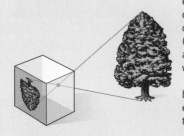

OPTIMUM PINHOLE SIZE	

The optimum size of a pinhole is best found by practical experiment, and it varies depending on who you ask. Use these figures as a guide.

FOCAL LENGTH	OPTIMUM DIAMETER
20mm	0.15–0.2mm
50mm	0.2–0.25mm
100mm	0.3–0.35mm
150mm	0.4–0.45mm

▲ **Pinhole camera artwork**
The basic effect of a pinhole is that light entering continues onto a surface in such a way that images on the surface are upside-down compared to the scene. A pinhole camera can be made from any light-tight box.

▶ **Pinhole image**
This image was made in a digital SLR camera whose body cap was drilled out with a 5mm diameter hole. This hole was covered in metal foil, and a much smaller hole, about 0.3mm diameter, was made. The resulting image is a small section of the image projected by the pinhole, so it does not display much distortion but still shows light fall-off. Note: any modifications you make to your camera are entirely at your own risk.

VIEWFINDER CAMERAS

The most widely used of all cameras are those aimed through a simple optical viewfinder. This is essentially an inverted telescope that gives you a direct view of the scene so the image is brilliant, easy to see in bright light, relatively colour correct, and detailed. In addition, the view is always "on", never needing to be powered. But the image is reduced and distorted, and its exact limits are difficult to determine. The view also suffers from parallax error: the centre of its image does not correspond to that seen by the lens because the

viewfinder is off-set to the lens. Some viewfinders can zoom in step with the zooming of the lens, but that, too, may be inaccurate.

TYPES OF VIEWFINDER CAMERA

Until the advent of the compact digital camera, film cameras were the most common. They were lightweight and easy to use but not robust. At the same time, the best viewfinder cameras from Leica, Zeiss, and others were capable of the highest professional quality and were extremely robust and reliable. The size of the viewfinder image limits the focal-length range to close to normal (not less than 28mm, not more than 135mm), while parallax errors limit the

▼ **Tabletop portrait**
The ideal snapshot camera, the viewfinder camera can engage in everyday living and record ordinary moments with great effect.

▲ **Inside the action**
At its best, the viewfinder camera can get into the centre of activity without causing great distraction or interruption. Here, with the lens set to 35mm, a quiet discussion has been recorded without attracting the attention of those involved.

TYPES OF VIEWFINDER CAMERA

Compact zoom
The bright-line viewfinder may be small but offers the most energy-efficient way of viewing, which works as well in low light as in bright conditions. The LCD screen is always available when needed.

Wide-angle compact digital
This camera is designed for photo-journalism with an ultra wide 24mm equivalent lens. You can use the large LCD screen or attach an electronic viewfinder, giving the best of both worlds.

35mm rangefinder
Top-level rangefinder cameras using film, such as this model, still define the best that photography can offer, especially in terms of low-light and wide-angle performance.

close focusing range. Many modern digital cameras use optical viewfinders, but these are rapidly being replaced by large LCD screens, which the majority of photographers find easier to use.

USES

Viewfinder cameras are ideal for snapshots and for informal and candid photography where picture making must be unobtrusive and equipment must be lightweight. The majority of autofocus models carry zoom lenses whose range may be modest, maybe 35–70mm, or more extensive, 38–170mm. One advantage of film-using compacts over their digital counterparts is the ready availability of true wide-angle lenses, down to 24mm.

Inexpensive film-using compact cameras employ inter-lens shutters so they can operate very quietly, but the motor drive for the film can be noisy. The quietest are manual-wind cameras from Leica, Bessa, and Zeiss. Viewfinder cameras offer the most precise wide-angle focusing and the ability to see outside of the image frame. As a result, these are ideal for photojournalism and documentary work.

▼ Rainy day
The natural habitat for the viewfinder camera is the street, where its rapid responsiveness to quickly changing situations and unobtrusive way of working is well suited.

▲ Compositions
High-quality viewfinder cameras – such as the Leica used for this image – enable the photographer to consider and frame the subject in an intimate way denied to other cameras. They almost force you to compose with care.

PROS AND CONS OF VIEWFINDER CAMERAS

- Light, unobtrusive, wide-angle available, accurate wide-angle focusing, viewfinder always available; film-using cameras capable of very high quality at very low cost.
- Limited close focusing, limited long-lens capability, framing and parallax error; viewfinder image may be small, distorted, and hard to view.

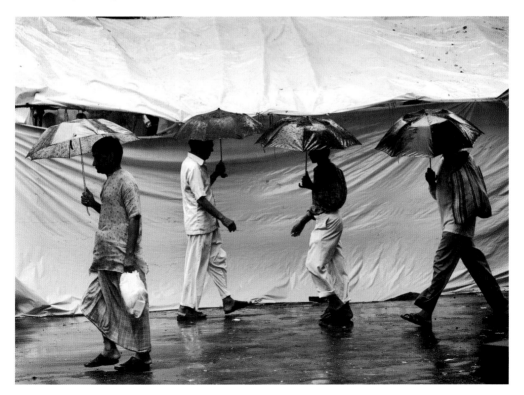

SLR CAMERAS

The name "single-lens reflex" is self-descriptive: there is a single lens used for viewing and taking, and the image is the reflection from a mirror. Single-lens view-and-take enables these cameras to use a variety of lenses – this is the key to their huge versatility. In fact, the range and scope of photography have been increased more by SLR cameras than by any other type. Historically, the most popular type is the 35mm SLR – taking 135 (35mm) format film – but in professional use it has been supplanted by the digital SLR (DSLR) camera.

TYPES OF SLR CAMERA

There are three main types of SLR in wide use; a fourth, the medium-format camera, is considered on pages 70–1. The 35mm film-using SLR offers precise and accurate framing of the subject with a large and bright image that is easy to view. The vast majority of

▼ Wide-angle
For the widest angle effects, it is necessary to use full frame – either of 35mm or sensors that cover the full 35mm format – so avoiding cropping the image.

PROS AND CONS OF SLR CAMERAS

- Versatile thanks to wide range of lenses and accessories; the best viewfinder clarity; capable of professional quality; some models operate very quickly.
- May be bulky and heavy, noisy, intimidating to subjects, expensive to equip and run, complicated to learn to use; wide-angle focusing may not be precise at near distances.

modern cameras have automatic focusing, exposure control, film wind and rewind, and film speed setting.

The 35mm SLR is the basis for the DSLR. One type uses sensors the same size as 35mm film, nominally 36 x 24mm. This means that a lens used with 35mm film will give the same field of view as on the full-frame DSLR. The other type of SLR uses sensors, which are smaller than 35mm – typically around 17 x 13mm in active area. This smaller sensor crops into the central area of 35mm format, giving a narrower field of view. However, the smaller sensor allows both cameras and lenses to be made more compact than full-frame models.

USES

SLRs are at their best with very long focal length lenses and for extreme close-ups. They also excel in any situation calling for precision framing, as in document copying. The main technical weakness of the SLR is that focusing of wide-angle lenses at large apertures is rather inaccurate. Modern SLR cameras are supported by systems consisting not only of a range of lenses – which can number over 60 – but also close-up, lighting, and electronic accessories. The result is that SLRs can tackle just about any task.

TYPES OF SLR CAMERA

Compact SLR
Digital SLRs with smaller sensors are deservedly popular, combining excellent performance and relatively compact bodies at affordable prices. Wide-angle performance is limited, but telephoto powers are enhanced.

Full-frame SLR
A relatively compact full-frame digital SLR that is less costly than other full-frame cameras and is capable of excellent, if not the finest quality. This model and its successors make superb cameras for the young professional.

Film-using SLR
Film-using 35mm SLRs represent the least costly way to achieve professional image quality, using a relatively robust medium – film – and being very easy to use. Secondhand prices make these even better buys.

▲ Precise framing

For precision framing – such as that needed to catch these figures in just the right positions behind the curtains – the SLR excels. When working at full aperture, it is also possible to monitor out-of-focus effects.

▶ Horse race

A 400mm lens was needed to bridge the distance between the spectator stands and the young horsemen racing from a distance. An SLR camera is essential for work that calls for extreme focal lengths.

ELECTRONIC-VIEWFINDER CAMERAS

TYPES OF EVF CAMERA

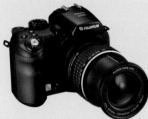

Compact EVF camera
EVF cameras that carry a 28–300mm equivalent or similar zoom offer much of the focal-length range that anyone requires. Such cameras are ideal for lightweight travel photography.

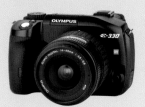

EVF/SLR hybrid
Cameras such as this model, which comply with the 4/3 standard, accept a wide range of lenses but also offer SLR and EVF viewing for added versatility and ease of use.

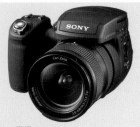

Large EVF camera
By accepting a bulk comparable to that of a DSLR, EVF cameras can mount no-compromise optics such as the fast 24–120mm $f/2.8$–4.8 lens and use an SLR-size sensor for better quality.

The electronic viewfinder (EVF) is standard on video cameras. It provides a preview of the image received by the sensor for framing and focusing. On digital cameras, the electronic viewfinder performs essentially the same function. There are two configurations. In one, the LCD screen may be large – at least 2.5cm (1in) across its diagonal – and designed for viewing with the camera held away from the face. The other uses a small, enclosed screen viewed through magnifying optics; these cameras also carry a large screen on the back of the camera. The key advantage of EVFs is their small size, but the disadvantage is that the camera must be turned on before you can even see an image.

TYPES OF EVF CAMERA

The simplest type, with the large exterior LCD screen, works essentially like an autofocus compact. Some sophisticated models offer a very extensive focal-length range with optical image stabilization.

The next type looks like an SLR but comes with a fixed, non-interchangeable lens. It is compact and operates quietly and with freedom from dust falling on the sensor. Accessory adaptors may be screwed onto the lens to increase the wide-angle and telephoto range.

The other type uses a hybrid technology that allows the user to switch between normal SLR viewing and a live, LCD-based preview. These models offer interchangeable lenses, thus giving far greater versatility. Some DSLR cameras offer the equivalent of an EVF: by raising the mirror, the sensor can feed a live image to the LCD screen. This is useful in static situations and studio work, where it is more

◄ Portrait
EVF cameras are very well suited to portraiture because they are not intimidating to your subjects, and their limitations, such as poor viewfinder quality, are not an issue.

comfortable to observe a large image than to peer through the eyepiece.

In all these cameras, the quality of the viewing image depends on the resolution of the screen – the greater the number of pixels, the finer the quality – and also on the refresh rate. As the screen is drawn by scanned lines, as on a TV screen, if you move quickly the image may not be able to catch up, resulting in a jerky, shaky image. In addition, the screens are usually designed to make focusing easier, which distorts colours and tonality. In bright light, cameras relying on the large external screen will be at a disadvantage as colours and exposure are very difficult to assess.

USES

Fixed-lens EVF cameras are ideal for landscape and travel photography because they combine compactness with good versatility. Some models offer uncompromising lens and image quality. Cameras that combine live previews with SLR viewing will be able to display the image with the camera held low down for ground shots or above the head.

The so-called "super-zoom" cameras are very versatile as they cover the entire usable focal-length range – from a moderate wide-angle of 35mm equivalent, to 400mm and beyond. But to make best use of these cameras, it is essential that the image be stabilized, either optically or via the sensor.

◄ Wide view *(far left)*
A slightly wider-than-normal view shows the full length of the street and distant buildings lit by the sun – a view that just about any digital camera could record.

◄ Long view
With an EVF camera capable of reaching 400mm focal-length equivalent, the distant buildings in the image *(far left)* are greatly enlarged and can now be seen in detail much greater than that visible to the naked eye.

MEDIUM-FORMAT CAMERAS

Medium-format cameras – those using 120 or 220 roll film – were once prized for offering the best balance of professional image quality, portability, and versatility. With the ready availability of digital cameras, which can match or exceed medium format in quality, the argument for medium-format cameras using film is largely lost. However, there remain the virtues of working with a comfortably large screen, the depth-of-field effects of longer focal length lenses, and being able to enjoy superlative lenses. The format may be any size on 120/220 roll film – from 6 x 4.5cm, to as large as 6 x 17cm.

TYPES OF MEDIUM-FORMAT CAMERA

The most basic medium-format camera is based on a rangefinder. These are relatively compact and lightweight for the format, but framing and focusing accuracy is limited.

The best-known types are square in format, classically 6 x 6cm, designed around waist-level viewing. The Rolleiflex type was a twin-lens reflex, using one lens for viewing and another for taking. That evolved into the Hasselblad-type SLR design, with interchangeable lenses and magazines. These cameras offer an excellent balance of affordability and very high image quality with film. Digital backs for modern medium-format SLRs offer sensors with 39 megapixels and more, representing image quality rivalling that of large-format film, but in manoeuvrable cameras.

USES

Medium-format cameras, particularly those with square formats, encourage a more considered, evenly paced, and careful kind of photography compared to that of smaller cameras. They are ideal for landscapes, artistic close-ups, portraiture, and, with some limitations, architecture. Medium format has been the mainstay of industrial, landscape, and portrait photographers since its invention in 1928.

◄ Graphic composition
The square format encourages the careful exploration of composition and form, while its technical quality makes it ideal for high-quality work.

PROS AND CONS OF MEDIUM-FORMAT CAMERAS

- Great viewing experience with reflex cameras; excellent quality for the cost; beautiful depth-of-field effects; relatively easy to make good scans.
- Can be slow and cumbersome to use; some models very noisy in operation.

TYPES OF MEDIUM-FORMAT CAMERA

6 x 7cm format
Large, heavy cameras with large lenses but with a long history and faithful following, 6 x 7cm-format cameras give peerless performance on easily viewed transparencies.

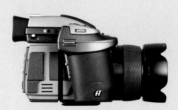

6 x 4.5cm format digital
Developed from an autofocus film-using camera into a fully integrated digital camera, 6 x 4.5cm format cameras offer an excellent balance of compactness and top-class quality.

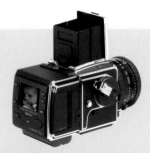

6 x 6cm format
The classic Hasselblad camera has endured by logical evolution, changing its film magazine for a digital back, while continuing to use all of its lenses and accessories.

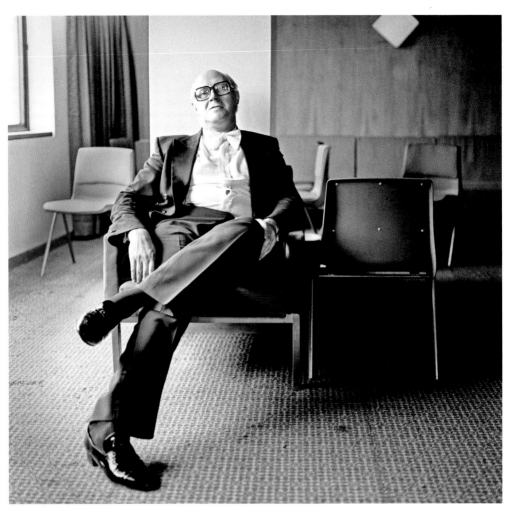

▲ Perfect for portraiture
From its very first day, the square format was recognized as ideal for the formal portrait, allowing easy operation, continuous visual contact with the sitter, and delivering the kind of smooth image quality required.

◀ Perfect for landscapes
Landscapes presented within the confines of a square format take on a dynamic that is refreshingly different from the rectangle. Here, a beach in New Zealand is shot with a 40mm, ultra-wide-angle lens.

MANUAL FOCUSING

Despite the predominance of autofocus systems throughout modern photography, manual focusing remains the best method for many purposes. And for large-format work on location or in a studio, it remains the only viable method.

WIDE ANGLE

Manual focusing using a coincidence-image rangefinder – the image is in focus when two versions of the image reference and a target are lined up – provides the sharpest results when working with wide-angle lenses in the near and close-up range. In low light, with low-contrast subjects, the argument in favour of rangefinder manual focusing is even stronger, as you will be using large apertures with the consequent reduction in depth of field. With SLR cameras, focusing accuracy improves with larger maximum aperture – hence, if you wish to use wide-angle lenses, you use the fastest possible, such as 24mm $f/1.4$, not for low light but for focusing accuracy.

FULL APERTURE

When you are working at full aperture, manual focusing is again recommended, particularly for relatively static subjects such as portraits. The main reason is that with the limited depth of field, the plane of best focus may not be targeted by the autofocus. At close distances, the technique of aiming the

autofocus point at one part of the scene, then turning the camera to recompose the image, can introduce errors. Indeed, you may be better off using manual focusing in any situation in which the part of the subject to be focused does not coincide with the autofocus point. This is particularly true with differential focusing, where you look through close obstacles to a distant subject.

IMPROVING QUALITY

The key to improving manual focusing quality is to decrease the depth of focus – the range of variation in the focus settings in which the image appears sharp. With rangefinder cameras, the depth of focus of a given lens is set by the optical base length – the distance between the focusing windows.

However, you can magnify the image of the rangefinder spot to help you line up the reference and target images more accurately. Magnifying the central portion of an SLR viewfinder image also helps improve focus accuracy. Accessory magnifiers that fit over the normal eyepiece help improve accuracy but can be cumbersome to use.

▼ **Traffic cop**
The subject – a traffic policeman in Kolkata, India – is relatively static, but the umbrella and hands can easily throw autofocus off the face, which is what needs to be sharp.

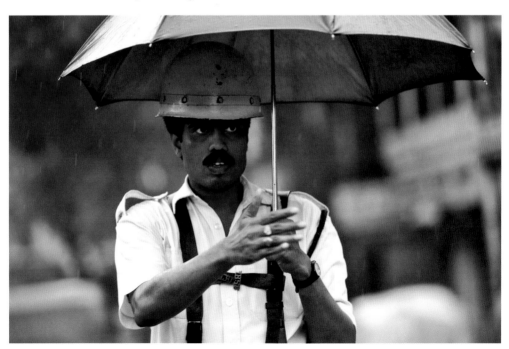

▲ Flat artwork
For a flat copy of artwork that is intended for large-scale reproduction, assisted manual focusing is essential as the smallest error will be evident – here with the aid of a magnifier over the focusing screen.

▲ Aircraft engineer
In the low light of an aircraft maintenance hangar, the lens had to be set to full aperture to snatch a portrait of an engineer at a conference. Focusing with a rangefinder is highly accurate in these circumstances.

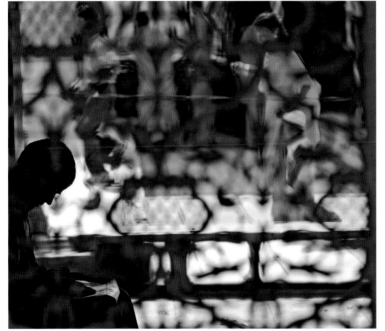

◄ Through a grille
Photographing through a stonework grille in Delhi, India, focus was held on the guard reading a newspaper (*left*) in the cool shade while visitors walked by: autofocus would have been quite useless in this situation.

▼ Taj Mahal tourists
In order to keep the focus on the distant building with the tourists milling in the foreground, it is easiest to turn off autofocus and watch for the composition to arrange itself.

PROS AND CONS

- Best accuracy and control; does not change if something passes between camera and subject; best for wide angle; excellent for static subject.
- Manual focusing is slow and may shake or move camera; varies with acuteness of vision of the photographer; may be less accurate than autofocus with very long lenses; less accurate in low light unless using optical rangefinder.

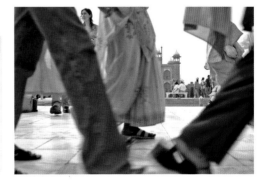

AUTOFOCUSING

Autofocus systems are at the heart of the majority of modern cameras. Autofocus solves many problems, and not only for the visually impaired: the best systems can focus more quickly and accurately than even the most experienced combinations of eye and hand. Some autofocus systems can work even where there is no light to see by.

ONE-SHOT AUTOFOCUS

The foundational autofocus system turns the focusing mechanism until focus is found, then alerts the photographer – usually with a focus confirmation signal such as a beep or light. In the majority of systems, the shutter is blocked until focus is achieved. One-shot autofocus is obviously most suitable for

static subjects, but it can be useful for quick action when you can anticipate the position of your subject: you focus just before it reaches the point. The focus point can be held or memorized by the camera, which enables you to use the technique of focusing on one spot, then recomposing the framing for the shot. This method offers a quick way to focus but can introduce errors. If you have the time, manual focusing may produce sharper results.

SERVO AUTOFOCUS

In order to handle moving subjects, servo systems continually track and adjust focus until just before the moment of exposure. This can save a lot of work when watching a mobile subject through the lens. The best

▶ **Street football**
Autofocus systems find this type of situation – shot in Marrakech, Morocco – very hard to handle: there is rapid movement, it is dark, and there is a very bright light source in the background causing flare in the optics.

◀ **Central autofocus**
The composition of these dramatic aerial acrobatics is poor because the camera was set to servo autofocus. Placing the helicopter off-centre would move the focus point and so lose focus – a fate worse than an irritating composition.

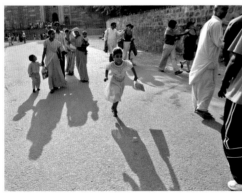

▲ **Servo autofocus**
Servo autofocusing enables fast-moving action to be captured, such as this girl in Agra, India, as the lens adjusts its focus to anticipate the subject's position at exposure.

▲ **Intelligent autofocus**
Autofocus has redefined and liberated the snapshot photograph. A fleeting moment in time can be captured quickly and examined at leisure later.

of modern systems can adjust quickly enough to keep a moving car or person in focus as it approaches the camera far better than the eye can. However, this slows frame rates for sequential shots as the camera is having continually to adjust focus as well as take the shots. Another problem with servo focusing is that if someone passes between lens and subject, the camera will try to focus on that person. With servo autofocusing you cannot hold a focus and adjust the composition, so you must rely on the focusing points offered by the camera; some models give you 45 points to choose from.

WORKING IN THE DARK

Autofocus systems in SLRs and the majority of digital cameras work best in good light with subjects with clear margins and markings; their efficiency falls very rapidly in dim light and low-contrast situations. Some cameras project light patterns into dark situations (from the body or accessory flash) to aid focusing. However, the flashes of light can alert your subjects that you are focusing on them. Other autofocus systems – such as those in film-using compacts – can work in the dark because they send out beams of infrared light to rangefind (*see* page 76).

PROS AND CONS

• Helpful for those with vision defects, rapid response possible, can track moving objects, can be more accurate than manual focusing.
• Tendency to keep focusing spot on the subject rather than frame correctly, may be inaccurate or focus on unintended parts of the subject.

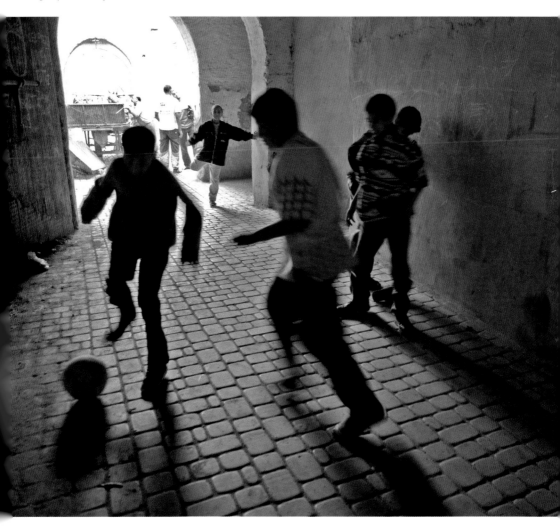

HOW FOCUSING SYSTEMS WORK

For the first 160 years of photography, manual focusing was the norm, with the photographer relying on visual feedback and acute vision to achieve sharp focus. As film formats became smaller and as quality standards rose, simple visual inspection was not accurate, and focusing aids had to be invented, the chief of which is the rangefinder. But as the demands for ever more responsive cameras rose, so autofocus systems had to be invented. The first attempts mimicked visual methods – focusing until the image was at its highest contrast – but these were too slow.

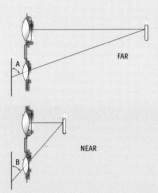

FAR

NEAR

There are two kinds of manual focusing system. The simplest examines the image on a screen and adjusts the lens or focus control until the image looks sharp – usually at the point of highest contrast. In contrast, rangefinding does not evaluate the image directly. It is based on triangulation: from a baseline, lines to the apex of a triangle are closer to right angle the further away the apex, so the distance can be calculated by measuring the angle. The best example is found in the Leica, but the split image and microprisms in SLRs are essentially also rangefinders.

◀ **Triangulation**
This diagram illustrates triangulation, fundamental to many focusing systems. The angle A at the base is greater than the angle B as the subject is further away, and the distance is proportional to the angle.

ACTIVE AND PASSIVE

There are two kinds of modern autofocus system. The active autofocus system rangefinds using a beam of infrared – such as that emitted by a TV remote control – in two different ways. Some cameras detect the strength of the returning beam: the weaker it is, the further away the subject. Others detect the returning beam from a window some distance from the emitting window and measure the angle of the beam: more oblique beams are returning from a subject further away.

The passive system also has two broad solutions. Contrast detection is used by the majority of compact

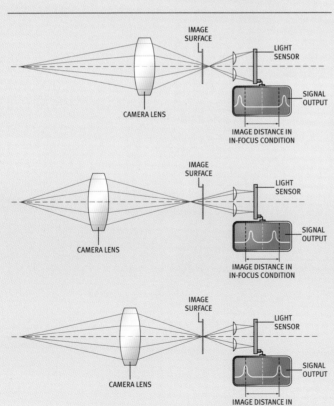

IMAGE SURFACE

LIGHT SENSOR

SIGNAL OUTPUT

CAMERA LENS

IMAGE DISTANCE IN IN-FOCUS CONDITION

IMAGE SURFACE

LIGHT SENSOR

SIGNAL OUTPUT

CAMERA LENS

IMAGE DISTANCE IN IN-FOCUS CONDITION

IMAGE SURFACE

LIGHT SENSOR

SIGNAL OUTPUT

CAMERA LENS

IMAGE DISTANCE IN IN-FOCUS CONDITION

◀ **Rear focus**
When the lens is set so focus is behind the image plane, the peaks are on the outside of the reference points and too far apart. The lens must move forward.

◀ **Front focus**
When the lens is set so focus is in front of the image plane – for a subject closer to the camera than it actually is – the peaks are too close together and lens must move back.

◀ **In focus**
When the lens is correctly focused, peaks from the separated images coincide, or are in phase, with the reference points.

▲ Rear focus
As the camera changes focus, if the contrast rises, it is going in the right direction. If the blur increases, micro-contrast drops, so we have to focus the other way.

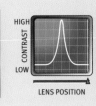

▲ Front focus
With the image out of focus, the camera does not know whether the lens is focused behind or in front of the subject: it looks very similar either way – only reference to other objects will provide needed clues.

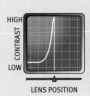

▲ In focus
With the subject in focus, the contrast is at its highest: where subject contrast is low (the peak on the graph is small), it can be difficult to determine the point of highest contrast.

digital cameras because of its simplicity: the sensor itself is used for focus detection. To start focusing, the lens is moved while the system checks the image contrast. If it rises, the focus movement is in the correct direction; if not, it is reversed to seek the highest-contrast part of the image. This method is hesitant and prone to error.

Phase detection requires extremely sophisticated, incredibly precise optics that split the light beam image into a pair (some systems employ as many as 45 sets). The two beams fall on a line sensor that measures the distance between them against a reference, which represents the in-focus point.

If, for example, the distance between the two images is narrower than the reference distance, the system knows that focus is too close to the camera: it then knows which way to drive the focusing mechanism and by how much to achieve an "in-phase" condition – when the peaks match the in-focus reference. In advanced systems, the camera can predict the position of the subject by analysing its movement through variations in the phase, so that focus is set for the moment of exposure and not before. This is so-called predictive focusing, which takes account of delays in the camera's electronics and shutter.

Phase detection is extremely successful technology that has proved itself not only reliable but superior to the best photographers.

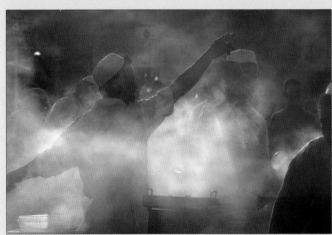

◄ Smoke and steam
Constantly changing soft targets, such as smoke and steam, present many problems for any autofocus system: it is difficult to find a static target offering good contrast.

▼ Slats and high contrast
Passive autofocus systems may stumble with targets such as this: the detail is very high contrast, repetitive, and oriented horizontally. All tend to provide signals that are difficult for the system to analyse.

► Behind glass
Active systems are blocked by obstacles in front of the camera such as railings, windows, and glass. This portrait cannot be photographed with active autofocus but needs passive focusing.

SHORT SHUTTER TIMES

▲ Bird in flight
An exposure of 1/125sec is sufficient to stop the majority of ordinary movement, but it is not short enough in this case – to catch a pigeon in flight at a monastery.

▼ Arresting movement versus depth of field
The need for a short shutter time to arrest movement has to be balanced against obtaining maximum depth of field to render as much of the red carpet, at a Hindu wedding, in focus as possible.

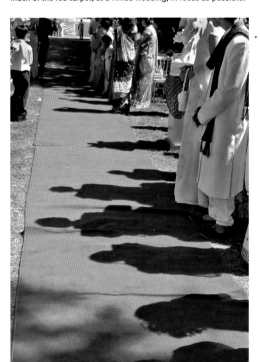

Shutter time measures the duration of exposure – the time during which the capture surface is exposed to light. In English usage it is very commonly, and somewhat misleadingly, referred to as "shutter speed". The shutter travels at exactly the same speed irrespective of the exposure time. A high shutter speed means an exposure of short or brief duration.

EXPOSURE TIME INFLUENCES
The exposure time influences two photographic properties independently of each other. One is to contribute to the camera exposure; the other relates to stopping or freezing movement in the subject. The choice of shutter time can make the difference between capturing a sharp image – of a horse-riding event or aircraft – or not. And with a careful selection of shutter time, you can create deliberate, evocative motion blurs of, for example, people moving in a street.

SHORT SHUTTER TIME
When autoexposure systems can set shutter or aperture freely, such as in program mode, they are usually designed to choose a shutter time that is as short as possible, with an appropriate aperture, for the correct exposure. This policy minimizes the effect of camera shake and prevents subject movement from reducing the image quality. In addition, shorter shutter times allow cameras to shoot sequences at their fastest rate. In average lighting conditions, this results in shutter times in the range of 1/125–1/500sec.

STOPPING MOTION

The table suggests nominal shutter times needed to freeze the action. These are calculated on the blur that is just less than perceptible, so the image appears sharp, with a subject at a distance of 20–30m (65–100ft). Longer shutter times can be used when the subject is approaching the camera than if it is travelling at right angles to the camera.

SUBJECT	TOWARDS CAMERA (sec)	RIGHT ANGLES TO CAMERA (sec)	DIAGONALLY TO CAMERA (sec)
Walker	$1/30$	$1/125$	$1/60$
Jogger	$1/60$	$1/250$	$1/125$
Cyclist av. speed	$1/250$	$1/1000–1/2000$	$1/500–1/1000$
Galloping horse	$1/500$	$1/2000–1/4000$	$1/1000–1/2000$
Car av. speed	$1/1000$	$1/4000$	$1/2000$

If you wish to set a specific shutter time – for example, to cover a race meeting – you can set the autoexposure to Shutter Priority or Time Value Priority, then choose the shutter time directly. The lens aperture will vary to give correct exposure. Also, use the fastest film or set the highest sensitivity compatible with the quality you need.

Note that, because shorter shutter times require larger lens apertures to be set, in dim light short shutter times will hit a limit set by the lens's maximum aperture. If so, you will need to use faster film or set a higher sensitivity.

▲ Fighter aircraft
The paradox of freezing rapid movement is that the faster it is, the more stiff and frozen it looks when captured. This aircraft flying at over 300mph (480kph) looks static when exposed at 1/640sec.

◄ Beach in low light
With low light levels, if you need brief exposures to stop movement and have adequate depth of field, you need to increase camera sensitivity or deliberately underexpose a little – a strategy used in this image from Zanzibar.

▼ Cat antics
An exposure of 1/100sec is rather long for a restless kitten. However, the image appears adequately sharp because the kitten is moving towards the camera.

LONG SHUTTER TIMES

IIt is misleading to refer to exposures of long duration as "slow shutter speed" as there is nothing slow about the action of the shutter. A "slow shutter" actually means that the time interval between the opening and the closing of the shutter is relatively long – usually taken to be any exposure time greater than about 1/15sec. Exposure times longer than one second may be called "T" settings, referring to a way of setting mechanical shutters to stay open until they were clicked to close again.

LONG EXPOSURE

Low light levels generally call for long exposures, but other reasons include: low sensitivity of the capture medium – film or sensor; use of very small lens aperture to increase depth of field; use of filter attachments, which reduce the amount of light entering the lens; or use of lens accessories such as teleconverters (*see* page 160–1) or extensions to increase close-range focus.

Long shutter settings give rise to unwanted side effects. With film-based capture, sensitivity may be lost at long exposures, which causes underexposure if not corrected. This also has the effect of causing a failure in reciprocity of aperture and shutter (*see* page 48). A setting of one second at *f*/22 may produce a less

dense negative than a setting of 1/125sec at *f*/2.8. Consult manufacturers' tables for precise values.

With digital capture, long exposure causes an increase in noise, due to electrical interference with the image signal. This can be reduced using special built-in noise reduction processes designed for the specific camera's circuitry.

Another difference between mechanical shutters and those timed electronically is that mechanical shutters consume no electricity while they are open, but electronic shutters and those in digital cameras do.

PANNING AND SWIRLING

The range of exposure times that are longer than instantaneous – about 1/60sec – but shorter than one second is useful for techniques that combine one static element while other elements move.

The technique of panning follows a moving subject during exposure – this keeps the subject sharp and blurs the background. Rangefinder cameras are best for this,

◄ Night shot with noise
A magnified view of the night view of Paris shows the high level of noise in the image as uneven speckles, particularly evident in the darker areas. However, noise is preferable to no image at all.

▼ Night shot
A combination of very high sensitivity – ISO 1600 – and a relatively long exposure of 1/4sec caught the night lights of Paris and the low cloud.

as SLR cameras are blind during exposure. Alternatively, you can hold a subject still and allow movement around it to cause a swirling blur – exposure times of 1/8–1/2 sec are suitable for pedestrian movement.

PHOTOGRAPHING TV SCREENS

If you wish to photograph broadcast TV images, you need a shutter setting that allows for the complete frame to be recorded but no more. TV is shown as 25 fps (frames per second) for PAL/SECAM or 30fps (NTSC). Therefore, you need a shutter time of 1/25sec or longer. If you see a dark band across your image, you need to set a longer exposure.

You can use shorter shutter times with computer CRT (cathode-ray tube) monitors as they refresh at rates of 60Hz (cycles per second) or more. With LCD and plasma screens, you can use any shutter setting that gives the correct exposure.

▲ Cyclist blur
Following the cyclist with the camera during an exposure of just 1/8sec produced a relatively sharp image of the cyclist but a very blurred background.

▼ Shopping mall blur
Walking along a shopping mall with the shutter set to one second produces unpredictable blur trails of light, with fellow shoppers shown as more compact blurs because they were walking towards the camera.

▲ Fireworks
Blur during exposure can be caused only by objects that are a source of light or that reflect light. Fireworks are effective because the pyrotechnics "write" across a black sky – exposures of between 1/8 and 1/2sec should be ample.

◄ Photographing a TV screen
Using shutter settings of shorter than 1/25sec may be necessary to stop action on a TV screen, but you stand a chance of catching one of the blanking scans, resulting in a black band across the image.

HOW THE SHUTTER WORKS

The job of the camera's shutter is twofold. Much of the time it protects the capture surface from light – this is the case with all film-using cameras and many, but not all, digital cameras. At the moment a picture is made, the shutter opens to allow light to expose the film for a precise and repeatable time.

This means the mechanism must be accurately regulated, reliable, and able to move rapidly; ideally, the entire capture surface should be exposed simultaneously. There are three types of shutter: the inter-lens (leaf or diaphragm), the focal-plane, and the electronic shutter.

INTER-LENS SHUTTER

The inter-lens or leaf shutter is set in between the elements of a lens. It can be made extremely compact and simple enough for single-use cameras or extremely sophisticated and precise for use on professional cameras. It operates nearly silently and can be used with electronic flash at any shutter setting. However, the shortest exposure is usually 1/500sec (1/1000sec on some Rollei 6000 lenses) and longer on large-format lenses. It is widely used in compact cameras.

FOCAL-PLANE SHUTTER

Focal-plane shutters are placed very near to the capture surface. One type uses a pair of blinds (made of textile or thin metal) that roll up like window blinds. A more modern type uses sets of thin alloy blades that fan out to cover the shutter and collapse together to expose. Either type can be timed mechanically or electronically. It is commonly used in SLR cameras. The film or sensor is exposed progressively, as one shutter curtain rolls open and the other closes – it is somewhat like a scan. All types are capable of great reliability, and electronically timed shutters can be extremely accurate.

SENSOR SHUTTER

Many digital cameras use shutters built into the sensor: the light

◄ Leaf shutter
This diagram shows the opening and closing sequence for a leaf shutter. The curved blades pivot on an outer ring that turns to open the shutter and turns back to close it.

Leaf-shutter sequence
This sequence illustrates the appearance of the image at the focal plane with an inter-lens shutter in use (the image is normally upside down). The sequence starts (1) in the dark, when the shutter is closed. On first opening, a little light reaches the focal plane (2). This is followed quickly by a fully bright image (3). At the end of the exposure, the bright image is quickly replaced by the image becoming rapidly dark (4), then full darkness (5). As the entire image is projected on the focal plane at all times, flash can be used at any setting.

Focal-plane-shutter sequence

This sequence of images illustrates schematically the appearance at the focal plane (note the image is normally upside-down). At first it is dark at the focal plane because the first curtain is fully extended across the film gate (1). The curtain falls (2), revealing a strip of image on the capture surface. After an interval (equal to the exposure time), the second curtain (blue) starts to fall (3), following the first curtain, covering the capture surface at the same speed as the first curtain uncovers so the width of the slit between them is constant (4). Finally the first curtain has run its course and the second curtain closes off the capture surface (5). The second curtain (blue) covers the focal plane until the shutter is cocked, which pulls the first curtain (black) back (6), ready for another run.

collected on each pixel of the sensor is shunted under a neighbouring lightproof cover, where it is read. These "shutters" operate totally silently, can be reliable in the extreme, and are very accurate. But they reduce the sensitivity of the sensor.

SHUTTER LAG

In fast-moving situations, whether it's a lively birthday party or a football match, a short shutter time for freezing action is of little use if there is an appreciable time lag between the shutter button being pressed and the exposure occurring.

Shutter lag is caused by electronic systems completing checks before making the exposure, by a zoom lens adjusting the final focus, or from the time needed for simple mechanical movements. Professional-quality SLRs and DSLR cameras offer minimal shutter lag (15 milliseconds is good), but shutter lag in simple cameras may be 0.2 seconds or longer.

REDUCING LAG

You can minimize shutter lag by shutting down as many automatic functions as possible. For example,

set the camera to manual exposure, focus the lens manually, use the lowest resolution, set the white point manually, turn off post-capture processing functions, and do not use flash.

▲ Reduce shutter lag – pigeon
The camera was set to manual exposure and autofocus was turned off while waiting for a pigeon to fly into the space. However, the shutter was pressed a little too late as the pigeon is too close to the edge of the frame.

◀ Shutter lag – cat
You know you pressed the shutter button when the cat was in the middle of the viewfinder frame, but this is the image you obtained. The camera has taken too long to respond to the shutter command.

DEPTH OF FIELD

Depth of field defines the space within which an object will appear acceptably sharp. Depth of field is deep or extended if there is a great distance between objects in front of and behind the plane of best focus that appear sharp; and it is shallow or narrow if there is only a small distance between objects that appear acceptably sharp in front of and behind the plane of best focus. Note that depth of field is different from depth of focus.

Suppose we set a lens to focus at 5m (15ft): a person on a bicycle whose eyes are exactly this distance from

the camera will be in perfect focus. His nose and ears – lying in front of and behind the plane of best focus – may also appear acceptably sharp: these features of the face lie within the depth of field. But suppose the front and rear of the bicycle appear unsharp: they fall outside the depth of field.

ACCEPTABLE SHARPNESS

Whether the unsharpness of the image is or is not acceptable depends on the viewer's ability to discern or resolve detail. At normal reading distances – around

◄ Shallow depth of field
With a normal focal length and large aperture – f/3.5 – the depth of field is so shallow that even nearby flowers are rendered blurred, while no detail in the distance can be distinguished.

◄ Extended depth of field
A normal focal length combined with a small aperture – f/14 – increases depth of field, which appears to bring the distant trees closer. Note that the flowers nearest the camera appear almost sharp.

◄ Shallow depth of field
Limited depth of field can be used to your advantage, as in this portrait made through netting held in front of the girl's face. A large aperture combined with a close position throws the netting well out of focus.

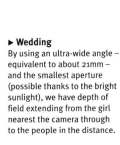

► Wedding
By using an ultra-wide angle – equivalent to about 21mm – and the smallest aperture (possible thanks to the bright sunlight), we have depth of field extending from the girl nearest the camera through to the people in the distance.

30cm (12in) – a viewer cannot distinguish between a point that is 0.2mm (½in) in diameter and one that is a little smaller. This is known as the circle of confusion: the size of image blur that is indistinguishable from a sharp point. The size of the circle of confusion varies with viewers' visual sharpness, viewing conditions, and the type of image – whether print or on a screen.

DEPTH-OF-FIELD FACTORS

The basic control over depth of field is the lens aperture used for the image: for a given focal length, depth of field is narrow at larger apertures and deep at smaller apertures. Depth of field is narrow at high magnifications and deeper at low magnifications. For a given subject distance, as you increase the lens focal length, depth of field narrows. Conversely, with shorter-focal-length lenses, depth of field increases. By the same principle, as you focus nearer – to get a bigger image – depth of field decreases, and as you pull away, to focus from further away, the depth of field increases.

Finally, because in smaller formats you need a shorter focal length to cover the same field of view as a larger format, it follows that as format size is decreased, depth of field increases. Depth of field also varies with scale of enlargement. If you make large prints, you need greater depth of field than if you make small prints or restrict viewing to a monitor.

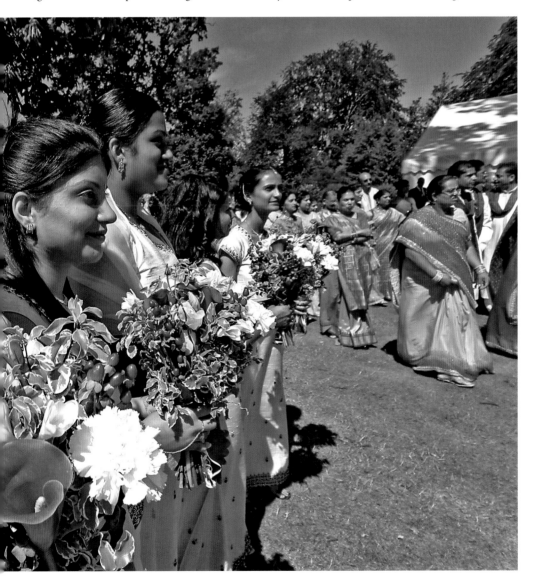

LENS APERTURE

The lens aperture settings – which, on modern cameras, are often made using controls on the camera body and not on the lens – influence more than simply the aperture setting. The aperture control gives you indirect – and often invaluable – control over three other factors: the shutter setting or exposure time, the depth of field, and the optical quality of the lens's image. The operational question is: to which aspect do you wish to give priority?

CONTROLLING SHUTTER TIME

By setting aperture priority in the autoexposure system, you can force shutter times to be long and obtain blurs from fast-moving objects by setting small apertures. In contrast, you force shutter times to be short, so you can shoot sporting events, by setting large apertures.

CONTROLLING DEPTH OF FIELD

The main reason for changing the aperture setting is to alter the depth of field. While other methods are available to affect the working depth of field, to exploit them requires that you change position, focal length, or even the camera. With the aperture control, the manipulation of depth of field is very simple.

- **To increase** depth of field – to make more of the scene appear sharp – increase the f/number, which means set a smaller aperture.
- **To decrease** depth of field – to make less of the scene appear sharp – decrease the f/number, which means set a larger aperture.

Note that many digital cameras using very small sensors can set a limited range of apertures between about f/4 and f/8.

◀ Short exposure
A small aperture and short exposure minimize camera shake with a zoom set to 200mm to capture the movement of these shore crabs.

▲ Maximum sharpness
For detailed images, maximum sharpness is paramount. The aperture was set to f/8 to balance quality with depth of field.

▼ Deep depth of field
An aperture of f/8 was set on a 24mm lens to maximize depth of field to extend from the nearby window to the distant houses.

CONTROLLING OPTICAL QUALITY

In the majority of lenses, image quality increases as you progressively stop down – use smaller apertures – from maximum aperture. This is because many aberrations, or their effects, are reduced by stopping down. However, diffraction effects increase as the aperture becomes smaller, so at a certain f/number, which varies with the lens, using smaller apertures impairs image quality with a marked lowering of sharpness, even if depth of field increases at the same time.

USING WIDE APERTURES

The most popular reason for using wide apertures is to limit depth of field for portraiture. Lens aberrations are at their maximum in portraiture; this helps soften images, as we often do not want the sharpest image. At the same time, the lens exit pupil is truly round, so the out-of-focus image is at its best (*see* page 89). Lenses such as the Summilux 80mm f/1.4, Nikkor 105mm f/2.5, and Tele-Xenar 180mm f/2.8 (for 6 x 6cm format) are beloved of portrait photographers because of their superb full-aperture performance.

▶ **Minimal depth of field**
A wide-open lens combined with long focal length and near focus helps to ensure that depth of field is very limited. Here the camera was set to ensure the nearby ferns lay in the same plane of focus.

▼ **Limited depth of field**
An aperture of f/3.5 with a 63mm focal-length setting ensures that focus is limited to the woman in yellow. Note that the necklace of the woman in purple appears sharp because its sparkle heightens contrast.

APERTURE EFFECTS

The lens aperture controls the amount of light entering the lens; it does so by limiting the diameter of the bundle of light rays travelling through the lens. But the effects of the aperture have far wider implications. It must be positioned with care within the optical construction, or it will impair image quality. Furthermore, while the shape of the aperture does not materially affect the quality of a sharp, in-focus image it has a profound effect on the quality of an out-of-focus image. Then, with small apertures, diffraction effects come into play to set an ultimate limit on lens performance.

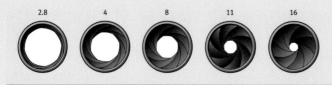

| 2.8 | 4 | 8 | 11 | 16 |

◄ f/number
This diagram shows that as the f/number is reduced, the size of the aperture is larger, which lets in more light. The largest f/number is the lens's maximum aperture, which lets in the most light.

f/NUMBERS

The relative size of the aperture is measured by the f/number or f/stop. It is the ratio between the focal length of the lens and the diameter of the aperture.

The reason for making the size of the hole relative to the focal length, rather than an absolute figure, is that it enables us to use the same f/number with different lenses and still obtain the same exposure setting. Because the aperture diameter is divided into the focal length, the smaller the f/number, the larger the aperture. The basic f/number series – 1, 1.4, 2, 2.8, 4, 5.6, 8, 11, 16, 22, and so on – moves in steps of one stop representing a doubling or halving of lens diameter, which corresponds to a doubling or halving of exposure.

APERTURE SHAPE

The lens aperture is formed by a ring of blades pivoted on the outer rim. The more they overlap, the smaller the hole for the light to get through. The simplest are like two L-shaped flaps that overlap to leave a square hole. Lenses have used as many as 19 separate leaves, which gives a near-circular hole. The rounder the shape of the hole, the better the out-of-focus image (*see* below), so we want to use as many blades as

▲ Aperture shape
This diagram shows how the aperture's shape varies with a lens using six blades. It is a perfect circle at full aperture (*left*), clearly hexagonal at middle apertures (*middle*), and nearly circular at minimum aperture (*right*).

◄ Internal reflections
The shape of the aperture imposes itself on internal reflections caused by stray light bouncing inside the lens. The more circular the shape, the less obtrusive the pentagons, which can be seen here (bottom left).

possible. In SLR cameras, the aperture is usually held open for viewing and focusing; then it must shut down instantly to the working aperture for the exposure and open up again at the end. This rapid action cannot take place with too many blades because of the high friction involved. Modern SLR lenses usually use between five and seven blades.

BOKEH

Photographers pay a great deal of attention to the sharpness of their images. But the fact remains that the main part of almost all images is actually unsharp, so the quality of the unsharp image plays a considerable role in the feel of the shot, particularly in portraiture and still life. This quality is the image's bokeh. Where this is smoothly gradated, with no sign of fringing or unevenness, it is regarded as good. Bokeh with uneven or irregular unsharpness patterns, such as the appearance of double images, is undesirable.

Generally, factors that deliver superior bokeh include lenses with circular or nearly circular apertures and high level of correction for astigmatism and spherical aberration. However, note that in digital photography subtlety in the bokeh may be reduced or lost by posterization, sharpening, low resolution, and JPEG compression effects.

DIFFRACTION

When light waves meet an edge, a small percentage turns the corner: this is diffraction. Around a small hole, the amount of light diffracted is a significant proportion of the whole and disturbs proper image formation. Where lens performance is limited by diffraction and not by other aberrations it is said to be diffraction-limited. It is best to avoid using the smallest apertures to avoid diffraction effects.

▼ **Mirror haloes**
The bokeh of mirror catadioptric lenses is very uneven, giving characteristic doughnut-shaped out-of-focus highlights and two-toned out-of-focus edges that limit its usefulness.

▲ **Bokeh and sharpening**
In this close-up view of an image, the combination of in-camera sharpening and JPEG-compression artifacting tend to reduce the difference between the sharp parts (rower) and unsharp parts (leaves) of the image.

▼ **Smooth bokeh**
The unsharp image from a first-class lens – the Schneider 180mm f/2.8 – at full aperture is beautifully smooth, with the most subtle gradations of tone and colour but still sharp where it is meant to be sharp.

DIGITAL CAMERA FEATURES

Digital camera features can be divided into three main categories, depending on how often you need to set them. First is the basic setup for the camera – you should not need to change this very often. Preferences set up the camera to work in a way that suits you and your photography; you may need to alter these from time to time as the subject matter or your shooting requirements change. The remaining settings relate to the most frequently used photographic controls, such as sensitivity, exposure settings, and flash.

SETUP

The basic settings include the time and date, menu language, video format (NTSC or PAL), and others that you will not need to change very often. Often, cameras offer a specific setup mode just for these settings. You may have to work through this setup the first time you use the camera. It is a good idea to change the time/date setting when you travel to a different time zone to synchronize with your travel itinerary. Some cameras may also place maintenance functions here, such as sensor cleaning or the formatting of memory cards.

▼ Soft saturation
The day is dull and the light is low, but for this portrait it is important not to be tempted to increase colour saturation, as that would render the face too richly coloured. We need only the graceful profile and highlight in the eye.

PREFERENCES

Preferences are settings that apply the majority of the time, but you may change them from time to time in response to working conditions.

File type and preferences

Here you decide on your image file format, such as JPEG or raw, and the level of compression. Whatever you decide will have an impact on the number of images you can keep on your memory cards. You can also decide on how your files are named. You can choose sequential numbering, in which every file gets a number that resets when you change the memory card.

Resolution

Digital cameras use either all the pixels available on the sensor – to give the highest resolution – or fractions of the total, for a lower resolution. You can fit more pictures on the memory card with lower-resolution files as they take up less room and are faster to process.

Flash mode

It is important to learn how to control the flash. If it is switched to on or automatic when not required, it may charge up anyway and drain the battery. In some situations – such as in open-air theatres or for distant night views – flash is not needed and should be turned off.

Sensitivity

The sensitivity, usually measured by the ISO number, is an important control as it affects image quality and the range of exposure settings available. Low settings, such as ISO 100, give good quality but need high light levels. Higher settings, such as ISO 800, enable work in poor light, but the quality is reduced.

Colour space and rendering

More advanced cameras allow you to choose a working colour space whose profile is also embedded in the image. Many cameras default to sRGB, but for the majority of digital photography needs, the larger space of Adobe RGB (1998) is much preferable. In addition, you may choose how colours are rendered – in a neutral way or one that emphasizes colour saturation or reduces contrast.

PHOTOGRAPHIC CONTROLS

The controls you will access the most often, such as exposure mode, exposure override, flash on/off, and the shutter or aperture settings, should all be easy to find and set.

Autoexposure mode and override

The standard choice on modern cameras is to use fully automatic or Program mode, in which the system selects the shutter and aperture setting according to a set program. In good light, the program is biased towards maximizing depth of field; in low light, the bias is to set to the shortest exposure time in order to minimize camera shake. The override control is essential to the autoexposure system, since it allows you to increase or decrease the overall exposure to suit the photographic result you wish to obtain.

Aperture

One marked difference between compact film and digital cameras is that the range of apertures available to small digital cameras is usually very limited. As a result, even if an aperture control were offered, it might not be very useful. However, direct access to aperture settings is important for manually set exposures. On professional cameras, apertures can be set to an accuracy of a third or half of a stop – fine control is important for accurately exposing transparency film.

▲ **Sensitivity – table lights**
A high sensitivity was set for this interior scene, resulting in an image that is very noisy when viewed on screen. When used at a relatively small size, noise is apparent in this reproduction only as poor blacks and uneven tonal gradations.

Shutter

The main reason for setting shutter times directly is to set manual exposures; this can help reduce shutter lag and offer a high level of control. On professional cameras, shutter times can be set to an accuracy of a third or half of a stop, the fine control being important for accurately exposing transparency film.

Focus mode

While autofocus is the norm, in some situations it will be ineffective and you will need to manually set the focus. One-shot autofocus means the focus must be obtained before exposure can take place, and that focus can be held. Servo autofocus follows the subject, focuses continuously, and anticipates the subject's position at exposure time. The camera is more responsive in this mode.

◀ **White balance – no correction (*far left*)**
Without white balance corrected, the image has an orange colour cast from the domestic incandescent lamp and pale yellow walls. It isn't accurate, but nor is it unattractive.

◀ **White balance – corrected**
With the white balance corrected (by using the sheets as the white target) the colour is truer, but it is not necessarily preferable to the other image.

White balance

Modern digital cameras are usually set to automatic white balance. Others allow preset values such as tungsten, or cloudy day, while some can be set to actual values – for example, 6500 K. Manual setting of white balance gives the best scope for correction at a later stage, but it is found only on more advanced models.

Picture scenes

Such are the complicated settings needed for some tasks, digital cameras collect them together under picture scenes or modes. The sports mode sets high sensitivity, servo AF, and short shutter times, while the landscape mode sets low sensitivity, small aperture, and saturated colours. These modes handily collect many settings into one menu and help minimize post-production on the images.

Image processing

If you are not saving images as raw files, they will be processed by the camera according to your settings for saturation, sharpness, or contrast. These may offer different strengths of effect. You may also choose from preset values optimized for portraiture, weddings, or product photography.

Zoom

Some small digital cameras are able to offer impressive zoom ranges, up to 16x. They do so by using two ways

of magnifying the image. The basic optical zoom is obtained by shifting lens elements to give up to 4x zoom. Then digital zoom is an enlargement of the central portion of the image using hardware or software interpolation. There is no true increase in detail with digital zoom, and the image will not be the best quality, but it can be handy to save working in the computer for the same effect.

▶ **Image processing – too hard**
If the camera is set to create sharp, lively, colourful images appropriate for, say, travel or landscapes, the results applied to a portrait are unlikely to be successful. Here the colours are too bright and saturated, and the sharpness is too harsh.

◄ Autoexposure
The "correct" exposure for this autumn scene was acceptable, but pictorially, a heavier image with stronger blacks was more effective – so the scene was deliberately overridden by one and a half stops (*below*).

▼ Exposure corrected
This exposure is correct, but it is lacking in sparkle and strength, partly because there are no true black densities in the image.

► Picture scene – fireworks
If you are shooting fireworks, it is useful to have a single setting that prepares all the camera's settings – lens set to infinity, flash off, long exposure – to obtain successful pictures.

▲ True 12x zoom
A zoom that reaches an optical focal length of 420mm equivalent provides a detailed view of a tower over a kilometre away with a good number of pixels, even if sharpness is a little lacking.

▲ Digital 12x zoom
A digital zoom reaching the 420mm equivalent is woefully lacking in detail and full of noise, as well as showing poor colour – all from the enlargement and interpolation of too few pixels.

EXPOSURE MEASUREMENT

The shutter time and lens aperture settings are ultimately the servants of the exposure that you wish to give your capture surface in order to capture the image to the best quality. Your guide is the exposure meter. In all modern cameras, the metering is through-the-lens (TTL): the light reaches the meter through the camera's taking lens. The process of metering brings together the measurement of the light with the capture surface's sensitivity, from which you can choose the combination of shutter and aperture that is designed to give desired results.

SENSITIVITY WEIGHTING

Exposure meters integrate the light falling on them; they add up all the bright parts with the not-so-bright parts, as well as the dark areas of the scene, to come to a single reading. The way the meter reads the scene may be spread or weighted in different ways. If spread evenly over the picture area, with no response at the edges, we have the averaging pattern, which is suitable for many situations but is inaccurate in extremes of lighting. In the centre-weighted pattern, the proportion of the meter reading is greatest over the centre of the image and falls off rapidly towards the edges of the frame. This is a good method for the majority of photography as it reflects the greater attention we give to the centre of the picture. Spot metering is obtained by confining sensitivity entirely to a central spot – only 2–3 per cent – of the image area. It can be the most accurate and versatile method but requires careful use.

◄ ▲ **Average metering**
The diagram shows a computer simulation of a typical average metering pattern. This is ideal for scenes such as this where the tones are evenly distributed, with no extremes of high or low. But the limited luminance range requires accurate exposure control because there is no room for error.

◄ ▲ **Centre-weighted metering**
This diagram shows how a centre-weighted metering pattern concentrates on the centre of the image, with more rapid fall-off towards the top than the bottom, reflecting the desire to pay less attention to the upper part of the image. Applied to this scene, a centre-weighted system has seen the darkish centre and exposed correctly for it, but the side effect is to overexpose the sky and clouds.

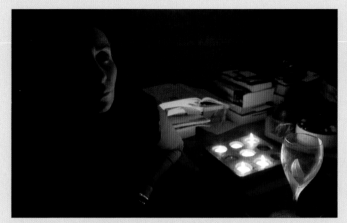

◄ ▲Spot metering
This diagram simulation shows the total concentration of sensitivity into a central spot. Outside the central spot, even bright light can be completely ignored for the purposes of metering. Accurate metering by candlelight is easiest with a spot meter, which can home in on the light on the subject's face to set the exposure.

LIGHT EVALUATION

Until the late 1990s, meters only measured light passively. But with computerization, so-called intelligent or evaluative metering was born. This reads different segments or portions of the scene and compares them against a look-up table (LUT) containing data about hundreds of different scenes.

The LUT tells the camera which exposure is most likely to match the scene. The LUT can easily tell the difference, for example, between a scene brighter in the lower half than in the upper half, such as a sandy beach with bright sunshine, and one that is darker in the lower half than in the upper, which is the majority of landscapes. Modern evaluative or matrix systems give very reliable results, but it is difficult for the photographer to know exactly what the meter is "thinking".

► Light foreground
Evaluative systems will recognize this situation as one in which to ignore the bright foreground and set the exposure for the sky; otherwise the overall image will be underexposed.

▼ Metering grids
These are two examples of different ways to divide up the scene into separate segments, which are read, then compared to data in a look-up table. By choosing to use only the central segment, we obtain spot metering.

METERING LIGHT

The earliest methods of light measurement called for the use of a candle as a standard. Naturally, this was replaced with technology that measured light directly. The selenium cell produces an electric current, this current varies with the amount of light falling on it. Although needing no battery, it is relatively insensitive and does not respond linearly to light levels. The CdS – cadmium sulphide – cell responds to differing light by varying its resistance. Some meters still use the selenium cell, but the CdS cell can be found in professional handheld meters. The silicon photodiode, or SPD, cell is highly accurate and linear. It is found widely in cameras and handheld meters. Nowadays, many digital cameras use the sensor for metering.

STABILIZING THE CAMERA

▲ **Unstable – camera high**
This hold is unstable and likely to lead to unsharp images, but it offers a useful height to one's viewpoint.

▲ **Common but unstable**
The majority of compact digital cameras are held this way, but it is inherently unstable and many unsharp images are caused by this hold.

The majority of photographs are made while holding the camera in the hand, rather than on a tripod or other support. Everyone has their own zones of comfort, but you should aim to support the camera at three points and without straining any joints so you can hold a position for at least a few minutes.

CAMERA HOLDS

For landscape-format shots, hold a compact camera with both hands and rest it against your forehead to frame the scene that you wish to photograph through the optical viewfinder. Digital cameras without a viewfinder force you to hold the camera away from the face in order to view the LCD screen; this is inherently shaky, hence the popularity of image stabilization systems.

 With SLR cameras, hold at the grip and support the lens in the palm of the left hand. Avoid controlling the lens with an overarm hold because you are not supporting the weight of the lens. The hold is unstable and becomes increasingly unstable with longer or heavier lenses.

 For portrait-format shots, most people find that turning the camera so that the right hand is underneath is easiest. However, this forces a change of grip and the wrist is twisted uncomfortably, which is tiring to maintain with heavy SLRs. Having the right hand uppermost involves no change of grip but can be even more tiring.

▲ **Stable**
The camera held to the face is the most stable hand-hold position, but you have to work with small viewfinder windows and distorted views. It is also awkward for portrait format.

▲ **Overarm hold**
Focusing or changing zoom settings on SLRs with the left hand held this way may feel comfortable, but it is unstable as the lens is poorly supported by the arm.

"SAFE" SETTINGS

The sharpness of handheld pictures depends on how steadily you hold the camera, the effect of vibration from the camera (from mirror slap and film wind), subject movement, and the effects of changes in the focal length on the image. Compact viewfinder cameras produce almost no vibration so can be handheld at longer shutter times than, say, medium-format SLRs, which are very difficult to hand-hold safely at any shutter setting.

 As a rule, the way you determine the longest shutter time that allows a sharp image is to divide the lens's focal length into one – the reciprocal focal length in seconds. For example, for a 50mm lens, a safe setting is 1/50sec, for a 200mm it is 1/200sec.

IMPROVISED SUPPORT

Sharpness in your images can always be improved with impromptu or improvised support by leaning on a wall, resting the camera on a table or chair, or crouching down into a lower position. Another helpful technique is to hold the camera strap tightly as you take the picture.

▲ **Underarm hold**
Supporting the lens in the palm of the left hand allows you to access lens controls, while providing a stable camera platform.

▲ **Change grip**
For portrait-format shots, this position is comfortable and fairly stable, but you have to change your right-hand grip.

TRIPODS

There are two approaches to using a tripod. You can use a heavy, rigid model that provides stability through its sheer mass. Or you could pick a lighter model, but you may need to supplement its rigidity and mass.

You can improve the mass and rigidity of any tripod by hanging a weight, such as your camera bag, from it using an elastic strap or bungee. You can also stiffen a tripod by leaning your own weight on it, but that is obviously not a good technique for long exposures or when using very long lenses. For the best balance of rigidity and portability of low weight, use carbon-fibre tripods. These use legs constructed from glued carbon fibre. Although they are expensive, they are the best ones for general photography. Tripod legs made from aluminium alloy are heavier and less rigid than carbon-fibre legs, but they offer excellent value.

For the best control over the camera's aim, use a 3D tripod head; for compactness, use a ball-and-socket head. Always direct the camera by using the handles on the tripod head or by pushing on the body – never on the lens or an attached accessory. With very long lenses, secure the lens – not the camera – on the tripod, using a rotating collar where provided.

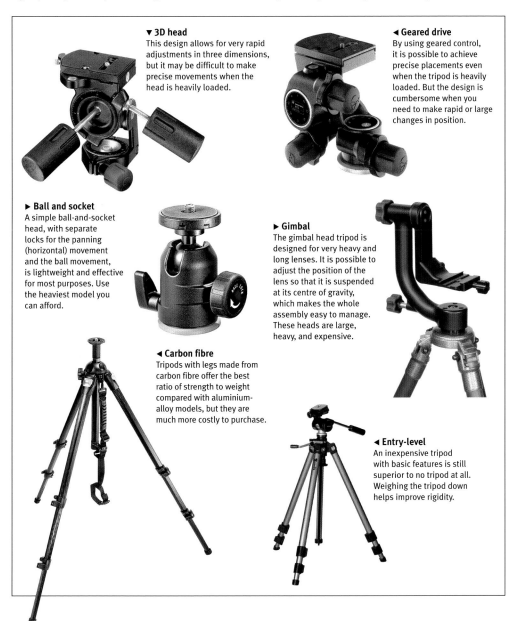

▼ 3D head
This design allows for very rapid adjustments in three dimensions, but it may be difficult to make precise movements when the head is heavily loaded.

◄ Geared drive
By using geared control, it is possible to achieve precise placements even when the tripod is heavily loaded. But the design is cumbersome when you need to make rapid or large changes in position.

► Ball and socket
A simple ball-and-socket head, with separate locks for the panning (horizontal) movement and the ball movement, is lightweight and effective for most purposes. Use the heaviest model you can afford.

► Gimbal
The gimbal head tripod is designed for very heavy and long lenses. It is possible to adjust the position of the lens so that it is suspended at its centre of gravity, which makes the whole assembly easy to manage. These heads are large, heavy, and expensive.

◄ Carbon fibre
Tripods with legs made from carbon fibre offer the best ratio of strength to weight compared with aluminium-alloy models, but they are much more costly to purchase.

◄ Entry-level
An inexpensive tripod with basic features is still superior to no tripod at all. Weighing the tripod down helps improve rigidity.

PHOTOGRAPHY EQUIPMENT

Because photography is an activity that takes the world as its subject, it is natural and practical to classify it into specialities based on the subjects photographed. Nature photographers, photojournalists, or portraitists define themselves by their subject matter, and that determines the equipment they need. There is no rule about which camera and lens combination you should use for a given task, but the combined experiences of many can help prepare you for a job.

PORTRAIT PHOTOGRAPHY

For flattering perspectives, use longer-than-normal-focal-length lenses: 80–135mm for 35mm format, and 120–180mm for 6 x 6cm format. For smooth rendering of skin tone, use medium format or larger, with low sensitivity capture. Waist-level finders such as those on Rolleiflex, Hasselblad, and Mamiya medium-format cameras are preferred, as these allow the photographer to maintain good eye contact with

the subject. Soft lighting – provided by soft boxes or brollies on flash – is the most versatile. Useful accessories for portrait photography include a reflector, diffuser, softening filter, and a toy for children.

TRAVEL PHOTOGRAPHY

For maximum versatility, use zoom lenses covering at least 35–200mm. Zooms with wider ranges are larger, heavier, and slower to use. Dust is a serious problem for digital cameras, so those with non-interchangeable lenses are at an advantage. You should aim to use a camera with 8 megapixels or more. Take extra batteries, memory cards, and backup storage, such as a hard-disk drive. If using colour film, amateur types tend to be more robust than professional films. Useful accessories for travel photography include a lightweight tripod, polarizing filter, UV filter, and lightweight flash.

▲ **Nature photography**
Compact cameras with super-zoom lenses are ideal for travel photography and general nature photography, as they enable you to zoom into the distance without the need for carrying large and very costly lenses. Cameras with fixed lenses save you from worrying about dust entering the camera body.

◄ **Informal portraits**
The compact camera is ideal for quick and informal snaps, but you may wish to ensure that worthwhile shots are captured using the best quality, in which case you need a high-quality camera, such as a DSLR.

PHOTOJOURNALISM

You need to work discreetly, produce high-quality images under adverse conditions, and be highly reliable. The ideal equipment is the Leica M-series of cameras, which meets all requirements and also offers the most accurate focusing system for wide-angle lenses. A digital version of the Leica is the Epson R-D1, a 6-megapixel camera that accepts Leica lenses. Digital cameras can offer near-silent operation, but the majority are limited in low-light conditions. Use wide-angle lenses from 21 to 35mm and a maximum aperture of *f*/2.8 or larger. For news and documentary work, a broad range of cameras – from professional 35mm or digital SLRs to medium-format SLRs – can be used according to the subject and speed of operation needed.

NATURE PHOTOGRAPHY

This is one field in which prime (fixed-focal-length) lenses reign supreme. The shortest normal lens for wildlife is 400mm, but 500mm is preferred – 600mm and longer lenses are exceedingly heavy as well as costly. Use tele-extenders of 1.4x and 2x power where lighting permits. With such long focal lengths, attention should be given to the design of the tripod head: those for video cameras or gimbal-mounted designs are best. For close-ups, macro lenses with longer focal lengths – 100mm and greater – provide flexibility and quality. Useful accessories for nature photography include a tripod, flash, polarizing filter, neutral-gradient filter, remote release, and a hide.

SPORTS PHOTOGRAPHY

The main needs of sports photography are similar to nature photography's: long optical reach and fast apertures. The camera must also be able to work rapidly: short bursts of rapid fire – at least five frames per second – on film or digital SLRs are essential.

For those supplying to news organizations, the ability to connect wirelessly to a local network for transmitting images may also be essential. Shorter focal lengths are useful for covering press conferences. Useful accessories for sports photography include a monopod, flash, and wireless transmitter.

▲ Travel camera
Cameras such as this 8-megapixel model, which has a 35–420mm zoom and can be further extended with conversion lenses, can offer an ideal package for serious travel photographers.

▼ Compact camera
Models such as this are excellent for photojournalism because they combine discreet size and operation with a usefully wide (28mm) zoom and high (12 megapixels) image quality together with low cost.

▲ Fast camera
Modern DSLR cameras are capable of exposing eight or more frames per second for 40 or more exposures – a better performance than any but highly specialised film-using cameras.

▼ Medium-format film
By combining superlative image quality with reduced depth-of-field effects on a large area of film, a motor-driven medium-format camera such as this Rolleiflex 6008 is ideal for portraiture.

▲ Macro lens
A specialist manual-focus macro lens such as this 65mm *f*/2.8 model enables first-class imagery, focusing continuously from life-size to 5x life-size in a compact package.

▲ Teleconverter
Modern teleconverters, which mount between the lens and body, offer a high-quality method of increasing the focal length, at the cost of reducing the maximum aperture.

▲ 400mm lens
A 400mm lens for 35mm format is equivalent to 600mm on a DSLR using an APS-sized chip, making it the ideal combination for sports photography. Adding a teleconverter further increases your optical reach.

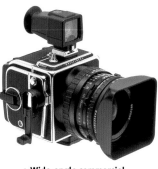

▼ Architectural
Cameras such as this model from Ebony are sturdy and versatile, able to give a range of movements sufficient for architectural and landscape photography. They also accept interchangeable lenses as well as digital backs.

▲ Wide-angle commercial
A legendary workhorse of a camera, the Hasselblad SWC super-wide camera captures a 90° view across the diagonal with extremely high resolution and even light coverage, and is almost completely free of distortion.

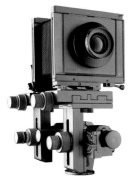

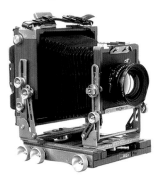

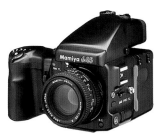

▲ Studio monorail
Sturdy and capable of many years of daily use, monorail cameras, such as this one from Sinar, are built for quick and reliable setting up as well as stability during operation.

▲ Compact medium format
Compact and rapid in use but capable of excellent results, 6 x 4.5cm-format cameras such as this model are widely used for portraiture and weddings.

COMMERCIAL PHOTOGRAPHY

The commercial photographer must be versatile: able to make ultra-wide-angle shots of an oil refinery one moment and close-up portraits of executives at another. Use focal lengths from 14mm or wider (35mm equivalent) to at least 200mm. Medium-format wide-angle cameras such as the Hasselblad SWC are good for impressive interior and exterior views. For top-quality work, use the highest-resolution digital camera backs or medium format loaded with fine-grain film. Accuracy of colour reproduction may be important, too, especially if you are photographing company signs. Useful accessories for commercial photography include colour-correction filters, special effect filters, tripod, laptop computer, and hard-disk backup.

WEDDING PHOTOGRAPHY

Medium-format photography is the preferred approach to weddings and other important life events that call for not only high image quality but also longevity. The 6 x 4.5cm format equipped with a standard 75mm lens is popular because it combines a serious-looking camera with economical film usage. A longer lens may be needed for format portraits. For informal or reportage-style wedding photography, a 35mm camera or DSLR will be suitable. For all styles, a flash is essential for lighting dark interiors. Useful accessories for wedding photography include a tripod, flash, reflector, and softening filter.

ARCHITECTURAL PHOTOGRAPHY

Photography of the built environment calls for the highest technical quality: images free of distortion and converging verticals, with maximum depth of field. Use large-format cameras – 5 x 4in at least – with focal lengths varying from wide angle to medium-long. Technical field cameras – with a base that folds out – are the most popular, but studio cameras are widely used too. Working on a tripod is essential. Supplementary lighting is considered only for the very largest productions, so the rule is to make the best of available light. Useful accessories for commercial

photography include colour-correction filters, gradient filters, remote release, and a handheld meter.

STUDIO PHOTOGRAPHY

The ultimate demands in image quality and control of lighting are made in the studio, where it is possible to work for days in order to achieve a perfect shot. The minimum format is generally regarded as 5 x 4in, with preference being given to 10 x 8in or very high resolution digital backs used on monorail cameras with extensive camera movements. Normal focal lengths, such as 150mm for 5 x 4in, are usually used, with very short or very long focal lengths being the exception. Lighting from flash, an extensive armoury of light shapers is central. Useful accessories for studio photography include a handheld meter, remote release, and Polaroid/Fuji Instant if using film.

▶ **On location**
Even if the work takes place in dangerous or risky environments, industrial photographers are expected to return with the highest-quality images.

▼ **Architectural**
It is tempting, in confined spaces such as this whisky distillery, to use the widest-angle lens to capture the whole scene. But this would result in projection distortions, which exaggerate the proportions of objects at the edge – something that is unacceptable to the majority of architects.

Capturing light

FILM AND SENSOR

TYPES OF FILM: BLACK AND WHITE

CAPTURING COLOUR

COLOUR FILMS: TRANSPARENCY

COLOUR FILMS: PRINT

FILE FORMATS AND APPLICATIONS

MEDIUM AND LARGE FORMAT

EXPOSURE METERING

METERING TECHNIQUES

DIGITAL IMAGE CAPTURE

WORKING IN LOW LIGHT

DIGITAL COLOUR CAPTURE

WORKING WITH SENSOR FORMATS

FILM AND SENSOR

Photography is fundamentally the exploitation of light's ability to do work: the energy of light is absorbed in the recording medium and transformed to create a record. In film, light energy is absorbed to confer charge to silver-halide crystals, so causing a chemical change. In digital sensors, absorbed light is turned into electricity. From this point on, however, there are few similarities between the way film and sensor capture an image.

DIFFERENCES BETWEEN FILM AND SENSOR

Film absorbs the light projected from a lens in a uniform way across the area of the film, recording detail with only slight and random variations depending on grain size and distribution – but with no substantial gaps.

Digital sensors, however, absorb light at specifically designated light-receptive spots – the photosites or picture elements (from which the word pixel derives) – that are set out in a precisely ordered array and with equally regular and specific gaps in between.

One practical consequence of this difference is that film does not suffer from moiré artifacts, whereas it is a limiting defect for all digital sensors.

When the exposure is made, the image is latent on both capture surfaces, which means it is there but is neither usable nor visible. With film, the image was once considered rather labile – prone to change – but compared to the instability of the latent digital image, film's latent image is a model of stability.

Indeed, films discovered 50 years after they were lost in the Antarctic could still be developed. In contrast, the latent image on a digital sensor will disappear within microseconds if there is the slightest disruption to the sensor's electrical supply.

TYPES OF DIGITAL IMAGE CAPTURE

Although film exposed by a focal-plane-shutter camera is exposed in a scanning-like manner, the whole area of film is exposed in one single shot. The majority of sensors in digital cameras are also essentially one-shot or instantaneous. This type of image capture is sometimes referred to as "progressive frame" – a term borrowed from video technology. Digital images can also be captured by scanning, recording all colours one line at a time; this is the method used in film and flatbed scanners (see pages 286–7) and by large-format scanning backs for studio cameras.

A third type of capture records in three stages, capturing red, green, and blue images each time. In stills photography, this method is obsolete. Three-pass scanning is rare, but cameras using triple sets of sensors – separately recording red, green, and blue – are standard in professional video.

WHICH IS BETTER?

Images from digital SLR cameras with a pixel count of 11MP (megapixels) or more are superior to 35mm ISO 100 transparency film. In the digital image, sharpness is greater, grain is somewhat smaller, but noise is significantly less, while tonal gradations are almost as smooth. With pixel counts of 16MP or more, digital images are superior even to medium-format 6 x 4.5cm film. But the colour palette of film, which has been developed over many years, is hard to match in the digital image.

However, photosites on CCD or CMOS sensors are larger than typical dye clouds (grain) in films. On digital SLRs, which have larger chips, each sensor is about 12 microns (millionths of a metre) square. On smaller digital cameras, sensors are about 4 microns. In contrast, the diameter of a typical dye cloud varies between 1 and 3 microns.

▶ **Sensor recording**
The best digital cameras can offer a combination of resolving power as good as that of medium-format cameras together with the flexibility and responsiveness of 35mm SLR cameras. This is demonstrated in a street scene in Jaipur, India, caught on the Canon EOS-1Ds Mk II, where more detail than was visible to the naked eye has been captured.

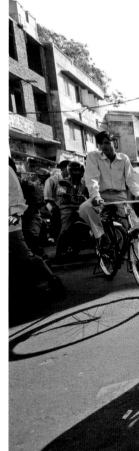

▼ **Digital detail**
A enlarged section from the centre of the main image reveals an immense depth of detail and information.

▼ **Digital noise**
As in film, the higher the sensitivity of a sensor, the more noise or grain will be visible – seen in this digital image exposed at ISO 1600. However, the picture is broken up by the pixel structure, which becomes evident at very high magnifications.

▲ **Multiple exposure**
Only a handful of modern digital cameras offer the commonplace film-using technique of multiple exposure. In this instance, the effect of multiple exposure has been laboriously imitated by blending several separate digital-camera exposures.

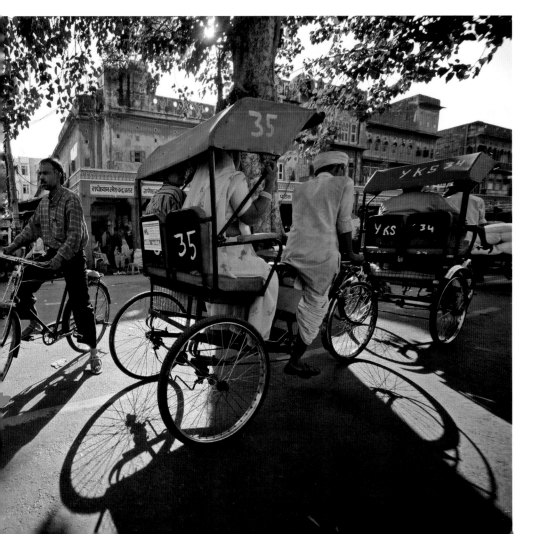

TYPES OF FILM: BLACK AND WHITE

Black-and-white films translate colour variation, as well as changes in brightness, into a tonal map of the scene. It is created by a mix of greys that run from white to black. This does not mean that black-and-white films ignore colours. Films are often more sensitive to short-wavelength light than to longer wavelengths. As a result, their response to light may depend on its prevailing colour – being more sensitive under skylight than domestic lighting, for instance.

FEATURES

There are two types of black-and-white film in common use. The classic type carries a suspension (often incorrectly referred to as an emulsion) of light-sensitive silver-halide crystals in a layer of gelatin. On processing, the image records in negative using silver deposited in the gelatin. The image appears negative because more silver – which corresponds to greater light – blocks more light, appearing dark.

The modern type of film also carries light-sensitive crystals in gelatin, but these incorporate dye couplers – chemicals that will be activated by developed silver to combine with dyes. The final image is formed from the coloured dyes, giving the name "chromogenic" to this type. On processing, the exposed crystals activate the dye couplers to create dye clouds, which form the image in negative – more dye cloud representing more light – while all the silver is removed.

◄ **Colour sailing**
These white sailing boats are contrasted beautifully with the blue seas off Picton, New Zealand, which are in turn contrasted with the golden light on the hills. But arguably the colours of the hills distract from the main subject, which are the sailing boats. Compare with the monochrome version below.

▼ **Monochrome sailing**
A black-and-white version of the colour image throws the emphasis on the contrast between the sails and the landscape by reducing differences within the landscape. Whether the black-and-white or colour version is your favourite depends on what you want the image to communicate.

PROS AND CONS

- Greyscale reproduction eliminates colour distractions, easy to make tonal adjustments, wide variety of developers.
- Colour information is lost forever, colour variations may be lost in greyscale, silver-based images difficult to scan, grain tends to increase with high exposure.

USE OF BLACK-AND-WHITE FILM

For many, black-and-white film remains the photographic medium of choice for subjects as diverse as landscapes, portraiture, documentary photojournalism, and fine-art still life. The reason is that with careful processing, the tonality of the final print, when made in the darkroom, is deeply satisfying in its almost tactile qualities, and remains unrivalled by digital photography.

Familiarity with a certain film means you can match your artistic vision to the film's characteristics. Furthermore, you can choose from numerous ready-made developers or easily make up your own, giving you huge control over tonal rendition.

FAST FILM

Fast, or sensitive, black-and-white films are regarded as those of ISO 400 or greater. They tend to exhibit grain even at moderate enlargements, provide pleasing, if not the smoothest of tonal changes, and offer medium to low contrast with a high level of base fog (non-image-forming density that is present over the entire film).

ISO 400 films such as silver-halide Kodak Tri-X, Ilford HP-5 Plus, Fujifilm Neopan 400, or the chromogenic Ilford XP-2 are excellent for general use but can be a problem in extreme brightness (needing a combination of short shutter time and small aperture)

and inadequate in very low lighting. Film that is faster than ISO 400 will be more grainy and exhibit more contrast and fog.

MEDIUM TO SLOW FILM

Films with low sensitivities are usually referred to by their main attribute – fine grain.

The benefit of using medium (ISO 100) or slow films (ISO 50 or less) is that average enlargements can appear virtually free of grain, thus offering seamless tonal gradation.

Thanks to fine grain, resolution is high, contrast can be high, and fog levels low. As a result, ISO 25 films can give the highest resolution and smoothest tonalities in all photography. However, exposure and development latitude (*see* page 231) are reduced, so accurate exposure and careful development are essential.

▲ **Negative**
A high-speed black-and-white negative shows characteristic fog – density in areas that should be blank, as in the top third of the picture, and highlights that are not black. The tonal range is compressed and is expanded on printing.

▲ **Print**
A black-and-white shot of a negative yields full black shadows as well as highlights, which cannot be brighter than paper white – that is, not very bright at all. But we simulate a full scale of tones by manipulating the grey to give high contrast.

▲ **Colour parrot**
At first sight, the plumage of the kea, a near-extinct parrot of New Zealand, appears rather drab, but it reveals its richly coloured plumage when the wing is lowered. Only colour photography can record this accurately.

▲ **Black-and-white parrot**
In black and white, the colours are lost in a range of a very few shades of grey. Use of a coloured filter may improve the black-and-white image, but only to separate some of the greys.

CAPTURING COLOUR

All modern ways to capture colour depend on the separation or analysis of hues into an equivalent triad of three standard primaries, varying in amount to match the colour. This is based on the discovery that just by varying combinations of three colours – such as red, green, and blue – it is possible to simulate just about any other colour. In fact, any combination of three colours equally spaced around the colour wheel (see page 205) can do the trick; some systems use cyan, magenta and yellow. Methods using four colours employ the fourth mainly to correct defects in the other three.

◀ **Cityscape**
A view of Jerusalem from the old city walls reveals some colour, but it is impossible to say whether it is digitally captured or caught on film.

▼ **Cityscape – magnified**
A highly magnified close-up from anywhere in the image will show a similar irregular structure of coloured dye clouds. Notice how they are most evident in the lighter midtones, and absent in the highlights.

ANALOGUE CAPTURE

In film-based, or analogue, colour capture, colour is recorded in overlying colour-sensitive layers.

In modern films, the layers are essentially black-and-white films but each has been made sensitive to one of the primary colours and insensitive to the others.

During processing, the appropriate colour dye is taken up by each layer, corresponding to its colour sensitivity and the exposure received. In this way, dye clouds – the film grain – are laid in several layers through the depth of the film.

DIGITAL COLOUR CAPTURE

In contrast, the digital capture of colour occurs essentially on a single layer – that of the light-sensitive photosites (pixels). Instead of separating colours through the depth of film, digital capture separates the colours across its surface. It does so by viewing the image through red, blue, and green filters laid over the image area like tiles covering a floor.

In practice, the differences in the way colour is captured in film or digitally have no substantial effect on the appearance of the image except in highly magnified views. You will still view a range of colours that are similar, if not perfectly identical, to those in the original scene.

TONALITY

Colour accuracy is not all that's important; tonality – the relationship of the subject's luminance to the image's gamma – must be considered too.

Gamma measures how the light and bright areas gradate into dark and shadow areas. Steep or high gamma indicates rapid gradations and gives the appearance of high contrast. Low gamma shows as reduced gradations, or dull contrast.

The gradation in the midtones is visually the most important, since viewers use it to judge whether the gamma looks natural or not. It is normal for the gamma in the shadow regions and near the highlights to be lower than at the middle tones.

WHITE BALANCE

All colour systems need to account for the colour of the illuminating

light. If it is reddish, then the scene will be coloured red. This is called a colour cast. To accurately record a scene with a colour cast, a correction must be made. White balance can be adjusted to account for colour tints in the illuminating light.

With film, the white-balance decision is made during its manufacture – long before the film is exposed. The result is a serious inflexibility when using film: if the lighting is not the daylight or tungsten that the film is designed for, colour reproduction is inaccurate. You should use correction filters to obtain the right white balance. Photographers have learned to exploit the "inaccuracies" for visual effect, such as increased warmth by using a daylight film under tungsten lights.

On a digital camera, white balance can be easily preset by the photographer. Alternatively, it can be set to automatic so the camera chooses the best white-balance setting for the particular surroundings.

It is one of the last steps in image processing prior to recording or displaying the image when not using raw capture.

◀ Point-and-shoot portrait
This portrait, taken in Northern Ireland, reveals nothing of the nature of its capture. In fact it was made on an 8-megapixel compact camera.

▼ Portrait – pixel view
A close-up of the image shows a completely different structure compared to the view of Jerusalem, *opposite*. It is made up of regular squares of even colour.

▲ Soft gradations
A view of the River Thames with low mist and pollution shows fine gradations of tone from the nearby barge to the low-contrast, hazily defined tower blocks beyond.

▲ Hard gradation
A high-gamma version of the scene has some merit as an image, but it is completely lacking in the atmosphere and delicate tones of the original image.

COLOUR FILMS: TRANSPARENCY

Colour transparency (slide or diapositive) film is positive-working and is viewed by shining light through it. Modern films are called integral tri-packs: the separations layers are on the single film. Historically, there are few variations on the types of colour film: the Autochrome gave delightful results but was clumsy in use, while the Polachrome instant transparency film worked on the same principle and was also short-lived.

TRANSPARENCY FILM

For much of the history of colour photography, transparency film was favoured by professionals because viewing the final result was as easy as holding the transparency, or slide, up to the light. Colours were bright and brilliant, shadows were deep, and contrast was very life-like. The slide thus served as the reference point for any subsequent print or publication of the image (however, an adjustment had to be made for the fact that transparency images are by nature brighter than prints).

But there are disadvantages in using transparency film. The difference between an exposure that gave poor results and excellent results – the exposure latitude – was relatively narrow. Not only did exposure control have to be precise, photographers had to find or light situations to suit the film. Too broad a luminance range would mean that either shadows were too dark or highlights too light – and frequently both. As a result, transparency films "trained" photographers to work with narrow luminance ranges or make deliberate use of dark shadows, thus shaping photographic styles.

▲ **Thai dancer**
A ISO 1000 slide film, exposed under the tungsten lamps of a floor show in Bangkok, Thailand, exhibits coarse grain with poor definition – not only of details, but of colours. They appear muted, and dark shadows are not black. Still, it is better than no record at all.

◀ **Transparency original (far left)**
This image has been adjusted to simulate the brilliance and contrast of a transparency as seen on a light-box. Highlights are bright and colours appear rich, while shadows are deep.

◀ **Print simulated from transparency (left)**
By comparison with the transparency, a print may look like this: the colours appear washed out and weak, the shadows are not densely black, and the highlights are light grey instead of brilliant white.

▲ Chinese protester
Colour transparency films excel with subjects of limited colour range and limited luminance range – as here, a protester in London – allowing this handsome face to glow with rich tones that would be lost in a black-and-white or colour print.

▲ Bazaar portrait
When using transparency film, you learn to work with its limited latitude. Here, the shadow areas are very dark in order to preserve tones in the cockerel. Even so, the highlights on the bird's back are dangerously close to being too white.

Furthermore, medium-format and smaller transparencies could not be examined in close detail except under a magnifying loupe. Also, prints are difficult to make, requiring either complicated processing or the making of an intermediate negative, which translates colours or tones between one stage and another. Nonetheless, the advantages for professional use outweigh the disadvantages.

COLOUR BALANCE
The majority of colour transparency films are balanced for daylight, about 5600 K, on a typical cloudy midday in middle latitudes. A handful of films are balanced for tungsten light at around 3400 K. Transparency films are very sensitive to variation in the colour of the illuminating light. For work under domestic light, tungsten-balanced film is preferable to filtration of daylight-balanced film because it is easier to fine-tune the resulting slide on printing or scanning.

FAST
Fast colour transparency films are those of ISO 200 and greater. They are useful for low light, shorter shutter times, or smaller apertures. However, as sensitivity increases, transparency films tend to show sharp increases in grain, fog, and contrast, while colour saturation or purity drops, as does sharpness.

MEDIUM TO SLOW FILM
In practice, ISO 100 offers a good balance between the advantages of fine grain and disadvantages of speed. Medium-slow films – ISO 100 or less – offer fine grain, good contrast, excellent colour saturation, and hue resolution, as well as good sharpness. However, since colour film has about a third of the resolution of black-and-white film, none is truly very sharp.

PROS AND CONS

- Vivid colours, high contrast, good detail and excellent apparent sharpness, high maximum density, low fog levels, designed for projection.
- Accurate exposure necessary, difficult to copy, difficult to scan, appearance on printing very different from appearance as transparency.

COLOUR FILMS: PRINT

Colour print film has been used in far greater volume than transparency film, because it has been the preferred choice for the majority of amateur photographers. It is ideal for amateur use as it can tolerate inaccurate exposure, is cheap to buy, and it is possible to make many inexpensive prints from it that are easy to handle and view. Its flexibility and versatility have also made it the mainstay of society, portrait, and wedding photographers.

WIDE LATITUDE
The reason for colour print film's popularity is its wide latitude – tolerance to error – in many areas. Primarily, its exposure latitude is wide: you can underexpose by more than one stop or overexpose by two stops and it can yield an acceptable print. Even with greater errors, it is still possible to obtain a usable image. The exposed film is tolerant of variable processing, as is the printing stage. However, the best results come from accurate exposure and processing.

The main problem with colour print film is that the processed film – the initial result – is in the negative: not only are tones reversed so that highlights appear dark, but colours are reversed so blue skies appear magenta or red. In addition, all colour print films carry an orange or warm-pink cast – used to aid colour reproduction – which makes it impossible to evaluate the negative just by looking at it.

USES
The tolerant nature of colour print films makes them ideal companions when you have to photograph in a wide and unpredictable range of circumstances such as holidays and travel. Colour print films are essential when many copies of an image are needed – such as portraits for publicity or wedding photographs. Professional colour print films are available with contrast and colour rendering designed to suit pictures of people.

COLOUR BALANCE
Like transparency film, the colour balance of colour negative film must be matched to that of the source illumination – usually either tungsten lighting or daylight. Unlike transparency film, however, the colour print is relatively tolerant of variations in colour balance because the printing process allows for colour corrections to be made. In mixed lighting such as where daylight and tungsten are seen together, colour print film usually give superior results to transparency films.

FAST FILMS
Sensitive colour print films – ISO 400 and greater – can give acceptable results in low-light situations because the high level of grain that accompanies high speed is acceptable on prints smaller than, say, 25 x 20cm (10 x 8in). Nonetheless, colour saturation and fog levels are greater than with slower films.

MEDIUM TO SLOW FILMS
Medium speed films of ISO 100–200 offer a good balance of fine grain, rich colour, and deep blacks. These are ideal for just about any use with ample light. They can also give excellent results from scanning but, for best results, should be exposed precisely.

◄ Dancer negative
A typical colour negative shows an orange cast with the image in reverse, so the dark lower portion of this image shows as being the lightest. It takes a good deal of experience to interpret a negative accurately just by looking at it.

► Dancer print
A print of the negative shows that what appeared to be a large area of colour in the background is, in fact, a near-neutral grey. The image shows that the film was slightly overexposed, resulting in too much lightness on the figure on the stage.

PROS AND CONS

- Relaxed exposure requirements thanks to large exposure latitude, tolerance to variable white balance, lively prints possible, printing papers with different contrasts may be used.
- Negative very difficult to evaluate, highly compressed image in the negative, each frame may need its own colour correction, contrast needs to be matched to printing paper.

▲ Interior – mixed lighting
Where daylight and domestic household bulbs appear in the same picture, colour print film is the best medium to tolerate the differences in colour temperature.

◄ Wedding group
The soft tonal values and gentle colours are not only appropriate for wedding photography, such as this formal group, but they also help mask variations between print runs – useful for making copies at different times.

▼ Medium to slow film – sea port
Medium-speed colour film is ideal for travel subjects such as this, the port of Dubrovnik, Croatia, since it easily controls the tonal range of the scene and can provide colourful and detailed prints.

FILM FORMATS AND APPLICATIONS

From the time of its invention, photography has been preoccupied with reducing the size of the capture surface to gain convenience without having to pay the cost of reduced quality. With the tiny sensors of modern digital cameras – 5 megapixels and greater, and small enough to fit into mobile phones – the goal has been achieved. However, small sizes bring inherent disadvantages, just as the larger sizes bring their own advantages. Modern photographic practice makes use of a wide range of sizes that best fit the purpose.

ULTRA-MINIATURE
The classic ultra-miniature size is the Minox, introduced in 1954. It is based on the now defunct 9.5mm movie film stock, with the film cartridges carrying 36 or 50 exposures of 8 x 11mm format. The attraction of the Minox was its exceedingly high quality of construction, which enabled the camera to produce very usable images from its 15mm *f*/3.5 lens. It is the classic "spy" camera because its small size – similar to a small MP3 player – made it easy to conceal. However, it was very difficult to make sharp exposures or sharp prints, whose maximum usable size was about 25 x 20cm (10 x 8in). A variant on the 8 x 11mm format was Kodak's Disc system, which carried 15 individual 8 x 11mm shots on the edge of a disk.

MINIATURE
Other than the Minox, formats smaller than 35mm are essentially reactions to 35mm. These include the half-frame in which the length of the format lies

◄ Classic format
The classic format – with image proportions the same as 35mm – clips the sides of the HDTV format to produce squarer image proportions.

► HDTV format
In the APS scheme, the HDTV format is the fundamental size as it makes the fullest use of the film available, producing a generously wide picture that is gaining in popularity.

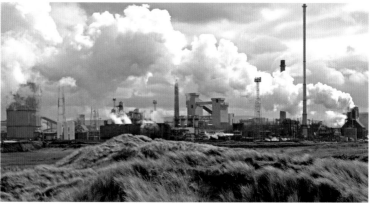

▼ Panorama format
The panorama format of APS slices the top and bottom off the HDTV format to give a letterbox effect that simulates a panorama but in fact actually reduces the angle of view.

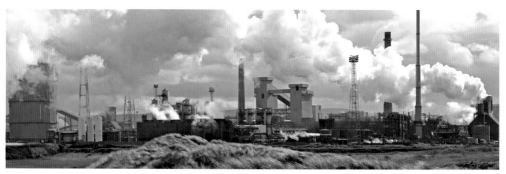

across the width of the film. The latest attempt was APS: this used a 24mm-wide film giving a basic format measuring 25.1 x 16.7mm (classic format) with two wider formats: 16:9 or HDTV format of 30.2 x 16.7mm, and a panoramic format measuring 30.2 x 9.5mm. Despite being designed with every consumer desire in mind, APS was not widely adopted. As the repeated use of the past tense indicates, all these formats are defunct, although it is possible to find services that process Minox, Disc, APS, and other formats.

35MM

The 35mm format, measuring a nominal 24 x 36mm was invented with the Leica, which was introduced in 1925. Despite its many failings – film waste due to the large sprocket holes, the difficulty in making the film lie flat, the need to rewind film back into the light-tight cassette – it remains the most popular and widely used, as well as technically mature, of all film formats. Cassettes of film carry 12, 24, or 36 exposures, while specialist cassettes can have as many as 250 exposures. 35mm film may be used to create a wide format to give panoramic views, using special backs for 6 x 4.5 cameras or specialist cameras such as the Noblex and Hasselblad XPan (24 x 65mm).

The key to the success of 35mm film is that it provides a balance between easily portable equipment and the ability to deliver quality that is suitable for a very wide range of uses, unable to reach only the highest magazine, commercial, and advertising requirements.

▲ **35mm – telephoto**
The 35mm format allows for relatively compact and affordable lenses that cover ultra-wide angle to long telephoto. Here a compact 400mm lens compresses the distance in an Italian street.

◄ **35mm – XPan garden**
A wide-angle lens on a panoramic format such as that of the Hasselblad XPan camera is capable of producing eye-catching views, despite the actual slimming of the field of view thanks to the unusual image proportions being more than twice as long as they are wide.

MEDIUM AND LARGE FORMAT

Professional and serious enthusiast photographers favour film formats larger than 35mm. This is because of their superior resolution – both of detail and tone – as well as their low grain, which becomes all but invisible with large formats. Another appeal of large formats is the shallow depth of field caused by the need to use longer focal length lenses.

MEDIUM FORMAT

Also known as roll film, this format is based on unperforated film, 60mm wide and backed with lightproofed paper. It was popularized by the Rolleiflex camera, which defined the so-called 6 x 6cm or 2¼ x 2¼in format. A popular relative is the 6 x 4.5cm format – because this is rectangular, either the camera or the film back needs to be rotated to accommodate portrait and landscape orientations. Formats larger than the basic square include 6 x 7cm and 6 x 9cm, all the way to a panoramic at 6 x 17cm.

The standard focal length is 75–90mm, with 40mm being an extreme wide angle and 150–80mm being favoured for portraiture. Lenses larger than 250mm are very heavy and bulky.

The actual image size of 6 x 6cm measures about 56 x 56mm making it 3.6 times larger than 35mm. This is the main reason for professional use of medium format: the larger original requires less enlargement for a given print size; equally, scanning requires a lower resolution to produce a file equal in size to that from 35mm. These requirements mean that, with care, it is easy to obtain results far superior to 35mm. Medium format is also easy to view without a magnifier.

LARGE FORMAT

Large-format films are unlike that of 35mm or medium format in that they are used as cut sheet film, not rolls. However, rolls are used in aerial photography, for example. They can be obtained in sizes from 5 x 4in through to 5 x 7in and 10 x 8in, and sometimes, although rarely, larger. The sheets are

▼ **Portrait**
A wide-angle lens on the medium format is a perfect tool for the environmental portrait – one which takes in the sitter's environs to display their situation and context – while the larger film renders details and textures with high resolution.

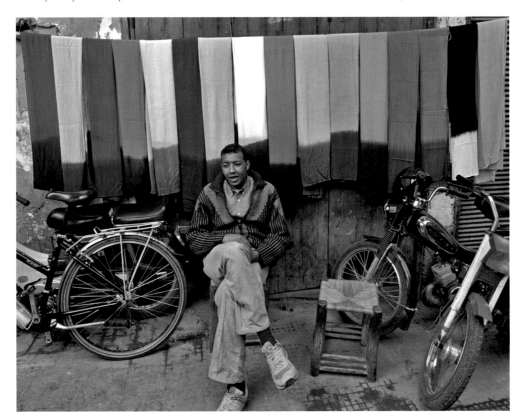

loaded into thin but rigid lightproof boxes. To use, you slide the boxes or film sheath into the camera, whose shutter is closed. Then you pull up a slide or sheath to ready the film for the exposure, which takes place when the camera shutter runs. You return the slide or sheath to cover the film and remove it from the camera. This description shows that photography with large format is done one shot at a time and requires methodical, steady work.

In fact, it is the requirement to work at a slow pace that is part of the appeal of the format – apart from its obvious larger image area, which gives it far greater fineness of grain and tonality.

The standard focal length for 5 x 4in is 150mm, with 75mm being an extreme wide angle and 210mm or longer being favoured for portraiture. Lenses longer than 300mm are seldom used.

▶ **Spices**
Fine detail, rich colours, and tonal gradations, such as those seen in this spice stall in Marrakech, Morocco, are best recorded on a format whose large capture surface allows for the smoothest tones.

▼ **Forestry branches**
For fine details of nature and landscape, the 6 x 7cm format offers a perfect balance between portability and the ability to capture images with a quality that is almost tactile.

EXPOSURE METERING

Exposure metering is the process of determining the level of light that will produce the best results. Together with focusing, it lays the foundation for great image quality. Generally, good exposure means that the brightest and darkest tones with significant detail in the subject are reproduced clearly in the image. For this to happen, the range of tones in the subject must fit in with the tones that can be recorded by the capture surface. In the great majority of situations, modern exposure systems are highly accurate and give excellent results, so they can be left to make settings automatically. However, there is some room for error – the exposure latitude – as adjustments are easily made during printing or image manipulation. The more accurately the exposure is suited to the subject, the more room for movement this will allow in any image adjustments you make later.

EXPOSURE METERS

Anything that reads the prevailing light levels and translates the reading to camera settings is an exposure meter. In modern photography, exposure meters may be found in camera bodies or as separate handheld units. Where built into cameras, the exposure meter may be an independent optical unit that feeds data or a signal to the camera. In digital cameras, the sensor, which captures the image, may also be used for metering exposure.

Literally speaking, we cannot measure exposure itself. What we do is a two-step process: first we measure the amount of light available, then we calculate the appropriate lens and shutter settings that will give us the correct result for the sensitivity or speed of the capture surface.

EXPOSURE COMPENSATION FOR HUE

With non-average subjects, correct the averaged meter reading by the following, as a guide:

SUBJECT	CORRECTION
Snow in full sun	+1 to +2 stops
Sand/beach in full sun	+1 to +1½ stops
Sunrise/sunset (sun in view)	+1 to +2 stops
Very pale skin	+½ stops
Dark skin	−½ to −1 stop
Night with street lights	−1 to −3 stops

MIDTONE CALIBRATION

Exposure meters are set up so that they read out camera settings that result in an image that averages out to a midtone grey. This means that a pure white subject will be exposed so that it appears a mid-grey. A black subject will be given a different exposure, but one that will also deliver a mid-grey. This is because when the midtone – the tone halfway between brightest and darkest – of the subject is correctly exposed, the rest of the image will be too. From this flows the simplest and most powerful way to ensure good exposure: locate the midtone in a scene and meter for that; everything else will fall in place.

However, exposure errors may be caused if a suitable midtone cannot be found (*see* table above). Broadly speaking, if the subject is brighter and whiter than midtone – such as a whitewashed wall, bright sandy beach, or snow – you need to increase exposure over that indicated by an averaging or spot meter. If the subject is darker than midtone – such as coffee-coloured skin, a black horse, or dark blue walls – you need to reduce exposure of the indicated reading. Note that these exposure corrections do not apply if you use an "intelligent" or evaluating meter in an SLR or digital camera as these have been designed to add their own corrections.

◄ **Night lights**
A normally metered exposure of this scene, in Enniskillen, Northern Ireland, would overexpose the street lights, exposing for the dark sky. Instead, the reading was taken from the nearby lit street and applied to the scene, effectively underexposing by around two stops.

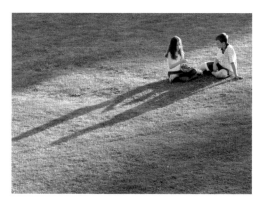

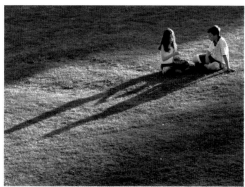

▲ As metered
The majority of exposure-metering systems would agree on the correct exposure for this engaging scene. And they would all be "wrong" in that our visual taste tends to prefer a little more depth and stronger colours, like that of a colour transparency shot.

▲ Preferred metering
For the colour-transparency look, with its usual technique of using underexposure to improve colours, we reduce exposure on the scene by ½ to ⅔ stop. This strengthens the shadows and colours, with an apparent increase in gamma (midtone contrast).

▲ White wall – dark
If exposed as metered, the bright white wall of this cottage would look a dull, midtone grey with the true midtones, such as the red flowers, appearing much too dark and losing their colour.

▲ White wall – bright
With a +1½-stop exposure correction, the white walls look acceptably bright – but a little darker than their actual appearance – while the flowers are perfectly reproduced. Allowing the walls to be too white would destroy the texture.

▲ Normal exposure
If exposed as metered, the dark sky and heavy shadows would call for a lot of exposure. The dark and moody tones would then be lost by being too visible and too bright. The rich colours of sky and buildings are also lost.

▲ Correct exposure
Exposed with a –1-stop correction, the dark tones define shadows with obscured detail, and at the same time colours are richer, with differentiation in the green leaves and a good contrast between the blue sky and the buildings.

METERING TECHNIQUES

The key to mastering exposure metering is to understand that the settings should fit the range of bright to dark areas of the subject that your camera or film can comfortably record. Used correctly, widely differing kinds of metering will yield the same results. While TTL (through-the-lens) metering is used for the most part, the most accurate and consistent results will be obtained from using handheld meters.

HANDHELD METERS

Handheld meters are made as self-contained units to read the ambient or available light. Being independent of a camera, the readings can be made with very high precision and resolution – accuracy to one-tenth of a stop or better is not unusual. Accuracy is also maintained throughout the metering range – from the brightest to darkest. Modern meters will also memorize several readings and make calculations such as the average of several settings. Overrides and matching ISO settings to individual preferences or camera behaviours can be programmed in.

Modern handheld meters may also be able to read flash exposures.

In addition, handheld meters can work at extreme ranges – from the darkest situations, to the fiercest sunny day. Meters using a selenium-based cell are very small and do not need a battery. CdS (Cadmium Sulphide) cell meters are inexpensive, but meters using SPD (silicon photodiode) cells are highly accurate.

However, there are disadvantages of using a handheld meter. These include: the need to transfer the meter reading to the camera/lens; the acceptance angle may not match the field of view of the lens; errors in the meter may be transmitted to the camera; and the need to set the camera's ISO setting manually may cause errors. However, handheld meters are invaluable for checking the camera's metering performance.

INCIDENT AND REFLECTED READINGS

You can read light in two ways: measure the light reflected from the subject, or measure the light falling on the subject. If you choose the first, reflected light reading, you point the meter at the subject from the

▲ **Driver's view**
For an accurate reflected-light reading of a situation, such as this, it is essential to use an acceptance angle that is not too wide otherwise too much account will be taken of the dark interior. This is exactly the problem that faces a TTL meter reading.

▶ **Monks and hay**
Brightly lit days with hard shadows are tricky for reflected light readings but can be confidently handled by incident light meters. For an image such as this one of monks gathering rice stalks in Bhutan, simply hold the meter in front of you with the incident dome pointing towards you to take a reading.

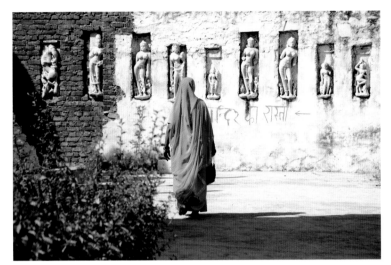

◄ Green sari
In the bright sun of Udaipur, India, the meter reading is 1/80sec at *f*/16 for ISO 100. In practice, the exposure was 1/320sec at *f*/8 as we want to avoid setting very small apertures (*see* page 163).

▼ Girls on grass
Subjects with narrow subject luminance range, such as this scene of girls gathering wedding confetti, will fit easily into the recording range of film or sensor, but inaccurate exposure will be obvious to any viewer.

camera position. How much of the scene is measured depends on the meter's acceptance angle: the majority of meters use a broad 40–120° acceptance angle. For precision work, we use a very tight 1–3°, also called a spot-meter reading. Spot meters call for great skill and care in use.

The alternative method requires you to place the meter so that it receives the same light as the subject. A translucent dome collects light over a large area to measure the light falling on the subject. This is called incident light metering and is good for dealing with complicated or high-contrast situations. Handheld meters are ideally suited to incident light readings.

EXPOSURE LATITUDE

Exposure latitude measures the range of exposures that gives acceptable images – if you are more critical, the latitude is of course narrower.

Colour slide films have, at best, a 1-stop range – a ½ stop over or under the correct exposure. Negative-based film – colour and black and white – tolerate about 3-stops or more error – 1 stop under to 2 stops over.

With digital cameras, exposure latitude varies considerably with the camera's image processing – from as narrow as plus or minus ½ stop, to 2 or more stops. Capturing raw image files may increase exposure latitude.

RULE OF THUMB

On a very sunny day, use an aperture of *f*/16 and a shutter time that is the reciprocal of the ISO speed for an approximately correct exposure. For example, if you are using ISO 100, set a shutter time of 1/100sec and *f*/16; for ISO 400, set 1/400sec and an aperture of *f*/16. What is even better is to memorize the settings of situations you commonly photograph so you can manually set them if you have to.

▲ Dark sunset
With a big subject luminance ranging from direct sun to deep shadows in the trees, no film or digital camera can accommodate the full range, but different exposures may all be "correct". This exposure concentrates on the setting sun and light on the river.

▲ Lighter sunset
A lighter version concentrates on the group of rowers closest to the camera at the expense of overexposing the more distant part of the river and also allowing the sky to lose much, but not all, of its colour.

DIGITAL IMAGE CAPTURE

The main principle underlying the capture of a digital image is the photo-electric effect: electro-magnetic radiation of an appropriate wavelength creates an electric current because the energy of the light gives electrons in the material the energy to move around freely. By using a system of changing voltages, these electrons can be trapped, controlled, and measured. Now suppose we reduce the area of our material to a tiny square and place thousands of them side by side in a grid. Each square then measures the light falling on it – as a whole, the grid constitutes an image.

CCD

The type of sensor most widely used in digital cameras is the CCD (charge-coupled device). Although these are relatively expensive to make, electronically complicated to use, and run on a relatively high voltage (typically around 15 volts), they offer the advantage of delivering a clean signal with low noise.

CCD sensors are made in different sizes – from the size of a chip on a credit card, to the same size as 35mm film and larger. Smaller sensors are measured by a reference to old TV sizes – for example, a 1/1.8in sensor measures about 7.18 x 5.32mm; a 2/3in sensor measures

8.8 x 6.6mm. Sensors can be populated with as few as 1.3 million pixels or as many as 22 million.

Individual pixel sizes vary from about 9 x 9 microns to 16 x 16 microns: as size increases, sensitivity tends to improve. In general, image noise tends to increase as the density of pixels increases on the chip and as the chip decreases in size.

Noise also increases on very large chips that are more susceptible to problems with heat. Even the smallest pixel on the smallest sensor is much larger than typical, average-speed silver grain or dye cloud in film.

CMOS

CMOS sensors use the same production lines as other computer chips. It may run at voltages as low as 2.5v, and the signal processing can be integrated on the same chip. This makes for an inexpensive product, which is why CMOS sensors are used in webcams and phone cameras.

Each sensor is individually addressable, unlike the CCD sensor. This means the sensor could be easily used for metering, even autofocusing. However, a great deal of processing is needed to produce a clean, noise-free image. As a result, relatively few digital cameras

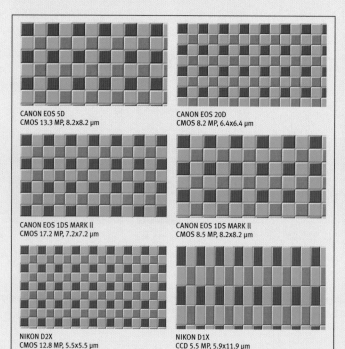

CANON EOS 5D
CMOS 13.3 MP, 8.2x8.2 μm

CANON EOS 20D
CMOS 8.2 MP, 6.4x6.4 μm

CANON EOS 1DS MARK II
CMOS 17.2 MP, 7.2x7.2 μm

CANON EOS 1DS MARK II
CMOS 8.5 MP, 8.2x8.2 μm

NIKON D2X
CMOS 12.8 MP, 5.5x5.5 μm

NIKON D1X
CCD 5.5 MP, 5.9x11.9 μm

▲ **Nikon D2H and Nikon D1X CCD**
Not all sensors use square pixels. The rectangular pixels are from the Nikon D1X camera, but the final image (*top*) uses square pixels by correcting for the rectangular shape during image processing.

◀ **Pixel pitch compared**
This diagram illustrates the comparative sizes of pixels from different cameras. More pixels on the sensor may mean more detail, but their size is smaller, which may reduce light-gathering power, adversely affecting their efficiency.

▲ CCD

To read out from a CCD, charges are transferred from one sensor to the next along the rows and are read off at the end. Some sensors allow several rows to be read at one time. The transfer process requires a relatively high voltage.

▲ CMOS

Read-outs from CMOS sensors are individually addressed: a sensor can deliver its signal independently of another. The design allows a high level of noise suppression at the individual sensor, giving very smooth images.

use CMOS chips, but those that do – such as the Canon 1D, Canon 1Ds Mk III, and Nikon D3 – are renowned for their high-quality images.

MOIRÉ

Moiré is the appearance of a new pattern when two patterns are superimposed on each other, resulting in an unwelcome artefact. The regular patterns may exist in the scene, or you could already have one in the scene; another pattern could be the grid of a sensor or a monitor. Moiré was formerly an optical curiosity but is now a real problem in digital photography.

While digital cameras rely on a regular array of sensors to detect an image, any finely detailed and regular pattern near the limit of the sensor resolution has the potential to cause unsightly moiré. The commonest approach – taken by point-and-shoot cameras – to this problem is to ignore it altogether. More advanced cameras use blurring or low-pass filters to cut out the higher-frequency detail that would cause the moiré.

FULL-FRAME AND INTERLINE

Full-frame CCD and CMOS sensors (not to be confused with "35mm full-frame") are also called progressive scan sensors. They use a mechanical shutter to protect the light-sensitive surface from light. During exposure, the shutter opens to allow charge to accumulate in the individual pixels. When the shutter closes, the charges are read and

sent in a stream of data to the image processor. In contrast, interline CCDs keep the light-detection and read-out registers separate but next to each other: one side collects the light, then it is shunted under a lightproof cover to be read out. As a result, no mechanical shutter is needed. Interline CCDs offer lower resolution and performance than full-frame CCDs.

▶ **Moiré on screen**
This shot is of the Millennium Bridge, London, viewed at 33.3 per cent. At this magnification, the curved moiré patterns are clearly visible on the lower part of the image. At 50 per cent magnification, the moiré disappears, but reappears at 66 per cent. This shows the moiré is not a characteristic of the image but is caused by interaction with the monitor.

WORKING IN LOW LIGHT

Photography in low-light conditions calls for one or any combination of high sensitivity, large aperture, and long shutter time. With very low light levels, we may need all three working together. Of these, long shutter time is the most flexible option, provided there is sufficient support for the camera and there is no movement in the subject.

PREPARATION

If you expect to encounter low light levels, prepare by using the fastest lenses – those with very large maximum apertures such as $f/1.4$. Generally, very fast lenses of any focal length are extremely costly. Zoom lenses are limited in the dark because only a few reach even a maximum aperture of $f/2.8$.

The other step is to prepare for high-sensitivity capture. With film, choose ISO 800 or faster: these films will tend to be grainy and less sharp than slower counterparts; colour film will also show less saturated colours, less dense blacks, and steep midtone contrast. With digital capture, simply set sensitivities of ISO 800 or greater: these settings will show more noise overall

▼ **Dance-hall lights**
In preparation for this image of a dance hall near Enniskillen, Northern Ireland, the camera was set to its maximum sensitivity – ISO 3200 – and to aperture priority plus an exposure override of $-1\frac{1}{3}$ stops, with the maximum aperture set on the lens, a 24–70mm zoom. Even so, the shutter time was only 1/20sec.

PHOTOGRAPHING STARS

A rule of thumb for determining the longest exposure in which the stars do not appear as streaks is to divide the lens's focal length in millimetres into 600 (for 35mm format). For example, using a 50mm lens, the longest non-streaking exposure is 12 seconds.

and much more in the shadows. But some cameras produce far more noise than others (*see* images, right).

A loss in image quality is a necessary cost of working in low light: lenses at maximum aperture show a lower level of aberration correction, but these are largely masked by the lower-quality image capture.

EXPOSURE CONTROL

Photographic subjects in dark conditions usually consist of small patches of bright light – for example, street lamps or the moon. This extremely non-uniform illumination makes it very hard for exposure systems to calculate exposure: their tendency is to read the dark areas.

An effective strategy is to take spot readings from bright areas – for example, from an illuminated street sign or a light spot on the road (this light area does not have to be in the final photograph). Or override the exposure by at least 1 stop. With digital cameras,

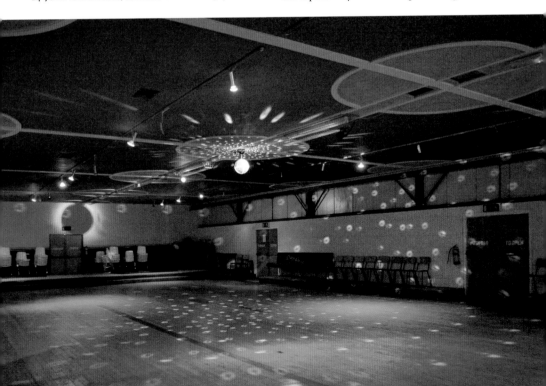

the best approach is to make an exposure on automatic, then assess the result. Working in the dark is one situation in which the camera's LCD screen can be used for evaluating the image.

MAKING THE EXPOSURE

For exposures longer than 1/30sec with normal lenses, steady the camera on a tripod. Use a cable, electrical, or remote release to avoid shaking the camera when pressing the button, or use the self-timer. With SLR or DSLR cameras, flip the mirror up manually a few seconds prior to exposure; some cameras will flip the mirror up about two seconds before the self-timer runs the shutter.

TWILIGHT EFFECT

When the human eye adapts to low light levels, its ability to distinguish between colours suffers. But film and sensors can capture a full range of colours. The result is that a dark scene is usually far more colourful than perceived and is always a pleasant surprise.

▲ Noise
A close-up at 100 per cent of an image from a camera set to ISO 200 shows a very high level of noise for a modest sensitivity setting. It is characteristic of a series of 8MP sensors that are widely used despite their excessive noise.

▲ Low noise
In contrast to the image on the left this was exposed at ISO 1250 and shows a more close-up view – 200 per cent – yet there is hardly any noise visible anywhere but the darkest parts. This is because the camera used a CMOS chip.

▲ Night lights
With low light levels calling for exposure of 1/8sec at f/4 with ISO 3200 sensitivity, the sky looked black, as were the trees. But the digital image uncovers amazing colours in the sky and lights in the tree.

▶ Pool
Even with the camera set to ISO 1600, an exposure of 1/4sec was needed to expose this swimming pool lit only by decorative lamps. You need a tripod, a steady hand, or a handy table to rest the camera on.

▲ Harbour
For this twilight picture of a harbour, the camera was left on automatic exposure, but the override was varied between –1 and –2 stops: the best results came from an underexposure of 2 stops.

DIGITAL COLOUR CAPTURE

Because the dominant method of recording colour is digital, the colours we capture in photographs no longer depend on the interplay of chemicals with silver, but on the interaction of electronic components and on use of the computer. The result is an unprecedented level of control over an image's colour: only the characteristics of the colour filter array and the sensors are fixed; everything else can be manipulated. For example, many digital cameras share identical sensors, but the images they produce vary widely in appearance solely because of image computations.

BAYER PATTERN

Apart from very minor exceptions, image capture is based on a grid of red, green, and blue sensors arranged in the Bayer pattern. Strictly speaking, the sensors are not coloured – they are all identical – but each is covered with a filter. Some Sony sensors use a pattern of four colours: red, blue, and two types of green; some Kodak sensors use a triad of yellow, magenta, and cyan filters.

In the typical sensor, any square of four pixels contains two "green" sensors, while there is one red sensor and one blue sensor. The reason for this is twofold. First, introducing a fourth colour increases the complexity of image processing, so is better avoided. Second, the human eye is most sensitive to green, which, for this reason, is given priority.

Each pixel can gather information only about the colour of the filter that lies over it. For example, the pixel with a red filter above it can only measure the strength of red light reaching it. In order to work out the value of the green and blue channels, we must look at the values of nearby pixels: this is the process of colour filter interpolation, which is also called demosaicking.

DEMOSAICKING

In the simplest technique (nearest-neighbour replication) each interpolated pixel value comes from that of the nearest pixel from a standard direction. A red pixel gets its red value, then its blue value comes from the upper-right pixel, and the green value from the left. The green pixel gets its own green value, obviously; then its blue value comes from the right, red from below... and so on. It is very quick to compute but gives inferior, artifact-prone results.

A much more complicated method – variants of which are used in today's cameras – involves working out how similar the surroundings are to the pixel in question, so we calculate gradients of values. These are a good indicator of whether there is an edge or just a smooth transition of tone.

To do this, the software looks at a square block of up to 25 pixels – sometimes more – centred on the one in question to calculate gradients in the eight compass directions: north, north-east, east, south-east, south, south-west, west, and north-west. The software calculates the steepness of the gradients based on threshold values. If they are not steep, we average out – smooth the data – more than if the gradients are steep; and if the gradient is very steep, we don't average out the data at all.

Demosaicking involves many subjective decisions by the programmers about which threshold values to apply for the gradients, on whether to give priority to colour or to detail, on the wish to avoid artifacts, on the speed of processing, as well as adaptations for the specific characteristics of the filters used in the array. For these reasons, the results from different cameras can vary even when it is known they use identical sensors.

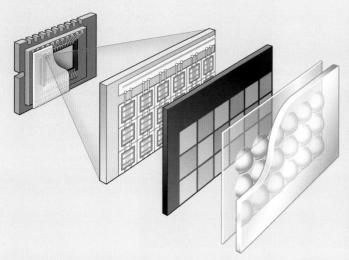

◄ **Sensor structure**
A sensor, greatly magnified, would look like this. A sheet absorbing infrared and blurring the image fronts the layer of lenslets collecting light, which is focused through the array of filters covering the sensors.

▲ Original
The original is built from colour channels recording colours in greyscale by analysing the red, green, and blue component in each pixel. The greyscale information in each channel is then converted into full colour by varying the strength of the red, green, and blue, then combining them additively.

▲ Colour separation – blue channel
This diagram shows the blue channel information. Looking at the orange dress, the pixels corresponding to the blue filter are nearly white, showing there is little or no blue colour. But over the blue dress, the blue pixels appear dense because there is a high level of blue.

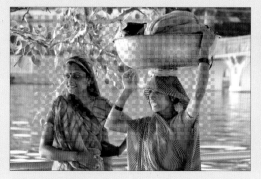

▲ Colour separation – all channels
This diagram shows the Bayer pattern of filters superimposed on the image: where the image is dark, the "pixels" look dark. We are gathering luminance information, but not colour. The image is made of greyscale channels.

▲ Colour separation – red channel
The diagram for the red channel information can be read in the same way as for the blue: high levels of red are shown as high density, such as over the orange dress, but weak red levels show as pale squares over the blue dress.

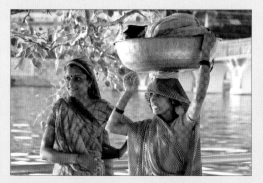

▲ Colour separation – master
This diagram illustrates how the image may look to the sensors: where the subject is bright, all three red, blue, and green squares are difficult to see because they merge with each other. Looking at the blue dress, the blue and green filters tend to merge because the colour contains both blue and green, but the adjacent red filters look pale because the region is weak in red.

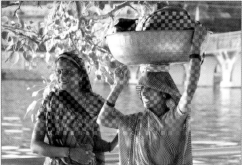

▲ Colour separation – green channel
The green channel is interesting because one can easily see the form of the subject under the squares, whereas with the blue or red, the pattern of squares often obscures the shape of the subject underneath. This illustrates the importance of the green in carrying detail information and shows the eye's greatest sensitivity to the green wavelength.

WORKING WITH SENSOR FORMATS

Digital photography has replaced the variety of cut and roll-film formats with an equally varied range of sensor formats, but with rather less standardization. As with film formats, the size of the sensor influences the size of the camera, the effective focal length of the lens, the effective depth of field, and sets a limit on the achievable image quality. Unlike film, however, the use of larger sensors does not necessarily result in a higher resolution – for example, a 12MP sensor can be twice the size of 11MP sensor.

▲ **Hotel landing**
A wide-angle scene that calls for an undistorted view needs wide-angle lenses and large sensors.

▼ **Long street**
Long focal length compression of scale is easily obtained with modern digital SLRs, which carry long effective focal lengths.

LARGE AND SMALL

Small sensors – the smallest of which are found in mobile-phone cameras – require small lenses of very short focal lengths. This means that cameras can be small. The entire package can be very light and compact, with extremely long effective focal lengths possible, plus high magnification zooms. For example, modern zoom lenses offering a 12x range to over 400mm focal length are smaller than a 35mm standard lens. However, image noise tends to increase as sensor size reduces, it becomes very difficult to offer true wide-angle lenses, and the lenses are more prone to diffraction limitation.

Larger sensors enable wide-angle lenses to be used with ease and capture images with much less noise because they are more efficient at gathering light than small sensors. And large sensors offer the possibility of very high pixel counts. However, cameras and lenses are naturally larger and heavier, with long focal length lenses being particularly cumbersome.

EQUIVALENT 35MM FOCAL LENGTH

With the proliferation of sensor sizes, it is hard to relate the focal length of a lens to the field of view. A 12mm focal length on a sensor that measures 43mm on the diagonal gives an extreme wide-angle view but is a telephoto on a sensor measuring just 4mm. As a result it has become customary to refer to the focal length in the 35mm format that gives the equivalent field of view. Thus, on a 1/2.5in sensor, the focal length range 7.4–88.8mm is said to be equivalent to 35–420mm.

FOCAL-LENGTH MULTIPLIER

DSLR cameras that accept lenses suitable for 35mm film cameras use a range of sensor sizes – from full-size (24 x 36mm) to APS (23 x 15mm) or smaller.

▼ **Sensor sizes**
This diagram compares the sizes and shapes of some common sensors. The actual size of the image may be smaller than the sensor, and its shape may be different according to numbers and locations of pixels utilized for image recording.

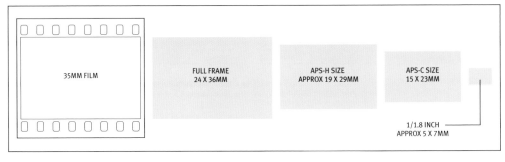

35MM FILM

FULL FRAME
24 X 36MM

APS-H SIZE
APPROX 19 X 29MM

APS-C SIZE
15 X 23MM

1/1.8 INCH
APPROX 5 X 7MM

The field of view or equivalent focal length again varies according to the size of the sensor.

One practice is to quote the focal-length multiplier: as the sensor reduces in the size, it crops a smaller portion of the field of view, which increases the effective focal length. Cameras with APS-size sensors have a focal-length multiplier of around 1.5x, so a 50mm lens is equivalent to a 75mm.

DEPTH OF FIELD

Another factor that varies with sensor size is depth of field. One of the key factors determining depth of field is focal length: as it reduces, depth of field increases absolutely (*see* pages 84–7). This means that even when a correction is made for a smaller sensor and for the difference in image magnification, the depth of field of the shorter focal lengths used for small sensors will appear greater than that of the same field of view that is captured on larger-sized sensors using longer focal length lenses.

The very small sensors of point-and-shoot compact cameras suffer the most from the inability to limit depth of field. But even with APS-sized sensors it is appreciably harder to obtain shallow depth of field than when working with full-sized 35mm sensors, which in turn can appear to produce too much depth of field when compared to the beautiful blur given by medium-format sensors.

If you wish to work with the most limited depth of field, you should use the largest available sensor, together with the longest lenses and widest aperture. A useful strategy for those using DSLR cameras with APS-sized sensors is to mount large-aperture fixed-focal-length lenses such as a 50mm *f*/1.4, which will be equivalent to a 75mm or 80mm lens.

▼ **Format and field of view**
This diagram shows how smaller sensor formats cut into the centre of the field of view to reduce the amount of the scene captured, effectively increasing the focal length of the lens in use.

▲ **Depth of field – big sensor**
With a working aperture of *f*/6.3 and a focal length of 70mm, depth of field is extremely limited with a full-size sensor. Only a sliver of leaf is sharp; the rest is visibly unsharp from focus blur. This image is a crop of the full photograph.

▲ **Depth of field – small sensor**
At the same working distance, an aperture of *f*/7.1 and a similar equivalent focal length of 62mm, depth of field on a 1/2.5in sensor is able to photograph the leaves as well as the stalks in the background.

35MM FULL-FRAME SENSOR (APPROX 24 X 36MM) EQUAL TO FOCAL LENGTH

APS-C SIZE SENSOR (APPROX 15 X 23MM) APPROX 1.6X FOCAL LENGTH

APS-H SIZE SENSOR (APPROX 19 X 29MM) APPROX 1.3X FOCAL LENGTH

▲ **Shallow depth of field**
By using a 70mm focal length and *f*/2.8 aperture on a full-size sensor, the background to the girl's hands is nicely thrown out of focus. With a smaller sensor, the regular pattern of the chair would be too intrusive.

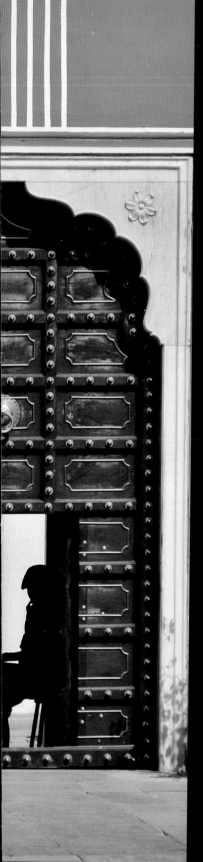

Using the lens

THE PHOTOGRAPHIC LENS

HANDLING LENSES

LENS SPECIFICATIONS

ZOOM LENSES

NORMAL TO WIDE ZOOMS

LONG ZOOMS

LENS FORMULAE

WIDE-ANGLE LENSES

NORMAL LENSES

ABERRATIONS

MACRO LENSES

MEDIUM–LONG FOCAL LENGTH

ANALYSIS: WORKING WITH LENSES

VERY LONG LENSES

SPECIALIST LENSES

IMAGE CLARITY

OPTIMIZING LENS PERFORMANCE

LIGHT-ADJUSTING FILTERS

SPECIAL-EFFECTS AND CORRECTION FILTERS

CAMERA MOVEMENTS

ANALYSIS: WORKING WITH MOVEMENT

PANORAMIC PHOTOGRAPHY

PHOTOGRAPHY IN CHALLENGING CONDITIONS

THE PHOTOGRAPHIC LENS

The quality of your lens sets the upper limit on the image quality that you can achieve with your camera. The best of lenses can outperform virtually any film that it is used with, while low-quality lenses will limit the image quality irrespective of how superb the capture surface, be it sensor or film. Understanding how lenses are put together and how they work, as well as appreciating their limitations and their individual qualities, will help you obtain the best from your lenses.

LENS CONSTRUCTION

Modern camera lenses are supreme examples of today's technology at work. The optical elements are made of the finest glass and highest-quality plastics. In a compact digital camera, the individual elements are much smaller than a contact lens. And a lens can consist of over a dozen separate elements. There are far more than just the glass elements, however: there are mechanical parts of the highest precision, which must be strong enough to protect the elements against shock, yet some must be light enough to be easily moved by an autofocus mechanism. Then there are electronic elements – from tiny processors that help control autofocus settings, to electromagnetic elements that stop down the lens or aid in focusing. The vast majority of lenses share the same basic structure. Lenses for large-format cameras differ by lacking a focusing mechanism.

Lens barrel

The barrel encloses the optical and other components of the lens and provides a foundation for mechanical parts, such as the focusing and lens mount. It can be made very substantial, such as classic lenses for the Leica or Hasselblad, or be constructed of very light materials, such as for compact digital cameras.

Front mount

The front mount is often designed to accommodate filters or a lens hood. If the mount rotates as the lens is focused, this is an inconvenience for filters – polarizing or graduated (*see* page 168) – which need to be oriented in a particular direction. Lenses on compact cameras may use an adaptor that fits over the lens barrel to carry lens accessories.

Focusing ring

Focusing rings are normally found on interchangeable lenses but may be missing from autofocus lenses. They may drive the optics for focusing or actuate a servo motor, which drives the lens elements. The latter method is used on digital cameras and can make focusing feel indistinct.

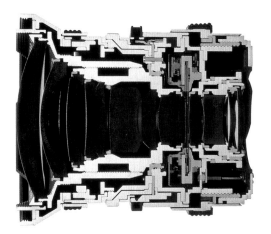

▲ **Lens structure**
This cross section of a Zeiss 40mm *f*/4 wide-angle lens for the 120 format shows its complexity, requiring ultra-high precision design, manufacture, and assembly.

◄ **Alpha rear**
The rear of a typical modern SLR camera shows the complex electrical contacts (left), the aperture stop-down lever (centre) as well as the socket (right), which connects with a lug to drive the autofocus mechanism.

◄ **Front mount**
The front mount of a medium-format lens shows the inner screw thread, which accepts filters and similar accessories. On the outer rim of the front of the lens are the lugs that accept a lens hood or bayonet-mount filters.

Rear mount

The rear mount interacts between the lens and camera, so it must be manufactured to the highest precision. In addition, the mount must be extremely durable, as it receives much wear when lenses are changed. The modern lens mount also transmits data between the lens and camera body. In the past, the data about lens aperture was sent mechanically; now the contacts are electrical and transmit digital data. These contacts must be kept clean and free of grease or oil. Some mounts still use a mechanical coupling through which the camera drives the focusing mechanism, or a lever is pushed to stop down the lens aperture.

Aperture

The control for the aperture is commonly found on the lens barrel of interchangeable lenses, but it is also frequently controlled from a dial located on the camera. All lenses can change apertures in steps of 1 stop, but for professional work it is important to be able to vary aperture by ½-stop steps or smaller.

Zoom control

There are two types of lens-based zoom control; the commonest is to turn a knurled ring, such as the focusing ring. The other type is to push or pull on a collar. Both types have their advocates, but the latter is more likely to suck air into the camera, which may attract dust into the innards. Autofocus compacts control the zoom through a switch on the camera body.

OTHER COMPONENTS

Some lenses, such as those used in medium- and large-format cameras, incorporate a shutter mechanism set in between the lens elements. Settings for this may be made on the lens or via controls on the camera. The majority, such as those in the Hasselblad and Mamiya systems, are mechanically actuated and governed (timed), but those in the Rollei system are actuated and controlled electronically.

▼ Vignetting
This view of rice harvesters, taken with a compact zoom lens set to 135mm, shows vignetting. A constriction along the length of the lens barrel cuts into the edge of the light bundle causing the corners of the image to darken. A larger lens would solve the problem, but it would cost and weigh much more.

▲ Lack of flare
Well-controlled flare from careful lens construction and design, as demonstrated in this image, does not cause multiple images of the light source – strictly the lens's exit pupil – and does not reduce contrast in the shadows.

▶ Veiling flare
Inadequate lens design can allow light to reflect on the inside of the optics and cause veiling flare – shown as artifacts representing the light source in the image. This degrades the overall contrast. It also introduces usually unwanted elements, but they can be used to communicate the brightness of the light.

HANDLING LENSES

To the extent that the camera lens sets the ceiling for the image quality obtainable on a camera, lack of care in using the lens is also one of the commonest causes of technical problems in a photograph. This section discusses how to use and care for lenses to make the most of their quality; also note the sections on holding the camera on page 96 and on optimizing quality through aperture control on pages 162–3.

USE THE LENS HOOD

A foundation for good lens performance is use of the lens hood. This not only protects the front of the lens from bumps and scratches, but it shields it from stray light as well as undesirable elements such as sea spray and dust. Use the hood designed for your camera. The petal-shaped hoods are best for zoom lenses but have to be aligned correctly or they will cause vignetting at wide-angle settings. The hoods for wide-ranging zooms are generally inefficient at the long focal length settings.

MANUAL-FOCUS TECHNIQUES

For static subjects, focusing manually is usually more accurate than autofocus. For wide-angle lenses used at distances of about 1–5m (3–16ft), focusing using rangefinders cameras is most accurate. For longer lenses, focus through an SLR viewfinder. As with all focusing methods, look for an edge or boundary that you wish to be sharp, such as a catchlight in the eye. Magnifying the central part of the image helps ensure critical focus.

The advantages of manual focus include: being able to focus off-centre without having to move the lens; being able to change composition without the autofocus changing focus setting; much greater accuracy in SLR at close-up ranges; and the ability to focus on specular highlights.

AUTOFOCUS TECHNIQUES

Modern autofocus systems are superior to hand-eye operation when the subject is moving and if you are sight-impaired. When your subject – be it birds, sportsmen, or racing cars – is constantly on the move, use continuous or servo autofocus; otherwise, use single-shot autofocus. However, the camera may not fire when the image is within the depth of field – this interferes with fast-action wide-angle photography. In these situations, it is best to switch to servo or manual focusing.

Some autofocus systems work in complete darkness by flashing a pattern of near-infrared or green light on the subject from the camera or an attached flash unit. Although the light may disturb some subjects, it is better than an unfocused image. Autofocus systems are confused by very high contrast, such as water reflecting the sun.

CLOSE-UP FOCUSING

With extreme close-ups, the easiest way to focus is to move the camera backwards or forwards, preferably on a focusing rail driven by a rack and pinion. This method also ensures the magnification is not changed by altering the focus control.

CARRYING LARGE LENSES

All lenses are high-precision instruments, and very long focal length lenses are doubly so. In addition, the camera's lens mount is relatively weak when a large

Shallow hood
For a zoom covering the range 28–105mm, the hood must be wide enough for the 28mm setting. The result is that the hood becomes increasingly inefficient as the focal-length setting increases.

Petal hood
A petal-shaped hood maximizes efficiency for a range of focal lengths – here, 70–200mm. However, it must be put on straight or else the petals will vignette into the wider fields of view.

Hood reversed
Do not use the hood reversed on the lens as shown here. This position is only for storage; it does not shade or protect the lens, it simply prevents you from making full use of the zoom and focus controls.

Square hood
The hood should be shaped to suit the format: here it is square for a 40mm wide-angle lens on a 6 x 6cm camera. The hood is deep to accommodate the wide-angle view.

lens weighing 2kg (4.¼lb) or more is attached. When transporting heavy lenses it is essential, for safety, to detach them from the camera. If a large lens is attached, never pick up the camera by the body.

CLEANING LENSES

It is best to ensure that the lens stays clean in the first place: fit a minus-UV or plain glass filter on the lens, and attach the rear lens cap when the lens is not in use. Pressured air from a puffer is effective at blowing dust and fibres from a lens. Pressurized air from CFC-free cans is good for stubborn dust or deep crevices on the lens barrel. Follow the safety instructions, and do not aim at glass elements because the sudden release of pressure at the nozzle causes a drop in temperature and may eject cold liquid. This could cause fine cracks in the glass.

Use microfibre cloths to remove dust and small amounts of grease on the lens; wash the cloths frequently with plain detergent. Remove fingerprints from filters or lenses immediately – if left, the acid may etch into the lens coatings. If you use a digital SLR camera, you must keep the rear lens mount very clean to prevent dust from settling on the sensor.

▲ **Hard to focus**
Autofocus is almost useless for this kind of shot. Not only are the targets constantly moving, they are also small and backlit. It is best to prefocus manually on the castle walls and wait for the blank sky to be filled by a flock of pigeons.

▲ **Lens-hood vignette**
With the lens hood incorrectly aligned, a wide-angle shot – 28mm in this case – is vignetted by the edges of the lens hood, which ruins the image.

◀ **Hard to focus – high brightness**
Autofocus systems struggle with extremely bright highlights such as the sun because they are unable to distinguish the brightness differences needed to focus. Manual focusing is often the easiest and most accurate option.

LENS SPECIFICATIONS

The specifications of a photographic lens describe the lens's optical features, that is, those that are designed and built into the optic. The main feature is the focal length of a lens: this measures the distance between a point in space, from which the image appears to be projected (the rear principal point), and the sharp image of an object, where the object is at infinity. In simple lenses, the image appears to be projected from the physical centre of the lens. Not so with multi-element photographic optics: with a wide-angle lens, the image may appear to be projected from a point behind the lens, and with telephoto lenses, the image appears to be projected from a point that is in front of the lens.

EQUIVALENT FOCAL LENGTH

In modern lenses, the focal length has very little to do with the physical length of the lens. In fact, many zoom lenses are longer at the wide-angle setting than at the longest setting.

▲ **Image circle**
This image represents the full image circle projected by a 24mm lens. Ordinarily we see only a rectangle cut out of the middle of this image.

And there is a further factor that may cause confusion: this is because the photographic effect of focal length depends on the size of the film or sensor being used.

Given the popularity of the 35mm format, it has become common practice to relate the focal length of digital camera lenses to the 35mm equivalent focal length (efl). For example, the 35efl of 35mm is 5.4mm on one camera but could be 7mm on another with a larger sensor. To work out the efl, the calculation is: multiply the actual focal length by the ratio of the length of the diagonal of the 35mm with the length of diagonal of the sensor. However, digital cameras use sensors with different proportions (3:2, 3:4, or even 16:9). Long, thin proportions tend to look wider than squarer ones, even if the angle of view is identical. (*See also* Focal-length factor, page 145.)

ANGLE OF VIEW

The main photographic effect of change of focal length is to vary the angle of view – how much the lens sees. With a greater angle of view, the larger amount of the scene we can see. Taking the field of view of a human eye as the standard, we say that a lens's field of view is wide-angle if it is wider than that of human eye. And if the field of view is less, the lens is commonly said to be "tele" or "telephoto". For a given format, lenses with focal lengths shorter than that of the length of the diagonal of the format will give a wider field of view: the shorter the focal length, the greater the field of view. Here, objects appear smaller because more of the scene must be fitted into the image frame, so very short focal lengths giving wide-angle views greatly reduce the size of objects. We use a long focal length lens, i.e. the focal length is greater than the length of the format diagonal, to magnify a narrow field of view to fill the capture surface.

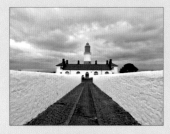

▲ **4:3 image rectangle**
A rectangle of 4:3 proportions is popular as it takes in more depth. Notice there is more sky and foreground than with the 3:2 image, but it can appear less wide.

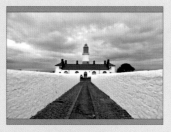

▲ **3:2 image rectangle**
A rectangle of 3:2 proportions, such as the 36 x 24mm of the 35mm format, is a good compromise between an image that is too square or too narrow. The diagonal is the same as the diameter of the image circle.

▲ **16:9 image rectangle**
The high-definition TV format of 16:9 (4:3 is equivalent to 12:9) looks wide but at the expense of less depth – there is less sky, for example. Of course, its diagonal is the same as that of the other formats.

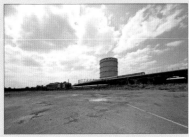

12MM VIEW

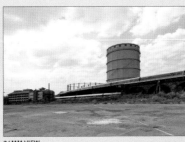

24MM VIEW

50MM VIEW

135MM VIEW

◄ **Fields of view**
These images show the approximate fields of view seen by 12mm, 24mm, 50mm, and 120mm lenses on the 35mm format. Note that field of view reduces very rapidly when the focal length increases. The difference of 12mm focal length between 12mm and 24mm lenses is far larger than the 85mm between 50mm and 135mm.

As there is less of the scene – say, just an animal's head – so this must be enlarged in order to fill the frame. The longer the focal length, the narrower the field of view and the greater the enlargement. Angle of view is normally measured as the angle at the camera over the diagonal of the view. Note that the perception of wide-angle also depends on the proportions of the frame: high aspect ratios look wider than frames with square proportions.

MAXIMUM APERTURE

The maximum aperture of a lens relates the effective diameter of the front element to its focal length. A lens with large front element for its focal length – a "fast" lens – offers a large maximum aperture: $f/1.4$ is considered fast for normal focal lengths, $f/2$ is fast for wide angle, $f/2.8$ is fast for super-telephoto.

Fast lenses are invaluable for working in low light. Large maximum apertures also project a bright finder image in SLR cameras, increase the effective rangefinder base of focusing aids, and may help autofocus systems.

Another advantage of fast lenses has become increasingly appreciated as sensors have become smaller, resulting in a large depth of field. The best way to reduce depth of field effectively is to use the fastest lenses. The 50mm $f/1.4$ lens is coming back into fashion with small-sensor DSLRs because of its maximum aperture and useful 75mm effective focal length.

MINIMUM APERTURE

Theoretically, very small minimum apertures promise extensive depth of field, but it is important to bear in mind that at very small apertures, lens performance will drop (*see* page 165).

MINIMUM OBJECT DISTANCE

All general-purpose lenses focus to infinity, but there is great variation in how close they can focus, measured by the minimum object distance. This is usually measured from the focal plane to the object. In earlier lens designs, focusing involved moving the lens closer to or further away from the film, but now focusing is often achieved by moving internal elements. Note that lens performance may drop significantly at close-focus ranges, particularly with zoom lenses (*see* pages 138–9).

TABLE OF ANGLE OF VIEW

This table shows how diagonal angle of view varies with focal length, and with size of sensor. Broadly, wide angle is coverage greater than about 45°; normal is 45–55°; telephoto is less than 55°; extreme telephoto is less than 10°.

	DIAGONAL MM		
	80	42	27.3
15mm fisheye		175°	112°
12mm		122°	97°
17mm		104°	78°
20mm		95°	69°
24mm		84°	59°
28mm		75°	52°
35mm		64°	43°
50mm	77°	47°	31°
70mm	59°	42°	22°
85mm	50°	28°	18°
100mm	43°	24°	16°
135mm	33°	18°	12°
200mm	22°	12°	7.8°
300mm	15°	8.2°	5.2°
500mm		4.9°	3.1°

ZOOM LENSES

Zoom lenses are designed to do two separate things. It is well known that zoom lenses can change their focal length so that they can vary their angle of view. Less well known is the fact that zoom lenses must also be able to hold the focal plane in a more or less constant position throughout the zoom range. For a lens to zoom, the focusing group must be divided into three parts: outer positive power groups, an inner negative power group, and a rear group. Moving this central group nearer the front or rear group changes the size of the cone of light reaching the rear group, which also changes the magnification or focal length. We need to add another negative power group to move with the negative group to keep the focal plane in position. It is clear that zoom lenses are very complicated optics: modern designs use over a dozen elements, moving four or more groups.

VARIFOCAL LENSES

Early examples of lenses able to change their focal length were varifocal. As the focal length changes, the lens must be refocused. This limited their use in SLR cameras. Some zoom lenses on point-and-shoot cameras (film and digital) are varifocal. This does not present a practical problem because the lens is not used for viewing and the autofocus system refocuses the lens just before exposure.

MULTIPLE FOCAL LENGTH LENSES

Some lens designs offer different, separate focal lengths within the same unit. This solution may be found in low-cost cameras because it avoids complicated internal lens mechanisms while also offering some versatility. In the case of the Leica Tri-Elmarit, a continuous zoom cannot be accommodated in the current range and viewfinder design, but three focal lengths – 28mm, 50mm, and 90mm – can be set, all providing high-quality images.

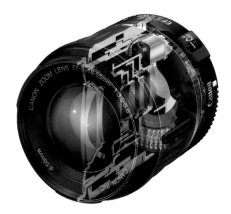

▲ 18–55mm zoom in cutaway
A modern, relatively simple zoom lens shown in a cutaway diagram reveals its complex interior – a fine assembly of mechanical and optical parts with micro-electronics.

▲ Zoom-ring control
The majority of interchangeable zoom lenses change the zoom setting by turning a ring around the lens. A few lenses change setting by pushing or pulling on a movable collar.

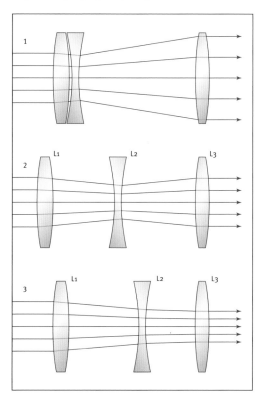

▲ How a zoom works
In this schematic diagram, the zoom is constructed of three groups, the rear being stationary. For telephoto views, the front groups are close together with the effect of enlarging the bundle of light rays, so magnifying the focused image (1). For wide-angle views, the two groups are slid apart (2 and 3), causing the light to converge, reducing the size of the ray bundle, so reducing the image magnification.

ZOOM-LENS SPECIFICATIONS

When selecting a zoom lens, the main points of the specification to consider are:

- **Zoom ratio:** The ratio between the longest and the shortest focal length is a measure of the lens's versatility. Those with large zoom ratios, such as 10x, so 35–350mm, are very versatile but also likely to be heavy and limited in their maximum aperture. A ratio of 4–5x – 28–135mm, for example – offers a good balance between versatility and compact size. Modest zoom ratios are more likely to give higher image quality.
- **Maximum aperture:** Many zooms feature a varying maximum aperture – for example, $f/4$–5.6 – which changes continuously when the focal length is altered. At the shortest focal length setting, the maximum aperture is $f/4$; this reduces steadily as the focal length increases so that, at the longest setting,

the maximum aperture is $f/5.6$. As a result of this change, apertures set manually, particularly using mechanical settings on an aperture ring, will not be perfectly accurate. This is important only if you are metering with an external meter and setting exposures manually. Only high-quality lenses offer that maximum aperture – one that does not change with the zoom setting.

- **Closest focusing** (minimum object distance): On some zoom lenses, the closest focusing distance varies with the zoom setting. Usually the very closest focusing distance is obtainable only at the short focal length setting or in a special macro mode. If so, the resulting magnification may actually be less than if you focused from further away using a longer focal length setting. Ideally, choose a zoom lens that focuses as near as possible at all zoom settings.

▼ Multiple focal length lens
Special lenses for rangefinder cameras, such as this 16–18–21mm lens for the Leica M8, can be set to three different focal lengths but not to any in between.

▶ Zoom streaking
Interchangeable zoom lenses offer the ability to change focal length during exposure, which gives a unique image, the zoom blur.

▼ Using a 300–800mm zoom
Modern zoom lenses combine tremendous reach and image quality. This lens, being used at an air show, may be extremely heavy but, by covering focal lengths from 300mm to 800mm, does the work of three or four cumbersome lenses.

NORMAL TO WIDE ZOOMS

The most common type of lens is a normal zoom covering a range from slightly wider than normal to slightly narrower than normal. A typical range is 35–70mm, while some cover from 28–90mm (35mm equivalent). Normal zooms offer a good balance between image quality, compactness, and affordability. If you are choosing a lens for a DSLR camera, it is best to start with a normal zoom.

USING NORMAL ZOOMS

Normal zooms are useful for:
• General photography. Most subjects can be covered with standard zooms.
• Lightweight travel. Their small size and weight,

especially those for compact digital cameras, make them ideal travel companions.
• Close-up photography. Compact zooms for digital cameras usually offer excellent close-focusing abilities.

To obtain the best results:
• Avoid using low-quality zoom lenses when photographing architectural subjects.
• Avoid using digital zoom (*see* page 92) if you find the long focal length end insufficient.
• Use manufacturer's lens adaptors to increase wide-angle coverage or supplement the long focal length setting.

WIDE-ANGLE ZOOM

The majority of these types of lens rely heavily on aspherical surfaces to control major aberrations, in particular spherical aberration, and all are exceedingly complicated designs of the extreme retrofocus type. In digital cameras, the lens can lie very close to the sensor, but retrofocus designs continue to be used. A relative newcomer to photographic tools, the wide-angle zoom was too difficult to construct using older lens technologies. As with all short focal length lenses, small changes produce a substantial shift in photographic ability. Thus a zoom offering a range of

◀ **Close-up details**
The optics of normal zooms favour performance at close-up distances, adding further to the lens's usefulness. Zooming also allows you change framing easily while working at fixed distances from the subject.

TYPES OF NORMAL TO WIDE ZOOM LENS

Wide-range zoom
Zoom lenses such as this model, which covers the range 27–202mm (35mm equivalent), are designed to cover sensors smaller than 135 format. They offer good quality and advanced features such as silent autofocus mechanisms in a compact form.

Stabilized normal zoom
Lenses offering a constant large maximum of f/2.8, such as this, which covers the range 27–88mm (35mm equivalent) are large and give excellent image quality. They also feature advanced technologies such as image stabilization and rapid, silent autofocusing.

Super-wide-angle zoom
Wide-angle zoom lenses with constant maximum aperture are rare. This 16–35mm zoom offers extremely high-quality images with f/2.8 maximum aperture throughout, but it is bulky and very costly.

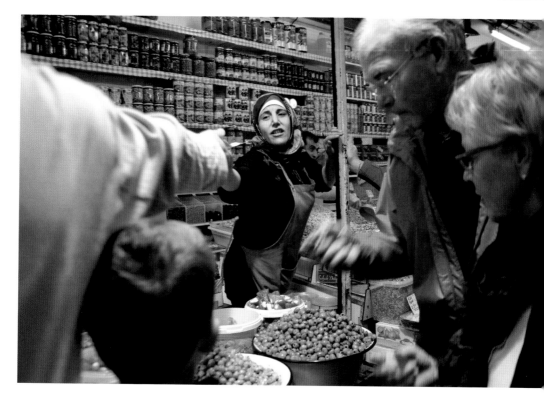

▲ Candid portraiture
The normal zoom, such as the 28–135mm, is ideal for candid and travel photography like this photo taken in Amsterdam, Netherlands. But high sensitivity needs to be set to compensate for a relatively small maximum aperture.

▶ Environmental portrait
A wide-angle zoom takes in the environment of the sitter. Here a crofter in Northern Ireland relaxes in her small garden, surrounded by her flowers, with the rolling countryside visible behind her, all comfortably sharp and detailed.

12–24mm may seem rather modest, but in fact it offers a stupendous range of photographic ability from the very wide (84°) to an ultra-wide-angle (122°) view. Small changes in zoom setting make a big difference: 28mm can be used in a wide range of circumstances for general views, but 24mm needs rather more care as projection effects at the periphery of the frame can distort shapes – and even more so if focal length drops to 20mm.

Ultra-wide-angle views are the preserve of 35mm film cameras or full-frame sensors. This is in part because 35mm film has had the most research and development and in part because the optics of sensors themselves mitigate against the use of ultra-wide-angle lenses. And of course, if you use a DSLR with an APS-sized sensor, it will increase the effective focal length of any zoom lens, so that even a 12–24mm zoom becomes an 18–36mm. On the other hand, the effective depth

of field at all settings is extensive, even at full aperture. Distortion is a problem with wide-angle zooms.

USING WIDE-ANGLE ZOOMS
Wide-angle zooms are useful for:
• Landscapes, townscapes, and travel photography.
• Documentary photography in confined spaces.
• Photography in crowded, fast-moving situations.

To obtain the best results:
• Avoid using zoom lenses in interior views as distortion projection effects at the edge of the view are unavoidable and usually undesirable.
• Avoid using for architecture where distortion will cause straight lines to be curved.

LONG ZOOMS

Long zooms cover a range from about 80mm to1000mm and beyond. The very first zoom lenses were long focal length zooms, and they remain the easiest to design and manufacture. The classic range was 80–200mm, and top lenses in this range still offer unimpeachable quality, matching that of prime lenses. But modern optics offer greater ranges, such as 50–300mm or 100–400mm.

ZOOM RANGE

Some modern digital cameras with permanently attached zooms offer ranges as large as 28–504mm and are not only compact and affordable, but also perform well. While it is easy to obtain sharp pictures handheld when the zoom is set to 35mm, at settings longer than about 200mm it is very difficult to produce sharp shots with a handheld camera. So-called "super-zoom" cameras should be equipped with optical image stabilization for general use.

The range of lenses may be increased by using extender optics. However, extenders reduce the maximum aperture by 2 stops, in the case of a 2x extender. This in turn can prevent the autofocus from working. As a result, 2x extenders can be used only on fast lenses.

DISTORTION AND VIGNETTING

The main technical drawback of zooms is distortion: barrel distortion at the short end, and pin-cushion at the long end. These distortions may be corrected with software such as DxO Optics. However, on some zooms, the type of distortion is difficult to correct.

Vignetting, or darkening in the corners of the image caused by a narrow lens barrel cutting into the light bundle, is another problem common with long zooms. It is seen most often at the longest focal lengths. Using the lens stopped down where possible will help reduce this effect. DSLRs using APS-sized chips, which crop into the centre of the image, escape much vignetting when using lenses designed for full-sized chips. Zoom lenses are also prone to flare. To reduce flare and internal reflections, always use a lens hood.

USING LONG ZOOMS

Long zooms are useful for:
• Shots of scenery, travel, and larger wildlife.
• Plant photography, using close-up lens for smaller details.
• Adjusting composition if you cannot change your position or distance easily.

To obtain the best results, avoid:
• Subjects with straight lines, such as buildings.
• Using long settings to sneak candid portraits.

ZOOM VERSUS PRIME LENSES

One lively debate pitches the quality of prime lenses against the convenience of zooms (many focal lengths in one lens). It is obvious that prime lenses – with only one focal length to design for – can be a no-compromise solution. But in practice, we seldom use the full resolving power of a lens – commonly losing a lot of quality to low-resolution capture, camera shake, and subject movement. Nonetheless, top-quality zoom lenses such as the Canon 24–70mm $f/2.8$ or the Canon or Sigma 70–200mm $f/2.8$ are in almost every way – resolution, contrast, and hue discrimination – the practical equal of prime lenses. However, zoom lenses do score lower in distortion control, bokeh (*see* page 89), and more pronounced light fall-off than prime-lens equivalents.

TYPES OF LONG ZOOM LENS

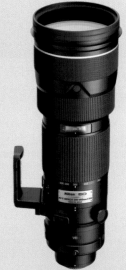

90–300mm zoom
Modern long zoom lenses are relatively compact and inexpensive and are capable of delivering excellent results. Their principal limit is a relatively small maximum aperture, especially at the long end: $f/5.6$ at 300mm is not suitable for working in low light.

Image stabilization
Specialist long lenses that offer image stabilization (IS), such as this 200–400mm zoom, enable handheld use to produce acceptable to good images. For example, an exposure of 1/500sec is needed for an acceptable image at 400mm focal length without IS. With IS on, shutter times of even 1/125sec may produce sharp images.

◄ **Usefulness of vignetting**
The darkening of the image corners caused by vignetting in long zooms can be an advantage in many situations where you might want the corners darkened to shade the sky, as in this landscape from Sikkim, in the Himalayas. The natural vignetting saves on having to apply burning-in when preparing the image.

▲ **Long zooms for nature**
For bird photography, extremely long zoom lenses offer high and variable magnification, which gives them greater versatility and flexibility than fixed-lens optics – ideal for chasing birds that stay in inaccessible mud-flats, such as this red wattled lapwing. 300mm is the shortest useful focal length for bird photography.

◄ **Long zooms for travel**
Long zoom lenses are all but essential for travel photography because they enable the frame to be filled from distant perspectives. The monumental steps to Fatehpur Sikri, Uttar Pradesh, India, are best seen from a distance, but figures then become tiny.

LENS FORMULAE

Modern photographic optics are made up of many separate groups of lenses or single lenses. Each of these lenses is either positive power – converges incoming light towards a point – or negative power – diverges the incoming light. With very rare exceptions, every element is one of just six fundamental shapes (seven if you count parallel-sided glass plates). Modern optics are built from these simple building blocks. A basic understanding of how a simple lens forms an image is key to an understanding of how today's complicated multi-element optics work.

CONVERGING AND DIVERGING LENSES

A converging, or positive, lens tends to focus incoming light to a spot: if the light is a parallel beam and is travelling along the lens axis, the light is focused to the focal point at a distance from the lens. This distance is the focal length, F.

If the lens is pointed at a distant object, a screen can be placed behind the lens to catch an upside-down image of it. This is a real image. If the object is very close to the lens, the image will appear to be on the same side as the object, and cannot be caught on a screen; this is a virtual image.

The principle is that of the magnifying glass. A diverging, or negative, lens has the effect of spreading out the incoming rays. The image also appears on the same side as the object and cannot be caught on a screen: it is virtual, upright, and appears smaller than the object.

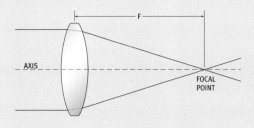

▲ Positive lens
This diagram shows how parallel light rays from a source at infinity are focused at the focal point, one focal length from the lens, to form a real image.

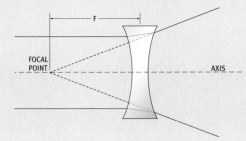

▲ Negative lens
This diagram shows how parallel light rays from a point source at infinity diverge on the other side of the lens. The rays point back to the source to a focal point in front of the lens, forming a virtual image.

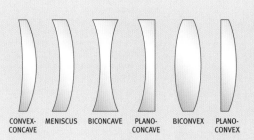

CONVEX-CONCAVE · MENISCUS · BICONCAVE · PLANO-CONCAVE · BICONVEX · PLANO-CONVEX

▲ Lens shapes
Essentially all lenses are discs of glass or plastic resin with two major surfaces that curve either outwards (convex) or inwards (concave). Convex lenses are positive power and converging, while concave lenses are negative power and diverging.

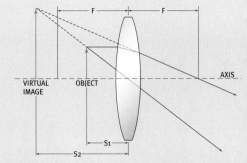

▲ Virtual image
Where rays of light from a subject do not intersect, the image is virtual. We construct by "following back" the rays of light. As a result, a virtual image cannot be caught directly on screen – a familiar example is the magnifying glass, shown above. The image in a mirror is also virtual.

THIN-LENS FORMULA

If the distance from the object to the lens is S_1, and the distance from lens to the image is S_2, the relation between focal length f and these distances is, for both converging and diverging lenses:

$$1/S_1 + 1/S_2 = 1/f.$$

This fundamental formula describes the fact that as the distance from lens to subject increases, the distance from the lens decreases, and vice versa. In addition, it shows that for a given lens-to-subject distance, there is a corresponding or conjugate distance from the lens to the image. The act of focusing is to find the conjugate lens-to-image distance corresponding to a given lens-to-subject distance.

Many other useful other formulae can be derived from this formula – in particular, the magnification factor of the lens.

The magnification, M, of the lens is derived from the thin lens formula, and is given by:

$$M = S_2 / S_1 = f/(f-S_1).$$

In the majority of picture-making situations, S_1 is much greater than S_2, so their ratio M is small and the image is reduced in size compared to real life. In camera lenses, S_1 is always larger than f, so M is negative, indicating that the image is projected real but upside-down.

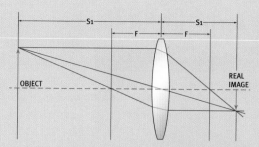

◀ **Real image formation**
A camera lens projects light to form a real image behind the lens, but one that is inverted. Here, the object is near to the lens, so the focal point is further away than f, the focal length.

APERTURE SIZES

In practical photography, the aperture of the lens not only determines the exposure at the capture surface, it also influences lens performance. The aperture is measured by f/number, which is given by: *f/number = f/d*, where f is the focal length, and d is the diameter of the entrance pupil, which is the image of the aperture stop as seen at the focal plane. It is a ratio, so it has no unit of measurement. The maximum aperture of the lens is obtained when the aperture is fully open and the entrance pupil is at its widest, letting in the most light when the f/number is low – e.g. f/1.4.

The minimum aperture is determined by the smallest hole left by the iris diaphragm when fully stopped down. The least light is let through, and the f/number is high – e.g. f/32. The diameter of the entrance pupil is not the physical size of the hole, but the apparent size at the capture surface, and this depends on the magnifying or reducing effect of the rear elements of the lens.

▲ **Rear view**
This shows the fully opened aperture more or less as seen by the capture surface. It is of a much smaller diameter than the front element, and its size must be communicated to the meter for accurate readings.

FOCAL-LENGTH FACTOR

The focal length quoted for lenses used in DSLR cameras usually assumes that the full size of the format – equivalent to the 35mm film format of 24 x 36mm – is used. But where sensors are smaller than the format, the focal length is effectively increased, because the smaller sensor crops into the field of view of the lens (*see also* page 136). This effect is measured by the focal-length factor (also called the multiplier or crop factor). The formula is:

$$F = D_n /D_s,$$

where F is the focal-length factor, Dn is the diagonal of the normal format, and Ds is the diagonal of the sensor format.

The diagonal of the 35mm format is approximately 43mm, and the diagonal of an APS sensor is about 29mm. Typically, the focal-length factor for a 35mm lens used on DSLRs with smaller sensors varies between 1.5x and 1.33x. In the case of 6 x 6cm format, the diagonal of the normal format is approximately

▶ **Field-of-view crop**
The use of a lens designed for a larger sensor on a small sensor crops the image to a smaller central rectangle (shown in green). This crops the field of view and has the effect of increasing the apparent focal length of the lens.

79mm, so the 6 x 4.5cm-format sensors produce a focal-length multiplier of about 1.5x. So, for example, a factor of 1.5x causes a lens of 50mm to be a 75mm.

WIDE-ANGLE LENSES

▲ **Circular fisheye effect**
A true fisheye lens crams an angle of view of 180° onto a flat image by distorting the scene: maximally at the edge but reducing distortion at the centre. This causes straight lines that do not run through the centre of the image to be curved, as seen in this image.

FISHEYE LENSES

For even wider angles of view – 180° and more – lenses have to deliberately distort the image. The characteristic spherical image – in which all straight lines are bent away from the centre – looks like a reflection in a fisheye, hence the name for these lenses. One type crops the image at the frame, giving a rectangular fisheye; the other – less common – type produces a central circular image.

Wide-angle lenses see more than the normal focal lens. Their focal lengths are shorter than normal for their format. For 35mm format, wide angle is usually taken to start with the 35mm with a coverage of 64° extending to 12mm, covering an ultra-wide 122° field of view. The wider field of view means that more of the scene has to be reduced to fit into the frame. This reduction has a greater effect as the focal length become shorter and focused distance increases, tending to exaggerate the size of near objects against more distant objects, which appear tiny in comparison.

DEPTH OF FIELD

Another result of the reduction in magnification is that depth of field is effectively larger with wide-angle lenses than with longer lenses. Again, the gain in depth of field increases as focal length is reduced. By the same token, wide-angle lenses tolerate camera shake better than longer lenses, which allows longer handheld shutter times.

FEATURES

Wide-angle lenses in the range 35–24mm are very popular for their ability to give high image quality in cramped conditions. The Nikon Nikkor 24mm f/2.8 and Zeiss Distagon 65mm f/3.5 for medium format are famed for their sharpness, while lenses such as the Leica Summilux 35mm f/1.4 and Canon 24mm f/1.4 are cherished tools for photojournalists because of their superb low-light performance.

Wide-angle lenses tend to distort, making straight lines slightly curved, and they also exhibit significant light fall-off (this may be reduced by stopping down). Their performance at close focusing distances may also be inferior to that at greater distances.

Any lens shorter than 24mm in focal length or equivalent is considered ultra-wide angle in

TYPES OF WIDE-ANGLE LENS

Rangefinder wide angle
Lenses designed for rangefinder cameras, such as the Leica M, Bessa, or Zeiss Ikon, generally offer superior quality to those for SLR cameras because the optical design can be made symmetrical.

DSLR wide angle
A modern design that is unusually compact for a wide-angle lens for SLR cameras, this lens offers the equivalent of a 30mm lens's field of view.

4/3 format wide angle
This very fast 25mm (37mm equivalent) optic with f/1.4 maximum aperture is typical of the new generation of compact, high-performance lenses for small digital SLR cameras.

that they strongly exaggerate depth and cover significantly more than normal vision. Visually their results can be arresting. Extreme wide-angle lenses such as the Zeiss Hologon 16mm $f/8$ for 35mm format and Zeiss Biogon 38mm $f/3.8$ for medium format are very sought after by landscape, architectural, and travel photographers.

DIGITAL ISSUES

Ultra-wide-angle effects are harder to achieve with digital cameras than with film cameras. This is because very small sensors – 10mm on the diagonal or smaller – require impractically short focal lengths to achieve wide-angle views. In addition, the light path from ultra-wide-angle lenses reaches the capture surface at a very shallow angle: these rays can be blocked by the construction of sensors where the photosite lies deep below the light-collecting micro-lens array covering the sensor (*see* page 123).

DSLR cameras with small sensors reduce the effectiveness of wide-angle lenses. For example, if you use a sensor with a 1.5x crop, the field of view of a 24mm will be reduced to that of a 36mm lens; to obtain the full view of a 24mm lens, you need a 16mm lens.

USES

Short focal length lenses are useful for:
- Working in tight, cramped conditions with no room for manoeuvre.
- Interior views using moderate wide-angle lenses.
- Low-light conditions needing relatively long shutter times.
- Producing images with extended depth of field.
- Exaggerating sense of depth using ultra-wide lenses.

To obtain the best results:
- Avoid placing objects with a regular shape, such as circular or square, at the edge of the image.
- Avoid working at full aperture if evenness of light coverage is important.
- For critical work, use a centre-gradient filter designed for the lens to ensure even light distribution.
- Avoid placing long straight lines, such as the horizon, right next to the image frame.

▼ **Ultra-wide-angle view**
A 12mm setting on an ultra-wide-angle zoom produces a stunning effect from a simple view of a landscape reflected in a window. The reflection and the strongly converging lines help convey a sense of space.

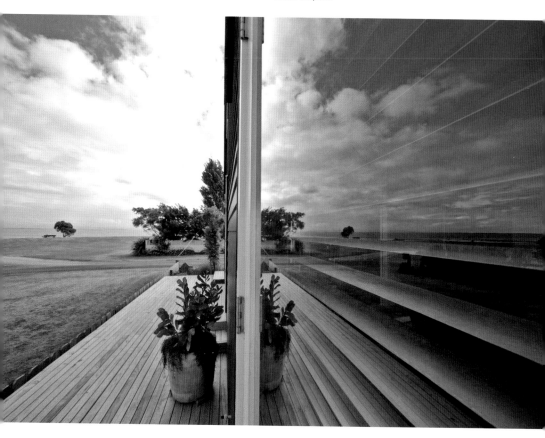

NORMAL LENSES

When we look steadily at a scene – without scanning around it – the part we are aware of is a central portion of the total view. This covers an angle of view of 45–55°, depending on the person. A lens with this angle of view is taken as a normal or standard lens. As it happens, the focal length for such a field of view is the same as the length of the diagonal of a film format. For example, the length of the diagonal of 35mm format film is 43mm: so lenses of focal length 40–50mm are regarded as "normal". You can test this by approaching a print or painting on the wall with

▼ **Discreet lens**
A normal lens is compact and discreet, which helps you to work closer to people and cause less intimidation than that from large, fast standard zooms such as a 24–70mm f/2.8 optic.

one eye closed: go up until you can comfortably see all of the picture without having to move your eyes. Now look through a camera with a standard lens or zoom set to normal: you will find the picture just fits into the lens's field of view.

FEATURES
The normal-angle lens is often regarded as the purist's lens, because it provides the most natural-looking view, with no distortion of perspective, so that objects retain their usual relationships of scale to each other. As a result, you find you have to work harder with this lens: you cannot create striking compositions by pulling optical or perspective tricks; the composition or dynamic within the picture has to do all the work.

▲ **Light study**
Standard lenses are ideal for the intimate study, since you must move to fit the composition, in contrast to turning a zoom ring from a distance.

TYPES OF NORMAL LENS

Digital standard
A standard lens for the 4/3 format, this 25mm f/1.4 optic from Leica is very compact and offers good usability at full aperture with high-quality image making. Its quasi-telecentric design makes it suitable for digital sensors.

Standard
Normal lenses such as this, made by Zeiss for Sony, typically show a narrow focusing ring as it is essentially an autofocus lens. There is no aperture ring, since aperture is set from the camera.

Ultra-fast
Standard lenses can be made ultra-fast: some have claimed the maximum possible aperture of f/0.7, but this f/1 lens has stood the test of time as one offering superlative imaging abilities.

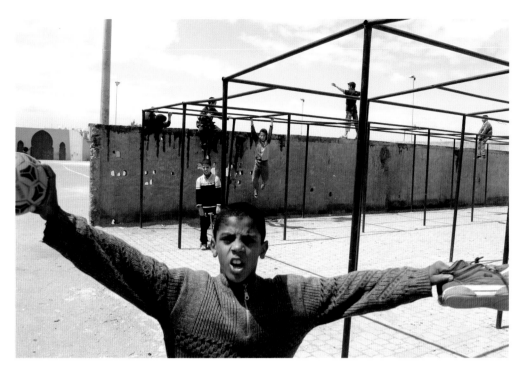

▲ Filling the frame
A boy in Marrakech, Morocco, expresses his feelings. A standard lens encourages you to fill the entire frame with details and incident, to create a rich composition.

Normal focal length lenses for 35mm and medium format have enjoyed a long evolution, with the result that they are consummate optics, many capable of giving near-flawless performance of high resolution and contrast with no distortion or light fall-off – and often at affordable prices.

Lenses such as the Leitz Summicron 50mm *f*/2 and the Zeiss Planar 80mm *f*/2.8 for 6 x 6cm cameras are legendary performers of the heyday of photojournalism – many of the world's greatest images have been captured using these lenses.

If you need a fast lens – that is, with a maximum aperture of *f*/2 or better – to exploit reduced depth of field, the normal lens is the best way. It is affordable and gives the best overall quality. In addition, with many normal zoom lenses – with ranges of 28–80mm – the middle setting often gives the best overall performance and least distortion.

The normal focal length is also ideal for macro photography, where the camera can approach close to the subject, such as in copying documents and art objects. Lenses such as the Nikon 65mm, Leica 60mm, and Schneider 90mm for medium format offer the highest image quality available to general photography.

USES

Normal focal length lenses are useful for:
• Working at average distances.
• Landscapes with little distortion.
• Still lifes and details.
• Product or catalogue shots.
• Working in low-light, high-contrast situations.

For best results:
• Avoid approaching people close to fill the frame with a face.
• Use a lens hood with large-aperture lenses.
• Move around to look for the best composition.

FORMAT AND NORMAL FOCAL LENGTH

The following are nominal focal lengths regarded as normal angle for various types of camera.

5 x 4in (13 x 10cm)	150mm
6 x 9cm	110mm
6 x 7cm	90mm
6 x 6cm	80mm
6 x 4.5cm	75mm
24 x 36mm	50mm
29 x 19 mm (APS-H)	35mm
15 x 23mm (APS-C)	28mm

ABERRATIONS

A perfect lens would project each point from the subject plane onto a corresponding point on the focal plane in a way that retained all the spatial relationships in the subject. However, no lens is perfect. Every photographic lens forms an imperfect or slightly defective image of its subject. The defects – called lens aberrations – are systematic in nature and can be deduced purely from the geometry of image formation and the properties of light. It is customary to examine aberrations one by one, but any optic is likely to suffer from the majority of, if not all, aberrations. What matters in practice is that aberrations are corrected – through the choice of glass and its shape – to make the lens useful.

It is vital to understand the nature of aberrations in order to design high-quality optics. Broadly speaking, the higher the level of correction of optics for aberrations, the greater the capacity to produce high-quality images – that is, those that are more nearly perfect. With advanced digital cameras, it is possible to integrate optics with software, so that certain aberrations are tolerated in a lens in the knowledge that they can be corrected by manipulating the digital image at a later stage. This helps keep the cost of lenses down, while offering very high image quality.

SPHERICAL ABERRATION

occurs where rays entering the optical axis from further away are focused closer to the lens axis than rays that are near to the axis. The lens thus focuses parallel rays along a line instead of into a point. Even rays parallel to – but at different distances from – the optical axis will fail to converge to the same point. The aberration is caused by curvature of the lens: rays near the axis hit the lens nearly at a right angle, but those away from the axis reach the lens at a steeper angle. This results in rays near the centre being less bent. Spherical aberration may vary with focused distance – corrected by using floating elements. Its presence may also cause a shift of the apparent plane of best focus when the lens is stopped down.

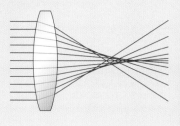

FIELD CURVATURE

describes the tendency of optics – which are formed of rounded elements – to project an image onto a curved surface rather than one that is flat. It is caused by marginal rays – those further away from the lens axis – seeing the lens as being of higher power than do the rays that are axial, or near the centre. As a result, the marginal rays are brought to a focus nearer the lens (for positive lenses), while the rays near the centre are focused further away. In consequence, when the centre of the image is brought into focus, the periphery falls out of focus, and vice versa.

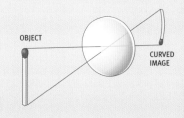

OBJECT

CURVED IMAGE

LENS DISTORTION

causes straight lines in the subject to appear curved in the image. It is caused by the magnification of the image changing across the image height: where the magnification increases from the centre, the distortion is positive, and is known as "pincushion". Where the magnification decreases from the centre, the distortion is negative and is called "barrel". In modern zoom lenses, the sign of the magnification may vary across the image width, resulting in a straight line looking somewhat wavy. While a simple change in magnification is easy to correct, the varying distortion requires software algorithms, such as DxO Optics, which is specifically designed for the lens in question. Generally, lines through the centre of the image remain unchanged.

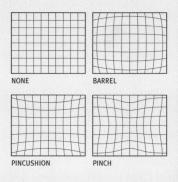

NONE

BARREL

PINCUSHION

PINCH

COMA

is most clearly seen in night-time images: points of light lying near the periphery of the scene – off-axis to the lens – are shown as comet-like blurs. Coma occurs because rays of light, oblique to the lens axis – not going through the axis – fail to meet at the focal plane and appear to fan out. The result is that highlights at the image margins appear comet-like, with a central bright patch and a trailing, blurred tail. Coma is positive when the most off-axis rays focus further from the axis, and negative when they are focused closer.

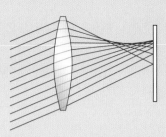

ASTIGMATISM

causes details that lie in different orientations, such as horizontal or vertical, to be focused at different distances. A classic example is that of a wheel with spokes: its image can be focused either on the centre of the wheel or on the spokes, but not on both. Astigmatism occurs because rays entering at different orientations into the system show a variation of focal lengths. In the diagram, the red lines represent rays lined up vertically to the y-axis: they meet at the sagittal focal plane. However, the yellow lines – from the same point on the subject but oriented to the horizontal or x-axis – will meet at the tangential or meridional focal plane. Notice that this plane is beyond the sagittal focal plane. This difference in focal length causes astigmatism.

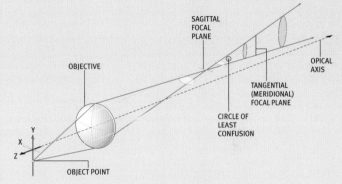

LIGHT FALL-OFF

is seen as a darkening of the image near the corners compared with the brightness at the centre. It is caused by a number of factors, collectively called the cosine effects, which cause light at the periphery of the image to be less intense than at the centre. In the diagram, you can see the cone of light at the centre of the image is larger and closer to the lens than the cone of light at the edge of the image. In addition, physical obstruction within the lens can cause the image to be darker at the corners: this is vignetting, caused by rays at the margins being blocked by the lens.

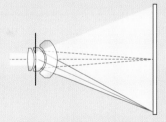

CHROMATIC ABERRATIONS

cause colour effects of different kinds and are the result of the optics focusing different colours of light to different points. It is caused by dispersion as seen when a prism splits white light into different colours. Where the focal point varies according to colour, we have longitudinal or axial chromatic aberration: this appears as colour blur and is most pronounced in very long focal length lenses. The magnification of the image may also vary with colour, giving rise to lateral chromatic aberration (also called "chromatic difference of magnification") and appears as coloured edges or fringes. It is most visible at the image periphery and is common in wide-angle and zoom lenses. This should not be confused with the colour fringing caused by defects in the digital interpretation of colours.

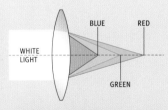

▶ **Colour fringing**
Colour fringing in digital camera images is caused by varieties of chromatic aberration as well as interpolation errors and sensor defects. The defects are clearest in details such as tree branches at the periphery of the image.

MACRO LENSES

Lenses designed to work close to the subject are called macro lenses – sometimes incorrectly referred to as "micro" lenses. Close-up photography starts where the closest focusing distance of an ordinary camera ends and is capable of magnification from about 1:10 (a 10th the size of the image) to life-size 1:1. Macro lenses are usually highly corrected and, because they are specialist optics, tend to be more expensive than normal equivalents. Focal lengths range from 50mm to 200mm or their equivalent.

Some lenses do not have a focusing mount, because they are intended for use on a bellows extension. Lenses that focus internally do not significantly change their length or centre of gravity during focusing. These are to be preferred to those that focus by moving all the groups together, as at the closest working distances the lens barrel is fully extended, becoming very long and ungainly.

FEATURES

Macro lenses are characterized by their short minimum operating distance (MOD) relative to their focal length. For working close to the subject – for example, when making copies of flat documents – use a short focal length for MOD, such as 50–65mm. Longer focal lengths, such as 150–200mm, are useful for magnifying the subject without having to get close to it, which is invaluable for insect photography.

It is accepted among lens designers that the hardest lenses to create are macro lenses. The requirement to focus close-up is, alone, mechanically demanding.

At the same time, macro lenses must provide high levels of correction of all aberrations.

Modern macro lenses offer a glittering parade of virtues that include very low distortion, very even coverage from centre to periphery, no perceptible light fall-off even at full aperture, and very high resolution with high contrast.

Of these the most attractive feature is the resolution performance: the sharpest lenses in all photography are members of this class – for example, the Leica Macro Elmarit 65mm *f*/2.8, Nikon Micro-Nikkor 55mm *f*/3.5, and Schneider Apo-Symmar 90mm *f*/4. The Nikon Zoom-Micro Nikkor 70–180mm *f*/4.5–5.6 is unique in being a zoom that is also a superb-quality macro lens.

USES

Macro lenses are useful for:
• Making copies of flat documents.
• Collections of objects (photograph a scale and colour patch alongside the object).
• Recording fine details.

For best results with macro lenses:
• Use shorter focal lengths (50–65mm) for copying flat objects.
• Use longer focal lengths – greater than 100mm – for working with flowers.
• Use lenses in the range 180–200mm for working with insects or small reptiles.
• Avoid using macro lenses for distant objects; their correction may be only satisfactory.

TYPES OF MACRO LENS

Small-sensor macro
The smaller sensors used in many DSLR cameras enable high-quality macro lenses such as the Canon 60mm *f*/2.8 to be more compact and inexpensive to produce.

Image-stabilized macro
Top-class lenses such as the Nikon 100mm *f*/2.8 offer advanced technologies such as image stabilization – extremely useful for handheld work – and internal focusing through ultrasonic motors.

Canon 65mm 1–5x
Specialist close-up lenses such as the Canon 65mm *f*/2.8 give research-quality images – in this case, between full-size and 5x magnification, according to working distance. Note the front of the lens is barely recessed in order to allow lighting to reach the subject.

◄ Limited depth of field
The extremely limited depth of field of close-up work is well illustrated in this image of a circuit board, where the narrow plane of sharpness runs clearly across the middle of the image, with rapid fall-off of sharpness either side.

EXPOSURE CORRECTIONS

Magnification	0.2	0.4	0.7	1.0	1.4	1.8	2.4	2.8	3.0
Increase exposure time by x factor	1.4	2.0	2.7	4.0	5.8	7.9	11.6	14.4	16.0
Increase exposure by x stops	½	1	1½	2	2½	3	3½	3¾	4

• Avoid using the smallest aperture – at close-up distances, depth of field will never be extensive, but diffraction effects will significantly reduce quality.

SETTING UP FOR FLAT DOCUMENTS

To photograph flat documents such as maps, posters, and books, first determine the largest size you have to work with. If not larger than A2 in size, it is easier to set the camera up on a tripod or stand pointing vertically down. If larger, fixing originals against a wall and photographing horizontally is best.

Set up the camera so it is square on to the copy: every side of a rectangular print must be parallel to the sides of the viewfinder. Set up two lots of lights behind the lens, at an equal distance away, pointing to the artwork at 45° to the surface. Ensure the lighting is even.

CLOSE-UP WITH DIGITAL CAMERAS

The small sensor and zoom construction on digital cameras lend themselves to close-up photography: many cameras can focus as close as 10mm. However, the closest working distance may be at the shortest focal length settings, which can cause unsightly perspectives.

CLOSE-UP EXPOSURE COMPENSATION

In order to focus normal, non-zoom lenses, you extend the lens away from the film as the subject is closer to you. Now, as the lens moves further away from the capture surface, it is as if the light source (the lens) becomes less bright, relative to the capture surface. Within normal focusing distances, there is no practical need to adjust for this reduction. But as you focus closer, failure to compensate for the reduction leads to underexposure. Cameras with TTL metering – all modern SLRs and DSLRs – will automatically compensate. For other cameras, such as medium-format or monorail cameras, the easiest method is to calculate the image magnification to correct the marked aperture.

Magnification equals the distance from the image to the lens, v, divided by the distance from the lens to the subject, u, so:

$$M = v/u.$$

Or you can divide the focal length, F, by the distance from lens to the subject, u, less the focal length, F:

$$M = F/(u–F); \text{ alternatively}$$
$$M = (u/F) – 1.$$

Next, the effective *f*/number N' is the marked *f*/number N multiplied by the magnification M plus 1:

$$N' = N (M + 1).$$

For view cameras, or when using a bellows extension extended to a distance, L, using a lens of focal length, F, the exposure factor, E, is calculated as follows:

$$E = L2 / F2 \text{ (see table, above)}.$$

MEDIUM–LONG FOCAL LENGTH

TYPES OF MEDIUM–LONG FOCAL LENGTH LENS

135mm f/1.8 lens
The Zeiss 135mm lens for Sony DSLR cameras is the latest example of large-aperture medium telephotos that are ideal for portraiture and travel photography, thanks to a combination of high speed and very high image quality.

200mm f/2.8 lens
Lenses of 200mm or 180mm and a maximum aperture of f/2.8 from Nikon, Leica, and Canon (shown here), are famed for their high performance and the excellence of their out-of-focus rendering (bokeh), which is smooth and even.

The medium–long focal length covers the range from about 70–200mm for 35mm format, 120–250mm for medium format, and their equivalents in other formats. Almost all basic zoom lenses on modern cameras will reach at least to 70mm focal length equivalent. Fields of view range from about 30° to 15°, giving modest magnification of the subject. The field of view comfortably encloses the area of best vision in humans, so these lenses are easy to compose with. And when we approach a person to the borders of the usual personal space, their head and shoulders fill the field of view.

FEATURES
This class of lenses is perhaps the easiest of all to use – their field of view is narrower than normal and helps you to crop scenes to their essentials. At the same time, the magnification is not extreme, so the perspective remains natural and no special technical demands are made on the photographer. These features make medium–long lenses a favourite for travel photography

▼ **Candid portraits**
Medium telephoto lenses are ideal for candid photography because they combine fast operation with discreet size while delivering high-quality images, such as this picture from Amsterdam, Netherlands, shot with a 200mm lens.

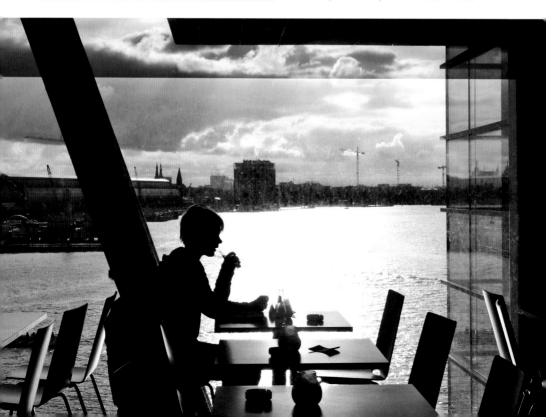

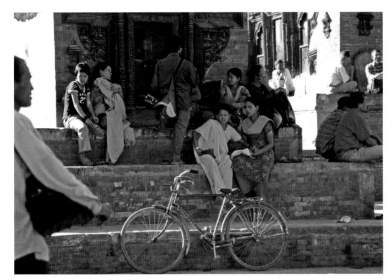

◄ **Street photography**
A lot of travel photography is conducted at medium telephoto lengths – portraits, street scenes, and views. In this shot, a 135mm lens has gently compressed the space of a busy scene in Kathmandu, Nepal, into a balanced composition with focus effects used to depict distance.

▼ **Spatial compression**
A 200mm lens for 35mm format or equivalent focal length is excellent for a visible but not exaggerated compression of space, making objects seem closer together than they are. In this scene near Pisa, Italy, the road, trees, and figures appear to be on the same physical plane.

and portraiture. Prime lenses in this range are relatively easy to construct and so can offer extremely high quality with good speeds at affordable prices.

The Nikon Nikkor 85mm $f/2$ and Nikkor 105mm $f/2.5$, Tamron 90mm $f/2.5$, Leica Summicron 90mm $f/2$, and Zeiss Planar 150mm $f/4$ for medium format are prized by portrait photographers for their excellent performance at full aperture, giving soft out-of-focus blurs and a pleasing, but just visible, touch of softness in the image.

Super-fast lenses in this range such as the Canon 85mm $f/1.2$ and Leica Summilux 80mm $f/1.4$ are prized by photojournalists. Together with medium-format lenses such as the Schneider Tele-Xenar 180mm $f/2.8$, these extreme speed lenses also give matchless extremely shallow depth-of-field effects that are increasingly appreciated by photographers using cameras with smaller sensors whose lenses produce excessive depth of field.

USES

Medium–long focal length lenses are useful for:
• Portraits from half-length to head and shoulders.
• Still lifes, details, and product shots.
• Travel and landscape views.
• Theatres and shows.
• Working in low-light conditions.

To obtain the best results:
• Avoid extreme close-ups.
• Use lens hoods when using fast lenses.
• Use maximum aperture for minimum depth of field.
• Exploit blur effects from narrow depth of field by careful focusing.
• In bright conditions, set a low sensitivity or use slow film in order to be able to use full aperture.

▼ **Large-aperture portrait**
A 180mm $f/2.8$ lens for a medium-format camera focused to its closest working distance – just right for portraiture – can create wonderfully smooth textures when used at full aperture. This is due to the limited depth of field from its large aperture, long focal length, and short subject distance.

Birds that are further away appear sharper than birds closest to the camera because their relative speed across the frame is lower and more easily frozen.

Although the birds are backlit, the combination of strong light and the angle of lighting has penetrated the wings to give them some translucence.

n the corners of the image, poor mage quality is evident in the shape of comatic blur, loss of sharpness, as well s darker tones caused by extreme

Converging parallels are usually undesirable in pictures of buildings, but here it is so extreme that it is one of the visual signs of dramatically

A flare spot is an image of the lens diaphragm caused by internal reflections that mask the subject, so reducing its contrast and making

The sun is behind some thin cloud but because of its intensity, and the extreme wide-angle view, it has caused veiling flare despite being outside the image area.

Darkening in the image corners due to light fall-off is severe in ultra-wide-angle lenses, but in this instance it has the beneficial effect of holding in the corners of the image.

ANALYSIS: WORKING WITH LENSES

The Taschichho Dzong monastic complex in Bhutan is a magical place where pictures will walk uninvited into the camera – all you have to do is keep the shutter clicking away. With an ultra-wide-angle setting, it was possible to capture the great buildings and the sky. A few minutes' wait and a flock of pigeons brings the picture to life, filling voids in the sky as well as providing a strong sense of movement and space. The extreme wide angle has exaggerated a low perspective on the buildings, and the angle of the framing is a sign that this is not intended as just an architectural composition.

Depth of field is extensive despite a modest aperture of $f/5.6$ being used in order to allow for a short shutter time to freeze action. The reason: the lens's focal length is only 12mm.

There is strong convergence of the horizontal parallels because the building is at an angle to the camera. The wide angle exaggerates the differences in scale.

VERY LONG LENSES

Very long lenses are those whose focal lengths are greater than 200mm for 35mm format, and their equivalent for other formats. Long focal length lenses used to be called telescopic lenses because they were derived from telescopes, often with very simple construction – with a single positive-power achromatic group at the front of a long tube extending from the camera. These lenses were about as long as their focal length and focused by changing the length of the lens tube. The long extensions required for close-distance focusing makes the resulting set-up very ungainly. Very long focal length prime telephoto lenses produce the very best image quality available for wildlife and sports work, but they are very costly and bulky.

TELEPHOTO LENSES

Telephoto lenses, however, combine a positive group or groups of lenses with a negative group – called the "telephoto" group – at the rear. This tends to make the lens more compact: their physical length is much shorter than their focal length. The addition of the telephoto group allows for aberration correction and for focusing. By moving internal elements, autofocus speeds are increased because only a few lightweight elements need to be moved, and the overall length of

TYPES OF VERY LONG LENS

▲ **Canon 400mm f/5.6**
Modern high-performance telephoto lenses can be relatively compact and easy to use, with rapid autofocus abilities thanks to internal focusing, and good close-distance working, as in this 400mm f/5.6 model from Canon.

▲ **Hasselblad 350mm f/5.6**
The focal length of 350mm on 6 x 6cm format is equivalent to 200mm on 35mm format, with a 13° angle of view. Despite its modest overall length of 162mm, as a result of incorporating larger optics, the lens weighs 1.8kg (4lb).

MAXIMUM EXPOSURE TIMES FOR HANDHOLDING

In normal circumstances, and working with care, you should be able to obtain sharp images with shutter times equal to, or shorter than, these listed. Note that shutter times are consistently longer with rangefinder cameras because they do not suffer from the shutter "slap" (vibrations) of SLR cameras.

FOCAL LENGTH	RANGEFINDER CAMERA	SLR CAMERA
20mm	$\frac{1}{15}$sec	$\frac{1}{30}$sec
28mm	$\frac{1}{15}$sec	$\frac{1}{30}$sec
50mm	$\frac{1}{30}$sec	$\frac{1}{60}$sec
100mm	$\frac{1}{60}$sec	$\frac{1}{125}$sec
200mm	$\frac{1}{125}$sec	$\frac{1}{250}$sec
300mm	$\frac{1}{250}$sec	$\frac{1}{500}$sec

the lens does not change with focus. This helps retain good balance and enables focusing to very close-up working distances. Modern long lenses are telephoto in design, so it is usual to refer to very long focal length lenses as long telephotos.

FEATURES

Ultra-long telephotos concentrate on a very narrow field of view: a 300mm lens takes a narrow field of view of just 8° then magnifies it to fill the picture frame. Taking a normal focal length as giving an image magnification of 1x, a lens that is, say, six times longer with a focal length of 300mm will give a linear magnification of 6x. Depth of field is very narrow indeed, so precise focusing is needed – ideally a slight manual correction of an autofocus setting.

Note that with long lenses – in contrast to wide-angle lenses – even quite large differences in focal length do not make an obvious photographic difference: a 400mm lens views over 6° compared to a 500mm's 5°. Yet the difference in cost and bulk between 400mm and 500mm lenses of comparable maximum aperture can be considerable. The reason for this is that, as the focal length increases, the diameter of the front element must increase to maintain maximum aperture. With very long focal length lenses, front diameters become extremely large – over 150mm wide in the case of a 600mm f/4 lens.

IMAGE STABILIZATION

As the focal length and magnification increases, so the lens will also magnify camera or lens shake: the slightest tremor during exposure can cause a streak in the image – a movement in the lens of less than 0.05mm ($\frac{1}{500}$in) can cause an image streak of 0.2mm

(½in) long, which shows up as obvious unsharpness. If handholding is necessary, it helps to ensure that the exposure time is as short as or shorter than the reciprocal of the focal length. For example, if the focal length is 300mm, use a shutter time of 1/300sec – or better still, 1/500sec if possible. The best cure is, of course, to use a tripod, but image stabilization built into the lens (as in a number of Canon and a few Nikon and Sigma lenses) is also invaluable. These lenses can allow shutter times of 2 or more stops longer than optimum to produce a sharp image. For example, with a 300mm lens, an image-stabilized exposure of 1/60sec or even 1/30sec may give an acceptably sharp image.

USES

Very long focal length lenses are useful for:
• Inaccessible subjects such as sports on a large playing field or birds in an estuary.

• Causing separated objects to appear close together.
• Images requiring extremely limited depth of field.

To obtain the best results:
• Work preferably in clear, calm, dustless, and dry conditions with the sun behind you when photographing over great distances.
• Stabilize the lens on a tripod or support.
• Use short shutter times.
• Use a deep lens hood.
• Avoid using the smallest apertures.
• Avoid using very large lenses when stalking nervous subjects, such as birds or mammals.

▼ Gannet in flight
Very long focal length lenses have transformed the photography of birds. They bridge considerable distances to bring extremely sharp, detailed images of normally inaccessible birds, such as this gannet captured using a 500m lens.

▲ Aerial acrobatics
Even when captured with a 500mm focal length lens, the Red Arrows appear small in the frame. For aerial photography, large-aperture very long lenses are a necessity.

▶ Surfing trio
Photographing surfers relies almost entirely on very long lenses. The spatial compression of long focal lengths – seen here as the horizon and headland seemingly on top of the surfers – helps increase the drama and sense of immediacy.

SPECIALIST LENSES

A large majority of lenses are set up to be perpendicular to the focal plane – this ensures the subject plane parallel to the camera is sharply focused from one corner to the other. Lenses are generally adjusted to give maximum sharpness throughout the visible spectrum. But there are many specialist tasks for which lenses can be adapted, through either the way the lens is mounted or the way its performance is specially tuned for the task.

TILT-SHIFT

Tilt-shift lenses enable small cameras, such as DSLRs and medium-format cameras, to enjoy some of the facilities offered by large-format studio or technical cameras. Lenses that shift the image cause the camera

to see a slightly different area than what it is pointed at: a shift lets you cut off foreground without having to point the camera upwards. Shift lenses are designed to project an image circle that is larger than the format they are covering (*see* pages 170–3). This allows the image to be decentred, giving freedom of movement from cropping of the image within the camera.

The tilt movement of a lens has the effect of inclining the plane of sharp focus so that it is at an angle. By varying the amount of tilt, you can control the position of the plane of sharp focus. This is most valuable when you need maximum sharpness over an inclined plane, such as the ground in a landscape. Using the tilt may enable you to obtain a sharp ground from near the camera to infinity, even at full aperture. Tilt is also useful for minimizing sharp focus to a very specific plane.

TYPES OF SPECIALIST LENS

▼ Wide-angle converter
Here a typical wide-angle converter is mounted on a compact digital camera. The front element is much larger than that of the lens being converted. The size of the attachment usually obscures the view from the optical viewfinder.

▶ 1.4x tele-converter
Moderate power converters such as this 1.4x tend to be smaller, retain higher image quality, and let through more light than 2x converters. The exposed front element may limit compatible lenses.

◀ Tilt-shift
This specialist lens offers shift movements (controlled by the knob on the left) and tilt movements (controlled by the knob in front) to give great picture-making versatility.

SOFT FOCUS

Not all lens aberrations, such as coma (*see* pages 150–1), are bad all the time. Coma can be deliberately introduced to improve light fall-off in wide-angle lenses. In portrait photography, spherical aberration can be used to create soft-focus effects. Images with under-corrected spherical aberration show a solid core to subject outlines with an even halo of blur, giving an exceedingly pleasing effect to skin tones.

The Rodenstock Imagon was designed for medium format and gives results celebrated for their finesse. For 35mm and DSLR cameras, soft-focus lenses have been made by Nikon, Minolta, and Canon in which the correction for spherical aberration can be set from full to over-correction, to give results ranging from full sharpness to extreme softness. An effect very similar to spherical aberration can be produced by using lens filters featuring irregular bumps on their surface – for example, the Zeiss Softar series.

CONVERTERS

Certain optical systems are designed to modify the behaviour of another optical system. These converters are used primarily to change the effective focal length of the lens to which they are attached.

Front converter

Front converters can be attached to fixed and interchangeable lenses by screwing into the filter thread or via an adaptor. Wide-angle converters increase the angle of view – effectively reducing focal length. Teleconverters increase image magnification – effectively multiplying focal length. Converters are designated by power: less than one for wide-angle converters, such as 0.7x on a standard 50mm lens, gives an effect roughly equivalent to a 35mm less. The power of teleconverters greater than one, such

◄ **Using a tilt-shift lens**
This shows the image circle (1) projected by the lens – it must be larger than the format, to allow for a shift movement vertically, sideways, or a combination. Centred on the optical axis, as shown (2), the image is at its best quality.

With the lens shifted vertically (3), the camera views a portion of the image circle that is above the centre line: the effect is like looking upwards, but without pointing the camera upwards. Classically, this is used to photograph the height of buildings while avoiding converging parallels.

With the lens shifted down (4), the foreground is greatly increased without having to point the camera downwards. This diagram shows the shift taken to the maximum – any further, and the image format will fall outside the image circle, causing darkening or loss of image in the lower corners.

as 1.6x on a 50mm lens, gives the view equivalent to 80mm. Thanks to simple construction, these can be relatively inexpensive, but large converter elements are needed to minimize vignetting, and converters tend to increase distortion but do not affect effective aperture.

Rear converter

Rear converters are teleconverters or focal-length extenders, which means they increase effective focal length. They attach between the back of interchangeable lenses and the camera body. They must therefore carry mounts for the prime lens and duplicate the rear lens mount to fit the camera body. The precision of the mounts is as important a factor in determining image quality as the optical quality of the converters. A 1.4x converter increases focal length by that factor, so a 300mm lens becomes a 420mm, and effective aperture is decreased by 1 stop. A 2x converter doubles effective focal length and reduces the aperture by 2 stops. Minimum working distances are not affected, so rear converters enable very long lenses to work relatively close-up.

▶ **Soft focus**
The classic soft-focus image offers a halo of blur around a core of relatively sharp edges in the image, where the halo's spread increases with loss of focus. With human features, this tends to smooth out skin textures while retaining details in face or hands. Note the tendency to reduce the maximum density, causing blacks to appear dark grey.

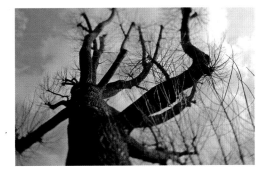

▲ **Reverse tilt**
A 24mm tilt-shift lens was used with the tilt angled to reduce depth of field. This creates a clearly demarcated and visually unsettling narrow plane of sharp focus despite use of a very wide-angle lens.

IMAGE CLARITY

A central ambition of all photographers is to produce images with maximum clarity – images that are full of detail. The capture of detail depends on the optical resolution of the system, which depends on its ability to separate detail with usable contrast. Another requirement is that the variations of hue in the image are accurately recorded: this depends on a high level of correction of achromatic aberrations. Here we discuss optical resolution and the factors that contribute to or limit it for camera systems – the key is the word "systems"; we need to look beyond lens performance.

OPTICAL RESOLUTION

Optical resolution is a measure of the ability of a capture system to depict subject detail. In essence, resolution measures the ability of an optical system to distinguish between two features that are close together. In practical photography, the resolution of the system determines how much information can be seen in the image and is fundamental.

RESOLUTION LIMITS

Two separate contributions make up a system's resolution: the effective resolving power of the optics in the camera, and the resolving power of the capture medium. In practice, the resolving power of the optics sets the upper limit of the system. This is because no matter how high resolution the capture medium, if the lens is faulty, the image quality will be low. The resolving power sets the lower limit because a high-quality lens may project a great deal of information but if the sensor is low resolution or fast grainy film is used, fine detail cannot be captured.

In good conditions, the eye can resolve some 30 pairs of lines per degree of fine vision at average distances, reduced to about 20 lines per degree in average conditions. At a distance of 3m (10ft), this is equivalent to about 500 lines over 1.3m (4ft 3in). Alternatively, a picture can be regarded as sharp if, when viewed from a distance of 25cm (10in), you can see about four line pairs per millimetre (lpm).

RESOLUTION AND CONTRAST

Generally, large or coarse detail is recorded with higher contrast. Contrast falls with finer detail. The contrast of the detail is central to perceived image quality: when the separation of detail is not easily visible, it has no practical value.

The level at which contrast is useful varies with the image, with processing conditions, and with capture resolution.

The modulation transfer function (MTF) is a method of combining resolution and contrast measures by evaluating the system's response to the image.

The resolution performance of modern lenses is usually described by showing variation of MTF. Some graphs show how MTF changes from the centre of the image to the periphery. Others show how MTF varies with changes in aperture. One form displays pairs of lines: one line plots detail that lies sagittal to the lens axis (cutting through the centre), and the other plots detail oriented tangentially. The closer the lines run, the lower the astigmatism (*see also* page 151). The higher the curves in the graph, the better the image quality.

▶ **Modulation transfer function**
This diagram illustrates the variation of MTF with spatial frequency – fineness of detail. In the top, a low-frequency subject is imaged with good contrast. Note that the sharp lines of the subject are blurred in the image; the degree of blurring is the measure of MTF. In the bottom of the diagram, high-frequency detail is imaged with low contrast – the image appears more blurred.

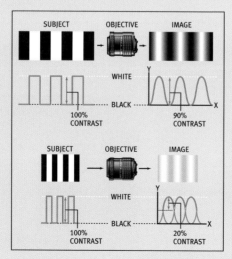

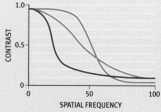

▲ **MTF and quality**
When MTF is plotted against spatial frequency, some lenses present behaviours that suit different uses. Curve A indicates a good all-round performer combining good contrast and resolving power. Curve B may be a good amateur optic, since it offers good contrast but poorer resolving power. Curve C may be suitable for professional use as it offers good resolution but at low contrast.

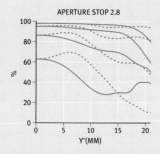

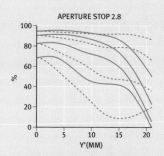

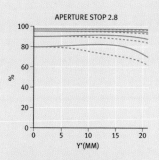

▲ **MTF for Leica 50mm R at f/2.8**
This diagram plots variation of MTF across half the image field, where the four pairs of lines represent line frequencies 5, 10, 20, and 40lpm. The continuous line is for the tangential target; the dotted for the sagittal. The further apart the pairs of lines, the greater the astigmatism. The plots demonstrate superior image quality when the lens is stopped down to f/2.8.

▲ **MTF for Leica 15mm R at f/2.8**
MTF traces for wide-angle lenses typically show wide separations tangential and sagittal (dotted/dashed lines). For an ultra-wide-angle lens, its MTF curves are very creditable. The traces for 5 and 10lpm show extraordinarily high quality out to 15mm from the lens axis. And the 40lpm trace shows very usable contrast out to 10mm from the image centre.

▲ **MTF for Leica 280mm at f/4**
This MTF trace is typical of top-class long optics: there is almost perfect imaging of coarse spatial frequencies of 5 and 10lpm right across the image field, shown by the level lines and closely aligned traces for tangential and sagittal targets. At 40lpm, the trace still shows very high imaging quality. This is an altogether impeccable performance.

Graphs can show changes in MTF with working aperture: generally, lenses show a rise in MTF as aperture is decreased from maximum, then a rapid fall as the smallest apertures are engaged. This will indicate which aperture setting to use for maximum overall MTF.

SUBJECTIVE QUALITY

Experiments have shown that the human eye favours a band of average frequencies over others, namely 3–12cpd (cycles per degree) with a peak at 6cpd, which is neither too fine nor too coarse. This is equivalent to 0.5–2lpm at a distance of 34cm (13³⁄₈in), with a peak at just 1lpm.

Therefore, images judged sharpest are those in which detail of about one line per millimetre of contrasty subject detail on the image is reproduced at a contrast close to that of the subject when viewed from a distance of 34cm (13³⁄₈in).

This is in fact quite a modest performance – a fraction of the capability of SLR lenses – and it demonstrates that a combination of average resolving power with high contrast produces the best-looking images.

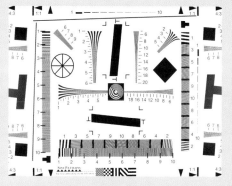

◄ **Lens-test chart**
A standard lens-test chart designed to test resolution, such as that shown, can be used for subjective as well as objective measure of sharpness. Software can be used to analyse suitably designed test charts, provided stringent lighting conditions are met.

MTF CASCADE

As each step of the imaging chain transfers the image from one medium to another, the concept of MTF can be applied as a rough message of the accuracy/quality of each step. Measurements (and theory) show that each step in the chain causes a loss, so there is a multiplication or cascade of losses. Early low quality cannot be regained by a subsequent high-quality transfer. This explains why the lens – the first step in the chain – is so important: low-quality images cannot be improved later. For example, the first line shows a system that performs averagely delivers only one-eighth of the detail compared to the original. Poor lens MTF (second line) cannot be regained by high-capture MTF, while high-lens MTF (third line) produces better results even with mediocre capture and enlargement MTF.

CAMERA/LENS MTF	CAPTURE MTF	ENLARGEMENT MTF	SYSTEM MTF
50	50	50	12.5
20	70	50	7.0
70	50	50	17.5
70	70	70	34.3

OPTIMIZING LENS PERFORMANCE

Lens performance measures the image projected by the lens. Fundamental features, such as focal length, are set by the specifications (*see* also page136), but the measured focal length may not be exactly the same as that specified. For example, a focal length may be said to be 50mm, but the actual, measured focal length could be anything between 47mm and 53mm. These variations from specification, and others such as minimum focused distance and the largest/smallest aperture settings, are not discernible in ordinary use. But another aspect of performance is very much a preoccupation of photographers – namely the quality of the image, in terms of clarity, sharpness, and freedom from aberrations.

FOCUS

The photographer's most important contribution to lens performance is to focus accurately on the key part of the subject. One of the reasons the Leica rangefinder produces excellent results for photojournalism is because its focusing system is unsurpassed in the 21–50mm focal-lens range.

Autofocus systems may be slightly inaccurate on point-and-shoot cameras and not perfect even on SLR and dSLR cameras. Whenever possible, focus manually for the best results, using the SLR's focusing screen, preferably exploiting focusing aids such as a split-image or multi-prism spot.

Manual fine-tuning as a supplement to autofocus gives the best results on SLRs and DSLRs. Where time permits, use a viewfinder accessory, which

OPTIMUM APERTURES

This table is a guide to the number of stops down from full aperture needed for optimum sharpness for typical different types of lenses. Use these as a starting point for evaluation.

LENS TYPE	STOPS FROM FULL
Wide angle	3–5
Normal	2–3
Macro	3–4
Fast normal	2–4
Zoom	3–5
Moderate telephoto	2–3
Fast telephoto	1–2
Fast ultra-telephoto	0–1

magnifies the central portion of the focusing screen. This has the effect of increasing the base length of the rangefinder, which increases accuracy.

OPTIMIZING PERFORMANCE

One of the most important photographic controls is your influence on the image quality, and a large part of that is due to the lens performance. While it is true that the most costly lenses deliver the very best image quality, poor technique will undermine superlative lenses. On the other hand, careful use of average lenses can extract superior performance.

◄ **Marsh heron**
This heron was photographed with a 560mm lens – a 100–400mm zoom lens with 1.4x teleconverter – from a distance of approximately 5m (16.4ft). The very narrow depth of field isolates the bird from the water. However, the combination of zoom and teleconverter gave inferior image quality. The low contrast of the image, caused by using the teleconverter, is not a great problem where the major outlines, such as the branches, are in sharp relief to the background. The image blur of the water is acceptable but not as smooth as would be given by a high-quality prime lens.

WORKING DISTANCE

For critical work, ensure that you operate within the lens's optimum range of working distances, even where the focusing range is extensive. Wide-angle zooms, for example, generally give poor service at their closest focusing distances. On the other hand, optics with large zoom ratios may give good performance close up but offer lower contrast at infinity. Naturally, macro lenses are best limited to close-up work even if they can focus to infinity. Check each lens for the working distance in which it is most comfortable.

CHOICE OF APERTURE

The majority of lenses show a performance profile in which image sharpness rises from full aperture as you set smaller apertures, then falls rapidly as the smallest apertures are used. The aperture for optimum sharpness is at the turning point; it is usually where the aberrations are most fully corrected but diffraction effects are still relatively small.

Note that while, say, best sharpness is attained by stopping down 2 stops smaller than maximum, other factors, such as light fall-off, may continue to improve for another 2 or more stops.

There is no rule about optimum apertures: they vary with different lenses. You can test your own lenses. Place your camera on a tripod facing a static subject. Focus carefully, make exposures at all apertures, changing shutter time to suit. Examine the results under magnification. The improvement from full-aperture performance will be evident, but the drop in quality may not be so apparent.

The use of small apertures to increase depth of field is constrained by increasing losses in quality due to diffraction effects. These losses are much worse for smaller formats with their smaller lenses. This is one of the strongest arguments for working with the largest format available.

IMAGE STABILIZATION

One of the most important ways to optimize lens performance is to reduce camera shake – the movement of the camera during exposure, which blurs the image. Image stabilization uses a combination of movement sensors and a compensating lens group shifted by actuators. The shifting lens is designed so that when it is decentred, the position of the image shifts slightly, without impacting on the image quality.

When movement is sensed, it is analysed by the sensors; this sends a signal to the appropriate actuator to shift the compensating group. The image moves in the direction opposite to that of the movement, thus cancelling it. The circuitry polls the sensors many hundreds of times a second and makes compensatory movements in response, to give virtually continuous monitoring of movement until the moment of exposure.

Obviously, it also helps to stabilize the camera by using a tripod and to use shutter times short enough to freeze movement (*see* page 75).

ABERRATION CONTROL

The control of aberrations is central to optimizing image quality. This table summarizes the factors influencing lens aberrations and lists practical measures that can be taken to decrease the impact of lens aberrations, thereby to obtain the best lens performance.

ABERRATION	INCREASES WITH	DECREASED BY	NOTES
Field curvature	Larger format, wider angle of view	Stopping down, angle of view	Stopping down does not directly reduce curvature but increases depth of focus/field
Spherical	Wider angle of view, larger aperture, closer focusing	Stopping down	Focus may shift with stopping down; may vary with focus distance
Chromatic (longitudinal)	Longer focal lengths	Stopping down	Controlled by choice of glass in lens design
Chromatic (lateral)	Zoom complexity, field of view	Stopping down	Best to correct in post-production
Astigmatism	Wider field of view	Stopping down	
Coma	Wider angle of view, larger maximum aperture	Stopping down	
Distortion	Wider angle of view, greater zoom ratio	Finding zoom setting with least distortion	Correct in post-production
Diffraction	Smaller apertures	Opening aperture	Impossible to eliminate completely

LIGHT-ADJUSTING FILTERS

Filters are used in photography to modulate the image as it enters the lens. Filters may be regarded as preparing the light prior to its capture. While image-manipulation effects have made some filters obsolete, there are some effects that cannot be replicated in software, while others are simply easier to achieve through the use of a filter.

DENSITY AND TRANSMITTED LIGHT

Density measures the light-stopping power of a material – for example, how much light is prevented from passing through a filter. The more dense the

▲ Boat and plain sky
This scene (above left) appears to need a filter to match the exposure for the sky to the darker waters in the foreground: ideally, there should be light on the boat itself. The image (above right) is an example of a common error – using a filter that colours the sky but fails to tint the foreground, creating an artificial effect.

▼ Trees with tobacco gradient
Where a gradient colour is carefully chosen to match the scene, a coloured graduation can be effective. The tobacco filter is a favourite among landscape photographers, and it applies a reddish-brown colour to a scene.

filter, the less light passes through and the darker it appears, as a result of which a corresponding increase in exposure is also needed. Density is a fundamental measure in photography: we compare the ratio of light falling on the material to the amount of light transmitted through it – this is the opacity of the material and is always greater than one. Density is defined as the common logarithm of opacity.

Transmittance is a related measure, defined as the percentage of the light falling on the material that is transmitted. It is the inverse of opacity and is always less than 100 per cent.

FILTER FACTORS

As filters reduce the brightness of the image entering the lens, a correction is needed for the exposure. This is measured by the filter factor – how much you need to increase exposure time to compensate for the light loss. A factor of 2x requires you to double the shutter time, for example, from 1/60sec to 1/30sec (or an increase of 1 stop in aperture – for example, from f/8 to f/5.6). Low factors such as 1.2x can be safely ignored for colour-negative and black-and-white film. You need to use filter factors only when using a hand-held meter. Metering through-the-lens – hence through the filters – automatically accounts for the filter factor.

NEUTRAL DENSITY

When ambient light level is very high but you wish to use a large aperture or a long shutter time or you are unable to reduce the sensitivity of film or sensor, you will need to reduce the amount of light entering the lens. This may be needed with compact digital cameras whose minimum aperture setting may be limited to as large as f/5.6. Neutral-density (ND) filters are designed to block all wavelengths equally, thus reducing the brightness without introducing any colour cast. This is a surprisingly difficult technical task, so high-quality ND filters are costly. ND filters are graded by filter factor – a 4x ND requires four times longer shutter time or an aperture that is 2 stops larger.

GRADIENT FILTERS

A variant on the neutral-density filter is the gradient filter. These are designed to reduce the exposure difference between the brighter part of a scene, such as sky, and the darker portion, such as the foreground. Gradient filters use a ramp of density: at one end is highest, becoming gradually less dense towards the centre, and tailing off to transparency at the other end. Filters are made in different grades according to the exposure difference between maximum and zero density. You match this to the exposure difference in

the scene that needs to be balanced. A 4-stop exposure difference may be partially reduced with a 2-stop gradient filter (often all that is required) or fully compensated with a 4-stop filter. The steepness of the gradient is obviously greater with higher maximum density and varies with aperture; you should check the effect of the filter at the working aperture.

The shape of the area that is graduated dark is fixed by the filter and is usually a transverse ramp – the boundary between darker or lighter areas is a straight line parallel to the width. When used on a rotating holder, the orientation of the gradient can be varied. However, the usefulness of the filter is limited to scenes with simple outlines.

The density may also be tinted with colours such as blues, yellows, or browns to give colour to the lighter area. The effect of gradient filters cannot be totally simulated by image manipulation.

ND CENTRE FILTER

The light fall-off or darkening of image corners seen by extreme wide-angle images set at full or medium apertures sets a limit on their usefulness in critical applications such as architectural photography. To combat light fall-off, you can use a centre filter. These are darkest in the centre and fully transparent at the edge. The filters are computed for a specific lens, such as a Schneider Super-Angulon 47mm f/5.6, and are very costly for what looks like a rather dirty piece of glass. The effect of this filter can only be partially simulated using image manipulation.

▲ **Thatched roofs**
Top left: The roofs of a village in Dorset, England, are nicely highlighted by backlighting from a low sun, but the hazy paleness in the upper part of the image is a distraction.
Top right: With a weak 1-stop gradient applied, the pale skies are reduced, but there is a loss of sparkle in the upper right-hand part of the picture due to unnecessary density.
Bottom left: With a stronger 2-stop gradient, the darkening of the skies is made more dramatic. This helps bring out the backlighting on the tree in the foreground. With dodging to preserve the backlighting, this image could be very acceptable.
Bottom right: The best result comes from using a 1-stop gradient rotated at angle to line up with the diagonal line of trees close to the background. This darkens the sky but leaves sparkle in the tree in the foreground.

TABLE COMPARING DENSITY, OPACITY, AND TRANSMITTANCE

This table shows that, with zero density, all 100 per cent of incoming light is transmitted, but as density increases, transmittance falls very rapidly.

DENSITY	OPACITY	TRANSMITTANCE %
0	1	100
0.5	3.2	32
1	10	10
1.5	32	3.2
2	100	1
3	1000	0.1

SPECIAL-EFFECTS AND CORRECTION FILTERS

Neutral-density and gradient filters may be regarded as those designed to cause minimal change to the subject. But filters can be designed to apply strong changes to the image. This ranges from adding overall colour in a variety of strengths, to creating gross distortions. Effects filters change images in a way that is all but impossible to simulate digitally, but they are also of very limited use.

POLARIZING

A polarizing filter consists of a polymer or plastics material whose molecules are arranged so they all lie parallel to each other – this is the polarization axis. The alignment of molecules is like a grating: it only allows light through that is vibrating in a plane that lines up with the direction of the molecules. So a polarizing filter allows through only light that is vibrating in line with its polarization axis. The amount of light it removes depends on the degree and direction of polarization of the incoming light. To use the filter, mount it on the lens and rotate the filter while watching for the desired effect.

Polarizing filters are best known for their ability to deepen the blues of clear skies, and they work most effectively when the camera is pointed at about 90° to the sun. It is an effect that cannot be imitated by software. Use with caution, though, for if you make the sky too dark, the underexposure will drain it of colour, giving you a black sky. Another use is the removal or reduction of reflections from the surface of glass, leaves, or water. You rotate the filter until the reflection disappears. Note that reflections from metal are not polarized. With wide-angle views it will not be possible to remove all the reflections.

A variable-density ND filter can be created by doubling up polarizing filters, provided the depth of the two filter rings does not vignette the lens. When their polarization axes are lined up, they pass the most light (already effective, at about 7x ND), but when their axes are crossed, they pass even less light.

CIRCULAR AND LINEAR TYPES

Linear polarizing filters were the first types to be used in photography and can still be used for non-reflex and older SLR cameras. However, cameras with through-the-lens metering and autofocusing systems – that is, all modern SLR and DSLR – rely on optical elements that pass linearly polarized light. If light entering the camera is already linearly polarized, it can upset the exposure or autofocus systems. Circular polarizing filters cut out linearly polarized light and so can be used to darken skies or remove reflections, but the circular polarized light it passes does not impair through-the-lens systems.

SPECIAL EFFECTS

Before image manipulation became commonplace, the easiest way to introduce special effects such as multiple images, starburst effects, distortions, and vignettes to photographs was to use special-effects

▲ **Colour target**
This colour target shows coloured squares in sequences of varying strength and hue, as well as neutral- and pure-colour sets, with a portrait of a girl to represent a light-skinned Caucasian.

▲ **Cooling 80**
Strongly blue filters convert tungsten light to look like daylight. The 80-series filters can be useful for digital work under weak tungsten lighting that is too red, to reduce image processing. However, these filters absorb 1–1⅓ stops of light.

▲ **Cooling 82**
Blue filters are regarded as cooling filters because the light feels like that of a cold day. Note that the colour temperature of such light is higher than that of warm light. It helps bring the warmth of evening light towards neutral colorations.

▲ **Warming 85**
A warming filter produces a well-tanned face and tints the neutral patches with an easily perceptible pale orange. Warm colours are enhanced, but differentiation between pale greens and blues is impaired.

▲ **Sepia filter**
A strong sepia filter turns flesh tones almost to warm neutrals, but the effect can be pictorially very useful in landscapes as well as portraiture. Note that green colours are strongly suppressed.

COLOUR COMPENSATION AND CONVERSION FOR DIFFERENT LIGHT SOURCES

Filters are named according to the Wratten series. The final column shows the exposure factors required.

FILTER	FILM EXPOSURE	KELVIN	ILLUMINATION	KELVIN	COLOUR	
80A	Daylight	5500 K	Tungsten house lights	3200 K	Dark blue	1 ⅓
80B	Daylight	5500 K	Tungsten photofloods	3400 K	Dark blue	1
80C	Daylight	5500 K	Tungsten clear flash bulbs	3800 K	Dark blue	1
81EF	Daylight	5500 K	Daylight shade under blue sky	7500 K	Straw	⅔
81D	Daylight	5500 K	Daylight shade/part cloudy	7000 K	Straw	⅓
81C	Daylight	5500 K	Daylight shade under daylight	6500 K	Straw	⅓
81A	Daylight	5500 K	Daylight overcast	6000 K	Straw	⅓
85	Tungsten A	3400 K	Daylight	5500 K	Orange	1
85B	Tungsten B	3200 K	Daylight	5500 K	Orange	1
85C	Tungsten	3800 K	Daylight	5500 K	Orange	1
82B	Tungsten B	3200 K	Tungsten lights 100W	2900 K	Pale blue	½
82A	Tungsten B	3200 K	Tungsten photofloods	3400 K	Straw	½
82C	Tungsten A	3400 K	Tungsten lights 100W	2900 K	Pale blue	⅔

filters. The disadvantages of using filters are that the original image carries the effects, the strength of effects is difficult to vary, and the strength or quality of effect may change with working aperture and focal length. Worse, a large number of filters has to be carried if many different effects are required.

COLOUR ADJUSTMENT

Coloured filters are useful for making adjustments to the way colour is reproduced by colour films. When using a digital camera, colour-adjusting filters have limited usefulness. However, if a strong effect is required, it may help to use a filter to reduce the need for post-processing. When using coloured filters on digital cameras, remember to set the white-balance control to a manual preset.

Light-balancing filters are used with tungsten-halogen light sources: they shift the effective colour temperature of the source to match the film's balance. They appear very pale blue (to match 3200 K sources for film balanced for 3400 K) or pale amber/pink in colour (for film balanced for 3200 K, to be used with 3400 K lights).

Colour-conversion filters enable you to use a film balanced for daylight under tungsten light, or vice versa – these are much more strongly coloured than light-balancing filters. Filters that enable daylight film to be used under tungsten lighting are strongly blue and have high filter factor of about 3.5x. Pink filters, which enable tungsten-balanced film to work in daylight, are lighter and more effective.

Colour-correction filters enable fine corrections or adjustments to be made to ensure colour-

▼ Multiple prism effect
A flat prism with six faces and a central hole can produce effects that are all but impossible to simulate using software. The exact nature of the multiple truncated views are hard to predict, which is part of the fun. Use filters designed for your type of lens.

transparency films record colour accurately. They compensate for slight variations in the lighting conditions or in the films themselves. They are available in a wide range of colours – all the additive and subtractive primaries – and in different strengths. To use them effectively requires the aid of a colour-temperature meter; using the eye for corrections is very unreliable.

In digital photography these filters are largely obsolete, particularly if final images are prepared from raw files.

CAMERA MOVEMENTS

In the vast majority of cameras, the lens is mounted so that it is set rigidly and permanently perpendicular to the film. This ensures the image is projected vertically into the middle of the capture surface. The only movement allowed is backwards and forwards along the optical axis for focusing. Varying the relationship between lens and capture surface, by changing the angle or position, enables three types of control over the image. You can vary the image shape, change the image's position, and you can control the depth of field. Tilt-shift lenses for SLRs allow a limited range of movements. Technical or field cameras are designed to allow a moderate range, while the monorail, view, or studio cameras offer the most extensive movements.

Cameras offering movements are constructed with four elements: a frame in front carries the lens (the lens standard); a frame at the rear carries the film holder or magazine (the film standard); third is a light-tight bellows or flexible connection between lens and film standards; and finally a flat base or narrow rail, carries the whole assembly. The lens standard can slide or be driven up, down, or sideways; the panels can also be tilted backwards and forwards. In the majority of technical or field cameras, the film is held in a fixed relationship with the base of the camera. In studio cameras, the film standard can also be moved up, down, and sideways, as well as being tilted.

TRANSLATIONS

Shift, slide, rise, and fall movements are all translations – that is to say, movements at right angles across the optical axis.

This enables you to control the placement of the image within the borders of the capture surface without having to move the whole camera or its support. This allows you to fine-tune your composition even after the camera position has been locked off.

Rise and **fall** refer to moving the lens or film up or down. Note that where the lens and film planes lie perpendicular to each other, the

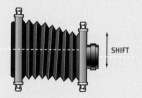

SHIFT

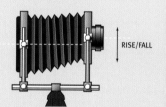

RISE/FALL

effect of a rise in, say, the lens standard is essentially identical to a fall of the film standard, and vice versa.

Shift or **slide** is a sideways movement that displaces the image to one side of the capture surface, in effect changing the composition.

One use is to avoid photographing yourself in a mirror, but in practice it is most used for fine changes in composition. With digital cameras, shift is excellent for creating a wide field of view from one position, using two separate exposures that are later stitched together.

ROTATIONS

Tilt and **swing** are rotations of the lens or film standards at an angle to the optical axis.

Tilts are rotations around a horizontal axis, like nodding – the standards point down or up. Tilts are most often used for controlling the place of plane of best focus, either to maximize depth of field, exploiting the Scheimpflug Rule (*see* opposite), or to minimize depth of field.

Swings are rotations about a vertical axis, like shaking your head

from side to side – the standards look to the left or right.

A rotation of the film standard alters the shape of the image as the image plane is no longer parallel to the object plane. This movement can be used to correct converging parallels, since the changes in shape can exaggerate or correct distortions in linear perspective.

When rotations of the film and lens standards are combined, the change in image shape is accompanied by a change in the position of the plane of best focus.

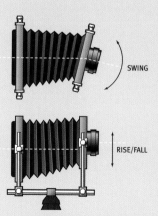

SWING

RISE/FALL

SCHEIMPFLUG RULE

Jules Carpentier appears to be the first to observe what Scheimpflug went on to patent: in the normal set-up, the plane cutting through the film, the plane cutting through the lens axis, and the plane of best focus all met – on a line at infinity.

Now, if the film plane is tilted, it will intersect with the plane cutting through the lens axis: this is on a line close to the camera (*see* right). The plane of best focus then also meets on the same line.

In practice, the Scheimpflug Rule says that you can tilt the plane of best focus by tilting the film or lens standard so that the three planes meet on the same line. If change of image shape is not desired, it is easier to tilt the lens standard, but if you do this, a shift movement may be needed to keep the image centred.

The Scheimpflug Rule helps set up the camera to maximize depth of field by placing the plane of best focus to fit the orientation of the subject.

Focus on the main subject, tilt the lens standard forward, and observe the plane of focus as it tilts backwards from vertical. The technique is obviously best suited to subjects that are relatively flat, such as a tabletop or field in a landscape, and can be rendered in full depth of field even at maximum aperture. The rule can also be applied to, say, the side of a building seen at an angle.

Conversely, a backward tilt – the lens pointing upwards – causes the plane of best focus to cut through the subject so there is minimal depth of field. This effect is useful in food and portrait photography. An opposite tilt minimizes depth of field for special effects – something used, for example, in portraiture.

▶ **Backward tilt**
Even with a 24mm lens at $f/4$, depth of field is unnaturally limited in this image. This is because 8° of reverse tilt was applied, using the full capacity of the Canon 24mm TSE lens.

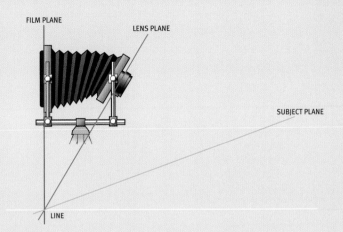

FILM PLANE
LENS PLANE
SUBJECT PLANE
LINE

▲ **Scheimpflug rule**
Assuming the film plane drops vertically, it meets the subject plane under the camera. You obtain focus along the subject plane if you tilt the lens so its axis crosses the common line of intersection.

Verticals in the subject appear vertical in the image because the capture surface is also vertical – possible only because a shift lens was used.

ANALYSIS: WORKING WITH MOVEMENT

The combination of a 35mm SLR or DSLR together with a tilt-shift lens is a potent one for a wide range of photojournalism, architecture, and landscape work. While a tripod is the way to get the best-quality results, it is still practical to use the combination on the hoof, for mobile photography. This picture of a newly refurbished mosque was obtained by climbing to the first floor and resting the camera against a pillar. With a downwards shift, more of the foreground could be seen without tilting the lens downwards, and a couple of degrees of tilt greatly extended depth of field, despite a using a large aperture.

Straight lines in the subject are rendered with minimal distortion when, as in this case, a highly corrected, fixed focal length lens was used.

The area of the image below this man was revealed by shifting the lens downwards to capture more of the foreground without tilting the camera downwards.

The lower corners are darkened because the downward shift of the lens is approaching the edge of the image circle, with marked light fall-off.

The many sets of converging parallel lines help give the impression of a much larger space than was in fact the case.

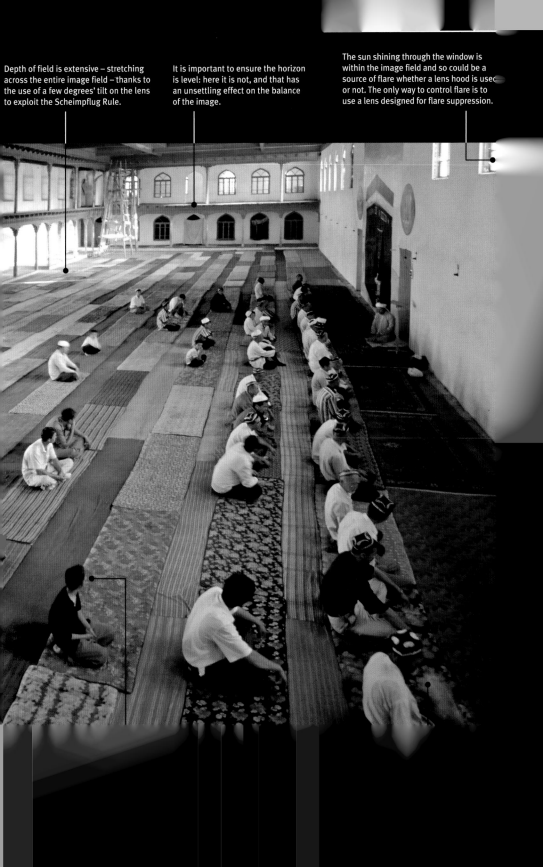

Depth of field is extensive – stretching across the entire image field – thanks to the use of a few degrees' tilt on the lens to exploit the Scheimpflug Rule.

It is important to ensure the horizon is level: here it is not, and that has an unsettling effect on the balance of the image.

The sun shining through the window is within the image field and so could be a source of flare whether a lens hood is used or not. The only way to control flare is to use a lens designed for flare suppression.

PANORAMIC PHOTOGRAPHY

A panoramic photograph is a scene projected onto a curved surface by a lens that rotates or swings around a vertical axis. The movement of the lens allows a wider view to be recorded than can be recorded with a stationary lens. Lines that do not go through the centre of the image are rendered curved, but objects at the sides are not projection-distorted.

PANORAMA EQUIPMENT

◀ **Noblex camera**
The range of Noblex film cameras uses 35mm and 120 film. The model shown covers an angle of view 146° over a film format measuring 50 x 120mm, with a shutter time range of 1/15sec to 1/250sec.

▶ **Nodal Ninja**
This effective and relatively inexpensive design of panoramic head allows a wide range of cameras and lenses to be mounted, and allows cameras to be turned onto their side for portrait shots.

▼ **VR head**
This complicated-looking head enables a wide range of equipment to be used for creating virtual-reality images with high precision.

▲ **Panosaurus**
An inexpensive panorama head suitable for lightweight cameras is the Panosaurus. It allows a range of settings to accommodate cameras weighing up to 0.9kg (2lb).

Certain "panoramic" cameras keep the film flat and use fixed lenses – such as the Hasselblad XPan, Fuji 617, or Linhof Technorama – by cropping their view to a wide, narrow format, so the result appears to be panoramic. These cameras do not cause straight lines in the image to be curved.

SWING PANORAMA

Panoramic cameras such as the Noblex or the Widelux swing the lens around an axis defined by its entrance pupil. As the lens turns, the shutter opens a slit that traverses the film – which is curved inwards – to expose it. Angles of view of around 140 x 55° are achieved on frames measuring 24 x 60mm. A Seitz camera rotates the film and the camera at the same time: this enables views of 360° to be obtained. Seitz also produces a digital camera that gives 360° views. As a result of the lens/film rotation, the images appear to lie on the inside of a cylinder, which means they are cylindrical and, strictly, should be viewed as if rolled up.

STITCH PANORAMAS

With digital photography, the commonest method for producing panoramas is to take a series of pictures and stitch them together. There are two main types: the cylindrical – used primarily in stills photography – and the spherical, which is used for virtual-reality images.

The procedure for creating cylindrical panoramas from individual shots consists of three parts. First, determine the axis of rotation for the shots, that will yield images with no parallax – for example, where their relative positions do not change when the lens is rotated. If overlapping images exhibit parallax, objects at different distances appear to move between shots, which makes it impossible for the software to overlap cleanly, causing blurs in the blend. Parallax is minimal at long distances and greatest with nearby objects.

The setting for zero parallax corresponds to the axis through the entrance pupil of the lens and can be located by turning the camera to one side and back again. If two objects – one nearer to you than the other – appear to move relative to each other, you have not found the axis of rotation.

Attach the camera equipped with a normal to wide-angle lens onto a panoramic head on a tripod and carefully level off to ensure the camera easily rotates horizontally or vertically – depending on which orientation you want your panorama to be. Experiment with the settings until the axis of rotation intersects the zero-parallax point. Determine the camera exposure, and set to manual so that exposure is constant throughout the sequence. Next is the capture itself: aim at one far side of the intended

Spherical panorama samples
These images of the Korean Bell of Friendship in Los Angeles, California, show the stunning possibilities given by virtual-reality views of spherical panoramas, as created by Carel Struycken. The views look up, level, and to the left. The only way to fully appreciate these images is to explore them on screen. Notice that if the view is too wide-angle – as in these samples – there is an error in perspective due to viewing the image from too far away.

panorama or at the centre of a 360°, focus, and expose. Turn the camera to one side so that the new framing overlaps the old by at least a third of the width, and expose. Some panoramic heads offer click stops matched to the lens field of view to allow rapid operation. Wide-angle lenses require fewer shots to create a panorama but cause more distortion than a normal lens.

Finally, the images are stitched together using software that identifies common elements of images and overlaps them with minimal joins. Modern software is able to compensate for errors of framing, so it is possible to photograph handheld and still achieve panoramas of acceptable quality.

SHIFT PANORAMA

Panoramas can also be created by shifting the camera with sideways movement parallel to the subject, taking shots at each position. The panorama can be as long as you like. This type of image has the advantage that the camera lens does not have to aim precisely horizontally, and the result is free of exaggerated

shapes or variations in magnification. It is also possible to get away with shooting handheld: simply point the camera at the scene and take one picture, then slide sideways a small distance, ensuring the view of the second shot generously overlaps the first, and take another, and so on. Finally, stitch the results together using stitching or general-purpose image-manipulation software.

▼▲ Shift-panorama shot
The shift-panorama technique – in which the camera is shifted parallel to the subject between each shot – is ideal on boat trips, where the passage of the boat in calm water is reliably in a straight line. Simply take one picture, as this shot of the Whanganui River, New Zealand, and a little distance later, take another – then join them together (as below).

PHOTOGRAPHY IN CHALLENGING CONDITIONS

Photography has worked successfully in highly challenging conditions, such as extreme cold and heat, from its earliest days. Cameras have gone into space and into the depths of oceans. The key is that cameras can work anywhere in which they can be protected from the environment. This section summarizes key issues and advice for maintenance.

PHOTOGRAPHY FROM THE AIR

The main technical challenge when photographing from aircraft is overcoming vibration. Set short shutter times to minimize camera shake caused by the aircraft, and use image-stabilization lenses if possible.

Generally, normal to telephoto lenses give the best results. Another common problem is finding a clean window to shoot through. When flying in a propeller-driven aircraft, remember you may not be able to see the propeller, but it can be easily caught in the picture.

For tethered aerial photography, modern compact autofocus digital cameras are ideal due to their size and weight. In addition, their large capacity for images enables you to photograph almost without limit, without having to download images to make room or change cards. Digital cameras can be attached to a kite to take local aerial photographs. Their electrical connections make them easy to operate remotely via radio signals, while some models offer infrared remote releases.

UNDERWATER

The best-known specialist underwater camera is the Nikon Nikonos series. Their extremely sturdy construction makes them invaluable in any hostile environment. The majority of the cameras use an underwater housing. This consists of two plastic shells that close onto, and squeeze, an O-ring: it is vital to keep the O-ring clean and free of grit.

Digital cameras with a large-capacity memory card can capture hundreds of images on a single dive – far

▲ Propeller fault
A view ahead in a light aircraft is marred here by the propeller being caught in frame. It was impossible to photograph through the movement and not catch one of the propellers.

◄ Aerial survey
Photographs from a light aircraft enable you to fly low for good records of land use, such as this felling and clearing activity in New Zealand's South Island.

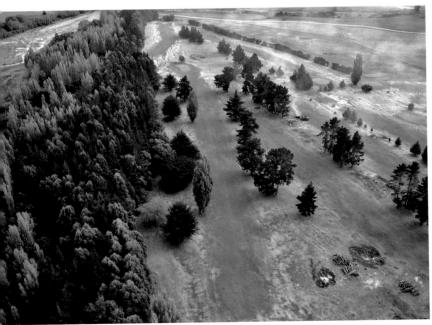

more than any film-based camera. However, wide-angle views are limited as seawater adds its own focal-length factor of 1.3x, unless compensating optics such as a negative-power dome over the lens are used. When using compact digital cameras, use lenses offering true wide angle.

Water adsorbs light selectively: it appears green because it absorbs reds, with adsorption increasing with depth. At 5–10 m (16–33ft) below, reds and oranges are absent and full colour correction is not possible. From 20m (66ft) below, only blues and greens are visible, with greens disappearing by about 30 metres (100ft)below. The best way to provide accurate colour is to use flash units designed for underwater photography.

COLD CONDITIONS

Very cold conditions attack photographic equipment in three ways. Even moderate cold – around freezing – reduces the power or capacity of batteries. You may need to keep NiCd-type batteries warm to work at all, and while Lithium-ion batteries tolerate cold conditions, you cannot use them for long.

Moving from cold conditions to warmth can cause water from warm air to condense onto the equipment, which may cause malfunction at worse, and at best, need a long time to dry out. When moving from cold to warm conditions, enclose the equipment in plastic bags or an airtight box and allow them to warm up before removing. Even moderate temperature changes, such as moving from an air-conditioned hotel to tropical temperatures outside, can cause condensation.

Mechanical threats are caused by extreme cold: this can thicken lubricants, which clog up the mechanism, make film brittle so that it cracks or tears if wound on too quickly, or cause controls to seize up or become difficult to move.

HOT CONDITIONS

Modern cameras can work in higher temperatures than can the majority of photographers. Dust can be a problem in many hot countries, which can scratch film or settle on sensors.

Always change SLR lenses with the camera turned off in a sheltered spot out of sun and wind. In extreme heat, film can deteriorate rapidly – colour films lose contrast and balance, so ensure they are stored in cool, dry conditions.

In high humidity, mould grows freely on film and equipment, while moisture can cause electrically powered equipment to malfunction. It is essential to keep all equipment in waterproof containers, with interiors kept dry by using packs of silica gel.

LONG-DISTANCE PHOTOGRAPHY

Spotting scopes are high-magnification telescopes made relatively compact by using binocular-like

prismatic systems. Typically offering a magnification range of 20x up to 60x, they are used for target spotting and birdwatching, as well as wide-field astronomical observation.

Spotting scopes are easily adapted for use with compact digital cameras, using rigs that hold the camera to the eyepiece or using intermediate optics that connect the camera directly to the scope, thus creating a "digiscope".

Digital cameras are easily fitted to spotting scopes now widely used for birdwatching and plane spotting and also suitable for astronomy. A simple adaptor is all that is needed to connect a digital camera to the scope, which turns it into a very powerful instrument.

The lightness and freedom from vibration of digital cameras compared to film cameras are also two of their main advantages.

EQUIPMENT

▲ **Underwater camera**
Specialist underwater cameras, such as this film-using model, are excellent not only for the rigours of open-sea diving, but with suitable lenses, they will work well through a range of challenging conditions.

▲ **Digiscope support**
Various designs of adaptor are available to attach a compact digital camera to a spotting scope, aligning the camera to the optics, sometimes via adaptor optics. The resulting arrangement may be awkward to use in the field.

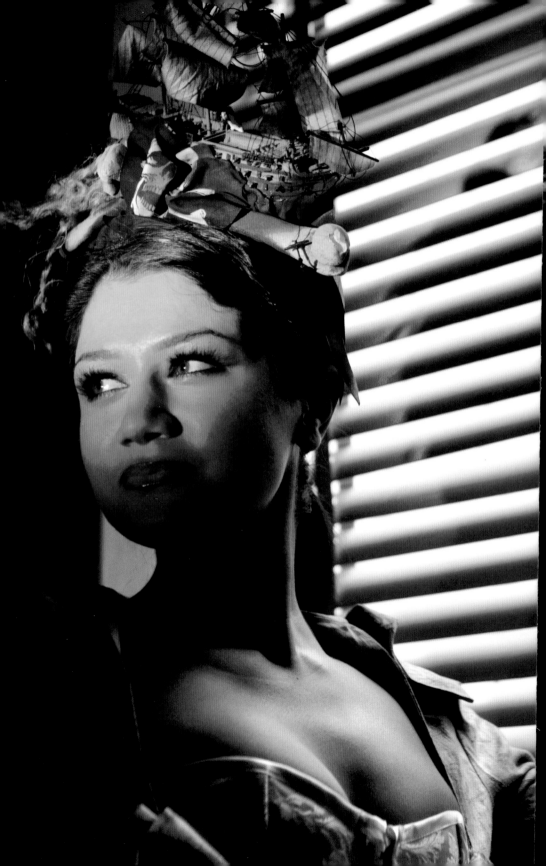

Manipulating light

PRINCIPLES OF LIGHTING

CREATING THE STUDIO

ANALYSIS: WORKING WITH MULTIPLE LIGHT SOURCES

LIGHT MODIFIERS

LIGHTING SET-UPS

ACTINIC LIGHT AND EXPOSURE

PORTABLE FLASH

USING ELECTRONIC FLASH

PRINCIPLES OF LIGHTING

As photographers we respond so rapidly and almost instinctively to changes in lighting that it may come as a surprise to realize there is a systematic way to understand and use light. Indeed, a systematic approach is what you need if you wish to work efficiently with man-made light. It helps to visualize the effects you wish to obtain before you arrange any lights – very often these are effects that occur in real life. With the visualization, you can anticipate the kind of equipment and set-up you will need. You will also need to consider the 11 key characteristics of the lights and their set-up.

QUANTITY
The power or brightness of light falling on an object being photographed sets the overall brightness, which in turn determines the correct exposure for the scene. An equally important consideration, however, is the relationship between any other light with the quantity of light on the object (*see also* Ratio, page 182). In a well-controlled studio, such as one with black walls, there may be no light at all apart from that from the lamps being used. But typically there will be some light reflected from walls and reaching the subject from other sources, such as windows. All of these light sources integrate to determine the character of the lighting on the object.

DIRECTION
The direction of the light affects two independent elements of your photography. The most important is the way the direction can hide or reveal textures, shapes, and form according to the angle the light falls on the subject's features. In general, the more obliquely the light falls to the subject, the longer the shadows, and the result is the subject is shown in strong relief. Secondly, the direction of the light affects photographic controls. One is the metering – light from behind the subject is more difficult to meter for than light from behind the camera or light from the side (*see also* Position, page 183).

QUALITY
The quality of light is determined by the degree of divergence of its rays. This ranges from tight bundles of rays travelling in the same direction – such as from a spotlight – to disorganized rays that travel in every direction – such as those of a dull day or of a large interior lit with light from many windows.

Tight bundles of light are called "hard" because they cast hard shadows and bright reflections, creating clear highlights. This usually results in high-contrast lighting. Disorganized light, called "soft" or "diffused", creates dull highlights and soft reflections, casting soft shadows or none at all. This results in low-contrast lighting. Quality is determined by the size of the source: hard quality comes from a small source, such as a bare bulb; softer quality comes from larger sources, such as diffuser panels.

▶ **Lighting interiors**
The lighting of this spa was achieved through the careful balance of daylight, interior lights, and, crucially, three floodlamps placed out of shot and aimed to bring light into dark areas. Two lamps were behind the camera to light the curtains and foreground, and another was placed behind a wall in the distance to light a door.

DISTANCE

The distance between a light source and the subject affects three factors. The most obvious is that as the source is more distant, the brightness of light on the subject reduces rapidly. This is commonly known as the Inverse Square Law (*see* page 47), which only applies to a light source that radiates equally in all directions. Photographic lighting rarely radiates equally in all directions; instead, the light may be concentrated into a tight beam or greatly diffused through a soft box. As a result, diminution of light with distance varies considerably according to the luminaire and light shaper in use.

Another effect is that, as the light source is further away from the subject, its rays appear to originate from a smaller source and therefore appear to be tighter, resulting in harder light. This is usually obvious only where there is no other light source or reflective surface present.

SHAPE

The shape of the light illuminating a subject may be spread out to encompass it, or it may be confined to a small area. If it is smaller than the subject, the margins of the light may be clearly demarcated – as with a spotlight – or it may be fuzzy. Even if the light appears to be evenly spread over the subject, it is usually brighter at the centre of the beam, compared to the edge, where it is obviously weaker. This, too, is part of the shape of the light.

COLOUR

The colour of the illumination is crucial to the quality of the image's colour reproduction. Colour temperature correlates the temperature of a standard source with that of your light. A light source with high correlated colour temperature, such as 6500 K, produces a bluish-white light, while one with a lower correlated colour temperature, such as 4500 K, produces a red-yellowish light. Digital cameras can compensate automatically for variations in colour temperature to ensure accurate colour reproduction. When you are using colour film, accurate colours call for films matched to the lights or the use of colour-correction filters.

The measure of ability of illumination to reproduce colours accurately is called the colour rendering index (CRI). A full spectrum covering the range from red to indigo ensures good reproduction, even if some colours dominate: the light is said to have a high CRI. But a spectrum with gaps, such as a deficiency in red, is likely to cause poor colour reproduction, since any red colours in the object will be rendered too dark; it is said to have a low CRI. The CRI of daylight, for example, is nearly 100; that of sodium-vapour street lamps is around 25. The green deficiency in vapour lamps results in certain greens and blues appearing nearly black under these street lamps, however bright they may be.

▼ **Single lamp on location**
A single lamp producing hard light may seem limited in scope, but by varying its distance from the subject, and through control of its balance with daylight, a good range of possibilities can be created. Here the photographer is being filmed photographing a horse with a portable tungsten lamp. Compare this with the image on page 39.

NUMBER

When creating a lighting set-up, it is tempting to use many lamps to create excitingly varied effects. If you do that, you soon realize that each light causes the subject to cast a shadow in a different direction – as many shadows as lights. Basing our lighting on natural light, the norm is to light a subject so there appears to be only one main light, casting one shadow; all the other lights supplement the main – even if there are several – but none of them is allowed to cast its own shadow. However, modern lighting styles encourage the use of multiple lamps.

RATIO

Where you have more than one light source, you will be working with their relative strengths to create the lighting effect best suited to your subject. You may balance a weak flash against the sun, or use two equally bright lamps, in which case, simply moving one lamp further away from the subject has the effect of weakening its effect on the subject. Lighting ratios are measured by the number of stops difference between the brightness of the lamp. If one lamp is 1 stop brighter than the other, your lighting ratio is 1:2; a 2-stop difference gives a 1:4 ratio.

High ratios create dramatic, emotional lighting effects with high contrast and deep shadows in the image. Low lighting ratios create flat, open lighting, with low contrast and open shadows.

STABILITY

In practice, we assume our light sources produce stable output – surely the power and colour is the same at the end of the session as it is at the start. In fact, it is good practice to meter light output

◄ Focused light –
hard shadows
**◄ Focused light –
hard shadows**
Tightly focused light delivers
high contrast and clearly
defined, deep shadows. Even
with an inherently soft subject
such as the female body, this
type of light is hard and harsh.
Here, hard light has been put
to work to create contrasts not
only in tone, but also in texture
and shape: the details of the
fan's shadow would be lost in
softer light.

▼ Soft light – soft subject
Light diffused through a large
soft box placed near the
subject provides the softest
possible lighting with barely
any shadows and minimal
modelling. The image relies
entirely on eye contact and
tonal variations due to colour
to outline features.

throughout a long session, even where there is no
change in lighting set-up or settings, since lamps at
the beginning and near the end of their working life
can change characteristics. If a scanning back is used,
the lamps must be very stable, and specially designed
ballasted lights should be used. Flash lighting produces
the most repeatable results, but beware in some units
that the first flash after a reduction in the power setting
may be higher than indicated on the unit.

POSITION

The exact position of the light source relative
to the subject determines not only the direction
of the lighting. The position of the light may cause
problems for the camera operation – a spotlight
shining directly into the lens may cause flare. A
change of position may solve the problem. Try
placing the spotlight so that it is obscured by the
subject's head. In the majority of cases, the lights
and lighting stands in use are positioned to be out
of shot. Of course, lighting equipment can be
deliberately left in shot – in which case, they function
both as luminaires and props.

SURROUNDINGS

Although the surroundings and background are not
light sources as such, they become secondary light
sources if they reflect any stray light back on the

subject. This is why a well-controlled studio has its
walls painted black or is draped with black curtains.

On the other hand, the surroundings can be
exploited for their ability to reflect light – for example,
when a flash unit is pointed to a wall or ceiling for
bounced flash (*see* page 197). The surroundings not
only contribute reflected light – which may fill in
shadows – but the colour of the surroundings will also
tint the reflected light. Therefore, if the thought of
black studio walls fills you with horror, they should
at least be painted a neutral white or light grey.

CREATING THE STUDIO

One of the most desirable of facilities in all photography is a dedicated studio. It provides a permanent space for photography, with minimum effort to set up. But such a space is extremely costly: for professionals, the studio space usually accounts for the greatest portion of the overheads. However, the beauty of modern equipment is that you can easily turn any space into a studio. One or two lights, some pieces of paper, and a few clips can be enough to photograph enough still-life studies for an entire book.

CONTINUOUS LIGHTING

One of the key decisions is your choice of light source. Luminaires, which use incandescent or gas sources, put out an effectively continuous flow of light. Flash, of course, pushes its light out in a very brief burst.

The chief benefit of continuous lighting systems such as TH (tungsten halogen) or HMI (hydrargyrum medium-arc iodide) lamps is that you can see what you are doing: every adjustment and movement you make is visible, and it is easy to fine-tune positioning. For this reason, continuous lighting is favoured for elaborate portrait lighting. Another benefit of the continuous light is that you can make sequential pictures as rapidly as you like, although the rate may be limited by the need for longer exposure times.

The down sides are that TH lamps can produce enough heat to make it uncomfortable for a model. At the same time, the lamp heads become dangerously hot to touch. Another problem is that, because of the heat output, it is not possible to mount diffusers on the front of the lamp, so soft lighting effects have to be obtained by bouncing the light off reflectors or pointing through self-standing diffusing panels – both cumbersome solutions. HMI lamps are four to five times more efficient than equivalent TH lamps, but they are very costly compared to TH luminaires.

The greatest problem with continuous-source luminaires is the variation of colour temperature with their power. It is impossible to maintain the colour of TH lamps as they dim. They become progressively more red – that is, their colour temperature drops from, say, 4000 K to 3000 K or less. In fact, TH lamps also change colour in the course of their life. Some HMI lamps can be dimmed to about 40 per cent of maximum using very costly ballasts, but their colour temperature is rated at a useful 5600 K, or daylight equivalent.

FLASH LIGHTING

Electronic flash units are most commonly used for today's photography. There are two types. Monobloc designs integrate the power pack, controls, and lamp head together. These are compact and portable but can be top-heavy on stands. Studio lights use floor-standing power packs that offer greater power, more rapid recycling, and easier control.

Flash lamp heads can accept a very wide range of light shapers and diffusers, their output is highly adjustable and stable in colour temperature, and the short flash duration stops movement blur. However, flash units need to recharge before being able to give another flash. This slows down operation. A typical studio flash will limit you to just one or two exposures per second, and even that cannot be sustained without danger of overheating.

Another disadvantage is that you cannot see the exact effect of the flash until an exposure is made. It is easy enough to make an exposure on a digital camera and preview the image on the camera screen, but only a rough judgment is possible.

Studio lamps, and some portable units, use modelling lights in conjunction with the flash. These are normal incandescent bulbs whose brightness can be set to be proportional to the power of the flash. In a studio, modelling lights can give a fairly reliable preview of the relative balance of different units and the accuracy of their aim, but of course modelling lights do not indicate the actual flash light level.

◀ **Impromptu studio**
A modern bathroom, with its white walls and pastel furnishings, is easily turned into a studio because the addition of a single studio lamp can turn the room into a mixing box, with light bouncing onto the subject from every wall. The result is beautifully soft but radiant lighting.

▼ Sekonic L308S meter
Professional meters such as this model provide ambient, flash, and mixed lighting, as well as multiple flash measurements with both reflected and incident light readings, all with digital read-outs and the ability to set a wide range of ISO with good abilities in low-light conditions.

▲ Monobloc design
The monobloc flash, such this model from Elinchrom, builds the power unit, flash head, and controls into one body. Overall it is very compact, uses fewer cables, and offers a less costly instrument than those using separate power packs.

▼ Light table
An elaborate light table, such as this model from Elinchrom, will serve a product photographer for an entire career and beyond. It is highly flexible, big enough for a large majority of products, and encourages the photographer to produce the highest-quality work.

▼ Kobold HMI
Modern HMI units such as those made by Kobold offer rugged construction – some are substantially weatherproof and work from compact and portable ballasts, which can dim to 60 per cent. This unit has optional barn doors attached to the lamp head.

▲ Portable background
Portable backgrounds, such as this model from Sharpics, offer a convenient solution for the occasional tabletop set-up. Outfits including lamps and clamp for a compact camera may also be obtained. If ordering electrical equipment from abroad, ensure that it is compatible with your local electricity supply.

EXPOSURE METERING
Flash meters ignore steady light levels and measure only a sudden rise in brightness, to calculate a sum of the total light output from the flash. Flash meters may measure only the flash exposure; these are adequate for the majority of tasks. The more capable models can evaluate the ambient (continuous) light as well as the flash exposures. Some models connect by cable to trigger and measure the flash, while other models can measure both by remote triggering.

You can substitute the review of a digital picture for a flash-meter reading. Ideally, the camera is tethered to a computer so you can review images on a calibrated monitor. Otherwise, ensure you view the image and its histogram to judge exposure. But note that many cameras base the histogram only on the display pixel, which could lead to inaccuracies.

BACKGROUNDS AND SETS
Special backgrounds for photography are not always essential. It is often possible to force a plain wall of a light colour to vary from white to grey, or a wall of dark colour to vary from grey to black, simply by controlling the balance of lighting and exposure. Of course, studio backgrounds are useful for busy photographers who need to provide services – such as portraits and product shots – quickly and with minimum set-up time.

For portraiture, you can buy painted backgrounds and rolls of paper in different colours. You will need stands to carry the backgrounds; some squeeze-fit between the ceiling and the floor. For work at a smaller scale, such as photographing objects for online auction, you can buy a simple white background, a light tent, or elaborate light tables with adjustable tilt and height.

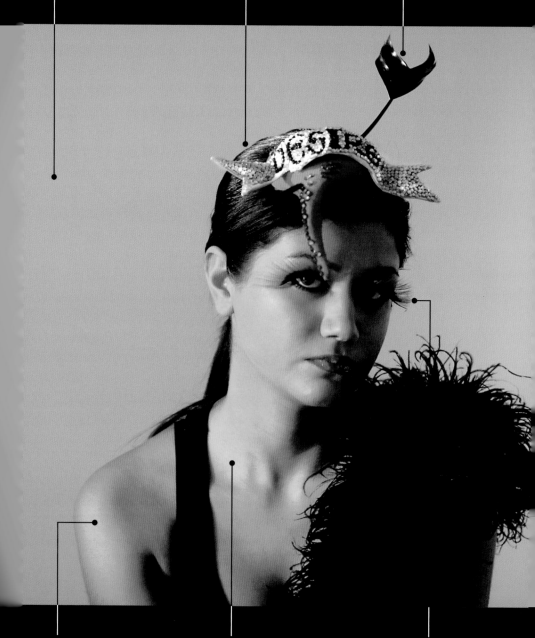

The white wall is softly lit by window light. It appears bluish because the white balance has adjusted for the warmth of the tungsten lights.

It was essential to bring out the sparkle of the stones in the hat. For this, the lamp was tightly focused and just skims the top of the model's head. This has the side-effect of giving an attractive sheen to her dark hair.

The tightly focused light from the lamp on the left-hand side is picked up by highlights in the arrow's feathers.

The light from the left was adjusted to model the skin and curves softly, to ensure it looks attractive but without drawing attention away from the hat. One may wish to clone away the stray wisps of hair.

Care was needed to ensure that the model's skin did not become too shiny. It was powdered to dull reflections, and the lighting was dimmed and angled to avoid highlights developing.

This shot was selected because the stuck-on eyelashes just catch the light, which brings a touch of colour into the shadow side of the face.

It is important to the feel of the shot that the gradation from the lamp to the window light is as smooth as possible: this was achieved by using a Dedolight, which gives the cleanest and smoothest of light throws.

ANALYSIS: WORKING WITH MULTIPLE LIGHT SOURCES

Lighting effects that look simple may need multiple lamps and extreme care in positioning and balance to achieve the look. For this fashion shoot, the hat designer wanted a background that could take graphics and text but one that was not entirely plain. At the same time, the emphasis had to be on the hat – a heart called "Desire" with an arrow through it. Three lamps plus daylight were used. One was on the left and tightly focused on the hat to bring out the glitter. Another on the left softly lit the model, while the third, on the right, cast a soft pool of warm light on the wall that gradated to cool whites from light let in through the window.

The broad, even areas of tone are ideal for accepting added graphics and text but also help push the model forward to our attention.

Great care was taken to avoid a "hot" spot of brightness that could have distracted attention from the face and hat. For this, the spot was defocused and shone on the wall at an oblique angle.

LIGHT MODIFIERS

The quality of natural light from the sun can vary from the hardest direct light – casting pin-sharp, hard shadows – to the softest glow with hardly any shadows. The function of studio light modifiers is to simulate this range of quality in the studio in a convenient and repeatable way.

While many effects can be improvised by fixing aluminium foil to sheets of cardboard with sticky tape, for convenience and professionally reliable results, and where quick set-up is needed, the best solution is to have a stock of different light modifiers. These fall into three groups: reflectors, which gather light and bounce it to the subject; barn doors and goboes, which shape the light; and diffusers, which force the light to emit from a larger area.

REFLECTORS

The light sources without built-in reflectors, such as flash tubes and the majority of incandescent and discharge bulbs, emit light in nearly all directions. The role of a reflector is to gather all the light that is emitted backwards and sideways in order to reflect it towards the subject. The design of the reflector then determines the quality of light emitted by the luminaire. If the reflector's surface is matte, light will be softer than if it were polished shiny. The surface of the reflector can be dimpled to soften light, or it could be arranged in rings for a harder effect. The larger the reflector, the softer the light.

One type of reflector is the umbrella, also known as a brolly. The umbrella is fixed in front of the flash,

▼ Basic outfit
A basic electronic flash outfit, such as this set from Elinchrom, can meet 90 per cent of photographic needs. The soft box (*left*) is excellent for small product, and portraiture, and the brolly (*right*: silvered one erected and white folded) provides soft sparkle for portraiture and is capable of filling a small room. All items fit into a portable case.

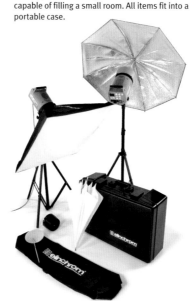

▲ Deflector
The inside of a typical soft box contains a deflector such as this, or a diffusion panel, with the metallic interior surface. This will be concealed when the soft box is fully assembled, with the addition of the large diffusion panel.

▲ Snoot and honeycomb
The combination of a snoot – which blanks off all peripheral light – and a honeycomb grille provides an intense spot of light. It is not as hard or controllable as a spotlight but is an inexpensive alternative where focusing spots are not needed.

▲ Large bowl reflector
A large reflector with a diameter approaching 1m (3ft) can produce an excellent balance of directional light with good modelling abilities, but shadows are likely to be too hard for portraiture without some fill or balance.

▶ Bowl reflector
Smaller bowl reflectors produce relatively hard light but are efficient light sources that are excellent for bouncing off umbrellas or walls.

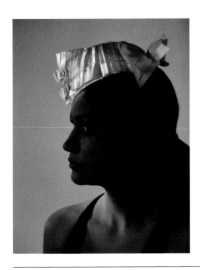

◄ **Light shaded**
For this image, the window light was cut off and replaced with a very weak lamp on the wall. The light on the face has been shaded so that light falls mainly on the hat. The third lamp just grazes the shoulder and neck of the model for a gentle and flattering glow.

► **Full light**
The model is lit with two lamps: one to the back to pick out the hat, one on the face, and some window light on the wall. The modelling is effective enough, but the face and hat compete with each other for attention.

which is pointed away from the subject: the light from the flash is bounced off the brolly, which, being a very large and irregular reflecting surface, gives a pleasantly soft light. If the brolly is metallic, the light is harder than from a brolly that is plain fabric. And if the metallic coating is silver, the light is cooler or neutral. A golden coating would give a warm light that has the effect of tanning a portrait sitter's skin.

SHAPERS
Essentially, a light shaper limits the spread of the light. The way it does so determines the quality of the edge of the beam of light: it may be hard or soft, it may be straight, or it may curve to wrap around the subject or be uneven. The possibilities are endless. Light shapers are most conveniently held at the lamp – this gives the softest shadow. But a light beam can be shaped by casting shadows using cards or materials. The closer you move to the subject to cast the shadow, the sharper the shadow.

Barn doors are the commonest light shaper. They consist of four movable flaps that have no effect when opened flat out but increasingly restrict the light beam as they are folded further in – finally blocking all light. Barn doors are also useful as a surface for taking gaffer tape to stick on gels or diffuser paper in front of the lamp, keeping these away from the hot housing.

Another type of shaper is the honeycomb, which is a grille-like cover for lamp heads. The sides of the grille are deep and black, so they cut out side reflections and off-centre rays of light. The result is a channelling of light into a beam – wide and harder than from a reflector, but not as hard as from a spotlamp.

The focusing spot is highly efficient at gathering and focusing light onto the subject. Good spots can focus from a small, hot circle of light to a broad beam with no hot spot and smooth light distribution.

Goboes are special shapers that look and operate like stencils: they let light through the cut-out areas. They work only with specially designed focusing spots to project sharp shadows – to simulate a window frame or leaves, for example.

DIFFUSERS
The advantage of working with light indirectly – that is, by interfering with the light beam as little as possible – is that you make the most of the available power. Diffusers, usually in the form of a soft box, interpose diffusing material directly between the light source and the subject. There is considerable loss of light, but the gain is a softness very similar to that of light from an open window on an overcast day. Soft boxes are tent-like structures that consist of a light nylon frame over which is stretched material with a reflective inside surface. The front is covered by a diffusing material. There is often a second diffuser close to the lamp. The larger the soft box, the softer the lighting effect. A single soft box may be sufficient for a very wide range of subjects – from products, to portraits.

REFLECTORS
Any surface can be turned into a light source simply by shining a light onto it. But the surface adds its own characteristics to the light. Strongly coloured surfaces will tint the reflected light. Shiny surfaces will give a harder, brighter reflection than textured or matte surfaces. Larger surfaces produce a softer effect than smaller ones. In the studio, reflectors are often placed on stands or held on articulated arms. They are ideal when placed facing the main light as the light can be reflected back into the shadows, while there is no danger of causing a counter-shadow.

LIGHTING SET-UPS

The best way to learn about how to light your subjects involves two steps. The first can be done anywhere, at any time: analyse the lighting wherever you are. Check the main source light – whether it is the sun or a lamp indoors or in a built environment. Examine the surfaces that may be reflecting light into the shadows or absorbing light to make it darker. Look for the secondary light sources, and evaluate their effect on the scene. Work out how each element contributes to the whole; check out the source of specular highlights. Think about how you might recreate the lighting effect in the studio. Another exercise is to look at photographs – shots of cars, portraits, etc – and try to work out the lighting used.

The other part of learning is, of course, to work with lights yourself.

ONE-LAMP SET-UPS

You do not need a photographic studio to carry out very successful photography. Using just a desk lamp and pieces of paper, you can create product shots of such high quality that eBay clients will think they are catalogue pictures. The great German editorial photographer Reinhardt Wolf once photographed an entire coffee-table book on Japanese food using two handheld flash units.

TWO-LAMP SET-UPS

The addition of an extra lamp brings huge new potential to the lighting but also carries a few problems. The reason is that shadows arrive with any extra light sources: these need to be carefully managed or their appearance will disturb any attempts to

▲ **Single lamp – hard light**
A single lamp equipped with a small bowl reflector produces a hard light, as seen in this portrait with its defined shadows and specular highlights. Such a light is good for chiaroscuro effects – in which textures are defined through distribution of shades of dark and light. Although the model is not near the background, the hard light creates a gradient.

▲ **Single lamp – medium**
The same lamp using a small soft box produces a relatively soft light, which, while it does not cast hard shadows, is still capable of defining texture and shape, as well as bringing out colour. Notice that with the softer light, the lighting on the background is more even than that from the harder light source.

▲ **Single lamp – below**
Lighting a subject from below always brings drama into the picture. This is probably because such lighting is intrinsically unnatural, one that is hardly ever seen in nature. With some types of face, this lighting is extremely unflattering; with others, the results can be intriguing.

simulate natural light, which produces only one shadow. Even if the lighting is not intended to appear natural, a second shadow usually causes a distraction. However, the main problem is how to balance the lights. Usually one is regarded as the main light and the other as the fill, which is used to lighten the shadows. Balancing can be done directly, by altering lamp power, or simply by moving a lamp. Moving it closer increases its effect on the subject, and moving it further away decreases the effect.

THREE-LAMP SET-UPS

With three lamps at your command, just about anything can be lit to good effect. In particular, the third light can be used to vary the brightness of backgrounds. It can also be used to provide light to the back of the subject. This may seem ineffective, but the spill of light can pick up highlights in hair or provide a glowing halo of light around a portrait sitter's head.

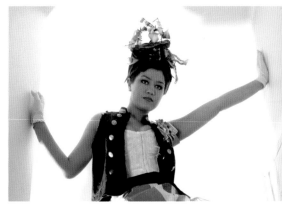

▲ Portrait with two lamps
Just two lamps were needed to produce this image: one set to very bright to burn out the background and cast some forward shadows; another on the camera side, to light the model.

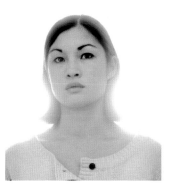

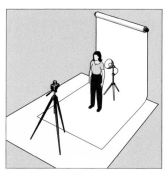
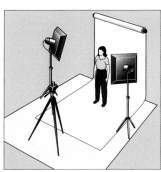
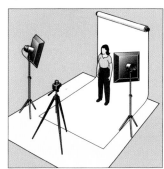

▲ Single lamp – behind
An unusual effect is to light the subject strongly from behind so that the light on the face actually comes from light reflected from neighbouring surfaces. This produces a brilliant white background and the softest modelling on the face. It may also cause flare in the camera – an effect that can be exploited.

▲ Two lamps – balanced
If you wish to eliminate shadows caused by lighting that emanates from one side of the subject, using another lamp will fill the shadows fully. However, at the same time, the loss of shadows robs the subject of light and shade effects that define contours and texture. As a result, the image can look unappealingly flat.

▲ Two lamps – 40/60
If the two lamps are slightly unbalanced – so that one is just over a ½ stop brighter than the other – and both at similar angles to the subject, you will obtain softly outlined features, but you will also be able to give some definition to contour and textures.

BRACKETING

One advantage of working in a studio is being able to obtain precisely the right exposure. This can be done either through measurement, using a meter, or by bracketing exposures – taking sets of three or more exposures either side of the measured exposure, each changing by a small amount. This is calculated to obtain additional insurance exposures based on the best exposure estimate. First take a meter reading. This gives you the starting point for subsequent adjustments. Take one picture using this exposure. Then make another using ½ stop more and ½ stop less exposure. For extra insurance, repeat, with 1 stop more and 1 stop less.

HIGH KEY

High-key images are created by eliminating dark tones and shadows so the image appears full of light in every part. In short, the image lacks tones darker than midtone, and even midtones occupy only a small area of the image. Two sources of very soft light in balance plus generous exposure are usually sufficient to create a high key.

LOW KEY

In low-key images, tones brighter than midtone are minimized or they cover a smaller area than the dark tones, leaving the tones darker than midtone to dominate the image. The role of the lower midtone in shaping low-key images gives these images their characteristic intensity, because the eye has to work harder to discern the shape and texture. In these images, the structure or composition is important, otherwise it is easy for the subject to sink into poorly differentiated darkness. A small bright area of colour can help point to the low tones by offering a contrast.

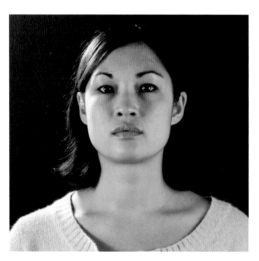

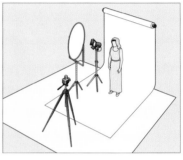

◄ **Portrait with three lamps**
In this set-up, the model was placed in front of a black-painted polystyrene panel and lit with two lamps from the side and a third aimed at her hair, with a little allowed to spill onto the background. This demonstrates that black hair can be photographed against a black background, provided you add some light to lift it from the darkness behind.

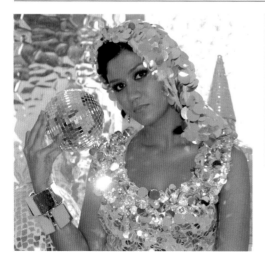

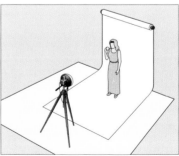

◄ **Ring-flash**
One approach to photographing such an extremely reflective subject as this model with silvery sequins is to use a ring-flash. The even light minimizes shadows, while the occasional direct reflection of flash gives the picture a pleasing sparkle.

RING-FLASH

A ring-flash arranges the flash tube around the front rim of a lens, like a ring doughnut. It mounts directly on the lens filter ring or via a bracket, which carries the camera. It provides very even, virtually shadowless light; any shadows are even on all sides of the subject, so it may appear as if outlined with a dark edge. Ring-flashes are ideal for close-up photography of small subjects such as insects and non-reflective jewellery. They are also favoured for some styles of fashion photography.

Ensure that the ring-flash is large enough for the lenses you wish to use – for example, portable units designed for close-up photography may accept lens mounts no larger than, say, 58mm in diameter. You can cover up a portion of the ring to vary the modelling effect of the ring-flash. Some modern designs use light obtained from a normal flash unit.

LIGHT TENTS

The softest lighting is obtained by using light tents, which are essentially pyramids or cubes made from diffusing material. The object is placed inside, and the camera points at it through a small hole. You can aim any kind of light source; the tent effectively diffuses even spotlights, giving few if any specular highlights even from highly reflective subjects such as watches, pens, or coins. In fact, the lighting can be rather dull and flat, so arrange for stronger lighting from one side to provide modelling and gradients. Light tents have become very popular as the growth of online auctions has created a strong demand for high-quality product photography.

Light tents can easily be made by cutting out the sides of cardboard boxes to leave the skeleton, or by bending coat-hanger wire into a frame. Then you cover the frame with fireproof diffusing material such as nylon, leaving one side open.

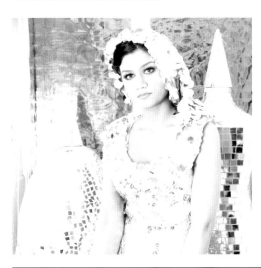

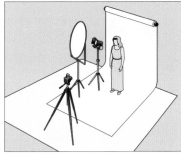

◄ **High-key portrait**
For this portrait, a single flash was bounced off a large panel with silvered dots – like those in the dress – and exposure was more than 2 stops greater than normal. It is essential to keep some skin tone and a few dark tones – such as in the reflection behind the model – to help key the overall tone.

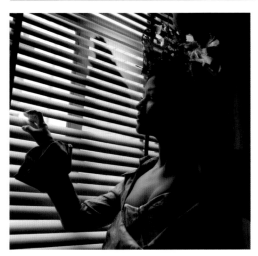

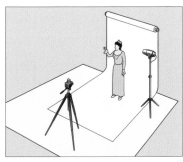

◄ **Low-key portrait**
In this portrait, exposure was aimed at reducing the light from the window to just above midtone. As a result, everything else falls into almost complete black apart from facial features and the gloved hand. A spot on the hat brings colour into the image.

ACTINIC LIGHT AND EXPOSURE

While photographers are mainly concerned with the broad visual quality and quantity of light, there are subtle effects that are influential on the way the camera's film or sensor surface records the image. We are used to the rise and fall of light over a day, or the more sudden change when a light is turned on and off. However, with electronic flash, the rise and fall of light is so rapid that it does not register directly, but through the persistence of vision on the retina: we "see" the flash after the event. The flash needs to conform to quite precise limits for the light to be useful in photography. Similarly, in colour photography we are concerned with broad colour reproduction, but in the studio, minute features in the colour of light can profoundly impair the quality of the photograph.

POWER SPECTRUM

The ability of light to record colours depends on the relative strength of different wavelengths of light. This is described in the power spectrum (*see* opposite page). For example, with tungsten light, which is rich in reds, the spectrum shows the majority of power around the longer wavelengths, with weakness at shorter wavelengths. In contrast, daylight shows a more or less even power distribution throughout the visible spectrum. On the other hand, discharge or fluorescent lamps show highly uneven or discontinuous spectra with some very high individual peaks. This not only affects the ability of the light to render colour accurately (*see* page 180), it can also also cause miscalculations in some types of exposure.

SENSITIVITY

The majority of meters are set up to measure daylight: the assumption is that there is a broadly even mix of different wavelengths. In artificial lighting, however, the scarcity of green and blue wavelengths means the light is less powerful so has reduced ability to expose compared to daylight. With colour, the exposure meter compensates, and exposures are usually more or less accurate, although there may be a tendency to underexpose. However, with panchromatic black-and-white film – film sensitive to all wavelengths – the problem becomes serious because the weaker artificial light definitely underexposes the film. For proper exposure of black-and-white film, you need to add between ½ and ⅔ stop of exposure to obtain a well-exposed negative. Household bulbs, with their very orange output, require even more extra exposure, while tungsten halogen or industrial incandescent lights require less extra exposure (*see* page 118–19).

HOW THE FLASH WORKS

When you first turn the flash on, it must charge up before it can be used. This employs electricity (from the battery or mains current) to charge two capacitors to store a high voltage (300 volts or greater), often making a high-pitched sound in the process. One capacitor is small and will be used to trigger the flash; the other is large, and both are permanently connected to electrodes in a glass tube filled with xenon gas. On firing, the small capacitor sends a current through a transformer, which increases the voltage to a few thousand volts.

This high-voltage pulse causes the xenon gas in the tube to ionize, which makes the gas conductive. This shorts the big capacitor, which discharges through the xenon gas – the energy exciting the ions to produce light. Since the resistance of the plasma (ionized gas) is low, the discharge is extremely rapid. In modern units, the amount of light emitted by the flash unit is controlled by cutting short the discharge by using a device called a gate turn-off thyristor, which allows unused energy to be retained in the capacitor. The left-over energy is temporarily kept for the next flash.

FLASH EXPOSURES

All photographic flash exposures consist of two separate exposures: ambient light provides one, and the flash provides another. These exposures operate separately of each other, so the effect of the flash exposure depends on their relative contributions.

The ambient component may be reduced to nearly zero, as at night, so any area not lit by flash is black. Or the ambient portion may dominate, and the flash merely flicks a little light into the shadows (*see* pages 198–9).

It is not only a question of balancing exposure: the colour of the daylight component may be different to that of the flash, and the sharpness of areas lit by ambient light may be affected by the shutter setting.

Flash exposure time depends on the way in which the flash builds up from zero to the full brightness, then decays or dies off to no light. In modern units, the build-up is extremely rapid, while the decay takes longer. The total exposure is integrated by the capture surface over the intensity of the light and its duration, where it is longer than the shutter setting.

Flash units vary the power of their light output by varying the duration of the flash: full power is longest. Flash duration in portable or built-in units is usually extremely brief – less than a 1/10,000sec. As a result, on-camera flash is capable of stopping or freezing all ordinary movement.

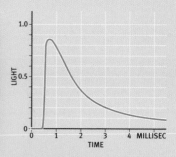

▲ Flash and ambient light
This pair of images shows the marked difference between flash only (*right*) and flash plus ambient exposure (*left*).

▲ Flash discharge
This diagram shows the very rapid rise of brightness from a typical portable flash unit, reaching its maximum virtually instantaneously, then decaying to nearly zero within 5 milliseconds (thousandth of a second). The actual flash duration is around 1/1000sec.

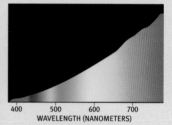

▲ Tungsten power spectrum
This diagram shows an idealized power spectrum for a tungsten incandescent light source. It shows an almost total absence of indigo and blue colours, a little green, but generous amounts of yellow, and a peak in red and beyond red. The continuous spectrum means that all colours can be well rendered, but greens and blues will look darker or weaker than they would in daylight.

▲ Fluorescent power spectrum
This diagram shows a power spectrum from a fluorescent lamp – one in which phosphors are made to glow from ultraviolet light produced by excited gases. While all of the spectrum is present, there are high blue and yellow peaks. This combination is the cause of the greenish tint. The strong blue component may make the lamp usable as a visual, but not photographic, substitute for daylight.

▲ Mixed light
The model was lit with a mix of tungsten light and daylight from the window, with the very shallow depth of field focused on the hat featuring a jewelled skull. The skull is well coloured where lit by the daylight, but the subtle green on the crystals is less clear on the side that is lit by the orange household lamps. Note that, as always, highlights appear white irrespective of the colour of the light source.

PORTABLE FLASH

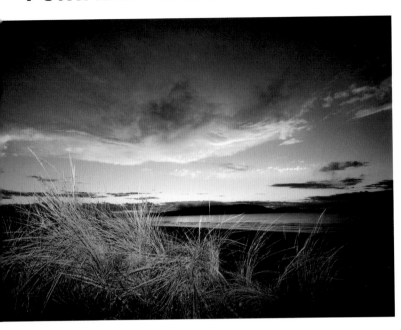

◀ **Evening flash**
For this late twilight scene, the exposure was set to ensure the luminous cloud was correctly exposed. This leaves the foreground in almost featureless black. The flash coverage was inadequate for the 100° field of view, but that suits the subject, since – when set to underexpose by 2 stops – it just picks out the marram grasses in the foreground.

▼ **Flash portrait**
A small difference in flash power setting changes the colour balance from warm – in which the ambient light is dominant compared to the flash (*left*). When the flash is stronger, the colour of its light takes over, so the balance is now cool (*right*).

Electronic flash is the most energy-efficient lighting available to photography, its efficacy founded on packing a high luminous flux into a very brief time together with highly energy-efficient electronics. Modern flash tubes are extremely compact, energy efficient, and powerful. They open up the darkness to photography, can help control high-contrast situations, and at the same time, they can freeze motion. As a result, portable flash is by far the most widely used type of photographic lighting: it can be found in many phone cameras, is universally present on compact cameras, and is even found on many DSLRs.

ACCESSORY FLASH

The flash built into cameras obviously has the advantage of being compact and always available. Disadvantages such as its use of the main camera battery and slower recycling compared to larger units are in fact minor compared to the major disadvantage: the poor quality of lighting. The reason is that these flashes aim the light directly at the subject, which gives the most unflattering modelling. In addition, because the flash is very close to the lens, the light shines into the back of the subject's eyes. The light is reflected off the blood-rich retinal surface, which results in red-eye – extremely unflattering.

To produce good photography, you need an accessory flash. This can be carried on a bar or bracket that attaches to the camera or, better still, mounts onto the camera via a mechanical socket with electrical contacts – the hot shoe. Accessory or hot-shoe mount flashes are much more powerful than built-in units, they recycle more quickly, and some can vary their coverage to suit the lens in use. However, they can be costly, are bulky, and unbalance all but the heaviest cameras.

A further advantage of accessory flashes is that they can expose much more accurately than built-in flash. Automatic flash exposure works on a feedback loop: the sensor reads the light reflected from the subject by the flash and cuts off the discharge when the light sensed equals a setting pre-determined by sensitivity, overrides, and other settings. The electronics must respond within millionths of a second, so the more sophisticated they are, the more accurate they can be.

FLASH-UNIT FEATURES

Modern flash units are packed with many features, and camera dedication is a central one. The electronics and

contacts of flash and camera are matched so they can communicate with each other. For example, quite apart from the flash output being controlled by through-the-lens metering in the camera, the flash confirms there was sufficient power for a flash, tells the camera when it is recycled and ready to fire, sets the camera to the x-synch time, and so on.

Other features, such as exposure corrections, can be controlled from the camera to modify flash behaviour. If you wish to use automatic features on your flash, dedication to your digital camera is essential.

However, with certain subjects such as a lone figure dressed in black at night, the most reliable exposures are obtained by manual control of the flash. For this, many flash units offer a calculator dial or display to help you work out the *f*/number to set for a given distance and speed/sensitivity setting. Calculators with backlighting are easy to use in the dark. Naturally, you may also be able to use a flash meter.

BOUNCE LIGHTING

Another important feature of a flash unit is its ability to light a subject indirectly. This is achieved by directing the flash at a suitable surface so the light bounces off it and lights the subject.

Now the surface is transformed into the light source. Because it is much larger than the flash tube, the modelling effect is much softer than direct light. Bounce lighting calls for a flash head that can tilt upwards and preferably rotate as well. Rotation allows the flash to aim to one side or even backwards, which makes it easier to find a suitable surface, such as wall, ceiling, or door. For some units, you must ensure the flash sensor points to the subject to ensure accurate exposure.

Bounce lighting is also useful for increasing the angle of coverage of the flash so that it fills the field of view when you use very wide-angle lenses (for more on flash coverage, *see* page 199).

SYNCHRO-DAYLIGHT

A fundamental notion of flash exposures is that they comprise two separate but simultaneous exposures: one from the flash, the other from the ambient or existing light. In darkness, of course, the ambient light component is almost non-existent, but in bright light it is substantial.

The photographer's task is to balance the two. Many modern flash units make it easy to vary the balance between flash and ambient light. In fact, many compact cameras use flash in synchro-daylight mode by default.

In dark conditions, you can choose to let the dark remain dark by allowing the ambient exposure to be underexposed, but you can increase exposure time so that the low ambient light has a chance to contribute to the exposure. To do this, meter the ambient light

and set the camera manually to, for example, *f*/5.6 at 1/15sec, then set the flash aperture to *f*/4. This forces an underexposure of the flash, which usually gives the most acceptable results. Modern flash units will make the calculations and adjustments for you.

In bright conditions, you can choose to balance the flash exposure to daylight. Set the camera to expose correctly for the daylight, then set the flash to underexpose slightly. You may find, in very bright conditions, that the setting for ambient light calls for an exposure time that is too short for flash synchronization: this can be a problem with digital cameras that cannot set lens apertures smaller than *f*/8. Try setting a lower sensitivity, or use a polarizing or neutral-density filter.

◄ Entry-level flash
Small and lightweight units provide good power of around GN20 (*see* page 198) and offer a head that can tilt up to 90°, but without rotation and with simplified operation.

► Short-synchronization flash
Modern units offer synchronization at short shutter times as well as dedication to many different camera models, plus a full specification, which makes them highly versatile for the experienced user.

▼ Macro flash
Specialist units can produce marvellous results in macro photography. The two flash units can be separately adjusted and are released wirelessly, which improves reliability and convenience in the field.

► Flash near lens
This shows an extreme example of the flash being placed close to the lens axis, which almost guarantees red-eye when photographing people in dark conditions. However, this arrangement reduces shadows behind subjects.

USING ELECTRONIC FLASH

Digital cameras have enabled the amateur to catch up effortlessly with professionals in one significant arena: evaluating images exposed with electronic flash. While once only professional users could afford the numerous instant-print packs needed to check each tweak of flash exposure and positioning, now anyone with a digital camera can instantly review their images at no cost. Nonetheless, modern flash units can be complicated to use, and their mode of operation is not always obvious.

GUIDE NUMBER

The light output of accessory flash units is usually measured by the Guide Number (GN). The figure holds good for a specific film/sensor speed – usually ISO 100 – in either metres or feet and for a specified angle of coverage. The Guide Number may be quoted as GN45(m), for example, indicating the distance scale is metres. The GN of a typical small camera is 5–10(m); accessory flash units offer 30–50(m).

The Guide Number scale is defined:
Subject distance x f/number = Guide Number

The f/number for a correct exposure is the result of dividing the GN of your unit by the distance between the flash/camera and the subject. For example, if your subject is 3m away and your flash's Guide Number is 24, then 3 into 24 equals 8: you set f/8. For other film speeds or sensitivities, a doubling of film speed increases the Guide Number by 1.4. Therefore from ISO 100 to ISO 400 film, the Guide Number doubles. From ISO 100 to ISO 25, the Guide Number halves.

If the flash power is constant, you must open up the camera's aperture as the distance between the flash unit and the subject increases. With studio flash, light output will be greatly influenced by the light shapers or diffusers used, so Guide Numbers are inaccurate, and light output is usually measured with a meter.

Guide Numbers may seem obsolete in days of automatic flash units, but in fact you can obtain very accurate exposures using them – often obtaining better results than with automatic flash. This is because Guide Numbers ignore conditions that can confuse automatic systems, such as a distant figure in total darkness, or a white subject close to the camera.

▼ **Flash light fall-off**
The power of a flash falls off rapidly with distance, as is clear in this shot of prayer flags in Darjeeling, India. The fall-off is not as rapid as the Inverse Square Law because the light is focused, but it still presents a problem where the nearest and furthest parts of the subject that you want lit are far apart.

► **Concentrated flash**
When using flash with an ultra-wide-angle lens, you have a choice of trying to ensure flash coverage fills the frame or is concentrated. At this wedding, the flash could be set to a narrow field as the daylight would even out the lighting. But the focused brightness helped ensure that near objects such as the woman's arm were not too bright, and that the light reached the bride.

▼ **On-camera flash**
Built-in flash units typically return this kind of result: it is fine for informal photography, but the flat light, misplaced specular highlights, and unattractive skin tones are all arguments for using hot shoe-mounted flash units.

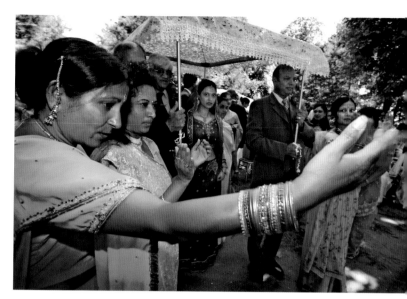

► **Red-eye**
The optimal situation for recording red-eye is with a ring-flash. When the model looks straight at the camera, we see the red centre to her pupils, which are opened wide (*bottom*). But when she looks away (*top*), the flash cannot enter the eye and be reflected out again, so the centres of the pupils are black.

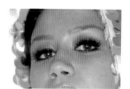

SYNCHRONIZATION

Synchronization is the arrangement that ensures the flash exposure occurs only when the film or sensor is fully exposed. In cameras with inter-lens shutters (*see* page 82), the flash is set to fire as soon as the shutter is fully open: this can occur at any shutter setting as the film or sensor is fully exposed in the middle of an exposure of any duration. With focal-plane shutters (*see* page 82) or progressive-scan sensors, the synchronization setting should be timed to coincide with the first curtain being fully open – to expose the entire capture surface – before the second curtain starts to cover up.

The shortest shutter time that allows proper synchronization is called the x-synchronization time. For 35mm cameras it varies with different models from 1/60sec to 1/250sec; for medium format with focal-plane shutters it may be as long as 1/30sec. Some flash units offer high-speed synchronization, which allows focal-plane cameras to use very short synchronization times, such as 1/1000sec. This is achieved by using a stroboscopic flash that fires multiple flashes during exposure, so the flash is emitting light for the entirety of the shutter run. Unless using such a unit, ensure your shutter time is set to the x-synch time or longer.

COVERAGE

For maximum efficiency, your flash unit should produce a cone of light that fills the field of view of your lens, and no more. While there may seem to be no point in lighting parts of the scene that are not seen by the lens, stray light can be useful for softening the effect of the light.

Many modern flash units incorporate a zoom lens, which alters the coverage of the flash. Some can be set to concentrate light into a smaller area for special effects. The Guide Number of the flash will increase with narrow coverage and decrease for wide coverage.

Working with colour

COLOUR AND VISION

COMPOSING WITH COLOUR

COLOUR SATURATION

COLOUR RECORDING

REDUCED COLOUR CONTRAST

ANALYSIS: WORKING WITH COLOUR

MIXED LIGHTING AND MIXED WHITES

COLOUR PALETTES

DIGITAL COLOUR

COLOUR MANAGEMENT

COLOUR SETTINGS

INPUT AND OUTPUT

COLOUR AND VISION

Colour in photography is a number of complex relationships between physical phenomena involving light, the make-up of photographic elements, such as film or sensors, and human perception with all its variations and vagaries. These three components form the colour photography triangle: without one, the others cannot function. In the digital era, the most important development is that photographers must now assume almost the entire responsibility for accurate, consistent colour reproduction throughout the process. This means that it is vital to understand colour in depth.

COLOUR

In photography, there is no single correct reproduction of a colour. The same patch of colour on an object can appear red in one light, black in another,

▲ **Colour circles**
This diagram illustrates the basic combinations of colour that give rise to the additive primaries (red, green, and blue in the main circles) and the subtractive primaries created by blending the additive primaries (magenta from blue and red, cyan from blue and green, yellow from red and green), with white where all three additive primaries blend.

▲ **CMYK gamut**
Compared with the colours in the RGB gamut, the CMYK colours in this simulation appear to be dull and lacking in brilliance.

▲ **RGB gamut**
This simulation of a typical red, blue, and green colour gamut offers brighter colours, higher contrast, and a greater range of colours than the simulated CMYK colour gamut.

and almost white in yet another. A photograph may record a white when one sees red, and red when black is visible. But colour variations may not be so dramatic: what is seen as natural in the scene may appear too pale in an image, and what appears bright on a screen may be impossible to reproduce on paper. At the heart of these variations are two phenomena: metamerism and colour gamut.

METAMERISM

Metamerism refers to a group of phenomena in which different colours appear to match under different conditions. Metamerism occurs when spectrally different colour stimuli appear similar under a given light source. This underlies all modern print technology: we use combinations of colours to simulate the appearance of another – such as cyan and magenta to appear blue.

In photography, the term metamerism is also applied to the variation of colours in changing circumstances. Observer metamerism occurs when two different colours match to one observer but don't match to another observer – both viewing under the same light source. This is important to photography, where one observer is the photographer, the other is the film or sensor – or even the client.

Illuminant metamerism is equally important. This occurs when two different colours viewed under one light source by a single observer match, but when the light source is changed, they don't appear to match. It is why a print may look fine in daylight but unbalanced under domestic tungsten light. Clearly, metameric phenomena ensure that it is impossible to guarantee that an image will look the same under all circumstances.

COLOUR GAMUT

The colour reproduction system of colour film, a printer, or monitor is called the colour gamut. In practice, we are most concerned with which colours cannot be reproduced. Compared to the human eye, the gamut of all systems looks very limited (*see* pages 220–3), yet our experience is that systems such as colour transparency film and high-resolution digital cameras perform well. This is because these systems gamut-map: large actual differences in hue are represented as smaller differences. Our eyes accept this approximation as long as we don't compare the image with the actual scene or subject side by side.

SCOTOPIC VISION

There is another way in which our appreciation of colour varies: when the human eye adapts from bright light to low light, the rod cells in the eye take over from the colour-sensitive cones. The result is a loss in sensitivity to colours. At the same time, the eye is less

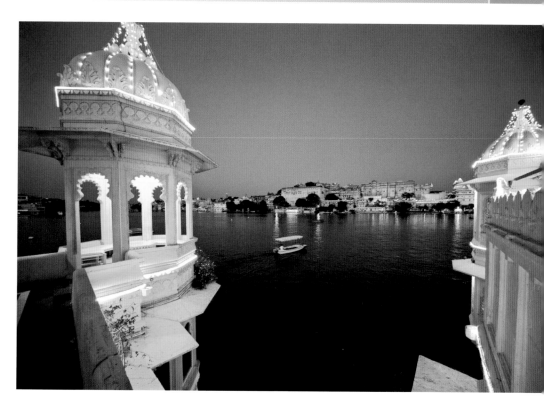

able to distinguish details in shadows. The result is that colour images of twilight exhibit much more colour than was visible to the eye at the time (*see also* page 55).

ADDITIVE AND SUBTRACTIVE COLOUR

Colours are combined in two ways, both fully exploited in photography. Additive mixing uses emitted light such as that from LCD or CRT screens: red and green combine to give yellow, green and blue combine to cyan, and red and blue combine to give magenta colours. When all colours are combined, the result approaches white. The recording of colour on sensors is essentially additive in nature. Films using additive colour-recording systems are all now of historical interest.

Subtractive colour works with reflected light. If we lay a red colour on paper, only one-third of the full spectrum will be reflected – the red, leaving two thirds, the blues and greens, absorbed. The result is a dark colour. Instead we use subtractive colours, such as magenta – a blue-red colour that absorbs only one-third of the spectrum – yellow – while reflecting two-thirds, red and blue. If you combine magenta with yellow, which reflects green and red, absorbing only blue, the result is a red that is much brighter than is possible if we used red ink alone. Subtractive colour recording is used in colour film and colour print, as well as in printers.

▲ **Twilight and metamerism**
In the evening light and under mixed tungsten light, accurate colour reproduction is all but impossible, but viewers readily accept the colours because they have no reference to compare with. Observers in the scene saw a sky that was almost black, and dull grey stonework.

▼ **Colour gamut of flowers**
Nature's bright colours show up the limitations of photographic colour gamut. The various shades of yellow are rendered as flat areas of colour because no system is able to reproduce yellow highlights visible to the eye.

COMPOSING WITH COLOUR

Photographers respond to colours in an emotional way, while the camera is broadly even-handed in the way it represents colours. Across different cultures, the emotional impact or meaning of colours appear to be broadly similar – although specific cultural significances may be contradictory. Therefore, knowing how to use colour can aid your ability to communicate meaning through your images. Colour photography is most successful when you work with the colour for a specific meaning or effect, rather than simply using photography to record colours. One approach is to photograph the colour rather than the subject, to treat the subject as if it were the incidental feature.

COLOUR SYMBOLISM

Broadly speaking, warm colours ranging from reds to yellows suggest energy and heat. Red, the colour of blood, is often associated with energy, determination, excitement, and passion, as well as with anger and violence. Orange, the colour of flames, is a hot colour with high visibility. It is often associated with joy, friendliness, enthusiasm, happiness, creativity, and stimulation. Yellow, the colour of sunshine, is usually associated with radiant energy, health, and wellbeing, as it can arouse good feelings and stimulates the mind.

Cool colours ranging from greens to purple suggest the opposite of heat. Green, the colour of plant life, is often associated with the natural state, restfulness,

▲ Fallen leaves
Strong colour contrasts such as the small patch of red against the dark blue of the wet road can be overwhelming, but here they are softened by the milder contrasts of yellows and browns against the cool colours of the road.

◄ Lighthouse
Despite patches of strong colour, the overall feeling is set by the large expanses of neutral and near-neutral colours of the boat, lighthouse, and sky, which have the effect of softening the impact of the reds and browns.

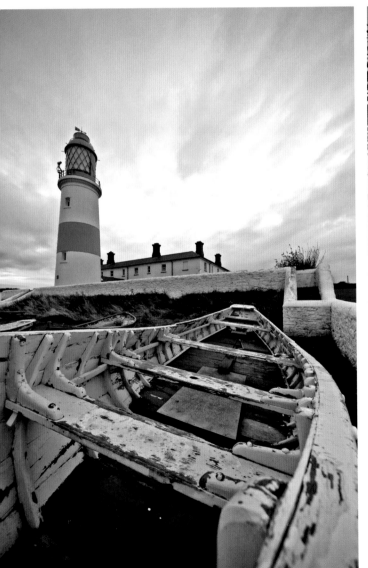

safety, and goodness, since it symbolizes harmony, freshness, and fertility. Blue, the colour of unclouded sky, often symbolizes trust, loyalty, confidence, faith, and heaven, while it also suggests coolness, distance, spirituality, and stability. Violet, or purple, appears widely to symbolize power, nobility, luxury, and ambition – hence it is commonly associated with royalty, wisdom, dignity, independence, mystery, and magic.

COLOUR COMBINATIONS

Experience shows that colour combinations with immediate appeal to the eye are those that correspond to certain relationships on the colour wheel. A harmonious and effective colour scheme for photography is to use colours adjacent or near to each other on the colour wheel. Desert landscapes are often effective because of the subtly rich combinations of

sandy, yellow, and rusty colours. Seas are endlessly fascinating because of the varieties of blues, cyans, and greens. At first, visually attractive, sharp contrasts, such as blues against reds, can be effective, but there can be too much going on for the eye, and it leads quickly to a visual fatigue or degenerates into visual cliché.

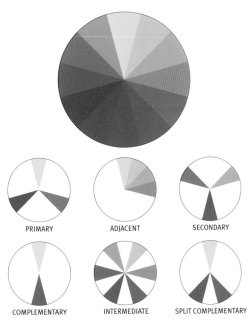

▶ **Colour-wheel combinations**
This diagram shows a simplified colour wheel, with some basic combinations of colours that either contrast (primary, secondary, complementary) or form harmonious groups (adjacent) or a combination of these (intermediate, split complementary).

PRIMARY ADJACENT SECONDARY

COMPLEMENTARY INTERMEDIATE SPLIT COMPLEMENTARY

▼ **Adjacent colours**
In this scene of peace notices displayed outside Cologne Cathedral, Germany, the browns of the notices are a similar colour to the woman's skin and clothes. The small area of green on her T-shirt and the blue sky provide small accents of contrast.

COLOUR SATURATION

Saturation measures the strength of colour: a fully saturated colour appears vivid, rich, and visually arresting. We can reduce the saturation of a colour without changing its hue by adding neutrals. Any grey or white lighter than the colour makes it paler, and any grey darker than the colour makes it darker. Any hue can appear to be strong if it is bright and richly saturated – it will offer strong visual impact. Using strong colours in photography is very tempting because our eyes respond eagerly to these colours. However, there is a number of issues that affect our use of these colours in photography.

VISUAL IMPACT

Blues and purples appear dark, however saturated and bright they are, in contrast to reds, yellows, and oranges, which appear bright even when they are less vivid or bright than they could be. It is well known that, in a photograph, a small but strong patch of red instantly pulls the viewer in. If there are many vivid colours in the scene, they all draw attention to themselves, and the result can be a visual chaos.

Red is useful as a means to direct attention to something such as a solitary figure in a landscape; it is a well-used – some would say, overused – technique. Try to limit the number of strong colours in a scene by framing closer in. You may balance a very vivid colour with a larger area of a darker colour, such as an expanse of greens against a small patch of orange. Note that any colour looks more vivid when placed against neutral backgrounds.

COLOUR REPRODUCTION

In general, colour film cannot reproduce the full vividness of colours that the eye can see. Failure to expect this can lead to disappointing results. Similarly, on-screen colours may look appealingly saturated but are out of gamut when printed out. Furthermore, where certain colours like reds are very strong, the film may not be able to distinguish between small variations in brightness or saturation that are visible to the eye, with the result that a uniform wash of colour is produced.

On the other hand, colour contrasts may provide the desired visual impact even where they are not fully saturated.

The correct exposure for a bright colour, such as yellow, is likely to be too low for a dark colour, such as blue. Colour-specific exposure errors are usually acceptable in the majority of photographs, but where a strong colour is the main subject, care with exposure measurement is needed.

Ensure your film or sensor can capture an important colour accurately by making tests. Determine exposure for the whole image by exposing for the most important colour: treat it as the midtone. Learn about the characteristics of different film stocks

▶ **Saturation contrasts**
The colours of the turban and face of the man in the foreground, a sadhu in Nepal, appear to be highly saturated and strongly coloured partly because of the "hot" colours and also because the background is largely neutral.

▶ **Saturation and gamut**
The top image (colour target) is a standard patchwork target of colours of varying hue, saturation, and brightness. If we turn on a gamut warning to show colours in grey that will not print accurately, we see that large swathes of the standard are out of gamut. To bring all the colours into gamut, we have to drastically reduce the saturation, to produce the bottom image. It is preferable to print some of colours inaccurately with good saturation (*top*) than all of colours accurately but with poor saturation (*bottom*).

or your camera sensor in order to match them with the subject and visual treatment required. When working digitally, the greatest flexibility results from capturing the image as raw files.

MAXIMUM VIVIDNESS

Where it is important to keep colours as vivid as possible, and where accuracy is not a high priority, set the colour-conversion options (*see also* pages 222–3) to "Saturation". In practice, you may simply raise the overall saturation by 10–20 per cent to ensure that all colours are printed out as vividly as possible. However, in both cases, you run the risk that areas of strong colour will blend into one uniform colour. Soft-proof on-screen images to ensure that highly saturated colours can be printed out (*see also* pages 224–5).

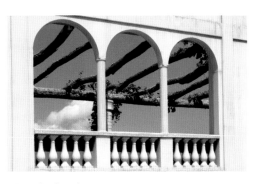

▲ **Exposing for colour**
The exposure was set for the blue sky to ensure it was saturated, but the side-effect is to underexpose overall, rendering the white walls in full sun darker than they appeared. Visually, however, the result is acceptable because the walls have a warm tone.

COLOUR RECORDING

The process of recording colour is best understood as an event that occurs when three independent factors come together. The subject is the primary colour contribution; it is the colour source. Then we have the illuminating light, which may also bring its own colour. And the third party is, of course, the colour recipient – the observer, sensor, or film. For example, a subject may be painted blue, but if the illuminating light is bright red, no one can either see or record the blue. The biggest variable is colour of the illuminating light, since the qualities of the illumination can change considerably, while factors such as the object's own colour and the recording devices we use remain constant.

COLOUR MEMORY

The camera does not have as reliable a "memory" for colour as you might expect or hope for. Film that is left in the camera may fade in time, and colour processing may be faulty, causing the colour in the printed image to fail to match that of the scene that was photographed. In addition, images captured in raw (*see* pages 240–1) do not have their colours adjusted.

Human memory for hue is also very unreliable: if you want to find a curtain carpet colour to match a curtain, you would be wise to take a sample with you, as relying on your memory is sure to lead to a mismatch. In consequence, the whole question of colour accuracy in photography is, on the whole, one that relies more on broadly acceptable colours than on absolute colour matches.

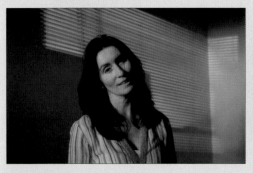

▲ **Original colour balance 5000 K**
In this image, taken under warm evening light in a room with blue-grey walls, the camera's automatic white balance has done a fair job of colour balance by erring on the side of being a little too warm.

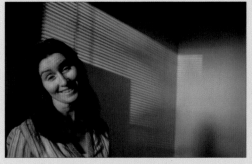

▲ **Balanced to 10,000 K**
If a white balance of 10,000 K (blue sky) is set, this tells the camera to expect a bluish white, so it compensates by giving a strong warm balance. This is useful for giving models a strong tan, and it flatters the subject.

▲ **Balanced to 2500 K**
If a white balance of 2500 K (domestic light bulb) is set, this tells the camera to expect a yellow-red white, so it compensates by giving a strongly cool balance. The result is very cool tones throughout, with the skin looking as if it were frozen.

▲ **Balanced to 3560 K**
With white balance set to 3560 K by photographing a grey card under the same lighting conditions as the subject, which was then set as the reference for manual white balance in the camera, skin tones are accurate, as is the colour of the walls.

◄ Tungsten-balanced
Normally the lamps inside this restaurant in Budapest, Hungary, would appear nearly white, and the exterior may look slightly blue. Photographic systems are unable to compromise, so a balance that is correct for the lamps gives a strong blue cast to the natural light.

▼ Daylight-balanced
This view into the restaurant shows the reflection of a city square superimposed with the lamps inside. With the white balanced for the exterior light, the tones are slightly blue but the lamps are strongly yellow.

In this regard, a few key hues – referred to as "memory colours" – are important for evaluating a photographic system's colour reproduction. The central colour is that of the human face or skin. While skin colour may appear to be very variable, the hues of different races lie within very narrow bounds though the lightness varies considerably.

The colour of fruits such as oranges and bananas, as well as items we are familiar with, such as the colour of our car, are also memory colours. We use these colours when we judge the colour accuracy of a photograph.

WHITE BALANCE

For reproduction systems to record colours accurately, the ideal is that the illuminating light be white – contain an equal mix of all colours. In practice, the stem must be able to compensate for any predominant colour in the light: this is the process of white balance.

With film, you would use daylight-balanced film for daylight or tungsten-balanced for indoors, making adjustments with colour-correcting filters (see page 169) where necessary. Digital cameras achieve white balance by equalizing the chrominance channels – the magenta-green, and the yellow-blue in the highlight pixels. More sophisticated systems analyse the entire image. If there is an imbalance of, say, red and green, that suggests a shift from white. The camera's software corrects that shift for the entire image, which remaps all colours round the new white.

Advanced cameras allow you to set the white point manually to match the situation or scene that you are photographing. Alternatively, you can aim the camera at a grey or white area and ask the software to set the white point according to the target. It is helpful, where possible and when necessary, to photograph a colour chart or grey card under the same lighting as the subject: this provides a reference for later correction.

You can deliberately set the "wrong" white point, such as tungsten for outdoors, to achieve a special effect. Or try choosing a "white" that is not white, such as pink: the white balance will then shift to a blue cast to compensate for the red-coloured "white". You could choose a pale blue – in which case, the white balance shifts to red to compensate.

WHITE POINT

The term "white point" has three meanings, according to the context of its use.

- Camera setting: The choice of white point (usually referred to as white balance) aims to calibrate the captured image to the correlated colour temperature of the light source. It determines the image's overall colour balance.
- Monitor calibration: The choice of white point, described by the correlated colour temperature of a light source, aims to match the monitor's colour rendering to match one of the standard viewing conditions, such as D50.
- CMYK conversion: The white point aims to match the white of the paper stock of the final print as it would look when observed under standard viewing conditions, such as D50 (see also page 225).

REDUCED COLOUR CONTRAST

Photographs using a limited range of colours – where the hues are close to each other on the colour wheel – offer one of the most effective strategies for producing effective colour images. The simplification of the colour palette is restful for the eye and encourages the viewer to give full attention to the composition and picture structure, and to concentrate on the subject matter. At the same time, the visual harmony that automatically arises from using a limited range of colours is easier to work with than having to organize an extensive range of colours.

COOL AND WARM PALETTES

The human eye is generally more attracted to warm palettes – with browns, yellows, reds, and oranges – than to cool palettes containing blues, cyans, and greens. The reason for this is the strong association of warm colours with positive, outgoing emotions,

◄ **Reflections in a creek**
The large bands of blues and areas of greens form a "wrapper" for the yellow-browns of the branches, which provide a soft contrast to the cool colours. Without the contrast of warm colours, the image would lack serenity and look uninviting.

▼ **Fly cover**
The strong reds of these ketchup dishes are diluted by the netting of the fly cover. The pastel and strong reds and browns are all essentially the same hue, so the only contrast is with the neutrals, which makes a pattern of whites necessary.

▶ **Sand and waves**
The near-monochrome nature of this image is essential to guide the eye to the patterns and simple composition. While the image's exposure needs to be spot-on, the narrow luminance range means that adjustments can be easily made in image-manipulation software.

while cool colours are associated with less active emotions (*see also* pages 204–5).

When working with warm palettes, there may be a temptation to use high-saturation colours for greater visual impact. However, working with weaker, almost pastel colours can be more visually rewarding. This is because strong colours make their impression by presenting a volume of colour, which can overcome the detailed texture of the subject. There is always the danger that colours that look lively and saturated on a monitor will print out less vividly on paper, particularly matte-surfaced paper. It is best to ensure the image works well with the weaker colours.

PASTEL SHADES

Pastel colours are desaturated, watered-down colours. This may sound negative, but their lack of saturation makes them ideal for suggesting calm. Images mainly made up of pastel colours therefore work well as part of a scheme of interior decoration in living spaces, such as bedrooms, as opposed to corridors. Pastel shades of different hues will blend easily together where their stronger equivalents will clash.

Pastel shades work best in low-contrast situations, where there are no strong highlights or deep shadows. In consequence, the exposure range is narrow, which means that exposure must be accurate or err on the side of overexposure.

MINOR CONTRAST

In nature, it is rare to come across a scene consisting entirely of adjacent colours. This is easy to work with as the dominant green colour of foliage, grass, and trees provides a context or background against which shapes and forms can be shown with greater clarity than if there were many colours.

▲ **Pastel-shaded grasses**
Architectural grasses present a fine, rhythmic pattern that does not need strong colours. In fact, it is important to resist the temptation to strengthen the colours, as the image is really about the leaves.

▼ **Blue lights**
This shop-window display appeared blue, but not as blue as the captured image. This is because the tungsten lights in the top of the image forced the white balance towards a low colour temperature, causing a blue cast, which reinforces the colours of the weaker pin lamps.

▼ **Purple poster**
The almost uniform colour of this image directs the attention to the pattern of cuts, textures, and gaps. This turns a photograph into a fine-art abstract. The key to the process is the unvarying hue across the image.

The blue of a clear sky is a key memory colour: it must be accurate for the picture to be accepted as one taken in broad daylight.

ANALYSIS: WORKING WITH COLOUR

Even when colours are presented to you in profusion, with lavish supplies of light and a wonderful scene, the picture is not yet guaranteed. The footbridge linking Punakha Dzong, the winter residence of Bhutan's senior monks, to the town, is in a wonderful location. An ultra-wide-angle lens is needed to capture the bridge, the monastery, and the mountain scenery. But even that is not sufficient to make a working picture. The passage of people across the bridge is a vital part of the location, and no picture of the scene is complete without a monk or someone in national dress.

Face and skin colour are memory colours: the viewer will accept excessive warmth but not excessively cool tones. This can be a problem when the face is in shadow: it receives light from the blue sky, which tends to cool its hue.

High density in the image from shadows should not be too dense otherwise the image will look underexposed. Only very small parts of the image are at maximum density.

Several sets of converging parallels give a strong sense of space and receding distance, which push the subject forward into our attention.

The small patch of bright red on the man's sleeve helps draw the attention back to him, without being too obvious.

The highlight exposure from the sun and cloud reduces any colour to white, which makes the building look darker than it is.

One of the key elements of the image is this red prayer flag at the Golden Section. Note how the saturation of the colour varies with exposure.

The broad band of dark greens stretching across the width of the image at the Golden Section serves to anchor the composition.

Neutral colours, such as the white-washed walls of the monastery, have taken on the colour of the illuminant – in this case, the blue sky.

The broad swathe of the cyan colours of the water serves to provide a background for the other colours. Too many colours would overload the image. But the lively texture from the light reflected on the water provides a lot of visual interest.

MIXED LIGHTING AND MIXED WHITES

When evaluating photographic opportunities in terms of the lighting, it is usual and simplest to consider the light as arising from a single source – the sun, room lights, or studio lights. In practice, all photographic situations, apart from those in highly controlled studios, involve light from mixed sources. On a sunny day, the main light comes from the sun. However, the sky itself is a secondary light source and it illuminates the shadows with cool light, while any clouds that are present in the sky will offer a softer and slightly warmer light than that of the sun. Colour recording therefore becomes an act of balancing the different weights of sources.

CHANGING SHADOWS

It is well known that the colour of the sun appears to change throughout the course of the day: yellow to red at sunrise, cooling to white as the sun rises, then becoming warmer in colour again as it sets. Photographers have long exploited this variation, but what is equally important is the changing relationship between lit areas and shadow.

Towards the beginning and end of the day the sun is low in the sky, and shadows are long, dark, and deep. For most practical purposes, these shadows are black. With a higher sun, the shadows open up and become lighter, and in doing so they take on the colour of the secondary illumination – that of the sky and clouds. In the process of being lighter, shadows become visibly coloured. This usually causes shadows to look rather bluish compared to directly lit areas.

FILM COLOUR BALANCE

This table shows the three principal types of colour balance used for colour film, the correlated temperature, and indicative uses.

FILM TYPE	COLOUR TEMPERATURE	USE
Daylight outdoors, flash	5600 K	General use
Tungsten halogen	3400 K	TV and video production
Tungsten photoflood	3200 K	Portrait or photo studio

▲ **Extreme mixed lighting**
Where subjects offer extremes of illuminant colour, such as this scene, only local corrections – to make the yellow incandescent lights more blue, and to warm the blue of the evening light – can render colours with any accuracy. However, a fully corrected image will lack the mood of the "incorrect" record.

◀ **Cool shadows**
On a sunny day in Kathmandu, Nepal, the sun lights the back of two men, while three others shelter in the shade. Note that the white shirts of the men in the shade are strongly tinted with blue. Neutralizing the blue will cause the rest of the image to turn a strong yellow-red colour.

This can cause problems with colour materials, since an overall correction aimed at the shadows forces the lit areas to look too warm. This is the classic "crossed curve" situation in which colour balance shifts with exposure. It is difficult to correct with film-based materials but can be corrected with image-manipulation software using different methods.

COLOUR CORRECTION

In the majority of photographic situations, you will find there are at least two different light sources, each offering its own colour characteristics. A full correction for colour calls for digital methods, and even then, a full correction may not be possible. On the other hand, the differences in colour rendering may well be part of the image's content and message – for example, the contrast between a warm fire indoors and the cold light of a rainy day outside, or the bright orange of street lamps against the blue of an evening sky. The key to a convincing colour correction is to make sure memory colours, such as face tones, are accurately or convincingly coloured and other memory colours are accurate – or ensure there are no neutral colours in the image.

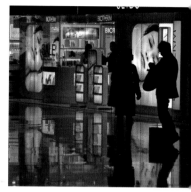

▲ Fluorescent lights
The mix of lights in a shopping mall provides a medley of colour renderings. But the green/cyan cast from fluorescent lighting is seldom welcomed. The worst damage is to the skin tones of the models in the posters: green casts turn skin tones to a pallid version of tan.

◀ Evening sky
The colour of daylight can vary from the near white of noon, to the yellows and reds of dawn and sunset. In extreme cases, the light at either end of the day can be almost a violent red. In this image, the main source of light is the sky, which is deep blue, giving rise to mixed lighting.

TYPE OF LIGHT	COLOUR TEMPERATURE DEGREES K.
CANDLE FLAME	1,500
INCANDESCENT	3,000
SUNRISE, SUNSET	3,500
MIDDAY SUN, FLASH	5,500
BRIGHT SUN, CLEAR SKY	6,000
CLOUDY SKY, SHADE	7,000
BLUE SKY	9,000

COLOUR PALETTES

The way our subjects are captured is affected by the characteristics of the recording medium. This is true whatever recording material we use – colour negative, transparency film, or sensor. All are technological products that compromise between what is technically feasible and what is affordable, flavoured by what is acceptable. For example, the sensor or film may reproduce red colours very enthusiastically but be unable to distinguish between different blues. By recognizing the limits and the strengths of your materials, you learn how best to use their strengths, and how to avoid their weak points.

FILM COLOUR PALETTES

The best way to learn about a film's colour palette is to expose it on a wide range of subjects in different lighting conditions. Concentrate on your favoured subjects and include a standard colour chart if possible. The chart does not have to be a recognized standard: as long as you have a good range of colours and some neutral greys that appear in the different shots, you will have a good basis for comparing results.

When studying a film's performance, note the way neutral colours are recorded, and look for a film's ability to differentiate between subtle shades, such as skin tones. Slower films are more likely to offer a wider palette, thanks to higher levels of saturation and better shadow and highlight rendering. Fast films offset high speed against weaker low- and high-tone saturation and much lower maximum densities, leading to restricted colour palettes.

CROSS-PROCESSING

Film colour palettes are essentially fixed into the film at the time of manufacturing. There is very limited scope for variation in the range and character of colour reproduction as film development and printing are limited to precise standards.

One method of making a radical shift in colour is with cross-processing. Colour negative film can be processed as if it were colour transparency: the result is a pleasant old-world look, with low contrast and low density but a tendency for mid to low tones to be slightly blue-green, and high tones tinted orange to yellow.

Alternatively, cross-processing colour transparency film as if it were colour negative results in an image with strong colours and contrast. Transparency film has greater built-in gamma than colour negative film, so the resulting print, which needs to be made with a blank piece of normally processed film to provide an orange mask, is very high-saturation, high-contrast.

Out-of-date film is favoured for the most startling cross-processing results, but of course these are hard to replicate if you take to a particular effect.

DIGITAL COLOUR PALETTES

Digital cameras also vary in the way they reproduce colour. Each camera sensor produces an image with its own basic colour palette and within its own gamut.

Many cameras offer controls that can increase or decrease colour saturation and vary gamma as well as

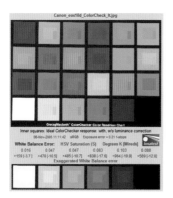

▲ **Digital colour palette**
This diagram shows an Imatest analysis of an image of the Macbeth chart. The inner squares in each colour square shows the ideal response: if it is difficult to see the difference, the colour record is accurate. Tests show that different cameras produce varying patterns of response, resulting in differing renderings of real-world scenes.

▲ **Transparency film as colour negative**
Slide film that is processed and printed as colour negative produces pale colours, typically with strongly tinted highlights. There are no true blacks but instead dark greys with a strong blue to green cast that are lacking in detail separation. The effect has its uses for portraiture and some editorial photography.

▲ **Colour negative in E6**
Colour print film processed as if it were a transparency generates strong contrast, typically with burnt-out highlights and highly saturated colours. With lighting adjusted for the high contrast, results – notable for a pink or yellowish tint – can be effective, if not overused, for fashion, editorial portraiture, or industrial shots.

colour tone. In addition, some cameras allow a choice of colour space – usually between sRGB and Adobe RGB (1998) – to be set. For advanced work, an input profile for the camera can be created, which, when applied to all images, can give rise to marked improvements in the rendition of colour.

Finally, if the camera allows images to be captured raw, the coding for colours is likely to be higher resolution – for example, a bit depth of 14 instead of eight. This enables the image processing to take place in a data-rich environment, which helps to provide the largest range of control over the final image (*see* pages 240–1).

However, the saturation losses seen with high-speed film are much less evident when sensors are set to higher sensitivities. Overall, the digital image depends on the sensor's basic capture, and that – like a film's colour palette – is set by the manufacturer.

AGFA RSX100

KODACHROME 25

VELVIA 100

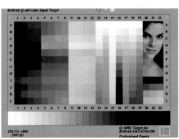
EKTACHROME 64

EKTACHROME 100

KODACHROME 200

◄ **Colour film palettes**
These images show digital simulations of the same scene as it would appear with different films. At first glance the images may look similar, but further examination reveals more differences. Compare the warmth of Agfa RSX100 (*far left*) and Velvia 100 (*near left*) with the cool tone of Ektachrome 64 (*below far left*) or the redness of Kodachrome 200 (*below near left*). The vivid saturation of Velvia 100 is well known and puts colours of Ektachrome 64 into the pale. The tonalities of these films also vary widely, with Kodachrome 25 being very smooth compared to the other films.

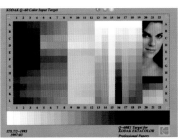
AGFA RSX100 KODACHROME 25

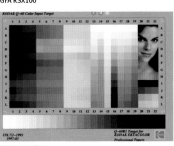
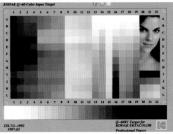
EKTACHROME 64 VELVIA 100

◄ **Target variation**
The different results of a film palette are clearest when assessing a standard target. Note the very different renderings of the neutral grey backgrounds. While Velvia gives the most neutral results, its colours are highly saturated, and its high contrast causes loss in highlight detail.

DIGITAL COLOUR

The recording of colour in photography – whether film-based or digital – consists of a sequence of analyses or separations into component channels, then recombination or synthesis of the channels into the coloured image. In the majority of digital cameras, light is analysed into red, blue, and green components, while some may analyse into cyan, magenta, and yellow components. In addition, some cameras use double sensors for each pixel site: one designed to capture images in lower light, the other designed for highlight capture. This is designed to record a wider dynamic range of light. In all cases, the task of processing the channels of colour information is to create an accurate final image.

DIGITAL STRUCTURE

The digital image is, unlike film-based images, fully three-dimensional in nature. Over two dimensions, it consists of an array of pixels. Penetrating the surface of the image, each pixel has a depth of colour channels. These can be thought of as separate layers of colour: in the case of an RGB image, each layer carries the information for its colour. The convention is that where a channel has no colour, it appears black and carries the value 0; and with maximum colour, it appears white and carries the value 255 or greater. Although we think of each channel as being coloured, each is essentially a greyscale map of lightness values superimposed on a separation colour. This is because each channel carries only brightness values. It is only when the separate channels are combined – and in register – that the full colours emerge.

CAPTURE RESOLUTION

The majority of digital cameras capture images in which the values for each channel vary between 0 and 255, at a depth of 8 bits per channel. But higher-grade cameras capture at a greater depth of 14 bits or more, allowing for a resolution of thousands of different brightness values. This enables a higher resolution record of colour. Note that the resolution may not be applied evenly across the whole

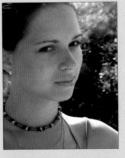

▲ **Banding artifacts**
When smooth gradients, such as those on shiny fruits, are recorded with insufficient bit-depth resolution, manipulation of the images can cause banding or posterization – the separation of smooth gradients into stepped changes. Banding is most commonly seen in high tones such as skies; is common in dark tones but less easily seen; and is much less often seen in midtones.

▲ **RGB colour channels**
This portrait of a girl consists predominantly of flesh tones and some dark-green background (*top left*). We can expect the blue channel to be dark (*bottom right*), with more or less equal weights of red and green. Note that in highlight areas, such as the light on her shoulder, all channels are lightly coloured.

▼ Greyscale channels

The red, green, and blue separations from an image of a flight of stairs with red carpet in warm domestic light can be expected to show a very light red channel, with very dark blue channel, and the green lying between the two in density. This is shown clearly by the greyscale separations.

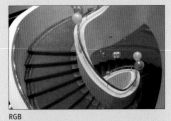

RGB

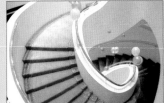

RED

GREEN

BLUE

range of brightness; because of the nature of visual perception, more data is reserved for coding the darkest and brightest tones than for the midtones. One of the advantages of raw capture is that the high bit depth is retained and used for colour calculations. It is turned to 8-bit only after conversion.

LUMINANCE/CHROMINANCE

A channel may be said to be carrying either chrominance or luminance data, which are terms used in video technology. In digital photography, however, a chrominance channel carries more on image colour than

image detail, whereas a luminance channel carries essentially no colour data but brightness data instead, which helps define detail.

The distinction is useful when images are sharpened, as it is best to limit sharpening effects to luminance channels. This is why the sharpening of the L channel in Lab is favoured.

In digital cameras, the luminance can be approximated to the green channel because it carries much of the detail due to the fact there are twice as many green pixels as red or green; the red and blue channels carry much, but not all, of the chrominance stream.

▼ CMYK colour channels

The most obvious feature of the CMYK separations is how light they are. This is partly because subtractive primaries reflect more light than the additive primaries of red, green, and blue. It is also because the colour information is spread over four channels rather than three. Note that the yellow separation appears weak and low contrast, while the black channel appears very high contrast; one is compensating for the other.

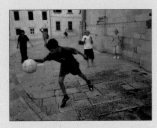

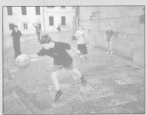

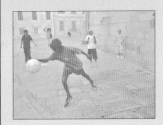

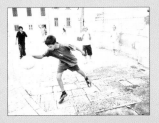

COLOUR MODELS

A colour model can be understood as a scheme for defining colours in a consistent way. The most intuitive, but mathematically awkward and now obsolete, is the HSV – Hue Saturation and Value – model, which described a colour in terms of its hue, saturation, and brightness value. The RGB model defines a colour as a triad of the three values of red, blue, and green light; it is quite intuitive and is widely used by digital cameras and monitors. The L*a*b* (commonly written as Lab or LAB) model defines a colour as a triad of its luminance or brightness value, its position between opponent colours magenta and green (a*), and its position between yellow and blue (b*). The CMYK model is used in printing and describes a colour in terms of a quartet of values of cyan, magenta, yellow, and key (black).

COLOUR MANAGEMENT

In the late 1990s, a digital image sent to five different printers would be printed with wildly different results. Today, if you sent the same image to five printers, they would produce more or less similar results. The variation between printers has narrowed but not disappeared. The aim of colour management is to control the imaging chain so that between the subject, its captured image, the image displayed on a monitor, and any of its printed forms, there is the least possible variation in appearance between all the various forms of its image. The key strategy is to define the behaviour of each component in terms of a common standard, called the profile connection space.

ANALOGUE COLOUR MANAGEMENT

Note that colour management is not new to photography. Film-based colour photography is equally dependent on systems that ensure colours are reproduced in repeatable, predictable ways. Film-based colour management is essentially a closed

system: colours had to be matched not only within the same laboratory, but for an individual enlarger, using its dedicated box of filters and colour analyser. Variations between individual films, and even frames, were compensated for on an individual basis. With digital technology, colour systems are wide open – an image created for this book could be printed in China, Italy, or India – and each version has to look the same as the others.

DIGITAL COLOUR MANAGEMENT

The central problem is that the colour gamut or range of reproducible colours of different devices vary considerably (*see* below). We could view images from a digital camera on a monitor to compare them with how the images print out on our printer. It is easy to make a set of adjustments that ensure our images look on our monitor as they print out – this was what the old Adobe Gamma control was used for. But we might change our printer or update our camera, and each

ADOBE RGB SPACE

SRGB PROFILE

GENERIC CMYK

PRO4000-ACHIV MATTE

PRO4000-PREMIUM GLOSS

PROPHOTO RGB

▲ **Colour gamut diagrams**
Ideally, colour gamuts of different devices share the same extent and shape. Every difference between one gamut and another signals potential problems in colour consistency. Notice the Adobe RGB space (*top left*) is larger than sRGB (*top middle*) but they are similar in shape – as we would expect. Compared to even the sRGB space, the generic CMYK space (*top right*) is much smaller and a different shape, with noticeably darker colours.

Equally small is the colour space for a professional printer, the Epson Pro4000 (*bottom left*). Thanks to its use of eight inks (six colours), the gamut is more rounded than for CMYK. When we use glossy paper in the same printer (*bottom middle*), the gamut is significantly larger than that of matte paper, which confirms our subjective experience of printing on glossy paper. But all spaces are dwarfed by the ProPhoto RGB space (*bottom right*), which is used when scanning transparency film for top-class reproduction.

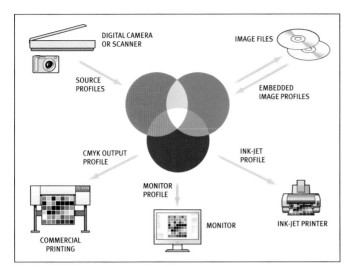

◄ **Colour-management scheme**
This diagram shows a simplified scheme for colour management. It conceals the various processes, such as colour engines and colour look-up tables – each of which can be individually controlled – that convert image files prior to use. What it shows is that any image from a camera, must enter the working colour space (which strictly lies within the profile connection space, which is device independent) before it is output or displayed. In the process, profiles are applied each time to the image to shape its colour reproduction (the device-dependent colour space) to ensure that it is as consistent as possible between different uses.

time we make a change – even of paper type – we need to make new adjustments. Worse, consider the different adjustments that would be needed for all the combinations of scanners, cameras, and printers – the sets of adjustments needed would rocket into the millions.

The solution is to use a common colour space – essentially one that can be seen by the eye to describe how the colour reproduction of a correctly set-up device differs from the standard. This generates the device's profile. Note that the device must be correctly set up: this is called calibration. Cameras and printers are essentially self-calibrating, but monitors need to be set up manually because several variables (gamma, white point, and so on) need to be set by the operator.

MONITOR CALIBRATION

There are software-based and hardware-based methods for calibrating monitors. The former is free but less accurate than the latter, which used to be expensive but now costs a fraction of what they used to. CRT (cathode-ray tube) monitors should be warmed up for 30 minutes before calibration and should be recalibrated at least once a month. LCD monitors need less time to warm up and should also be recalibrated regularly. After calibration, a profile for the monitor is created. This should be used as the monitor profile. In addition, you need to ensure that your work takes colour management into account – *see* pages 222–3 for colour settings.

VIEWING CONDITIONS

It is valuable to consider the features of ideal viewing conditions, if only to realize how far your own conditions fail to reach them. Walls should be painted white or a midtone neutral grey. Curtains should not be coloured – block light without filtering it. Neutral-

coloured blinds are best. Light levels in the room should be constant and preferably only bright enough to find your way around the room – about 4 lux; black on the monitor should look black.

The monitor should be hooded against local lights such as desk lamps. Prints should be viewed in standard daylight viewing booths and transparencies viewed on light boxes placed as close to the screen as possible. Booths should comply with ISO 3664:2000, which means they should use the CIE reference illuminant D50.

▲ **Normlicht Kombi**
This compact and relatively inexpensive viewer combines a light box for transparency as well as a lamp for reflected-light viewing – not to be used at the same time – and is compliant with ISO 3664. However, it offers no protection against ambient light, which is not colour correct, so it should be used in a darkened corner of a room.

COLOUR SETTINGS

As photography has become increasingly based on working digitally, the colour settings become more and more important. In fact, they can be said to rival exposure settings in importance. This is because they determine how your entire system handles colour: the settings are the foundation of your colour management. You make colour settings in your camera when you decide whether to work in sRGB or Adobe RGB colour space. In many scanners, your colour settings determine the bit depth of image files. And in your image-manipulation software, colour settings set out your policy for handling profile conflicts as well as setting the basic colour spaces. Obviously, colour settings assume that the devices involved are calibrated.

▲ **Photoshop colour settings**
This dialogue box and its many choices have frightened off photographers, but it is straightforward if taken one step at a time. The illustrated set-up has quite a limited range of options.

INPUT SETTINGS

The majority of digital cameras record JPEG images into sRGB space. Where you have the choice, it is preferable to set the camera to record in Adobe RGB colour space, since this encloses more colours (*see* page 220). Where possible, set your scanner to save 16-bit Adobe RGB files.

WORKING SPACE

In your software, three main sets of decisions are required – first, which of the various colour spaces to be working in. The primary working space is used for image manipulation and correction: common practice is to set Adobe RGB (1998). This was never intended to be a standard, but it has been adopted as a de facto working space for the majority of photographers.

Those who need a larger colour space (for making transparencies or printing on six-colour presses) can work in Kodak ProPhoto RGB.

Use your monitor's profile or sRGB if your work is for use on the internet.

The other main space is for print output, also called the CMYK space. While the working space is largely independent of the devices you attach, the output space is specific to the printer, ink, and paper combination being used. This setting is used for soft-proofing – when the image is checked for printed colour on screen.

POLICIES

Another set of decisions regards what to do when there are conflicts between profiles or missing ones. For example, you may set Adobe RGB as the working colour space but then import an image with sRGB as the embedded profile. You can automatically change the profile, ignore it, or ask what to do on each occasion. If you know what you are doing, it is easiest to set the policy to convert to the working space if there is a mismatch; this may slow down the opening of files that need conversion. The safest policy is to set the software to ask you what to do, then you will be aware of any mismatches.

CONVERSIONS AND RENDERINGS

The next policy is to determine how to convert between different colour spaces. Different systems and requirements will use their own conversion application or colour engine. Use the system default or that chosen by your workgroup. The colour engine needs to be instructed how to handle mismatches of colour, in particular how to bring colours outside the device's gamut into the working gamut.

Absolute colorimetric rendering reproduces in-gamut colours as exactly as possible and clips out-of-gamut colours to the nearest reproducible hue, even if saturation and lightness must be lost. It tries to reproduce the source white exactly, which may tint the white. Both effects result in changed relationships between colours, which is often detrimental to the image. Absolute colorimetric rendering is useful where the proofing device has a larger gamut than the final output device.

The other three rendering intents all translate the source white to the output white, mapping the other colours in proportion.

Relative colorimetric rendering is similar to absolute colorimetric rendering, but it scales the white point of the source to the white point of the target. Like absolute colorimetric rendering, it clips out-of-gamut colours to the nearest reproducible hue.

Perceptual rendering tries to fit the gamut of the source space into the gamut of the target space.

Typically, perceptual rendering lowers saturation of all colours to bring the out-of-gamut colours into the target gamut, while at the same time maintaining the relationships between colours, which helps preserve the overall appearance of images.

Saturation rendering maps the saturated primary colours in the source space to the saturated primary colours in the target space.

For digital photography, use perceptual or relative colorimetric according to the type of image. Relative colorimetric gives the most accurate mapping of pastel-coloured images. Perceptual best suits images with strong colours, which hide inaccuracies in mapping.

BLACK POINT COMPENSATION

Black Point Compensation (BPC) controls whether differences in black points are adjusted when converting between colour spaces. When on, this feature smooths out the toe of the reproduction curve to ensure that when the black of one profile is mapped to another, the tonal range is not reduced. Keep BPC turned on by default.

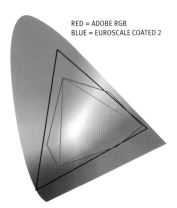

RED = ADOBE RGB
BLUE = EUROSCALE COATED 2

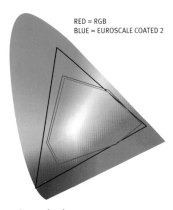

RED = RGB
BLUE = EUROSCALE COATED 2

RED = RGB
BLUE = EUROSCALE COATED 2

▲ **Perceptual intent**
The CIE Lab space is the horseshoe shape within which the larger triangle represents the input colours – those in the image. The smaller, red triangle represents the colours in a best fit within the space enclosed by the blue line, representing a CMYK space. The similarity in shape represents the rendering's attempt to map the colours without distorting relationships between colours.

▲ **Relative colorimetric intent**
In this diagram, the input colour space has been mapped to fully occupy the CMYK space (within the blue line). The gap shows that colours that do not fall within the CMYK space have been clipped – they are lost on conversion. This shows the CMYK space being fully utilized, compared to conversion with perceptual intent.

▲ **Saturation intent**
In contrast to perceptual or relative colorimetric intent, saturation intent maps as much as possible of the input colour (large triangle within the horseshoe) to the CMYK space. The change in shape of the triangle to the five-sided CMYK space represents a distortion in colour relationships, which is the price of ensuring levels of saturation are maintained.

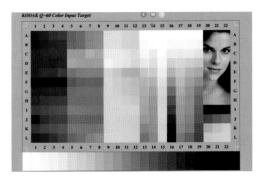

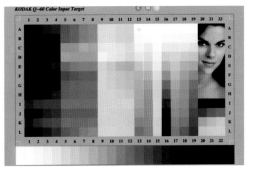

▲ **Black Point Compensation on**
This is a standard target rendered with relative colorimetric intent from Adobe RGB to Euroscale Coated 2 (a CMYK space) with Black Point Compensation (BPC) turned on. It shows more pleasant skin tones and good separation of the darker colours blocked with distinctions in dark shadows extending to Step 20 – further than with BPC turned off.

▲ **Black Point Compensation off**
This is a standard target rendered with relative colorimetric intent from Adobe RGB to Euroscale Coated 2 (a CMYK space) with Black Point Compensation turned off. It shows all the darker colours are rather blocked and greys on the bottom ramp of density being mapped to solid black from as early as Step 17.

INPUT AND OUTPUT

In the digital era the photographer has become almost wholly responsible for colour management, having to ensure consistent, accurate colour reproduction. The cornerstone of well-managed colour in digital photography is the consistent use of accurate profiles to mediate the translation of colour data from one device, such as a monitor, to another device, such as a printer. Photographers who produce images only for their own use and print at their own desktop may dispense with the disciplined use of profiles but will find themselves wasting less time and paper when printing their images.

CAMERA PROFILES

If you consistently change the tonality or colours of images from your digital camera, you can save much effort by applying a camera profile to the images. This essentially remaps all the colours to the palette that you like. To create a camera profile under controlled lighting, photograph a standard target and use profiling software to analyse it. The resulting profile is a description of how your camera's image differs from the target. But it applies only to that lighting condition. If you work under different lights or contrast ratios, the profile may no longer apply and you will need a new one.

▲ **Soft-proof menu**
This screenshot shows the Adobe Photoshop menu offering a choice of viewing the image in the working CMYK space or a custom space. Designers and graphic artists appreciate being able to view the various separation plates as well. This is useful for checking the colour make-up of added elements, such as text or graphics.

INPUT PROFILES

A camera profile is an example of an input profile, but its use is limited. In contrast, a profile for a film or flatbed scanner can save time and, ideally, even eliminate the need to adjust the scanned image. Different profiles may be needed for different colour negative films and, to a lesser extent, for transparency films. Kodachrome films tend to produce image files significantly different to those from Ektachrome or Fujichrome films.

Scanner profiles are created by scanning a standard target, then comparing the result with the target figures – the differences define the profile. This is then applied to files from the scanner. You may experiment with adjusting the scan before producing the profile.

OUTPUT PROFILES

Sometimes misleadingly known as printer profiles, output profiles describe the colour behaviour of the system consisting of printer with an inkset plus the paper being used. It is meaningless to profile a printer without reference to the other elements. The greatest range of variation can be seen here, and "canned" or manufacturer-supplied profiles may be inadequate to the task of fully controlling colour output.

It is worthwhile creating profiles specific to your own printer and your preferred paper: print a standard target – usually provided by profiling software – and analyse the print's colour profile. The best methods measure each colour patch individually in order to compare the readings with the target colour data. Manual methods are time-consuming, while a profiling service is most economical when you know which papers to use.

SOFT-PROOFING

An important part of colour management is to exploit the ability of a properly calibrated and characterized monitor to provide a soft proof, or on-screen preview, of what the printed result will look like. Set the working output profile in the colour settings or choose one from those listed in the software, then choose "proof preview".

When you first view a soft proof, it can look very disappointing, with dull colours and lacking in contrast. And that, indeed, is how the print will look. Soft-proofing is a very good reality check on whether a highly manipulated image will look good in print. It is good practice to view the image in soft-proof form from time to time during image manipulation, and always as the last inspection prior to print-out or sending the file to a client.

◄ Soft-proof of US Uncoated (*left*)
With strong colours, some may print well but others will be surprisingly weak. In this image of city light reflections in water, the reds are well printed, but the blues appear so weak as to be almost grey.

◄ Soft-proof of Pro4000 Glossy (*far left*)
Images with strong colours are best printed on a system with as large a colour gamut as possible – such as an eight-ink printer on glossy paper. While the blues are not as intense as they appear on screen, they are more brilliant than the uncoated paper print.

► Limited colour range
You may expect a colour range limited to mainly pale or neutral tones to be easy to print. In fact, the slightest unbalancing of colours will be evident. But inaccurate colour balance may be acceptable if the skin tone appears natural.

▲ Reproduction-tolerant image
Images such as this, with one dominant colour, are very tolerant of variable colour reproduction. A wide range of greens is permissible where there is no reference to the original, and the black puppies will be acceptable with anything from a bluish to a reddish black.

WHITE-POINT SELECTION

During monitor calibration, a choice of white point will be offered. Those that correspond to standard illuminants are:

D50 5000 K, warm white: pre-press and graphic arts standard; paper viewed under domestic light. Screen may look yellowish. For output to mass-production printing and most ink-jet papers.

D65 6500 K, average white: bright-white paper viewed under tungsten light; midday mid-latitude sunlight. Screen looks warm white. For output to bright-white inkjet-papers. Compromise between warm white and cool white. Best all-round choice.

D93 9300 K. Coolest indoor lighting; cloudless mid-latitude midday; good for office work. Screen looks bluish from far. For output to domestic TV sets and majority of web users.

Processing
the image

PROCESSING THE IMAGE

BLACK-AND-WHITE FILM DEVELOPMENT

DEVELOPERS AND OTHER CHEMICALS

SENSITOMETRY

COLOUR PROCESSING

IN-CAMERA PROCESSING

RAW PROCESSING

IMAGE PROPORTIONS

FILE TYPES AND USES

IMAGE WORKFLOW

IMAGE SHAPE

FILE SIZE

IMAGE LEVELS

CONTROLLING IMAGE TONALITY

BURNING AND DODGING

ANALYSIS: BURNING AND DODGING

COLOUR BALANCING

COLOUR-TO-MONO CONVERSIONS

CLONING, DUPLICATING, HEALING

MASKS AND SELECTIONS

LAYERS

LAYER BLEND MODES

DARKROOM EFFECTS

BASIC IMAGE SHARPENING

ADAPTIVE SHARPENING

PROCESSING THE IMAGE

Processing or development is a necessity in photography whether you work with a film-based or digital camera. The image caught on film is latent until it is developed, which means it is invisible until physical and chemical changes make the image visible. With digital capture, the image on the sensor is also latent, but the processes that make the image visible are of course electronic rather than chemical. The image is invisible even after processing: further steps are needed to display it on a monitor screen or print it out on paper.

FILM DEVELOPMENT

The purpose of film development is to produce a negative that is easy to print or scan, making use of normal materials and processes. The task of film processing is to:

- **Amplify** the latent image from its invisible to visible form by developing exposed silver-halide crystals into an opaque form;
- **Develop** the image to a suitable overall density and macro contrast (gamma);
- **Create grain** with the required characteristics of micro-contrast, granularity, and sharpness, which records fine detail.

Following development, the other steps of the process are to:

- **Remove unwanted chemicals,** such as unexposed silver and the by-products of development;
- **Prepare** the film, such as cleaning and drying it, ready for printing.

When exposed film is immersed in developer, the agents in the developer attack the exposed grains to produce silver. This turns transparent crystals into microscopic clouds of silver that are more or less opaque, thus having the effect of darkening film. Areas that received a lot of light appear darkest. The rate at which the silver is developed is crucial to the type of grain produced: rapid development tends to produce larger grains than slower development.

The controls you have over development are:

- **Type of developer used** – speed-enhancing for increased sensitivity, high-acutance for greater edge sharpness, or fine-grain for minimal gain size;
- **Concentration of developer solution** – stronger solutions shorten development times, weaker solutions may improve sharpness and produce smaller grain but take longer to work;
- **Temperature of developer solution** – higher temperatures speed up development and produce larger grains and higher fog and contrast levels. Best to work at standard temperature of 20°C (68°F);
- **Duration of development** – contrast as well as density increase with longer development time;
- **Amount of agitation used** – too little agitation may lower emulsion speed, causing uneven development, and too much may cause uneven development and large grain with loss of sharpness.

▶ **Cathedral at night**
Whether film or digital sensors are used, a great deal of magic is needed to capture a full-colour image in the low light of early night-time. Here, at Ely Cathedral, England, there is some light from the sky and from the tower. A very high-sensitivity setting enables a handheld shot to be obtained with fair sharpness, but careful processing is needed to extract details and colour from the shadows.

The choice of developer and development regime to match film and subject has been the subject of numerous books and pamphlets; it is the core of the craft of film-based photography.

DIGITAL DEVELOPMENT

The development of a digital image follows broadly similar lines to that of film for its purpose is similar: to produce a high-quality image that accurately reproduces the subject scene in terms of colour and tonality. In contrast with the film's latent image, which can be stored easily for quite a long time, the digital latent image is extremely fragile and must be processed immediately after capture. Digital processing must:

• **Read** the image signals, amplifying them if necessary;
• **Convert** the signals from the sensor to data;
• **Capture** other data needed for processing, such as camera settings;
• **Interpolate or interpret** raw data to obtain the full-colour image;
• **Linearize** the image – apply curves to produce visually attractive tonalities;
• **Apply** corrections to the image, such as white balance;
• **Apply** filters such as noise reduction and sharpening;
• **Adjust** the image colour space and data;
• **Save** the file to a storage device.

Digital development takes place within the camera or computer, controlled by electronic characteristics and software programming. However, if the camera is set to produce a raw file, then steps after linearizing are omitted. In this case you are choosing to do the image processing yourself (*see* pages 240–1).

BLACK-AND-WHITE FILM DEVELOPMENT

The essentials of black-and-white film development have not changed since the birth of photography. The magic of using some watery chemicals to produce a thing of such beauty and potential as a strip of film has never faded, and it continues to enchant photographers – even those brought up entirely on digital photography. The process is a supreme skill that can be carried out with chemicals mixed from scratch

and following the most scrupulous measures. Yet anyone can easily produce first-rate results with modern formulations.

PREPARATION

The key to successful film development is careful preparation. Make up the three chemicals – developer, stop, and fix – following instructions to the letter,

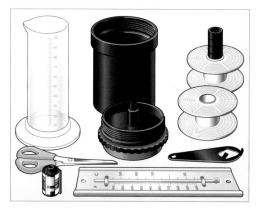

▲ 1. Assemble the equipment
Assemble a light-tight developing tank with a spiral (most tanks hold two or more spirals), a pair of blunt-ended scissors, a film-canister opener for 35mm film, and a darkroom thermometer. Everything, especially the film spirals and your hands, must be bone dry. Work at room temperature, ideally around 20°C (68°F). If you live in a hot environment, work at night if possible.

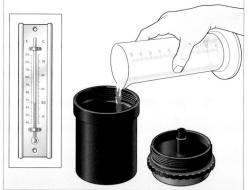

▲ 2. Make up and pour in the developer
Make up the developer to a temperature of 20°C (68°F) and pour into the tank; do not completely fill the tank with developer. Check again that the temperature is 20°C (68°F). If not, you may need to adjust development times by referring to the manufacturer's charts. Pouring developer in first is essential with larger tanks, as this ensures the film is quickly and evenly wet.

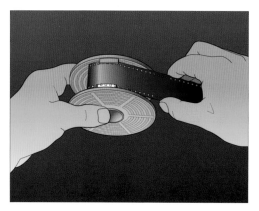

▲ 3. Load the film spiral
In total darkness, open the canister, trim the end of the film square into rounded corners, and feed it into the entry slot. If using paper-backed medium-format film, ensure that you roll in only the film, not the paper. Twist each side of the spiral alternately to inch in the film towards the centre of the spiral. If the film becomes jammed, start again; never force the film. At the end of the roll, carefully remove any sticky tape, as taking it off rapidly may cause sparks.

▲ 4. Load the developing tank
In total darkness, insert the spirals into the tank. Then shut the tank, ensuring the lid fits securely. Start timing. Hit the tank hard against the wet bench to dislodge bubbles, and agitate for one minute – that is, invert the tank, rotate a quarter turn, wait for the developer to stop flowing, then turn it the right way up again. Each agitation cycle lasts three to five seconds, so a 15-second agitation calls for three to five inversions. Continue agitation following manufacturer's instructions.

ensuring volumes and concentrations are as precise as possible. Pay particular attention to making up the developer: add ingredients in the order stated in the instructions. Dissolve all powder components thoroughly but without vigorous stirring, since you want to avoid folding air into the solution. Ensure the developer will be working at 20°C (68°F) when it contacts the film. In cold conditions, this may mean the developer has to be 21°C (70°F) to compensate for the cold spirals and tank.

DRY AND WET

It is important to work on two separate surfaces. The first is a dry bench, where you keep the spirals, load the film, and write your notes. The other side is the wet bench, where you make up the chemicals and carry out the processing and film washing.

PRACTISING

If you are not used to working in the dark, especially loading the film onto the spiral (*see* step 3), then practise in the light, then repeat with your eyes closed until you are confident you can do it in the dark.

RELIABILITY

A large part of a craft is reliability or the ability to reproduce results. Preparing chemicals contributes to reliability, so does consistent timing of each step. For example, you can start timing just after you place the film in the tank or after you have locked down the lid – as long you start timing at the same point every time, so that when you produce a beautiful set of negatives, you can confidently do it again.

PROCESSING STEPS

The first required step in film processing is that the film must become thoroughly wet; this is essential for the developer to enter the emulsion layer and get to work on the silver crystals.

Thereafter, there are essentially two processes: the first is the development of exposed silver; the second is fixing (the removal of undeveloped silver). Usually these steps are separated by an intermediate, or conditioning step, during which the development is stopped and film prepared for fix.

During development, the areas that receive the most light develop the fastest – the majority of development time is devoted to obtaining the shadow detail. At the same time, the contrast (gamma) of the negative builds up. Processing is halted when there is sufficient shadow detail with contrast suitable for printing on the enlarger being used.

Developing times vary with the developer, dilution and temperature of the developer, the amount of agitation and its pattern, the film used, as well as film exposure, and, finally, the results required.

Development takes place in a strongly alkali solution, so when it is time to halt development, the film is placed in a strongly acid solution, which is called the stop bath. Acid stops work almost instantly, but development can also be slowed, then halted, by replacing the developer with fresh water.

The fix bath dissolves all undeveloped silver, which, if left in the film, will continue to darken in light. Finally, the fix and dissolved silver must be washed out: residual amounts of fix may be left in the film, since it may help preserve it.

▲ 5. End development
When the end of the development period is signalled by your timer, immediately pour out the developer. With some developers you return the solution into a bottle for further use; with others, pour the developer away. Pour in the stop bath. Agitate for 30 seconds, then pour the stop bath back into its storage bottle. Pour in the fix, agitate intermittently or follow the manufacturer's instructions – usually a five-minute fix is ample. At the end of fix time, return the fix to its holding bottle.

▲ 6. Wash the film
The film on the spiral should look a clear, shiny black. If it appears cloudy, fix further. Clean the film by washing in clean filtered water for 30 minutes – ideally at 20°C (68°C). An efficient method is: fill the tank with water, close it, invert it 10 times and dispose of the water. Repeat a further nine times. Add a drop of wetting solution to the final bath, agitate for 15 seconds, remove film. If your water is soft, just hang the film in a dust-free area. If your water is hard, get rid of excess water before hanging.

DEVELOPERS AND OTHER CHEMICALS

Processing films and papers is very similar to the art of fine cooking in being very particular about matching ingredients to process, and in the belief that the most precise control of every aspect is essential for the highest quality. Fundamental to mastery of black-and-white film processing is an understanding of how the chemicals are made up and their properties.

COMPONENTS OF DEVELOPERS

Virtually all black-and-white film developers share common components. The most important is the reducing agent. Chemically, this is a substance that reduces the oxidation number of a chemical, often by adding hydrogen ions. In photography, silver salts are reduced to atomic silver. Only weak reducers are used, of which the most popular are metol and hydroquinone; but amidol, phenidone, and pyrogallol are also used. Reducers are used in small proportions – 10g (¼oz) for 1-litre (1¾-pint) solution, for example.

These agents need to work in alkali conditions – typically pH10–10.5. The added alkali combines with the reducing agent to make it more active, which is why alkali is also called an activator. The most common alkali is sodium carbonate; others include potassium carbonate and borax in small quantities – 2g (¹⁄₁₆oz) of borax in 1 litre (1¾ pint) of D-76, for example.

Activated developer will reduce anything it can, including oxygen in the air: as a result, it degrades quickly. A preservative, such as sodium sulphite, sodium bisulphite, or potassium metabisulphite, is needed. It usually makes up a large part of a developer – say, 100g (3½oz) per 1-litre (1¾-pint) solution. The preservative may have a side-effect of reducing grain

size. Finally, a chemical such as potassium bromide or potassium iodide is needed to control the rate of reduction. It is used in very small quantities, such as 50ml (2fl oz) of 0.001 per cent solution per 1-litre (1¾-pint) solution. Restrainers work by recombining with free silver, and thus have the effect of reducing fog and grain size. Developer chemicals are usually mixed in the following order: preservative, developing agent, accelerator, and restrainer.

TYPES OF DEVELOPER

The balance and type of components in developers are made up to favour certain characteristics or aims. Even if the four components are the same, different proportions can favour rapid development with high speed or finer grain with lower speed, while some need to be used immediately after mixing, and others have better keeping properties. The most common developer types are general-purpose developers such as D-76 (also ID-11), which combine fairly low contrast with average grain size, and micro-contrast with good shadow detail. They are based on metol and hydroquinone, are highly tolerant of processing conditions, and give modest speed gains. They are also capable of fine-grain results with increased dilution.

Acutance measures the sharpness of an edge. Acutance developers aim to give the sharpest results by enhancing the edge by using adjacency effects at boundaries between dark and light. One of the best known is FX-1, which is based on metol; others are Neofin and Rodinal. For best results, negatives must be carefully exposed to the minimum density needed for a good print.

▲ **Agfapan 25 in high acutance**
Agfa Agfapan 25 was famed for its extremely high sharpness and fine grain, resulting in smooth tonal transitions. With care, images on 35mm could match those of medium-speed medium-format film. This scan shows the fine smoothness of the image and excellent sharpness of the negative.

▲ **Tri-X pushed to 1600**
This high-magnification scan of 35mm Kodak Tri-X pushed to 1600 shows the expected graininess. But there is a sense of sharpness due to the increase in midtone contrast, although that is illusory, since the grain prevents the recording of fine detail. Note that the white in the number is actually grey.

▲ **Tri-X pushed with fine grain**
Kodak Tri-X pushed by 1 stop using a general-purpose fine-grain developer shows surprisingly low levels of grain, promising good tone, but fairly unimpressive sharpness, which is to be expected from the fast film. Note that contrast is lower than that of the more aggressively pushed Tri-X.

▲ Working at night
In low light, one must balance low image quality against failing to obtain any image at all. The trick is to avoid reliance on fine detail; instead, aim at balancing and working with broad blocks of shape and outline.

Push-processing developers allow film to receive less exposure than usual, thereby obtaining a speed gain of around 1 stop with little loss in quality, and greater gains with increasing grain, loss in definition, and rise in fog. These developing agents use glycin, phenidone, and hydroquinone (in the case of FX-11, one of the best-known formulations).

PROCESSING AFTER DEVELOPMENT

The stop bath aims to halt development, but if the solution is made too strong, the negative can be damaged by the sudden large change in pH from alkaline to acid. Fix is used until we are confident all unexposed silver is totally dissolved – this is based on timing and agitation. The active component of a stop bath is usually acetic acid in a concentration of around 1–1.5 per cent. An indicator dye may be added that changes colour when the bath is no longer acidic.

For fixing – removing undeveloped silver – ammonium thiosulphate and sodium thiosulphate are most commonly used. A hardener may be added when fixing negatives to make them more durable. No more than the recommended number of films should be put through a fixer solution, because old fixer contains a high concentration of dissolved silver, which can coat and damage film.

Washing fixer out of film can be a slow process because of its low solubility. We can add chemicals such as sodium sulphite, which combine with fixer to make a highly soluble compound and which wash away easily and reduce wash times.

HEALTH AND SAFETY

While the majority of photographic chemicals are not highly poisonous, if you follow good practice it will help ensure you do not develop hypersensitivities, such as skin rashes or eye problems, that will eventually prevent you from working in a darkroom.

• Use gloves, safety goggles, and a waterproof apron when mixing chemicals.
• Use a face mask or dust mask when handling fine powders.
• Always mix chemicals in the order instructed.
• Mix chemicals at the temperatures indicated.
• Never pour water on any acid; always add acid to water.
• Ensure all containers and graduates are dry before use.
• Measure chemical amounts carefully.
• Clean beakers, graduates, containers, and hands thoroughly after working.
• If you develop itchy skin or rashes, or if your eyes water, stop working immediately and identify the cause. Refer to a health and safety officer for advice.

SENSITOMETRY

Sensitometry is often said to be the study of the response of photographic materials to light. But that definition is meaningless without reference to the way in which the materials are processed. After all, different processing regimes change, and can even reverse, the way that a material reacts to light. In fact, sensitometry measures the changes in density of developed film relative to variations in exposure. From the data, we can understand the way the film records the subject's variations of light and shade, tone, and contrast. In the digital era, sensitometry is no less relevant than it was in the analogue era, since sensors share many of the characteristics and limitations of film.

▲ Tones and the curve
This image clearly shows the loss in detail in the high-exposure regions around the sun and in the bright clouds, as well as in the shadows in the buildings, thanks to their position in the shoulder and toe regions of the characteristic curve. The tones in the middle of the image, on the other hand, show rich gradations typical of the straight-line portion.

to film. With sensors, readings of the sensor's response are taken from the raw file data for comparison with the standard lighting. The ISO 12232 standard describes how to measure speeds for digital imaging, which allows ISO speeds in digital and film capture to be equivalent. In practice, we are aiming for an ISO setting on a film or digital camera faced with the same subject lighting using similar lenses to result in the same focal-plane exposure.

However, there are two ways of looking at digital sensitivity. One gives precedence to the best image quality, called saturation-based ISO speed. The other gives precedence to a higher speed by defining the highest exposure index that gives an acceptable image; it is called noise-based ISO. Standard film-speed determination is analogous to noise-based ISO because it depends on the level of fog deemed acceptable.

MEASUREMENTS

The laboratory method of studying film is to expose it to a stabilized and standardized incandescent light source for specific times. Alternatively, film is exposed through a step-wedge of different densities, which gives the film a range of exposures in one pass. The exposed emulsion is then processed under carefully controlled conditions. The film's varying densities are measured using densitometers, then the results are plotted against the corresponding exposure, and the resulting curve is valid for the specific processing conditions used. With negative films, the curve rises from near zero as density increases with greater exposure. With reversal films, the curve goes the other way, falling from a maximum density with zero exposure, to transparency with increasing exposure.

SENSOR SENSITOMETRY

Despite the fundamental difference between the sensitometry of sensors and film, it is nonetheless most convenient to be able to make digital-capture sensitivity equivalent

CHARACTERISTIC CURVE

Each film and processing regime yields a curve that plots the relationship between density and exposure and is characteristic of the combination, hence the term "characteristic curve". Its shape can tell us much about the tonal qualities of the film and tends to be the same for a film that is processed in identical ways.

TOE SECTION

With the lowest exposures, changes in exposure do not register as changes in density, but density is not quite zero because of contributions from the film base

and fog. The toe section is that part of the characteristic curve in which the film is just beginning to respond to changes in exposure. There is a slight but slow increase in density with exposure, so contrast is low.

STRAIGHT-LINE PORTION

As exposure increases, the film responds in step with exposure – equal increases in density with equal increases in exposure. With exposure on a logarithmic scale, this is plotted as a straight line and therefore a more or less constant slope. Note the gradient of the slope here is greater than in any other part of the characteristic curve. This is the core of the curve: it is where the low to high, or dark to light, midtones reside; it is where most detail is found and where the tonal quality of the image is judged.

SHOULDER SECTION

The upper section of the curve is a curved line that gradually levels off from the straight-line portion; it is called the shoulder. Like the toe area, equal changes in exposure do not produce equal differences in density: the levelling off indicates a lowering of contrast or loss in detail with high density. In normal exposures, bright highlight tones of the subject are reproduced in the shoulder section of the curve. With extreme exposure, the curve can point downwards, indicating a loss in density. This is known as reversal and may occur when the sun is captured on film, for example.

GAMMA

The slope or gradient of the straight-line section of the characteristic curve is measured by gamma. It provides a measure of the contrast reproduced by the negative. Gamma varies with the degree of development of photographic materials: generally gamma rises as development increases. Gamma needs to be matched to the printing paper used, the intended processing – whether toning is intended, and should also be matched to the type of printer used.

IMAGE STRUCTURE

The choice and control of development is not solely concerned with gamma, but also the image structure – that is, the film grain properties determining the film's ability to record detail. Development to give a high gamma may produce the high-contrast effects desired,

▶ **Idealized characteristic curve**
This diagram shows an idealized characteristic curve with rising density on the y-axis and the logarithm of exposure on the x-axis. The curve starts just above zero, at A, representing the base fog present on development whether the film is exposed or not. B marks the threshold turning point where the film starts to respond to light: the curve at first rises slowly as exposure is increased. At the point marked C, the slope of the line is constant until point D, when it starts to level off. Between C and D is the straight-line portion, which carries the important midtone detail. After D, the shoulder portion shows a loss in contrast as

but a side-effect may be increased grain size and fog, as well as very high densities in areas with high exposure.

Equally, minimal development gives the sharpest results with finest grain, but the negatives may be too thin and low-gamma to produce pictorially effective images.

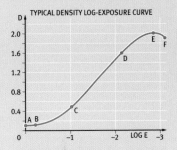

TYPICAL DENSITY LOG-EXPOSURE CURVE

exposure is increased. Smooth transitions at C and D are very desirable features of films for pictorial use. At E, the curve turns into the region of reversal.

TOE CURVE

MID-TONE CURVE

▲ ▶ **Regions of the curve**
These diagrams show typical characteristic curves and broadly mark the low-light toe region, the midtone straight-line portion, and the high-exposure shoulder regions. Small features of the curves and the way they change direction can have significant effects on the tonality of the image.

SHOULDER CURVE

▶ **Digital camera curves**
These curves, based on studies by Henri Gaud, show typical digital sensitometry – ISO 3200 far left, then 1 stop slower towards the right, down to ISO 50. Note the straight-line portion takes up the vast majority of the curve. Despite changes in sensitivity, the curves run almost perfectly parallel to each other, which shows there is no significant variation in gamma with different sensitivities. Amazing!

CHARACTERISTIC CURVES FOR CANON 1DS MARK II

COLOUR PROCESSING

The first step in colour film processing is essentially a black-and-white development: it targets exposed silver-halide crystals and produces a negative. Thereafter, colour film processing diverges from black and white in order to bring in the colour. Today, essentially two processes remain – the colour transparency and the colour negative. They are integral tri-pack chromogenic dye-coupler films, which means they use three separation layers for registering colour, and they depend on silver grains coupling with dyes to create the colour image. The processes' need for high-quality chemicals, costly machines, and careful management is clearly a weakness compared to the ease of digital processing.

NEGATIVE PROCESSING

In negative colour film, the colours are reversed or complementary to the primary colours: blue records as yellow, green records as magenta, and red records as cyan; see the diagram for a more detailed explanation. The hue reversal will be reversed on printing to obtain the true colours. There are four basic steps to the processing cycle: developer, bleach, fix, and stabilizer.

In colour development, the exposed silver is developed by a developing agent (paraphenylene diamine or CD-4), which becomes oxidized in the process. Dye couplers are agents that link oxidized developer with dye, which ensures dye is coupled only where developer is used up, and also in proportion to developer oxidation. The temperature of the colour developer is the most critical of

all the processing steps and must be 37.8°C ± 0.15°C (100°F ± 0.54°F). All other wet steps in the process can be within the range of 24–41°C (75–105°F), although as near to 38° (100°F) as possible is best.

Bleach takes the metallic silver still in the colour film and converts it to a form that can be fixed. All of the silver – exposed or not – must be removed. Only the colour dyes form the image. The bleach chemically converts the silver metal back to a soluble silver halide.

The fixer step is essentially the same in colour processes as in black-and-white processes. Finally, the stabilizer helps prevent unused magenta dye couplers from attacking the newly formed magenta dye.

REVERSAL PROCESSING

Colour transparency films form dyes according to a reversed silver positive. For example, a yellow-dye image forms in the top emulsion that corresponds to an absence of blue in the original scene; it thus subtracts blue. On the other hand, the blue image is formed by the magenta and cyan dye (respectively the dyes are minus green and minus red, which equals blue). Colours are recorded by subtractive mixes of secondary colours. The now universal process is the Kodak E-6. There are seven chemical steps: first developer, reversal bath, colour developer, pre-bleach, bleach, fixer, and final rinse.

The first step is a normal black-and-white development that converts the exposed latent image in each emulsion layer to a metallic silver. Like black-and-white negative processing, after the film leaves the first developer, there are undeveloped areas where the silver halides are unaffected by camera

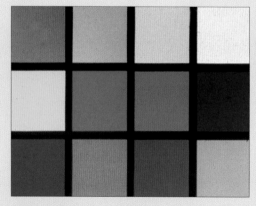

▲ **Fine-grain film 1**
A fine-grained transparency film shows good colours and fineness of grain but relatively high noise from grain.

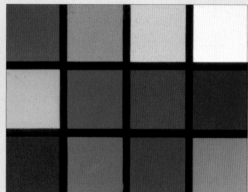

▲ **Fine-grain film 2**
This film shows excellent smoothness of tone, but its overall colour balance is cool, while colours are not very vibrant.

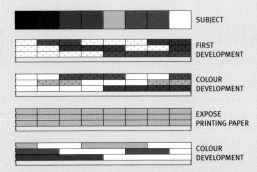

	SUBJECT
	FIRST DEVELOPMENT
	COLOUR DEVELOPMENT
	EXPOSE PRINTING PAPER
	COLOUR DEVELOPMENT

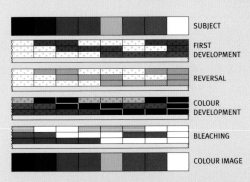

	SUBJECT
	FIRST DEVELOPMENT
	REVERSAL
	COLOUR DEVELOPMENT
	BLEACHING
	COLOUR IMAGE

▲ The colour negative/print process

The top bar represents the colours in the subject, with their effects on the film at the first development stage. Black in the subject leads to clear film, white exposes all three layers, while different colours expose one or more layers corresponding to their separation colours – red, green, or blue. With colour development, the top blue-sensitive layer picks up magenta (minus-blue) dyes, the middle picks up yellow as it is minus green, and the red-sensitive layer becomes cyan. On printing paper, black areas in the subject carry all three colours and so appear black, while two or more subtractive colours combine to reproduce the original colours of the scene.

▲ The colour reversal process

The top bar represents the colours in the subject, with their effects on the film at the first development stage. Black in the subject leads to clear film, white exposes all three layers, while different colours expose one or more layers corresponding to their separation colours – red, green, or blue. Note this is all in the negative; therefore, the positive image is carried in the undeveloped silver. The crucial step is reversal: this turns undeveloped areas into developable silver. This is colour developed, so colours are coupled to the positive image (and cannot attach to the negative but that is already developed). Bleach/fix removes the silver to reveal the subtractive primaries.

exposure. It is these undeveloped areas where the final colour-positive images are formed in reversal film.

After the first developer, the film is fogged or re-exposed in the reversal bath to form the positive image. After fogging, the film is developed in a colour developer, which works the same way in colour reversal processing as it does in negative processing. It changes the fogged silver halides to black metallic silver, and at the same time, cyan, magenta, and yellow dye couplers are formed by the exhausted developer.

The bleaching and fixer processes remove metallic silver, working in ways similar to that in colour negative processing. Once the silver is gone, only the dyes remain, forming the image.

It is possible to push-process (underexpose and over develop) or pull-process (overexpose and under develop) colour reversal film with some losses in quality. Push-processing leads to weaker blacks, reduced exposure latitude, and increased grain. For these reasons, push-processing greater than 2 stops is not recommended, except with certain films designed for push-processing. When the exposure index for the film is changed, only the first developer time is changed, while the rest of processing is unchanged.

▲ Pushed film
A transparency film that has been pushed shows a rise in graininess, but the gain in contrast may be useful.

▲ Coarse grain, ISO 400
A fast film shows not only high levels of grain or noise, but muted colours, with poor midtone contrast.

IN-CAMERA PROCESSING

The best-known film camera that processed images inside the camera used Polaroid or similar instant film, which had integrated developer components. However, no system could produce true negatives in-camera, only unique prints. Until the advent of digital cameras, true in-camera processing was a science-fiction dream.

Now, however, digital in-camera processing is one of the keys to the success of the digital camera, since it removes the need for separate processing facilities, thus enabling images to be instantly available for viewing, download, manipulation, wireless transmission, archiving, or even printing by remote printer.

ANALOGUE-TO-DIGITAL CONVERSION

The capture of the image on a sensor is essentially an analogue process: the charge (in the case of CCD sensors) or the voltage (in the case of CMOS sensors) that is present is proportional to the sum of the light energy falling on the sensor. This analogue variation must first be turned into numerical data – a process called quantization.

In the majority of sensors, the quantization is 8-bit, which means the level of charge or voltage is divided into 256 units. In many modern and all professional cameras, the quantization is 12-bit or greater, giving 4096 units to work with – some 16 times more accurate than 8-bit.

Cameras such as the Canon EOS 1D Mk III use 14-bit analogue-to-digital conversion, significantly improved from 12-bit in previous models. This means the maximum number of tone steps possible in

a raw file rises from 4096 to an awe-inspiring 16,384.

Although the final image is seen in only 8 bits per channel, the headroom offering by processing with 14-bit allows for computations with fewer errors, especially when working in the shadow and highlight parts of the image.

After quantization, we obtain a set of raw or unprocessed data: each item stores the quantized (measured) value representing the light reaching each individual sensor in the Bayer array (*see* page 126). Note that, unlike a ruler where units are equally spaced, quantization values may not be evenly spaced over the sensor values. This is important at the stage when the data is interpreted.

COLOUR FILTER ARRAY INTERPOLATION

The raw data is often called a "digital negative" because it has received no processing: the system just measures the light falling onto each sensor. So, for a sensor covered by a red filter, we have only the value for red; for the adjacent blue filter, only the value for blue. Essentially this is only a greyscale image – a map of luminance variation across the sensor surface – albeit one mapped with the corresponding information about which pixel in the mosaic of filters represents which colour.

In order to extract the full colour information, we must make calculated guesses, or interpolate the figures. For example, take a red

▼ **Image-processing pipeline**
The one-directional nature of image processing is shown here. Incoming light is converted by the sensor into analogue signals that are digitized by the analogue-to-digital converter (which may be built into the sensor) into a digital signal. This is then processed to create a data stream of the image that is sent to memory card for storage.

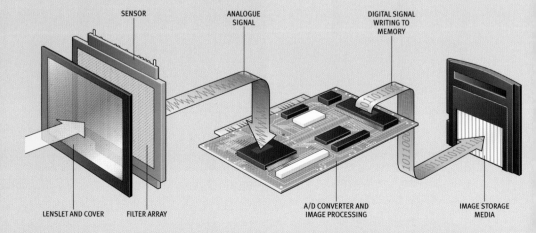

SENSOR

ANALOGUE SIGNAL

DIGITAL SIGNAL WRITING TO MEMORY

LENSLET AND COVER FILTER ARRAY

A/D CONVERTER AND IMAGE PROCESSING

IMAGE STORAGE MEDIA

pixel: we have direct information for red, but in order to obtain the full RGB values, we must work out – because we cannot measure – the G and B values. The process is called colour filter array (CFA) interpolation, or demosaicking (also spelt "demosaicing").

However, that is not all. In the process of demosaicking we need to preserve the dimensions and details of the image and at the same time not introduce artifacts. There are many ways of demosaicking; none is perfect for all tasks, but all require a surprising amount of computation (see diagram, right).

Consider that similar – usually more complicated – computations are needed for every one of the millions of pixels in modern digital cameras, some of which can process images at the rate of eight or more frames of 12 megapixels per second. To appreciate fully the amount of computation needed, let's consider a very simple demosaicking scheme.

DEMOSAICKING ALGORITHM

Here we describe a simple demosaicking algorithm or set of calculations called edge-directed, because the direction of the edge decides for us how to calculate desired values. Refer to the diagram on the right to see which squares are being calculated.

Suppose we know the value of red at square 5 – the central red pixel – and want to interpolate the missing green (G) value.

First we calculate the horizontal gradient by averaging R3+R5 and subtracting R5. The vertical gradient is the average of R1+R9 less R5.

Now, we need to know, if the gradient of green is changing, which direction it is going.

We compare the two gradients that we have; if the horizontal gradient is greater than the vertical – the change in red is faster in the east–west direction than in the north–south – in this case the value for G5 is the average of G2 and G8.

▲ **Demosaicking variations**
These images show how different ways of demosaicking result in images with varying virtues. One method produces few colour artifacts but creates false image detail with exaggerated contrast (*left*). While a simpler method creates many colour artifacts (*middle*) although some details – such as the top right-hand corner – are truer. The third method (*right*) delivers good details – such as at the top back of the image – but there is some colour artifacting.

If otherwise – red changes faster in the vertical direction – the value for G at square 5 is taken as the average of G4 and G6.

Otherwise, if the red vertical and horizontal gradients are equal, for example, then we can assume there are no imminent changes in any direction, so the value of G5 is the average of all the surrounding G values – G2+G4+G6+G8 divided by 4.

So now we have the second value for square 5. We still have to calculate the missing blue (B) value, using the same method. Special arrangements have to be made at the edge of the sensor – the easiest being to use the outer two or three rows to calculate the values for inner squares, but drop the outer ones from the image.

Other methods of demosaicking calculate with more squares contributing to each channel value or use sophisticated statistically derived weightings.

IMAGE FILE

The result of demosaicking is the raw image, which is sent down the pipeline to be converted into an image file. At this stage, various settings, such as exposure and tone, white balance, black and white points, colour saturation, and sharpening, will be applied.

In some cases, image size may also be set now, together with other

		1		
		2		
3	4	5	6	7
		8		
		9		

▲ **Demosaicking variations**
This diagram shows the central red square at 5 for which we need to interpolate the green and blue values. The algorithm described here uses values from the neighbouring eight squares, but others may use all 24 squares.

data such as EXIF (image file information), file name, and image metadata, such as colour profile. The result is then run through the JPEG protocol – where preset quality settings are applied – to produce the final, usable image file compressed to save space. Some cameras allow files to be processed to TIFF.

The result is an image that is sent to be stored in the memory card; the in-camera processing is complete. Further processing may be needed, as with a film negative, to produce the final print or image to satisfy the individual requirements of the photographer.

RAW PROCESSING

Camera raw files are much larger than JPEGs files containing the same number of pixels but can be smaller than uncompressed TIFF files. Some raw files are stored compressed (losslessly) and may also embed a JPEG image for reference. The unprocessed nature of the raw file allows you to interpret the data yourself and promises the best image quality. Different cameras read and organize the image data in different ways. As a result, there is no single raw image format, even with some manufacturer's own line of cameras. This results in a profusion of different formats – more than a hundred at the time of writing.

RAW FORMAT SUPPORT

In order to work with raw files, your software must support the format being offered – raw converters can be updated via the internet for the more popular new models. Alternatively, you can use the software supplied with your camera. As with film processing, there are different ways to "develop" the digital negative – some software reduces noise more effectively; others produce poor detail in highlights. Applications such as Phase One's Capture One is favoured by many for its excellent results, while Apple Aperture is winning converts. Adobe Camera Raw supports the largest number of formats and is the most versatile of them all. Others include Bibble, BreezeBrowser, and SilkyPix. Check your camera is supported before you make a purchase.

ADVANTAGES OF WORKING WITH RAW

While working with raw requires more time and effort than with JPEG files, the rewards are ample for those who require the quality and who demand a high level of control. Raw processing ensures you preserve the

◄ **Apple Aperture**
This is the adjustment control for Apple Aperture, offering very extensive tonal, colour, sharpening, and noise controls but lacking correction for chromatic aberration, vignetting, or distortion. Precise and repeatable settings can be made, but using the controls can be awkward. This is a floating control panel that can be moved around the screen while the image is displayed. Changes are not applied to images until exported.

maximum amount of original image data – especially in shadow and highlights – which helps ensure the highest possible image quality from each file. This is in contrast to JPEG files, which, by definition, remove a great deal of data. Raw processing offers you maximum flexibility with image brightness and its white balance and also removes the limitations of fixed in-camera processing, such as sharpening and colour space. Remember, however, that if you make prints smaller than the maximum recommended, many of the advantages of raw processing will be lost in the print.

WORKING WITH RAW

The key advantage of working with raw files is that the workflow is set up for non-destructive changes, that is to say, changes are not made to the original file, but the raw conversion applies all the required settings and

▲ **Close-up of JPEG image**
A 50MB file enlarged to 100 per cent is in the background, and a 400 per cent enlargement is within the "loupe". There is good detail in the highlights of the leaves and fair detail in the dark shadows of the tree. This is more than adequate for a print over 1.5m (5ft) wide.

▲ **Close-up of raw image**
A 50MB file enlarged to 100 per cent is in the background, with a 400 per cent enlargement within the "loupe". Compared with the JPEG image within the loupe, there is a great deal more tonal gradation and detail, even in quite deep shadow.

▶ Capture One

Phase One's raw converter offers a rudimentary file browser as well as a step-by-step system for adjusting the image processing. It has powerful batch-processing facilities and is famed for the superior results it can produce.

▼ Camera calibration

Tints or colour casts introduced by your camera may be a constant factor that you would apply to every image. These standard corrections can be set up in software such as Adobe Camera Raw but can still be adjusted at any time to suit specific needs.

▶ Adobe Camera Raw

The best-known raw converter, because it is a part of Photoshop, is easy to use and offers good corrections for aberrations. As understanding of raw processing has grown, so the controls have become more able and subtle in their effect. One strong point of the Adobe offering is that the controls are responsive and easy to set.

effects to a new version of the original file and saves the new file while leaving the original untouched. A simple workflow for raw files is as follows:

1. Upload files from camera to hard-disk.
2. Make a back-up set – some software allows you to upload images to two different hard-disk destinations at the same time.
3. Open the image using your raw converter.
4. Make settings – exposure, contrast, white balance, colour adjustments, correction for chromatic aberration, sharpening – or apply presets to the image to your satisfaction.
5. Set pixel dimensions, bit depth, resolution, and colour profile for output.
6. Output or export the image in JPEG or TIFF.

BATCH CONVERSION

The job of a raw file converter is to apply all the processing the camera would normally do to deliver vibrant, sharp, and well-exposed images. Some raw converters allow you to calibrate the conversion – make fine adjustments to colour reproduction – to match your own camera's characteristics; this has the effect of applying a camera profile to all images.

Where images are taken in identical circumstances, settings that suit one will suit the others. All raw-conversion software allows you to save settings, then apply the same setting to entire folders full of images; this is called batch processing and can save a great deal of manual effort and save supervised processing. However, processing large numbers of images will take some time, even on fast computers.

DNG

Adobe Digital Negative (DNG) is an attempt to bring order to the proliferation of raw formats by creating a common format. It provides a "wrapper" for the data, based on TIFF, which is designed to be extensible to allow for metadata (such as MakerNotes specific to the camera or manufacturer) but still allow for a raw converter to work for all raw data, irrespective of its source and to provide a format suitable for archiving. At the time of writing, many applications can read DNG but only three can write it, while just four camera manufacturers support DNG. It remains to be seen whether DNG is universally adopted.

IMAGE PROPORTIONS

In the digital era, our control over the image proportions is extensive, easily carried out, and extends to distorting image shape if required. This contrasts with film cameras, where adjusting image proportions is essentially limited to cropping into the image format. It is possible to make changes to the shape of the image during printing by tilting the lens board, negative carrier, or printing frame, but these are limited by the narrow depth of field available at the enlarger.

CROPPING

In film-based photography, cropping was a necessity, since many cameras recorded more on the negative than was seen in the viewfinder; the purpose of the crop was to trim the image to what the photographer wanted to record. With digital files there is no extraneous image except that allowed by the photographer. However, photographers do not always frame very precisely, so there are often parts of the image on the periphery that are unwanted. Cropping retrieves the intention by trimming the extraneous and superfluous, giving the effect of zooming into the subject. Cropping can be constrained to the image proportions or produce images with different proportions.

Some photographers regard cropping as a technique motivated by laziness in approach or caused by carelessness at the taking stage – something that is best avoided. A good technical reason to avoid cropping is that it reduces usable film area or effective file size, therefore reducing quality.

▲ **Snapshot – uncropped**
This snapshot is an untidy image due to several factors. It has been taken at an awkward angle and is not close enough to the action and movement of the worshippers. It also misses the interesting shadows, and the foreground is empty and excessively large.

▶ **Snapshot – cropped**
With a severe crop into the snapshot, we lose much of the visual distraction around the monks and also straighten up the verticals. However, such a crop greatly reduces the size of the image and the highest original image quality is required for acceptable results.

PANORAMAS

The extremes of image proportion are seen in panoramas, in which the length or height of the image can be greater than the depth or width (the aspect ratio is very high). Note that in a true panorama, the lens rotates to take in a field of view wider than is possible without movement. But the term "panoramic" is widely applied to formats that are very wide and narrow.

Irrespective of the actual angle of view, the effect of a panoramic or high aspect ratio is to give the impression of a wide angle of view. This is a visual illusion caused by losing the spatial information that would otherwise be given by the missing upper and lower parts of the image. A severe panoramic crop can strongly dramatize an image.

▲ **Panoramic crop**
A normal focal length view can be cropped severely to a wide but very narrow letterbox shape to convey the idea of a panoramic view. The removal of background from the top and foreground from the bottom gives the illusion of a wide view.

ROTATION

While the image is being cropped, the sides of the crop can remain parallel to the original image sides or be rotated at an angle. Typically, images are rotated to correct uneven horizons. The greater the angle of rotation, the bigger the crop on the resulting image in order to avoid having the corners cut off. More of the image is lost if proportions must be maintained. In addition, repeated rotations will blur image detail, so it is best to make the correction in one step.

▲ **Non-level horizon**
A grabbed landscape shot (1) produces a non-level horizon, but it is worth correcting. You can draw a large crop over the image, then try to turn it to correct the horizon but that is tricky because the edge of the crop is far from the horizon. In some software, you can measure the angle of the horizon, then rotate the crop by the same amount. But here is an easier way. Draw a narrow,

letterbox crop near the horizon (2). The lines of the crop are now easy to line up with the horizon by rotating the crop box manually. Now pull the crop box out so that its corners touch the margins of the image. Many programs have a "snap to" feature in which tools jump to the image margin or other guide. Do this for all four sides (3), and you will have a cropped image that is as large as possible and to the same proportions as the original.

FILE TYPES AND USES

File types are differentiated by the ways they organize information. While the bulk of an image file is the image date itself, in order for software to know how to interpret the data, it needs to know how the data has been organized – rather like knowing how to recognize paragraphs and chapters in written text. In addition, file formats also define the organization of basic information such as file name, other data or metadata, time of creation, type of camera and settings used, and so on. The data within a format may also be compressed to minimize space. For example, removing the vowels in text saves space, but compressed data must be uncompressed to be usable.

JPEG

In photography, JPEG (pronounced "jay-peg") is by far the most commonly used format. Strictly, JPEG is a protocol describing how to compress data. The standard is in fact IS 10918-1, the first part of which incorporates the JPEG standard. It is important to realize that what we refer to as JPEG is more than simply a compression method and more than a way of ordering data.

JPEG is a popular format because it enables image files to be considerably compressed yet retain their usefulness. Although JPEG is a lossy format – you trade loss of detail and lower quality for small size – depending on intended use, it is possible to reduce JPEG file sizes to 1/40 of the original size and still obtain acceptable image quality.

It is often recommended that you do not save and resave files in JPEG because each save recompresses the JPEG and loses more and more data. In fact, if you decompress and recompress images using exactly the same quality setting each time, there is very little degradation. However, the areas that you modify between saves can be degraded – and if you change the exposure, for example, that means the entire

▲ Compressed 17x
The original file was 4.9MB, but even with maximum JPEG compression (lowest quality) the file is some 284KB, a 17x reduction, resulting in a file nearly six times larger than that of the surfer (*left*). The difference is that the peacock is full of fine detail, and image noise is also high, which the compression algorithm sees simply as more detail that should be preserved.

◄ Compressed 100x
The original file was 4.9MB, but it has been possible to compress it to just 49KB – just over 100x – with lowest-quality JPEG. This is possible because there are large areas of near-identical colour and luminance values. In detail, the image is badly compromised, and banding has crept into the sky, but it is still visually acceptable.

image may degrade. Nonetheless, for mid- to high-quality settings, numerous resaves in JPEG make hardly any difference to the quality. Therefore, a few resaves in JPEG are not likely to do visible harm.

When JPEG bitstreams have to be used, such as to send pictures with emails, JPEG File Interchange Format (JFIF) is recommended because its simplicity ensures versatility over a wide variety of platforms and applications. This minimal format does not include any of the advanced features found in the TIFF JPEG specification or any application-specific file format as its only purpose is to allow the exchange of JPEG-compressed images.

TIFF

TIFF is widely used as the file format for delivery of high-resolution images for publication or high-quality printing. By a small margin, the majority of authorities say TIFF is an acronym for Tagged Image File Format. In fact, the latest standards for TIFF do not spell out the acronym, thus perpetuating the confusion over whether T stands for "Tag" or "Tagged".

More important, however, is that the tags – 47 are defined in version 6 of the standard, and private ones can be defined – are the feature that makes TIFF flexible and versatile. Thanks to them, it can be adapted by software engineers for a great number of uses.

TIFF is like a book: the basic structure (pages, chapters) is the same, while the contents vary – and the contents, like the tag – tells you what to find and where to find it. Many raw formats are TIFF in structure.

The format allows for compression: LZW (Lempel-Ziv-Welch), which can reduce file sizes without any loss of data by around 50 per cent, given the usual mix of detail and average proportions of even tone. LZW is, unlike JPEG, a lossless compression, meaning no data is discarded during compression, so files can safely

be compressed and decompressed. However, be aware that some RIP (Raster Image Processor) and other systems prefer to work with uncompressed TIFF files.

This method is said to be byte-oriented, which is important, since it means that the data can be efficiently compressed and stored whether it is saved for Mac or PC processors.

COMPRESSION

In the early days of digital photography, it was important to compress files to reduce the size because mass data storage was very costly. In these days of cheap mass storage, however, the need for compression is not as compelling. On the other hand, as pixel counts on cameras continue to increase and as more photographers capture in raw form, so the size of image files continues to rise and keep pace with the drop in cost of mass storage. Now, issues such as time needed to handle files and reliability are perhaps more important than ever.

If speed of operation is important to you, it is worth assessing whether you should routinely compress your files. However, it is important to note that all output processes are essentially lossy regimes: the output is always of lower quality than the information used to create it.

Printing discards data it does not need, so it is pointless to give excessively large files to a printer.

▲ **Growth of JPEG artifacts**
This set of images shows how artifacts caused by lossy compression can cause problems during image manipulation. The first image shows a very small portion of perfectly even blue sky, but JPEG artifacts have exaggerated noise to create uneven patches of colour. After tonal and saturation adjustment, the unevenness is clearer (2). But it is made unacceptable when sharpening (3) is applied.

JPEG COMPRESSION

The compression method used in JPEG involves a lot of computation: note that not all steps lose data. First, the Discrete Cosine Transform takes data in blocks of 8 x 8 pixels and converts them from the spatial domain to the frequency domain – similar to representing a graph of a continuous curve as histograms. This step compresses data, loses no detail, and identifies data that may be removed. Second, during matrix multiplication the data is re-ordered for quantization. Here, variable amounts of the data can be discarded through the choice of the quantization coefficient – this is what you set on the quality sliders. Third, the coding compresses and codes the results of the last step using a lossless process. In addition, some processes employ chroma sub-sampling – looking at the average of four pixels in a square, instead of the colours of each pixel. The sum of these effects helps achieve JPEG's very high compression rates.

IMAGE WORKFLOW

In the early days of digital photography, photographers muddled through image processing. Often the first step was to locate as quickly as possible all the "good" shots, improve them, only then belatedly to remember to back-up all the images. At this point we may have realized that profiles were not embedded in the images, they are all at 72dpi when we need them at 225dpi, so these had to be changed. And as collections of images grew, it became apparent the metadata attached to images was a significant part of the value of the images; speeding up metadata entry is now an essential consideration for the image-processing workflow.

he workflow suggested here is designed to save you time, help preserve quality, and produce results more reliably.

INGEST AND BACK-UP

Upload images from your camera directly or from the memory cards to your computer. In the process, use software that applies metadata such as date, location, copyright, colour profile, and resolution, if possible. Rename the images with sequential numbering – for example, Langsbeach001, Langsbeach002, etc. If you cannot upload to two hard-disks at the same time, back-up the originals immediately.

INSPECT

Make a quick check of the images: are they sharp, well exposed, well colour-balanced, of the requisite size? Do this quality inspection as soon as possible after the shoot: if any problems surface you may be able to re-shoot. But make this check under reliable viewing conditions. If your camera does not rotate images automatically, rotate them now.

EVALUATE AND KEYWORD

While the first two steps ideally take place during or immediately after a photo-shoot, this and following steps can be carried out at a more leisurely pace. Evaluate your images to locate the firsts, seconds, and rejects: apply star ratings or colours to sort the images out. If possible – while memory is still fresh – write captions and apply keywords. Note any applicable rights, such as if model releases are available, or if the images can be licensed royalty-free. Spot check for quality by examining a few histograms (*see* pages 252–3).

IMAGE IMPROVEMENTS

The previous steps do not alter any of the image data (rotation is not substantially destructive), but all the following steps do – and in increasing order of destructiveness.

First, ensure you are working on a copy of an original image by "saving as", with a new file name. This becomes the file you are working on. If possible, save to a storage device different from that holding the original image. Next, you will want to straighten or crop the image – resize it if the image is larger than required.

APPLY TONAL CORRECTIONS

Next you will want to correct image tone – the exposure and contrast – to normalize the blacks and highlights. Err on the side of less contrast rather than more: colour adjustments and sharpening may

▲ 1. Ingest
Upload the contents of your memory card or back-up device to computer. Add basic metadata, rename if required, change resolution, add profile, and create a back-up copy.

▲ 2. Inspect
Identify firsts, seconds, and rejects, and rotate images as needed.

▲ 3. Evaluate
Mark up chosen images with colour codes or stars.

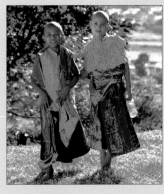

▲ 4. Add detailed metadata
Add caption, keywords, rights, and editorial information. Work to IPTC standards where possible and use a controlled vocabulary – that is, one with carefully chosen hierarchy of terms and concepts to make searches easier.

▲ 5. Check Levels
Check the Levels histogram display of a sample of images to confirm they contain a good range of data and there is a pattern of inaccurate exposure determination.

▲ 6. Check gamut
Check gamut warnings: the grey areas show out-of-gamut colours.

heighten contrast. If available in your software, apply these changes on Adjustment Layers so they do not affect actual image data. With good tone in the image, you can then correct any colour imbalance, as well as normalize colour saturation or vividness. Again, if available in your software, apply these changes on Adjustment Layers. At this stage you may apply more drastic changes, such as conversion to monochrome or sepia. This is a good time to soft-proof the image to check it will print out or appear on the web correctly or display colours that are out of gamut, which are ones that cannot be printed or preview printed colours.

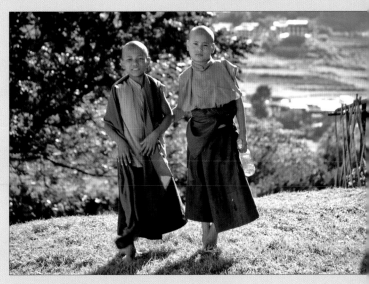

▲ 7. Process the final image
Correct exposure, tonality, colour tone and saturation, control highlights, and shadows, apply Unsharp Mask if necessary, and size up the image for final use.

CLEAN THE IMAGE

After you have completed tonal adjustments, you can repair the image: examine it closely and remove any dust spots. It is tempting – and some authorities recommend it – to clean before applying tonal adjustments. But increases in contrast or saturation may reveal earlier cloning or healing efforts, so you will have to clean up again.

FINAL IMAGE EFFECTS

Now you can apply more advanced image effects. If you make very complicated manipulations, make sure that you save intermediate versions in sequential order so that you can retrace your steps if your software does not have a "History" feature, like Photoshop. The best practice is to leave noise reduction to almost the last step – this often involves image sharpening too. If no noise reduction is needed, leave image sharpening until last, unless the contrast-enhancing effect of image sharpening could be detrimental, as it would be for portraits.

PREPARE FOR USE

Now you need to prepare the image for use by a third party. If you used layers, save the layered image as a Photoshop file if needed in the future. Finally, flatten the image – that is, render the different layer effects onto a single final image that occupies the Background layer. Then save the changes to a new file name following naming conventions, in a file format required by the third party, ensuring the required profile is embedded.

IMAGE SHAPE

Given that the current norm is for pictures to be held within a well-defined rectangle, variations of the image shape usually take place within the rectangular picture frame. Within this constraint, an image can be freely distorted in image-manipulation software. You can use this ability to make partial compensations for perspective distortion: converging parallels can be corrected – in full if the convergence is modest and does not vanish to a point. What the correction does, in fact, is line up sides of the object that are vertical or horizontal with the sides of the picture frame, which are taken to represent the vertical and the horizontal.

ADJUSTING PROJECTION DISTORTION

Commonly this is referred to as perspective correction, but that is inaccurate: a certain perspective results from the camera position – that cannot be corrected in image manipulation. But the way the

camera is held relative to the subject causes the image to be projected in a certain way, and we can certainly play around with that.

One key point to keep in mind is that the adjustments take place only within the confines of the image canvas: if you pull a part of the image off it, you lose it. If you wish to keep a stretched portion, you should first increase the canvas size. Make it a generous increase so you have flexibility in case you need to crop off excess at any time.

Professional software, such as Photoshop, offers tools for so-called perspective correction. These can be tricky to use but, on the other hand, also offer you a chance to make deliberate "errors" for special effects.

DISTORTION CORRECTION

An image is distorted when its magnification varies across the format. The variation may be very small – less than 5 per cent – but that is enough for straight

▲ 1. Converging parallels
Converging parallels are caused by the higher parts of the building being further away and therefore appearing smaller than the lower parts when you point the camera upwards. It is worse with steeper angles and wider-angle lenses.

▲ 2. Correcting the projection
Converging parallels are not a distortion, but merely the product of an oblique projection of the image. We correct it by enlarging the upper part of the image to match the size of the lower part: this is easily done directly with Image Distort or with more control in DxO Optics. You can also stretch the image a little to prevent too squat a shape emerging.

◀ 3. Corrected image
Although the converging parallels are corrected, nothing can be done about the fact that we were looking upwards and can see the underparts of features such as balconies. The result is that the image does not look entirely natural.

▲ Slanted blinds
In order to obtain suitable colours to be seen through the blinds and reflected on the blades, it was necessary to photograph them at an oblique angle. The camera was also not perfectly level, pointing upwards a little. The result is an awkward shape that lacks the abstract quality that was wanted.

▲ Blinds distorted
The shape of the image is distorted so that the blinds appear as if shot directly from in front. The converging parallels are corrected by increasing one side of the image.

▲ Blinds corrected
Within the picture frame, the blinds now look suitably graphic, with no convergence of parallels to suggest three-dimensional space. Careful examination will show that the left-hand part of the image is less sharp than the right because it has been enlarged. However, the loss in sharpness is an acceptable cost for the correction.

lines in the subject to appear slightly curved and for distortion to be evident. Nearly all built-in zooms for digital cameras suffer from noticeable distortion – usually pincushion or positive at the long focal length end, and barrel or negative at the wide-angle end. In the middle, the two cancel out and there may appear to be no distortion, but in reality a line may show slight waviness. Lens attachments, particularly those increasing the field of view, greatly increase distortion.

Photoshop can be used to correct these defects, but the most obvious tool – the Spherize filter – is limited in scope. The trick to using this filter is in creating the correct amount of extra space around the image before applying it: you may need to change the proportions of the sides in order to match the filter to the distortion.

This is not the most elegant of methods, but it is effective. If working on a very large file, work on a low-resolution version to speed things up and to avoid harming the original data. It helps to display a grid, so you can straighten up lines. You may obtain better results by applying the filter twice with small settings, rather than once with a large setting.

PIXEL ASPECT RATIO

The typical digital camera image uses square pixels, but not all do; some use oblong pixels. Images obtained as frames from video-camera footage may also not be made up of square pixels. If you work with such images, you will need to be able to correct for the

pixel aspect ratio. This is either done directly, by manipulating the aspect ratio of the pixel, or indirectly, by changing the proportions of the entire image by re-sizing one side of the image with the "constrain proportions" box left unchecked, which distorts the shape of the image to force the pixel shape to be square. In Adobe Photoshop, pixel aspect ratio can be selected directly.

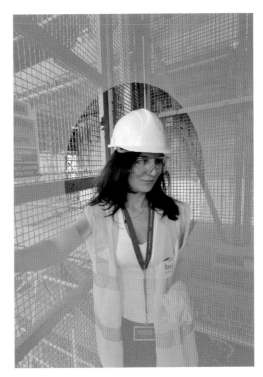

▶ Oval crop
A rounded crop can create a novel effect, especially in today's hard-edged, squared-off designs. The crop also has a way of forgiving busy backgrounds when applied to portraits, because the shape concentrates the gaze on the face.

FILE SIZE

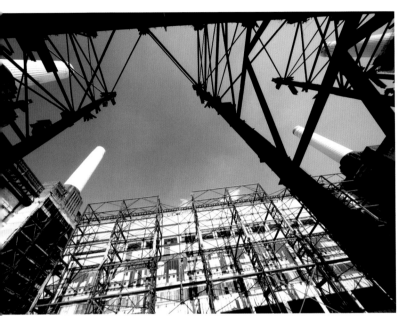

◀ **Graphic image**
This graphic image may be contone – continuous tone – but its impact relies on the graphic lines. When enlarged, we want to keep the crisp, taut lines, so the usual best interpolation – bicubic – may not actually be the best.

▼ **Bicubic Sharper**
Enlarged with Bicubic Sharper interpolation, we see edge halo effects have crept in that help give the impression of sharpness but are artifacts nonetheless.

▶ **Nearest neighbour**
With nearest-neighbour interpolation, a close-up view shows severe aliasing – jagged edges. However, when viewed at normal print size, the image appears much sharper than that enlarged using Bicubic Sharper.

The need to print a larger image than the file is originally designed for does not automatically mean an increase in file size is needed. The majority of viewers cannot tell the quality difference between an image that is at full size and one that is 10 per cent – maybe even 15 per cent – larger. At a certain point, degradation of image quality becomes apparent – the point of acceptable enlargement has been passed. This is the margin of enlargement: it appears to be greater with small, low-contrast, low-resolution images on matte papers, and less with large, high-contrast, high-resolution images on glossy papers. These factors working together determine how much you can enlarge output before you need to increase file size.

RESOLUTION

File size is related to resolution in an extremely complicated way. Broadly speaking, the size of the file sets the upper limit for resolution, in that detail that is smaller than about two pixels wide cannot be displayed. In setting the upper limit, a file's size obviously gives no guarantee regarding how much detail is actually recorded in the file. In general, a file resolves much less detail than its theoretical limit thanks to blurring from colour filter array (CFA) interpolation, lossy compression (if any) and other image processing, such as sharpening, in addition to losses from limited lens resolution, and errors such as movement during exposure.

FILE SIZE

You can reduce resolution in step with the increase in output size until image degradation becomes apparent; this keeps file sizes the same, so there is no resampling. This is available if your file was originally larger than it needed to be – you are exploiting the quality reserve. This is an advantage of the practice of working at 300dpi for mass printing. In the majority of cases, the resolution needed is 225dpi, so supplying a 300dpi file for the final print size provides a 33 per cent reserve. Not only is resizing instantaneous, printing is usually faster when resolution is reduced.

CONSIDERATIONS

- **Nature of image:** Grainy black-and-white film tolerates more enlargement than finer images because it offers an already noisy or degraded image.
- **Viewing distance:** Larger prints tend to be viewed from further away, which lowers the need for quality. If you view a poster so that its apparent size is that of

an A4-size print held in the hand, the file size of the poster and A4 print are the same.

- **Viewing conditions:** Higher-quality output is needed under critical viewing conditions, such as an art gallery compared with display in a shop window, for example.
- **Nature of substrate:** A surface with a hard glossy finish will accept files of high resolution that would be wasted on a rough surface like that of handmade Japanese papers. Halve the resolution of a file intended for a rough surface.
- **Printing method:** Methods that use photographic output will print good-quality results from lower-resolution files than the file sizes needed for ink-jet prints of the same size and quality.

INTERPOLATION METHODS

Interpolation is the name given to various methods of introducing new data in between existing data – in this context, to enlarge the image file. All methods must balance between tendencies to create blur, aliasing, and exaggerated edges. The most widely used are "non-adaptive" techniques that are applied evenly throughout the image.

- **Nearest neighbour** simply enlarges the pixels – it is best for enlarging 1-bit graphics – with only blacks or whites.
- **Bilinear** interpolation considers the closest 2 x 2 pixel neighbourhood of known pixel values surrounding the unknown pixel and takes a weight average.
- **Bicubic** interpolation considers the closest 4 x 4 neighbourhood of known pixels, looking at 16 pixels. Closer pixels are given a higher weighting in the calculation.

Bicubic interpolation can be tweaked to favour sharpness – allow a bit of edge exaggeration – or for smoothness, which allows more blur. These choices are offered in software such as Photoshop.

There are other software approaches, such as spline (in PhotoZoom Pro), Lanczos (in IrfanView and Qimage Pro) and fractal (Genuine Fractals).

STAIR INTERPOLATION

The normal method of increasing file size is to call up the Image Size command and input the required numbers. For small percentage increases – up to around 20 per cent – that method is fine. However, for larger percentages, you may find it beneficial to break down the increase into a series of smaller steps. It can be used with any interpolation method, but bicubic is best, since this exercise is about the preservation of image quality. For example, if you wish to double image size instead of increasing it by 100 per cent, increase it by 10 per cent, then another 10 per cent and so on. For the final step, you can make the fine adjustment in the resize box to obtain the precise size you need. To automate the work in Photoshop, create an Action or use the FM Stair Interpolation.

▲ **Bicubic Smoother**
When the eye is enlarged from 622 pixels wide to 5000 pixels using Bicubic Smoother, detail is reasonably well held, but the eyelashes show a blurring, and the noise in the image also benefits from the blurring.

▲ **Bicubic**
The eye enlarged with Bicubic interpolation shows a slight jump in contrast and also a slightly noisier image, because blurring has not been applied. The net result is the image looks sharper than that from Bicubic Smoother.

▲ **Bilinear**
Bilinear interpolation returns the poorest result of the three here, with loss of detail in the form of artifacts, as well as some reduction in the delicacy of the face tones and details in the skin.

IMAGE LEVELS

▲ Poor histogram
This shows two signs of bad quality of image data. There are many values with gaps, which means no pixels with those values. The irregular columns indicate few pixels with adjacent values – causing more gaps.

▲ Acceptable histogram
This shows a good range of values. But shadows are a little clipped, and high-value pixels are lacking, suggesting underexposure. Spikes sticking out of the main mass indicate a high level of noise.

▼ RGB and Luminosity displays
In an image with strong reds, blues, or greens, such as the one below, the RGB histogram is not the same as the Luminosity histogram. The RGB histogram (*below left*) shows a peak of pixels darker than quarter tone. But these pixels are bluish-green, which appears quite bright. This is reflected in the Luminosity histogram (*below right*), which correctly shows a peak in the midtones.

The Levels control, which may be called intensity and contrast, is perhaps the best-known manipulation tool. It is certainly the most used, in one form or another. This is because Levels allows for manipulation of exposure and contrast. Levels allows you to change the distribution of levels of pixel brightness. With this control, you select pixels by their brightness level; other controls enable you to select pixels by location.

HISTOGRAMS

A histogram display is integral to the Levels control because it displays essential statistics about the image's pixels. For a given brightness, the more pixels of that brightness, the taller the column in the histogram display for that brightness. By convention, dark pixels are referenced on the left of the display, bright ones to the right. Early in digital photography, it was assumed that a histogram display of the combined RGB channels accurately displayed brightness distribution. We now know that we need to correct for the fact that R looks brighter than B, and G is brighter than either. This gives us the luminance histogram (*see* left).

The basic features of Levels control are common to most implementations. There are sliders that set the black and white points (effectively controlling contrast), while the central slider is best regarded as setting the exposure (the overall brightness). Some software offers sliders for the quarter tones, too. There

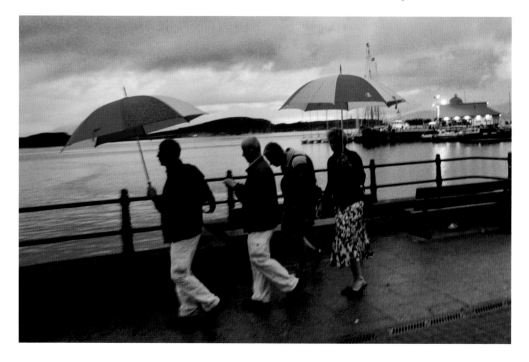

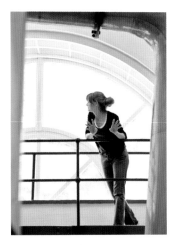

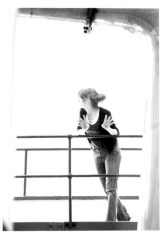

▲ **Original portrait**
This original shot suggests promising spaces and shapes within the frame that need extreme exposure changes in order to be realized.

▲ **Highlight dropper**
If the Highlight dropper is applied on the copper tubing, the sampled area turns white and also pulls up the brightness in the image.

▲ **Shadow dropper**
Using the Shadow dropper, the area sampled was on the jeans of the subject. That was turned to black, and everything else in the image was made darker.

may also be sliders that set the blackness and whiteness levels (clipping) of black and white.

The most intuitive way to use these controls is to push the sliders around and watch the effect the changes have on your image (if you don't see any change, you will need to check the Preview box).

DROPPER TOOLS

Less well known than the sliders are the dropper tools: they set or apply a tone, and force other colours and tones to remap or swing around to the new values.

- **Shadow dropper:** This dropper samples the image to set all pixels of the same brightness or darkness to black, and everything else shifts in proportion. If the sampled area is coloured, the shift to black also causes a corresponding shift in colours.
- **Midtone dropper:** This dropper maps the image colours around the sampled area, which is taken as the aim point corresponding to neutral grey. This provides a very quick way of colour balancing, provided you have a reliable neutral grey to work with. In some software, correction is made to exposure; in others, only to colour balance.
- **Highlight dropper:** This has the opposite effect and function of the Shadow dropper, taking the sample point as a highlight and mapping all pixels around it – not only in brightness, but colour too.

Use these droppers if you know where your highlight or shadows tones are located in your image. In advanced software, you can preset the droppers' target colour or aim point, so that, for example, the Shadow dropper does not create absolute black but a dark grey, and one that could also be tinted.

▲ **Apple Aperture Levels control**
This shows how the Levels control is implemented in Apple Aperture. The input from the top is compressed to cover a narrower range than the output level (*bottom*), so the change from black to white is more rapid, or higher contrast, resulting in the image.

▲ **Aperture low-contrast setting**
This is Apple Aperture's Levels control for producing a low-contrast image. The input (from the top) of quarter through to three-quarter tone is spread out over a larger range in the output. The change from dark grey to light grey is slower, or low contrast.

CONTROLLING IMAGE TONALITY

The Levels control is adequate for broad changes in image exposure and tonality. But where we need more control over a key tone or more precise changes, we need to be able to adjust the contrast gradient or gamma over a small range of tones. For this task, Curves is a potent tool.

CURVES CONTROL

The Curves control enables you to adjust an image's entire tonal range by defining how the new pixels values output by the control will vary from the input values. It is also known as a transfer function for this reason. So all curves start off with a straight diagonal line – the relationship between the input and output values is unaltered. There are different ways to implement the control: you can move the curve by clicking and dragging on it, or sliders control portions of the curve.

Allowing too much freedom to draw curves causes wild effects, so some software programs limit how much you can do, to help ensure you apply tonal corrections rather than distortions.

▲ High dynamic range
This exposure of a hotel interior is balanced for the shadows, to extract detail – but not too much.

▲ Exposure for highlights
This exposure is aimed at keeping highlight detail, while allowing shadows to go completely dark.

▲ High dynamic range combined
The two exposures combined show a remarkable improvement over either of the original images.

► Curves with ink scale
The scales on the Curves control can be set up for ink or pigment – zero or white to the left, running to black or maximum ink, on the right. In this case, a convex or bulging curve increases density.

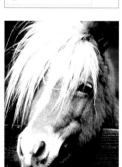

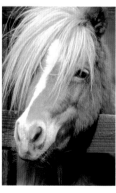

▲ Scan of pony portrait
The scan of the unexposed transparency is dark and lacking in contrast.

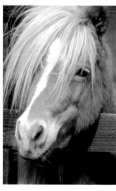

▲ Brighter pony
This curve brightens up the pony and brings out some shadow detail.

▲ High gamma
A very steep curve, which also clips whites and blacks, gives a high-contrast image.

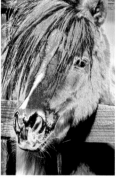

▲ Extreme curve
This reverses many tones and colours and unevenness caused by lack of data.

For all curves, bear in mind that a steep gradient always indicates a rapid change in contrast or high contrast, and a shallow or oblique curve indicates slower changes or low contrast. Once you have changed the shape of the curve, there will be steep portions and rapid tonal changes, with shallower portions (lower contrast) in between. This is inevitably the cause of artifacts if not controlled, and areas of too high or low contrast will look unnatural.

For the highest-quality work, avoid drawing very steep curves as this places tough demands on your data. Increasing the contrast requires data that was sufficient for normal contrast now cover a larger range of output values: any deficiencies in data are revealed as bands of sudden changes in colour or tone. Generally, curves are very powerful at increasing the contrast of low-contrast images but less successful at compensating for high contrast. For this we need blending techniques.

BLENDING FOR HIGH DYNAMIC RANGE

One way to look at subjects with very high contrast is that the bright parts need one camera exposure setting, while the darker parts need another. In this case we should try making two different exposures – one optimized for the lower midtones and one for the upper high tones – and blend them to capture the subject's entire dynamic range.

The photography is best done on a tripod to ensure the two images line up perfectly, which also means this technique works best with static subjects.

First determine the exposure for good highlight detail and then the exposure for good shadow detail – err on the side of underexposure. Set the camera to manual, frame up, and make two exposures with the measured settings. Save the images to raw if possible. Blend the images in software. Photoshop offers automated tools that line up images for you.

TONE MAPPING

The effect of high dynamic range blending is to achieve tone mapping – the compression of a large range of light values (wide dynamic range) in the subject to fit the limited reproduction range of a display or print. The Curves control is essentially a tone mapping control of the globally or spatially uniform type: changes are applied only by colour value. The Shadow/Highlight control in Photoshop is a locally or spatially varying type, in that the effect depends on the relative positions of contrast values.

CONTRAST COMPENSATING

One of the commonest needs is to compensate for high contrast in images – those with very bright highlights and dark shadows.

One technique, based on darkroom practices, is to use a blurred negative as a mask to compensate for

highlight areas. It is quick and very effective.

1. Turn the Background into a Layer, and duplicate it.
2. Select the duplicate layer and Desaturate – this will turn the image grey but retain RGB data.
3. Invert the same layer to the negative.
4. Set the blending mode to Overlay in the duplicate layer (for stronger reduction in contrast, try Soft Light). Set Opacity to 50 per cent to start with.
5. Blur the duplicate layer, adjusting the effect to remove any edge artifacts.
6. Adjust the layer's opacity for best effect. For refinement, use Levels or Curves to alter the tonality of the duplicated image, to adjust the base layer.
7. Flatten the image before saving.

◀ **Contrasty original**
The original, shot against the sun, is very contrasty but well exposed.

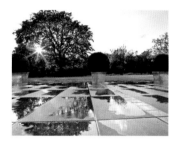

◀ **Desaturation**
The image on a duplicated layer is desaturated, but underneath the image retains its colour information.

◀ **Negative blurred**
The desaturated top layer is inverted to the negative and blurred, so when it acts as a mask, its effect will not be sharp-edged and cause artifacts.

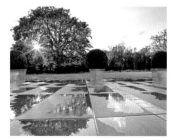

◀ **Masked and compensated**
The final image has softer contrast, as seen in the livelier details in the large tree and hedgerow, with slight improvements to the sky.

BURNING AND DODGING

Burn and dodge are techniques that arose from the very first days of photography, when it was discovered that local adjustments in the lightness and darkness in the print made a big difference to the visual quality. Dodging reduces the light reaching the negative, thus causing that area of the print to become less dense, while burning does the opposite, giving more light to that area, making it more dense in the print.

In fact, we are not only lightening or darkening, but trying to increase the contrast where it is normally weak, such as in deep shadows and near highlights. Technically, we are linearizing a non-linear response – trying to make the image's tonal reproduction look as natural as possible.

▲ **Ishak Pasha Saray, Turkey**
The original image, on a transparency, was a pale representation of the glorious lighting at the time. The sky was more dramatic and the foreground much livelier.

VISUAL DISTRACTIONS

The basic rules for successful dodge and burn are to work steadily and to allow the eye time to assess the result – not judging too quickly. The aim is to balance the impact of the image so that the viewer can appreciate and enjoy the image without being distracted by tones that are too bright and visually draw attention to themselves, or to tones that are too dark where the eye expects to see some detail. If you find yourself working a lot on the midtones, then the overall exposure is probably incorrect.

SETTINGS

The basic Dodge and Burn tools are only useful for elementary corrections – ones that cover a small area or involve no colour correction. However, we will see that other tools, such as gradients and layer modes, can be just as valuable.

Start your dodge or burn operations with very low brush pressures – not more than 10 per cent at first, and preferably as low as 4 per cent. Apply in several separate strokes in order to produce accumulative results. If your software allows Undo, you can always retrace your steps if you find that you've applied too much correction.

Burn and Dodge tools are available in all image-manipulation software – they are essential to our work. Some tools darken or lighten all pixels equally, others darken pixels only within selected tone bands – midtones, shadows, or highlights. See table opposite for the recommended settings. Remember that other operations, such as changing local saturation may appear to give a dodging/burning-in effect.

▲ **Linear Burn to sky**
Having created a new layer, set to Linear Burn, a series of light gradients, only 17 per cent in strength, was applied to burn in the sky while retaining some of the bluish colour in the highlights. Simple darkening would kill the blue patch of cloud. The darkening in the sky has the effect of making the foreground appear brighter.

▲ **Linear Burn and Colour Dodge**
With a new layer created, this time with the blend mode set to Colour Dodge, we pick a warm white from the stonework on the building and apply a light gradient, which brightens up the foreground considerably. If the effect is too strong, the opacity of the layer can be reduced.

◀ Waterfall (*far left*)
A sculpted waterfall in Cambridge, New Zealand, lies on the shadow side of a valley and is overshadowed by trees. In addition, it was a dull day, so the result is a low-key image with largely darker-than-midtone values throughout.

◀ After burning and dodging (*left*)
First, parts with highlight, such as the water and grasses catching a little light, were all dodged, which brought a sparkle to the image. Next, distracting brighter areas in the background and beyond the line of trees in the upper part of the image were ruthlessly darkened. This brings the attention forward to the water and grasses in the centre of the image.

TECHNIQUES

It is important to choose the correct tone band to work in. When you reduce dark areas with the Dodge tool, start with the lighter areas. And when you darken light areas, start with the Burn tool on the darker areas. In this way, effects are applied progressively, and as lightly as possible. Work with appropriate sized brushes: diameters should be roughly equal to, or a little larger than, the area to be covered. This works only when very low pressures are used for the brushes. A useful rule of thumb is: if you apply the tool and you can immediately see its effect, the pressure is too high.

USING BRUSH OR LAYER MODES

The Burn and Dodge tools are achromatic – they work with brightness. But you can also burn and dodge in colour by setting the brush or a new layer to the Colour Burn and Colour Dodge blend modes.

The advantage of the Colour Burn and Dodge tools is that you can control the strength of effects in four different ways: the pressure, darkness of grey or strength of colour, opacity, and mode of the layer. With later versions of Photoshop you may experiment with even more: layer modes such as Linear Dodge, Linear Burn, or Linear Light all offer different effects.

Note that a difference between these brushes and the usual Burn or Dodge tools is that the effect is not cumulative – once you have painted an area a full colour, it cannot change unless you change the colour.

USING GRADIENTS

While brushes are ideal for touching up small areas and are far more controllable than their darkroom counterparts, they are poor at covering large areas evenly and smoothly, which is easily done in the darkroom.

The digital technique for large areas is the gradient: large swathes of colour that transition smoothly from a high density to a low density or transparency. These are particularly effective when used to shade down bright skies, but they can also be used to brighten dark foregrounds. You can apply gradients directly to an image, or first you create a new layer (*see* pages 268–73) and set it to a suitable mode such as Colour Burn to darken skies. Select a suitable gradient – usually a very pale grey blending to transparency. Draw the gradient over the layer and assess the result. You can redraw the gradient or add to it, alter opacity, and even change the layer mode.

For further elaboration you can apply colour to the gradient. This can have a dramatic effect on the image and is equivalent to placing a coloured graduated filter over the lens, but far more controllable.

You can apply gradients to the image or work with layers, applying different modes to each layer. For example, to the same image you can apply Colour Dodge to a gradient from the bottom, to lighten the foreground, and Darken to a gradient from the top, to darken the sky.

CHOOSING THE TONE BAND

This table helps you choose the correct setting for the Burn or Dodge tools.

EFFECT WANTED	TOOL TO USE	TONE BAND TO SET
Lighten deep shadows	Dodge	Midtones or highlights
Lighten dark midtones	Dodge	Highlights or shadows
Lighten grey highlights	Dodge	Midtones
Darken white highlights	Burn	Midtones or shadows
Darken pale midtones	Burn	Highlights or shadows
Darken grey shadows	Burn	Midtones

This corner of the image is quiet, so it was "held in" by being darkened with a grey gradient set to Colour Burn.

The red fringe was dodge bring out its colour. Incre saturation would have th same effect.

ANALYSIS: BURNING AND DODGING

The clear air and incisive light of Kathmandu, Nepal, make for images with wonderfully intense colours. The problem is the scene luminance range is extremely large. In the fast-moving city, high dynamic range techniques, which call for multiple exposures with different settings, are impossible. So you have to photograph, hope for the best, and then use the Burn and Dodge tools to refine the results. For this image the exposure was biased towards the sky, turning the foreground into almost total blackness. An application of Shadow/Highlight retrieved shadow detail, but the rest was pulled out of the shadows using dodging, with a little burning to intensify colours.

The umbrella was dodged to make the colours more transparent, with a little increase in saturation. Careful localized dodging makes the face appear acceptably exposed.

The girl's top is carefully dodged, but only on the brighter sides to help bring attention to her.

More local dodging helps bring out small details such as the glint on the cart and the red string.

The girl and parts of her dress were dodged, but only partially, to avoid unnatural lightness.

The rays of sun were brought out by applying a Colour Burn gradient of very light grey to the whole sky, which also intensifies the sky.

The man's shirt was also dodged but only in some parts to keep the appearance lively.

The red fringe was dodged to bring out colour, but without overdoing it and avoiding lightening the sky, so that it looks natural.

There was strong veiling flare from the sun being directly in view: this was burnt in, but not completely, since its effect helps organize the image space. It could have been removed by cloning.

Instead of dodging the dog – which is black anyway – it was brought out by dodging the surrounding areas.

COLOUR BALANCING

The aim of colour balancing is neutrality for accurate reproduction. When the image is first captured, white balance helps ensure neutral colours. But when we open the image, we may have to take the process further and colour balance our images using a variety of techniques. Colour balance does not ensure accurate colour; it does not concern itself with saturation, so good neutrality may be present in an image, yet the colours could be over- or undersaturated.

CORRECTION SPACE

While the image is typically delivered by digital cameras or scanners as RGB, its processing can take place in a variety of colour spaces – chiefly RGB, Lab, and CMYK. Working in RGB space is simple and intuitive, if seldom wholly satisfactory. CMYK loses a good deal of data because of its reduced colour space, but by spreading out data over four channels, colour corrections are easier to manipulate. As output to print will be in CMYK space, for critical pre-press work, CMYK space is best for its accuracy and speed in resolving colour-balance problems. Lab space is useful where strong changes to colour balance are required.

COLOUR BALANCE CONTROL

The intuitively obvious control for colour balance separates settings over three tone bands – shadows, midtones, and highlights. This enables you to correct colour balance where it varies according to the exposure; typically, open shadows on sunny days are strongly blue while midtones may be neutral but highlights could be yellowish. One advantage of working in Lab space is that the Colour Balance control is simpler: there are only two sliders to adjust.

DROPPER TOOLS

If you choose the Shadow dropper and click on the image, the sampled area is set as the black point, all pixels of the same brightness or darker are turned black, and everything else shifts in proportion. If the sampled area is coloured, the shift to black also causes a corresponding shift in colours, thus forcing a colour correction. Clicking with the Midtone dropper on your image maps all pixels around the chosen point to a neutral colour. This provides a quick way of adjusting colour balance, provided you have a reliable midtone grey to work with. Having the opposite effect and function of the Shadow dropper, the Highlight dropper maps all pixels around a highlight. This dropper is particularly effective for balancing colour using a numbers-based method.

USING CURVES

The Curves control is a powerful way to correct colour by altering the curves of separate colour channels. You can reduce blues in the shadows and increase greens in the midtones to reduce any magenta cast in mid-greys. It is easiest to work by eye – adjusting until you see the result you wish for – but for best control you can analyse the colour in neutrals and manually put in corrections to the curve. Working in CMYK using Curves gives a great deal of control and the best results for print.

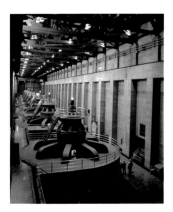

▲ **Hoover Dam**
The hall of the great generators of the Hoover Dam is lit with a variety of different lamps, so there can be no true "correct" colour balance, if only because visually one wants to retain the sense of different coloured lights present.

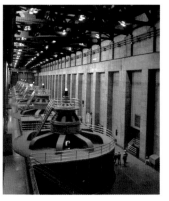

▲ **Midtone dropper**
When the Midtone dropper is applied to areas of bare metal, such as that on the railings, midtones are correctly mapped to neutral, but the reduction in reds has caused the image to look too blue. You have to balance technical-accuracy areas against the overall image.

▲ **Highlight dropper**
The Highlight dropper was applied to a highlight on bare metal. The result shows that the exposure is remapped as well as colour. It has changed the sampled pixels to bright, neutral whites. The result: neutralized metal colours and a brighter exposure.

◄ **Marrakech garden**
This image is attractive and colourful, with a good range of colours from one of the spectrum to the other. However, an improved colour balance not only helps accuracy; it also allows a richer range of colours.

▼ **Lab colour balance**
Small changes in overall tone are easiest to achieve by converting the image to Lab colour; then you have only two sliders to work. However, the range of corrections available is very small.

◄ **Colour balanced**
With adjustments throughout the tone bands – increased magenta in the midtones, increased yellow in the shadows, and a little cyan in the highlights – the image becomes even richer in colour than in the original.

OTHER METHODS

Any control that affects colours in an image may be useful for colour balancing. Try non-standard methods if your image is not responding to the usual treatment.

Channel mixing is effective where a small imbalance in the strengths of the component channels is the cause of colour imbalance, due, for example, to using a coloured filter or shooting through tinted glass.

Hue/Saturation is worth considering for colour balancing as the hue control can shift the entire range of colours in one mass – but use only small settings.

This can be useful when the colour imbalance is due to strong colouring of the illuminating light. It is easiest if the illuminating light is only of one colour, but if not, you can select bands of colour and vary the hue.

LOSSES WITH COLOUR CONVERSION

Some colour manipulations are easier to do in particular colour spaces, and colour balancing is often easier in CMYK than in RGB. But conversions between colour spaces entail slight losses of data, so avoid converting too often from one colour space to another.

▲ **Buildings curves**
This screenshot shows that blues have been reduced in the highlight areas, and other curves are substantially untouched. A similar result could have been achieved with the Colour Balance control set to adjust highlights, but without the same precision as in Curves.

▲ **Buildings in afternoon glow**
At late afternoon on a clear day, surfaces receiving the sun's rays are coloured golden, but shadowed surfaces are strongly blue from the sky. We want to correct the blue without causing the buildings to become any warmer.

▲ **Buildings corrected**
We open Curves and choose the blue channel, then manipulate the curve to reduce blue in the upper midtones. The white chimneys offer a good area to check for neutrality. Although the chimneys are now neutral, they appear warm because of the other colours in the image.

COLOUR-TO-MONO CONVERSIONS

Different black-and-white films convert the full-colour world into achromatic greys that differ subtly according to their sensitivities to different wavelengths. The history of photography has been recorded by the colour-to-mono conversions of well-loved films, such as Kodak Tri-X. Compared with film, digital conversion is far less subtly modulated, and as a result, these conversions are often unsatisfying. Modern software tools, however, enable conversions to be matched to the subject with a flexibility that was impossible with film.

▲ Black and White
This control combines six-band conversion to colour – the subtractive and the additive primary colours – with preset filters offered in the menu at the top. In addition there is an option to tint, if the box at the bottom is ticked.

▲ Channel Mixer
The Channel Mixer produces greyscale images if the "Monochrome" box at the bottom is ticked. There is a choice of "filters" that mimic the effect of using coloured films with panchromatic black-and-white film. These offer a good starting point before the sliders are adjusted.

COLOUR IN BLACK AND WHITE

A typical colour image consists of three channels of greyscale information. Any one channel can be used as the greyscale image, or they can be combined in varying proportions. This is the essence of black-and-white conversion of RGB images made possible by using the one-step greyscale conversions built into digital cameras and image-manipulation software. These compute the luminance at each point from a weighted average of each channel – for example, $L = 0.3R + 0.6G + 0.1B$ (30 per cent from red, 60 per cent from green, 10 per cent from blue). The weightings reflect the relative perceived brightness value of each primary colour – so, green has a weighting six times that of blue.

CHANNEL MIXER

This control takes the concept of different weightings further by giving you precise control over your own set of weightings for each colour channel. Ensure that the output is Monochrome or Grey, and adjust the sliders until you obtain the result you like. Most often we like greens and reds to reproduce lighter than blues.

Note that when the values of the three channels add up to 100 per cent, there is no overall change in exposure. This is essentially the same as the Monochrome Mixer in Apple Aperture. But there are now better ways to convert to monochrome, such as the black-and-white image adjustment in Photoshop.

▲ Brass band
A brass band assembles in the grounds of Ely Cathedral, England. The brilliant uniforms contrast vividly with the green turf and the soft colours of the stonework. But it is arguably a little too much.

▲ Black and White control – red
The Black and White control of Photoshop, with a low green but high red, gives us very pale uniforms that contrast against a dark turf.

▲ Black and White control – green
A high green makes the grass very pale and sets the red as darker than the grass, which does not correspond to their relative strengths in colour.

▲ Black and White control – auto
The default conversion gives the monochrome we would expect from film: reds and greens are similar in tone but skin tones are perfect.

BLEND MODE CONVERSIONS

The usual conversion methods can be confusing as you have to manipulate three or more sliders whose effects are interdependent, so you often have to adjust one slider after you have changed another. The following method lets you work just one slider, but gives great scope for subtlety. It is a layer-based adjustment using the Colour mode. The idea is to alter the lower layer according to the colour of the top layer.
1. Open the image.
2. Duplicate the image into a new layer.
3. Select the new layer, and desaturate the image – turn it grey but stay in RGB.
4. Change the layer mode of this layer to Colour.
5. Select the Background layer.
6. Open the Hue/Saturation control, ensure the "Preview" box is ticked, and move the Hue slider. Working with individual channels or restricting the hue bands provides more control.
7. Flatten the image when satisfied, and save.
For stronger effects, try using Saturation mode in the blend layer, and adjust the saturation or hue sliders in the Hue/Saturation control. It is preferable to have the Hue/Saturation adjustments effected through an Adjustment Layer, if that is available in your software.

BLACK-AND-WHITE TONING

Pure, neutral greys often look cold and mechanical. A little hint of colour in the monochrome adds a sense of depth and richness to lower tones and midtones. Toning should not be confused with duotone (or its variants, tritone and multitone), which is a colour mode that should be changed to RGB for output.

There are many ways to tone a monochrome image. The simplest is to turn a greyscale image into RGB colour, then use the Colour Balance control. In software in which you can limit the adjustments to broad bands of shadow, midtones, and highlights, you can create attractive split-tone effects in which the hint of colour in the lighter tones is different from that of darker tones. Monochrome conversion controls offer toning as part of the package.

For complete control, it is best to work in Photoshop's Duotone (Tritone and Quadtone) mode. You can add one duotone "channel" to make a duotone, two to make a tritone, and so on. In each channel you can change colours and the curve or transfer function, which controls how much colour is applied across the tone range.

For extensive work with black-and-white photography in colour, it is best to work in CMYK. You will find that tonal manipulations in the K channel have powerful effects throughout the image, and that the same channel is often the best place to sharpen the image or reduce noise. For printing, results are sometimes better if you return the image to RGB space.

◄ **Beach scene**
This image is full of light and perhaps too much colour. A straight monochrome image is, in contrast, rather dull. So we create duotones instead.

◄ **Beach duotone**
With a pale brown tone as the second tone – which is stronger in dark and lighter areas than in midtone areas – we have a warm, slightly old-fashioned looking image.

◄ **Beach tritone**
Three tones here: a blue, brown, and black. The blue tone has been superimposed on the duotone but with tones reversed to give a split-tone effect. Tones are distributed according to the image's density.

▲ **Tritone screenshot**
This screenshot shows the three colours used and the curve – at the arrow – which shows a reversal of the usual slope. This puts the weight in the highlights and reduces it in the midtones and bottoms out before full black. This has the effect of making the tone very pale.

CLONING, DUPLICATING, HEALING

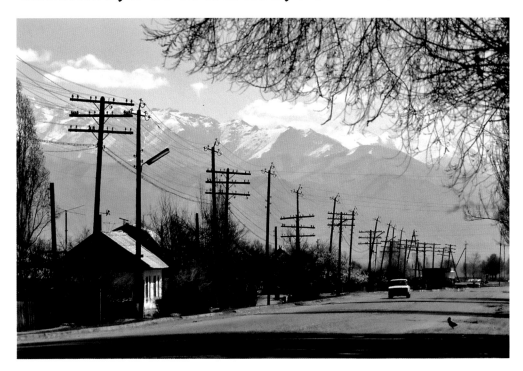

In the early days of digital photography, cloning – copying parts of one image (the source) onto another part of the image, or onto another image (the target) – was one of the most exciting and sophisticated features. It promised to make painstaking retouching a thing of the past. Now, it is only a simple technique on which other, more sophisticated, retouching techniques are based. But the need for skill, care, and patient application of the tool is as great as ever. However, there is one great advantage over working with film or prints: errors are easily – and invisibly – retraced.

CLONING

The relationship of source to target can be straight-forward or extremely elaborate. In practice, there are two types. Aligned keeps the source and target points at the same distance and orientation. Non-aligned means that cloning samples the same part of the image as the source with each mouse click, but the source moves aligned with the target while the clone tool is dragged around. Aligned can be elaborated so that the target creates variants like a reflection or a distortion of the source area.

In practice, the most common cloning error is working too quickly with too big a brush. It is better to use a brush only slightly bigger than the detail you are working on. Change the size of the brush as you go:

▲ **Colour transparencies**
Colour transparencies used for publications are usually marked with dust, oil left from drum scanning, and deterioration of the gelatin. High-resolution scans find these defects, even with dust-removal solutions.

avoid using too large a brush on a small speck, to reduce the size of artifacts you make. To make sure you mop everything up, work at high magnification, sufficient to make individual pixels just visible. Also, avoid blurring of details. This is caused by the brush being set to apply the clone only at intervals as the brush is run over the image. This is controlled by the Spacing option setting – a control usually found in the brush controls.

BLEND MODES

The normal blend mode is to cover the target area directly with the source pixels, with varying opacity: 100 per cent means the target area is wholly covered by the pixels cloned from the source; 50 per cent means that the target area can show through the cloned pixels. Opacities should be varied to suit the detail and texture. With noisy images, use a lower opacity; with very clean images, you can use a higher setting. Also try other blend modes – with scans from film, Normal blend will blur grain and introduce

artifacts. Try Lighten mode when removing a spot from a transparency, or Darken mode when removing a dust spot from a scanned negative. Remember that in noisy or grainy images, it is not necessary to completely eliminate a spot: a reduction in contrast with surrounding pixels is usually enough.

HEALING AND PATCHING

While cloning replaces one set of pixels with another, the concept can be elaborated to one of preservation of the underlying texture or colour while dust spots or other defects are replaced: Heal, Repair, or Patch tools sample from the surrounding area to blend the cloned pixels seamlessly into the target area.

The Heal or Repair tool works like the Clone tool: you define a source and paint into the destination. It adds together the source pixels with pixels on the outside edge of the tool. For this reason, it is best to choose a hard-edged brush, in contrast to the soft brush best for cloning. For certain types of image detail, particularly specks of dust or fine fibres, healing saves a lot of time over straight cloning. Note that current implementations of these tools do not work well next to high-contrast edges, as the wrong information is picked up: use the Clone tool instead.

The Patch tool works better than the Clone tool over large areas. In Photoshop, you can draw over an awkward shape, define it as the destination, then move the area to be the source. Or you define an area as the source then move it over to the target. Patching is powerful at correcting large defects such as a smear on scanned film, but it works best in skies and other areas lacking detail. Some software makes the changes directly to the image, others, such as Apple Aperture, work on a proxy image and implement the changes only when the image is exported for use.

▲ Flags close-up
This magnified view of a scan from an old transparency shows defects that were not removed, despite the use of dust-removal algorithms by the scanner. This is because the defects were too large, and their removal would cause artifacts to appear.

▲ Big clone
A clone using a spot that is too large and a source taken from too far away leaves an obvious defect. Note that the small brightness difference between source and target has been apparently increased: this is through simultaneous contrast.

▲ Hair removed
The hair can be efficiently removed by cloning or healing, but note that the source has been taken as close to the destination as possible. The brush size was also made as small as possible: the result means the removal is unnoticeable.

▲ Healing too close
If you use the Heal tool to clean up the spot near the red flag, pixels quite far beyond the brush will be sampled to establish a blend, with the result that red bleeds into the blue area. It is necessary to use the Clone Stamp tool when a defect is close to a margin.

▲ Patch tool in use
It is possible to remove all three defects in one go using the Patch Tool: first you lasso around the defects and call that the target. This illustration shows the selected area moved over to a clear patch of sky prior to the blend: the lighter top area shows the source pixels.

▲ Heal and Patch tools
In Photoshop, you have a choice of tools – some do not require sampling but are less accurate than those that do. The Patch tool works with large areas so is best for skies, walls, or water. The Red-eye tool does not clone but desaturates red to remove red-eye caused by flash.

MASKS AND SELECTIONS

There are fundamentally two ways to apply effects to a selected area of an image. The most intuitive is to use a brush, which applies effects such as burn and dodge or "paint" on an area limited by the diameter, and other settings, of the brush. The other way is to use masks or selections to define the areas to be edited – hence, selections are also called editable areas. A mask works by protecting an area from an effect – like an umbrella shading the ground from sun. A selection does the opposite: it limits an action to within the area it encloses – like sowing seeds in the seed-bed but not outside.

SELECTIONS

A selection defines the border of the editable area, normally by showing a line of "marching ants" or moving dots. To be more precise, the line joins the mid-points between pixels that are wholly selected and those that are fully ignored; others lie on a transitional zone – the so-called feather region. It follows that selections are most accurate when the feather region is not wider than a few pixels. With wide feathering it becomes difficult to know exactly where the editable area starts or stops. Selections are best suited to defining an area that is cleanly bounded – such as a building against the sky, or a figure against a white background.

There are two fundamentally different ways of making selections. Arbitrary selections such as the Lasso tool do not take account of pixel values. Value-sensitive selection tools, such as Magic Wand, look at pixel value and location before deciding whether to select or not.

FEATHERING

As mentioned, feathering controls the width of the area of transition between unselected to fully selected. The setting for feathering has a side-effect: as the feathering region becomes wider, it tends to smooth out the line of selection. For example, a rectangular marquee selection has sharp corners with 0 feather, but the corners become more rounded with greater feathering. In practice, set a small feather for intricate selections.

▲ **Petal confetti**
In this image of rose petals scattered around the feet of a bride, the idea was to select the grass and remove much, but not all, of the colour. This is an extremely complicated selection to make: it is out of the question to go round each petal and blade of grass, so you must select by colour.

▲ **Colour Range tool**
The Colour Range tool allows you to select pixels similar to those that are sampled – the same as the Magic Wand tool. But with Colour Range, you can change the Fuzziness setting dynamically and watch the effect. This screenshot presents the selection as white areas.

▲ **Selected petals**
This is the appearance of the image when Colour Range selection has been made; it is crawling with "marching ants", and its complicated form makes it impossible to see what is inside and what is outside.

◄ **After manipulation**
With the grass selected, by using the Hue/Saturation control, saturation was considerably reduced, but not quite to zero. Notice there are some blades of grass that have not been desaturated – they fell outside the first selection, but it is useful to leave them, since a touch of colour in the grey helps give it texture. You can refine results using the History brush to regain colour or the Sponge tool to remove colour.

◄ ▲ **Adjustment layer**
The Brightness/Contrast adjustment layer quickly exaggerates the outline of the bird against the water. There is a fine balance between the image being too dark and too light.

LASSO

The Lasso tool is best for selecting disparate areas with different colours and exposure. Software such as Photoshop offers other types of Lasso tool that are good for selecting objects easily distinguishable from the background because of the colour and exposure. Magnetic Lasso, or the equivalent, is a good choice. Also, if you have an unsteady hand, Magnetic Lasso is ideal because, as the name suggests, it keeps to the object. If you need to select irregular areas with straight-line borders, the Polygonal Lasso is the obvious tool.

MAGIC WAND AND COLOUR RANGE

The Magic Wand tool enables you to click directly on the image to select pixels that are similar to the sampled area, within the limits or tolerance you set. You can also choose to include only pixels that touch each other (are contiguous) or not.

With the Colour Range command, you click on a preview to select all related pixels. You can modify the selection by holding down Shift (to add) or Option (to subtract) as you click. The control is useful for locating out-of-gamut colours in order to bring them into gamut.

MASKS

When the selection is tricky to handle, the mask comes to the rescue. It shows, by gradations of black through white, the extent of a selection. Black by convention indicates unselected, while white is fully selected, and greys show corresponding degrees of selection. In short, a mask is a greyscale representation of a selection.

In applications such as Photoshop, masks can be applied using normal brush tools in the Quick Mask mode. The usual practice is to display it as a red

▲ **Extract filter**
Extract filter or similar tools in other software, such as Extensis Mask, can be used to extract complicated subjects. The workflow is first to define the transition region between selected and non-selected by drawing a line – here in green. The more refined and narrow this line, the more precise the extraction. Then you define the area to be kept, shown here in red. When you hit "OK", the background is removed, and the bird is placed on a new layer.

"rubylith" – derived from the darkroom practice of applying red paint on negatives to mask areas and cause them to print as white. Thus, what is not covered is the editable area, which receives the full force of the manipulation, while the image lying under the red "paint" is masked from editing. The Quick Mask mode is well suited to selecting softer or more complex shapes, such as faces and landscapes.

For complicated subjects, such as glass or hair, specialist masking tools, such as Photoshop plug-in Fluid Mask or software program Extensis, give the best results.

Note that a selection hovers over the entire image and is effective over any active layer or layers, including any channels. Masks tend to have their action limited to the layer on which they were created.

LAYERS

From the notion of masks, the concept of layers arises very naturally. A mask works like a layer that lies over another layer. It controls how effects are applied to it, from above. By adding to the number of layers, we can create ever more complicated shapes and interactions. Layers are the basis for compositing – the combination or montage of different elements to make a complex whole. At the same time, layers can interact with each other in ways limited only by the imagination of the programmer.

OPACITY

There are fundamental controls over a layer, the most basic being whether it can be seen. A layer that is not seen may be present in the image, but it has no effect on other layers. The opacity of the layer is another fundamental control. In the normal mode, the opacity set to 100 per cent means that you see only the top or source layer and nothing underneath. Conversely, 0 per cent means you see right through the top layer – the top is effectively not visible, and the layer below is visible. In some modes, the opacity control has the effect of determining how strongly the source layer is applied to the destination layer. In other modes, changing opacity can be understood as altering the strength of the blend.

TURN BACKGROUND TO LAYER

A further control over the basic image is whether it is left as the Background or whether it is turned into a layer. To make full use of layer modes, you must turn the Background into a floating layer. In Photoshop it is a simple matter of giving the layer a new name. Some workers prefer to duplicate the background layer, which has the same effect, but leaves the original layer intact.

▲ **Sky pasted in**
A part of a dramatic sunset from New Zealand has been pasted into this scene from Bukhara, Uzbekistan, in order to add drama to the sky. It is too small, so it has to be stretched to fit.

▲ **Sky blended**
With the sky stretched and positioned on to a new layer, the blend mode was changed to Darken Colour. This blends the lighter parts of the sunset well, but the dark cloud covers the buildings.

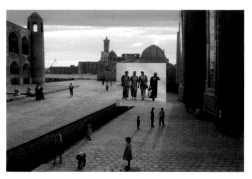

▲ **Extra figures**
We would like more figures, so a suitable set is found and pasted in. They are too large, so are scaled down. Setting blend mode to Darken, we do not need to erase bright parts around the figures.

▲ **Layers palette**
This shows the three layers used: the top carries the sky and is set to Darken Colour. The middle layer carries the extra figures and is set to Darken mode. Both layers are set to 100 per cent opacity. The background layer carries the main image.

FLATTENED IMAGE

Ultimately you will need a background with no layers at all – that is, flattened – because that is the recommended state in which to output the file. This is necessary because layers are coded in different ways by software, and a flattened image is also the most compact form for it. You can always save the layered image separately, with all layers preserved for future manipulation.

IMAGE COMPOSITING

The skilfully composited image will have all its elements not only seamless but matching as well. After all, there is no point striving for a perfect seam between two elements if they do not match in other ways. To get the perfect match you need to observe the following factors:

- **Gamma:** The tonal qualities of the elements should be appropriate to their position, distance, and relation to the lighting in the image. For instance, a very distant object should be at a lower contrast than one that is nearer. An object in the shadows should not only be darker; its gamma should be lower, too.
- **Density:** The maximum and minimum densities of the elements should also be appropriate to their position, distance, and relation to the lighting. Nearer objects are more likely to be fully dark and less likely to be very bright, except in specular highlights.

- **Colour Balance:** That of composited elements should match each other and be appropriate. This does not mean that balance should be neutral – it should work with your background. If it's a sunset scene, for example, all elements should be warmly balanced, to an extent appropriate to their relation to the lighting.
- **Image noise:** Whether your elements are sourced from film scans or a digital camera, you need to ensure their resolutions match. If the match is poor, you usually have to add noise or deliberately lower the resolution of the finer-resolution image.
- **Sharpness:** Related to the need to match contrast as well as resolution is the need to match sharpness. An object that is behind the point of focus should not appear sharp; objects near the main focal point should not be too blurred. The sharpness of each element should be appropriate to their position in the view.
- **Direction of lighting:** Ensure shadows fall to the same side to suggest they share common lighting. You will find it easier to make composites with flatly lit objects. However, that can diminish the sense of reality.

▼ **Complete composite**
The composite aims to appear completely natural so that anyone looking at the image will not notice any manipulation, even on careful examination. In this image, an unexpected improvement is that the mosaics on the far right – originally very dark – now reflect some colour from the sky, and there is an attractive rim light to the tower on the left.

LAYER BLEND MODES

A pair of layers can interact in many different ways. Consider one pixel that lies above another: the pixel in the upper layer, also called blend or source, could add, subtract, multiply, shift, or combine its value with that of the pixel on the underlying layer, also called base or destination. Each different interaction, when applied across the image, produces a different blend mode.

Different software applications implement blend modes in slightly different ways, so results may vary. Note also that images deficient in data may change their on-screen appearance between the blend and being flattened for print-out. While the most popular use for blend modes is for "creative" effects, they are also invaluable for tonal corrections. For example,

in increasing the contrast of an image, you may lose highlight detail. This can retrieved by keeping the original image on another layer, then blending the two to combine the best of both images.

Note that certain blend modes may be available to the painting or cloning tools – depending on software. This means that, for example, colour can be applied by brush, but instead of covering the receiving layer, as it would in Normal mode, it tints it when set to Colour mode.

A selection of modes in Photoshop are shown. In each case, the Levels in each layer were adjusted in order to obtain a usable result. When experimenting with blend modes it is useful to create separate adjustment layers to fine-tune the results.

◄ Layers options
One of the strengths of Photoshop is its extensive choice of layer blending modes. And it is a list that grows with each new version upgrade. They are helpfully organized into darkening, lightening, and enhancing effects.

◄ Layers palette
You can set up the two layers with separate adjustment layers. This gives you total flexibility over the tonality of the blends, and for extra fun, you can change the blend modes of the adjustment layers, too.

▲ Original images
The two images chosen to illustrate blending also illustrate the type of combination that often gives the most usable results. One image has clear lines and shape with even gradations of tone and simple colours, while the other image is full of texture and detail yet offers clear forms.

▲ Normal
Normal must be used with a reduced opacity in the source layer to have any visual effect and blends in a way not replicated by other modes. It is also useful for contrast adjustments between layers.

▲ Dissolve
This randomly distributes source and destination pixels around the image depending on the opacity setting, with more destination pixels as opacity is reduced.

▲ Multiply
Multiply imitates the overlaying of two transparencies or negatives. It makes the image darker overall and reduces contrast by multiplying the base colour by the blend colour.

▲ Darken
Darken is similar to Multiply, but the darker pixel of the source layer is the one that is used. It is useful for blending images, since it has minimal effect on hue and saturation.

▲ Colour Burn
This darkens the colour in the destination layer to reflect the source colour, resulting in increased contrast and saturation. Blending with white produces no change.

▲ Linear Burn
Similar to Colour Burn, this compares colour information to darken the destination colour to match the source colour, but it minimizes gain in contrast. It is best controlled by varying opacity.

▲ Lighten

This mode selects the lighter colour from source or base as the final colour, replacing the darker pixels of the base layer with lighter pixels of the source layer. Lighter pixels in the base layer do not change.

▲ Screen

Screen imitates shining two transparencies on top of each other so the result is always brighter than either image. This is effective for aggressive dodging, especially when the Brush tool is set to Screen.

▲ Overlay

Brightening the image overall, with preference for highlights, Overlay gives a slight increase in contrast by mixing colours from both layers. It is useful for balancing contrast when the source layer is the inverse of the destination layer.

▲ Soft Light

This is a useful starting point for blending two images. Try changing the contrast of one of the images to make one dominate the other. Painting with white or black can be effective for burning or dodging.

▲ Hard Light

This mode aggressively increases brightness and contrast. It can be used for improving tonality and adding tone to highlights with a blend layer that is grey, or lighter than 50 per cent.

▲ Colour Dodge

This creates a dramatic increase in contrast, since the source layer dodges the base layer, making the image much brighter. It is useful for aggressive dodging, to add contrast when you paint with greys on a layer to dodge the underlying layer.

▲ Linear Dodge
Similar to Colour Dodge but with a softer effect, Linear Dodge lightens the base colour to reflect the blend colour. Blending with black has no effect. This is useful for quickly creating a high-key effect.

▲ Hard Mix
This blend mode is similar to Colour Dodge but produces a hard, high-contrast effect that is posterized. Reducing the source layer opacity softens the effect, but it remains posterized while the receiving layer is a continuous tone.

▲ Saturation
With Saturation, the base layer changes to that of the corresponding pixel in the source layer. A strongly coloured source layer boosts the colours of the base layer, or it can be reduced, as shown here.

▲ Colour
One of the most useful modes, this adds colour and saturation from the top layer to the underlying layer luminance. It is excellent for colouring greyscale images and is the opposite effect to Luminosity.

▲ Hue
The colours of the source layer are combined with the saturation and luminosity values of the base layer to give a toning effect. Base colours come through as black in the source layer.

▲ Difference
This mode identifies the brighter of the base or blend pixel, then subtracts one from the other, depending on which is brighter. A blend with white reverses the colour, while blending with black produces no change.

DARKROOM EFFECTS

One of the great advances of digital photography is that it has opened up the glories of darkroom manipulation to everyone. Effects that used to require a darkroom, hard-to-find chemicals, and hours of preparation can now be done on-screen and with clean hands. However, the more you know about the true darkroom processes the better – then you can strive to imitate the beautiful subtleties of a well-made lith print or aim to match the delicacy of split-tone effects produced chemically. This section outlines the darkroom techniques, as well as the digital techniques for achieving the equivalent results.

▲ **Bridge**
A simple original is relatively flatly lit despite the clear day because of the amount of midtone. But there are strong blocks of colour in the sky and ground.

▲ **Transparency cross-processed**
This image simulates cross-processing of transparency film in chemistry intended for colour negative film: the result is very high contrast, with exaggerated colours and a tendency for highlights to blow out to white. With digital simulation, the final result can be carefully tweaked, while maintaining the visual impact.

◄ **Curves screenshot**
This screenshot shows the manipulations of all four curves – the RGB, as well as separate channels – which together create the cross-processed look. Saving this and applying it to other images is the equivalent of cross-processing your images.

SOLARIZATION

In the darkroom, the Sabattier effect is the result of a second overall exposure to a print while it is about halfway through development. Developed areas mask some parts, while others are grossly overexposed to the extent that tones are reversed. This last effect is known as solarization, which gives the process its alternative name.

The darkroom procedure is to give a light exposure – that is, to give an underexposed print, then developed in a black tray to the minimum density needed to give a good black. Give a brief second exposure (3–10 seconds) with the print under developer but with no ripples. Continue with development and normal processing.

Digitally, obtaining true Sabattier effects is a simple matter of applying arch- or U-shaped curves (depending on the orientation of the axes on the Curves control), and it gives highly repeatable results where the original images are similar in exposure and contrast. The curve shape means that half the tonal range from shadow to midtones is reversed, while the upper half of the tonal range is neither reversed nor normal in tone.

The fine manipulation rests on where you place the point of reversal – small shifts in the position of this, as well as very small tweaks to the shape of the curve, all have a substantial effect on the image. The key to success here – as is so often the case in digital photography – is to start from strongly shaped monochrome images while working in colour space.

If you start with a colour image, the half-reversal of the curve can create intriguing results, since some colours are flipped to their complementaries as well reversing in tone.

Beware these extreme shapes to curves will bring out every deficiency in image data, including any previous retouching. Clone areas, in particular, will be revealed. In addition, the extreme shape of the curve places high demands on the image data and breaks up tonal transitions into stepped or posterized results, so if you wish to avoid artifacts, work in 16-bit RGB mode (*see* pages 56 and 288).

CROSS-PROCESSING

Taking up the idea of using digital processes where the chemical one is tricky to control, a good natural candidate is cross-processing. In this, you either

▲ Transparency in C-41
Specialist applications, such as DxO FilmPack, are effective at applying accurate cross-processing effects: the range is limited but controls are good. This shows a Kodak Elite 100 colour transparency film processed in C-41. Software such as Alien Skin Exposure (*right*) offers an excellent choice of different films but with less control. You can always adjust results in your image-manipulation software.

▲ Optima cross-processed
This shows AE Exposure simulating the result of processing Agfa Optima colour print film in E-6 chemistry. The result is strongly cross-curved – blue in shadows, but magenta in highlights. However, it is possible to colour correct to a fairly natural-looking result.

expose colour reversal (transparency) film then develop it in colour negative processes (slide in C-41), or you can work with colour negative film but process it in reversal process (colour negative in E-6). On the whole, the most usable results come from starting with transparency film: its higher inherent gamma, as well as greater colour saturation, gives dynamic colour and vibrant effects. But the price is tricky exposure control as highlights have a tendency to burn out to white, which reduces exposure latitude. There is wayward colour balancing to contend with, too – the processing is non-standard and, besides, the high saturation confuses the proper balance.

For predictable results, it is easiest to apply Curves to normally captured or scanned colour images: a separate curve is given to each channel, which corresponds to the effect of non-standard chemistry on the colour layers.

A standard curve, created to mimic actual results, can be saved to be applied again and again to any image. And of course the curves can be tweaked and manipulated to suit particular needs. You may also wish to apply some desaturation if the colours become too bright for your liking, and correct colour balance if the image leans too far towards blue.

▲ Church interior
This type of image – with strong shapes, clear lines, and a full range of tones – is suitable for manipulations using extreme shapes for Curves.

▼ Sabattier effect
With the Sabattier effect applied, it is not immediately obvious that some tones have been reversed while others have not. The effect causes a visual discomfort because of the partial reversal of tones.

◄ Curves screenshot
This screenshot shows that the axes of the Curves control are set for ink – darkest to the right – so the curve is U-shaped. If the axes were set for light – darkest to the left – the curve would be inverted. Experiment by making small changes to the position of the curve.

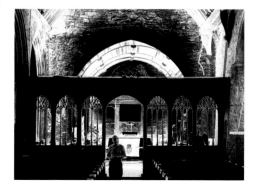

LITH PRINTING

Lith printing uses lith developer – usually designed to make line negatives with only black or white. It also works with ordinary black and white, or colour negatives and paper. You heavily overexpose the black-and-white paper by 2 or 3 stops, followed by partial development in highly diluted lith developer. The high dilution lowers the contrast of the developer a little, and the partial development results in a weak midtone. An attractive yellow-brown tone is introduced to the image due to the rapid development. Digitally, the manipulation tracks the chemical process once the image is fully desaturated to black and white: first an adjustment in Curves, which compresses the tones to make a very dark and flat image, then readjustment in Levels or Curves to return to a normal brightness. This re-expands the tones but with gaps that correspond to flat areas of tone. The Colour Balance control then adds the warm colours.

TONING AND SPLIT-TONING

Another popular technique, also notoriously difficult to control, is split-toning. If toning is the replacement of silver in a print by other metals or compounds, split-toning changes silver in proportion to its size or density. This results in more toner being complexed into the shadows than in the highlights, giving rise to extremely soft shifts in colour with image density.

Digitally, there are several ways to mimic this. One is to correct colour balance differentially by tone – for example, by shifting shadows towards blue and moving highlights towards orange. Another is to adjust Curves. Alternately, select tone bands using Magic Wand or Replace Colour. The selection methods are limited to introducing very small shifts in colour: large, obvious changes will create unsightly border regions.

More control, and smooth transitions, can be obtained by duplicating the layer prior to applying different colours to each. Then you turn to Layer Styles in Photoshop to blend the layers. The sliders in the "Blend If" control let you decide how much the

▲ Layer Styles
The Layer Styles dialogue enables you to control the blend. Hold the Option/Alt key down while separating the sliders. Here much of the low to midtones of the upper layer (in this case an adjustment layer) are blended with the lower layer.

bottom layer shows through the top layer according to ranges of bright and dark that you set. Thus, you could set it so that only the blue shadows from the bottom layer show up, leaving a warm-coloured top layer with warm highlights.

Duotone printing gives an image similar to split-toning. It is an effect of mechanical printing presses, not one of the darkroom, but it too can be imitated in image-manipulation software (*see* pages 262–3).

CYANOTYPE

These are attractive blue-coloured negative prints perfect for showing off the complicated forms of plants and objects with intricate outlines. Normally a cyanotype is made by placing the object directly onto sensitized paper, then exposing it with a point source of light to produce hard shadows. This leaves the object isolated in a field of intense blue, which is slightly uneven due to hand-painting of the sensitized solution and irregularities in the paper.

Digitally, we can make a cyanotype of anything. The steps are first to create the blue background from a suitably irregular original. The outline of the subject is then obtained by using the Magic Wand or Colour Range tool. This is used to create a mask, which, when applied to the blue, leaves the selected area white against the blue background. If you wish to add a sense of the irregular cyanotype finish, you can rough up the edges of the print using the Eraser set to a large, dry brush.

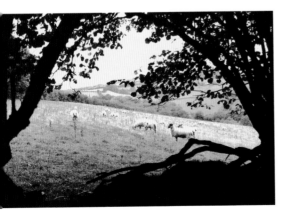

◄ Lith processed
This image was strongly reduced in contrast and darkened, then returned to normal exposure and contrast. Severe loss of data leads to the uneven tonal transitions typical of lith-processed prints. A yellow-brown tint was applied to the highlights to mimic typical lith-processed tone colour.

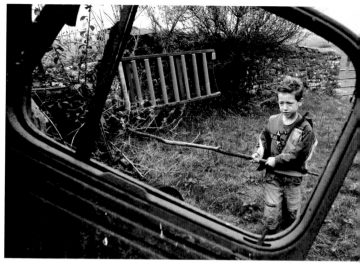

▶ Boy in frame

The result on a desaturated picture coded with colour information is an image with strong colour tints. By using the Hue/Saturation control, the saturation was greatly reduced in order to produce a gentler image. Then Colour Balance was used to apply red to highlights and blues to shadows.

▲ Split-tone – shadows

Using the Colour Balance adjustment layer set to shadows, we force a fully desaturated colour image, which appears grey, to a blue colour cast.

▲ Split-tone – highlights

On the same image, but with a new adjustment layer, we use the Colour Balance set to highlights and force the image to a red colour cast.

▲ Split-tone – window

Finally, the Levels and Hue/Saturation controls are used to soften the colours to let weak reds appear in lighter regions with a hint of blue in the low to midtones.

▲ Component blue

For the background we take a textured, blurred image, then reduce its contrast. Next we apply a strong blue colour by creating a new layer, fill it with blue, then change its blend mode to Colour. We adjust contrast to make it even flatter and richer in colour but retaining an attractive unevenness.

▲ Cyanotype component 2

Fir trees are attractive and symmetrical without being regular, but the clouds are a distraction. Although not a classic subject for a cyanotype, it will work well. We use the Magic Wand to select the black branches and, from that, create a mask to remove the clouds.

▲ Cyanotype final

With the mask active, we apply the blue layer, leaving the selected area transparent. Only the blue and its mask are visible. When we flatten the image the masked areas become white. Finally, we pick a dry brush (one with uneven edges) to simulate the appearance of uneven coating of sensitizer.

BASIC IMAGE SHARPENING

▲ **Original image**
The original image offers a mix of small details as well as broad areas of slowly changing tones to demonstrate USM effects.

All digital images benefit from being sharpened at some stage in their life. That is because they suffer from blurring, which occurs when the representation of an object is at a lower contrast or retains less detail than is present in the original. Sharpening compensates for blurring by improving the visibility of the information in the image. It works by applying a convolution kernel – a spatial filter – over the image. This is a matrix of numbers that is applied to a grid of pixels, with the matrix centred over one pixel at a time. Sharpening cannot add genuine information although it can add artifacts – image data that do not represent the object.

LUMINANCE CHANNEL

The simplest way to sharpen an image is to apply a sharpening filter. Of these, the most used is the Unsharp Mask (USM) because it is highly controllable. However, applying USM to the entire image can cause artifacts and unwanted results. The

▲ **USM settings 111, 11, 1**
This combination of settings (Amount, Radius, Threshold) can be applied to a wide range of images. It is easy to make and has a visible but mild effect on all but very small images. Notice the gain in contrast in the flower.

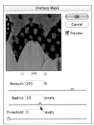

▲ **USM settings 200, 10, 0**
With a strong Amount setting, there is a marked gain in the appearance of sharpness, as well as the addition of lively local contrast. This makes the image appear lively but a little surreal. A smaller Radius setting will moderate the sharpening effect.

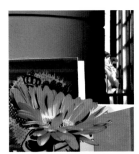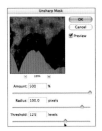

▲ **USM settings 500, 100, 1**
With extreme settings of Amount and Radius, we create a cartoon-like image with strong haloes, exaggerated local contrast, and a rise in saturation. A good deal of artifacting as noise is now easily visible too.

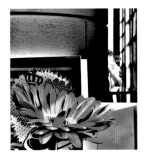

▲ **USM settings 500, 100, 125**
With extreme Amount and Radius but a high Threshold, we apply the Amount and Radius to only borders with very high contrast: the effect is greatly reduced and is similar to applying smaller Amount and Radius with lower threshold.

cleanest results come from applying USM to the part of the image that carries the sharpness information: this resides mainly in its luminance. If we confine sharpening to luminance, that should have maximum effect without cross-talk – affecting the image's colours.

The technique is to apply USM to the L or lightness channel in Lab colour mode. To sharpen in USM, you first convert your image into Lab space. Locate the Channels palette and click on the L channel. The image will turn into a black-and-white one. Now apply USM with settings suited to the image (*see* below). Turn the image back to RGB.

SETTINGS

Unsharp masking is provided in a wide range of software – from scanner drivers and management utilities, to image-manipulation programs – all presenting slightly different controls. The best known is that from Photoshop, which shares its basic features with other software. Note that each variable interacts with the other, so it is possible to obtain very similar effects with very different settings.

- If your image consists mostly of fine details, set a strong amount of sharpening, with very small radius and low threshold. For example, Amount: 200, Radius: 1 or 2, and Threshold: 1–5. This improves all boundaries in the image over a small distance, while it will also increase grain or noise that is hidden by the detail.
- If your image has large areas of even tone, set a little sharpening and a large radius with relatively high threshold. For example, Amount: 50, Radius: 20, Threshold: 10. The high threshold cuts out noise.

Amount measures the strength of the sharpening effect, roughly as a percentage of the increase in edge contrast. Most of the time you will work within the 50–200 per cent range.

Radius measures the number of pixels over which the mask strongly operates; in some software it can take fractional values. Photoshop is unusual as it permits an extremely large radius setting. It needs to be set with great care, since it has the biggest effect. In practice, low figures give crisp edges, and larger figures produce broader edges and increase overall contrast.

Threshold measures the minimum lightness difference between two edges that the mask will operate on. Zero threshold tells the mask to operate over the entire image. As higher and higher thresholds are set, the mask ignores more and more.

STRATEGIES

In general, you should leave USM until last – after you have made all the adjustments and manipulations you need to, and just before you save your work. For this reason it is best to turn off any in-camera sharpening. Beware of micro-contrast changes. Because USM works by creating localized changes in contrast at

boundaries, if these boundaries are close together they can join up and create bald highlights. This should be avoided on critical parts of subjects, such as faces and metallic subjects. Faces are therefore an exception to the rule of making USM adjustments last: after applying USM to faces, you should recheck Levels to ensure that contrast gains are not excessive.

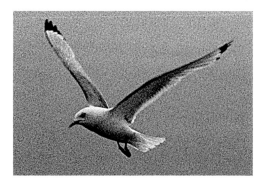

▲ **Sharpening without noise**
In this image, the gull has been sharpened with high Amount and Radius settings, and noise has been avoided with a high Threshold setting. You can raise the Threshold a few points at a time while increasing the Amount to visually judge the balance between desired sharpness and undesirable noise enhancement.

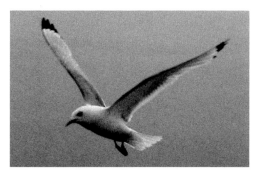

▲ **Sharpening with noise**
Effective sharpening calls for a balance between enhancing the details you wish to make clearer and also making noise or grain easier to see. The simplest way to control this is with the Threshold setting. With Threshold set to zero, all boundaries are sharpened, including those around noise, leading to a very grainy image.

ADAPTIVE SHARPENING

The purpose of varying USM (unsharp masking) settings is to match the USM effect to the type of image detail and to the effect required. But, of course, the majority of images contain fine details as well as areas of even tone. In order to respond to the need to sharpen these images, we need methods that adapt locally to the character of the image: these are adaptive-sharpening techniques, also called "smart" or "edge-localized" sharpening.

In fact, there is a family of sharpening tools that are adaptive, which means they modulate the amount of sharpening in response to image character. In essence, we are trying to enhance fine pictorial detail while ignoring film grain or digital camera noise, which carry no pictorial content.

▲ **Wall in France**
This image of a wall in Arles, France, is slightly soft. In addition to what obviously needs to be sharp, there is texture in the wall, which need not be sharpened.

◄ **Duplicate layer**
This shows the background has been duplicated to a new layer and its blend mode has been set to Overlay. This enables you to preview the results of any application of a filter to the source layer.

◄ **High Pass Radius 100**
With a large Radius setting, the High Pass filter allows you to see almost the entire image and all very fine detail. The result is that a large Radius generates very gentle sharpening over broad outlines and shapes.

SELECTIVE SHARPENING

With images containing large areas of sky or water, you restrict sharpening to a selected area of fine detail. Apply a gradient or use the Magic Wand to select the sky or sea of the image, invert the selection – so the mask will apply to all but the sky and sea – then apply USM. Selective sharpening is handy for working on eyes in portraits. In Quick Mask mode, use a soft brush to paint round the eyes, exit Quick Mask and invert so the selection is on the eyes, then apply light amounts of USM to sharpen eyes and eyelashes.

A further level of sophistication is to examine the image channels to locate the best one. In a landscape, much of the detail may be in the green channel, whereas in nude studies, the detail resides in the red and green channels. When you have located the channel, use it as the basis for loading a selection.

One method is to select the channel then duplicate it. Make your changes, such as increase contrast, then invert and blur in preparation for loading it as a selection. In Photoshop, you use the menu item Select > Load Selection and pick the copy of the channel as the source.

Alternatively, you can use the Magic Wand or Select tool to make a selection. Now you can apply USM limited to the areas you want to change.

▲ **High Pass in Normal blend mode**
This image shows the appearance of the top or source layer with High Pass applied. It appears largely greyed out apart from the details made visible according to the Radius setting chosen.

▲ **Wall sharpened**
The final image has been gently and selectively sharpened, without the artifacts caused by USM, and with the softness of texture on the walls preserved.

FIND EDGES

Further up in fine discrimination is a method based on the Find Edges filter. This ensures USM hits only the major subject boundaries, while leaving untouched areas of more or less even tone.

First we duplicate the Background layer then apply the Find Edges filter – either to the whole image or, for even more control, to a channel. Next, soften the Find Edges using Gaussian Blur. Now invert this so that white defines the areas to be sharpened. Using Levels, make a high-contrast, clean-cut mask – where black is black and white is white. Finally, load this as the source of the selection: black areas are masked; white unmasked areas are selected. Sharpening, when applied, is then limited to the edges.

HIGH PASS

Some software programs offer a High Pass filter, which masks out low-frequency data (large areas of tone) and lets through only high-frequency data – fine detail, such as edges, are visible. The strategy is to combine this ability to locate fine detail with sharpening limited to the fine detail by use of a blending mode, which works with the masking effect of High Pass.

First duplicate the Background image and change the blend mode of the duplicate layer to Overlay. This sets up the interaction between the top layer and the background. Next apply the High Pass filter: the image is likely to look immediately sharper. You can adjust the Radius setting of the High Pass filter to control the amount of sharpening obtained, as well as its Opacity, to control the tonal qualities.

You may also try different blend modes such as Soft Light or Pin Light for softer effects, or Hard Light or Linear Light for stronger sharpening.

Using High Pass is very useful on images with high JPEG compression, since you can easily evaluate the balance between sharpening artifacts and true image detail by watching changes in the image as you alter Radius and Opacity. Furthermore, you can add to the High Pass layer by painting with a midtone grey to remove areas from sharpening.

The disadvantage of this method is the accompanying change in tonality, so you have an additional step to return the tonality to how you want it. However, it provides results that lack the hard edge of USM sharpening.

There are several specialist applications designed for adaptive sharpening, such as Magic Sharp and Nik Sharpener, while the latest versions of Photoshop offer a Smart Sharpen option and variants of bicubic interpolation. But if you find yourself continually in need of these applications, it is advisable to look at the quality of lenses being used, as well as at your technique: the best sharpness filter is careful focusing and a steady camera.

◄ **Quick Mask**
After using Magic Wand to select the sky, which we do not wish to be sharpened, we apply Quick Mask to check what has been selected. This covers the foreground, which shows we need to invert the selection first.

◄ **Quick Mask inverted**
We must exit Quick Mask mode (which turns the mask into a selection), then select the inverse. Re-entering Quick Mask, we see the sky is now covered in pink, so we can sharpen the foreground. We can paint and erase the mask to fine-tune the selection.

▲ **Before sharpening**
The foreground of this "grasshopper's view" of the ground is not as sharp as we'd like, since we want to give it a sense of great depth of field.

▲ **After sharpening**
Limited to the foreground, the grass and clover flowers appear much sharper. However, the distant blades of grass may be too sharp for our purposes. If so, we can paint onto the mask and limit the sharpening action to the grass blades that are in the immediate foreground.

Digitizing the image

FROM ANALOGUE TO DIGITAL

TYPES OF SCANNER

SCANNER FEATURES

SCANNING WORKFLOW

ADVANCED SCANNING

IMAGE MANAGEMENT

FROM ANALOGUE TO DIGITAL

Desktop scanning was, for a short time, a subject of central importance to photography: as the bridge between the analogue domain of film and the digital world, it enabled photographers to take part in digital photography, while continuing to exploit their "legacy work" that existed on film. However, as film became less and less used, so did the need for scanning. Nonetheless, it remains a technology crucial to photographers who use film-based products and the most cost-effective way to use large-format film. Modern scanners are capable of extracting all detail of any practical consequence out of film and print at relatively low cost and high speed. As a result, there is a continuing case for using film, particularly those in larger formats: you can obtain very high quality at capital costs that are much lower than those of using medium-format digital cameras.

▲ **Provence sky – high resolution** *(above top)*
This image contains 2500 pixels along its width and 1606 pixels in depth. The result, if printed large, would show sharp twigs on the trees, sharp leaves of the palm, and an even blue in the sky. At the size used in this book, that detail is virtually lost.

▲ **Provence sky – low resolution** *(above bottom)*
This image contains only 417 pixels along its width and 268 in depth. At the size used here, the poor image data is visible, but only if you look carefully. However, even moderate enlargement would be beyond the abilities of this image – the details would be all blurred and pixellation obvious.

SAMPLING AND QUANTIZATION

There are two modes in which scanners operate: reflected light, which is used to scan solid flat objects, such as prints; and transmitted light, which is used to scan partially transparent material such as film.

For both, scanning comprises two quite separate steps. The object is lit by the scanner's lighting, and the light that is reflected or transmitted is then measured for its colour information one small area at a time. The measurements are then turned into digital data, or quantized. The key to this process is that the scan checks on its own light output before measuring the sampled light, thus ensuring accuracy. The capture steps are closely analogous to what happens when an image is captured by a sensor, but the difference in scanning is that the subject is sampled one pixel at a time and one row at a time, whereas a camera sensor sees the whole scene at once.

The smaller the area examined – the closer together the sampled points – the greater the detail that can be extracted from the object being scanned. This is measured by the resolution of the scanner. The quantization also has its resolution figure: it is the bit depth, which measures the detail to which colour information is recorded (*see* pages 56–7).

RESOLUTION

In scanning, there are two types or modes of resolution. The input resolution controls the amount of detail you obtain from the scanned object – that is, the detail input from the object scanned to its digital image. In contrast, the output resolution refers to detail but primarily determines the physical size of the image when the image is output to print.

The key issue is to ensure that you feed enough detail from the scan into the output print to ensure that details are preserved as far as possible. If the input resolution is not sufficient for the output size, then you lose detail and the picture may become pixellated, which means squares of even colour become visible.

Many photographers scanning for the first time are confused by the fact that in working out what input resolution they need to set, they have to work backwards from the output. Once you realize this and you keep in mind that the scanner's currency is pixels, then the calculations are easy. Note that you can generally work out the figures just by looking at, say, the length of a print, for the calculations work in proportion on the other side, the width.

RESOLUTION CALCULATIONS

Suppose you wish to make a print that is 25cm (10in) long, with an output resolution of 300 dpi (dots per inch). This means that you need a total of 3000 pixels

► **Cattle grazing**
This pastoral scene of cattle grazing in a nature reserve was shot on 35mm transparency film of ISO 100 then scanned at 3600 ppi. Even greater resolution would be needed to capture all the fine details in the grasses and cattle. However, the limiting factor is the film grain.

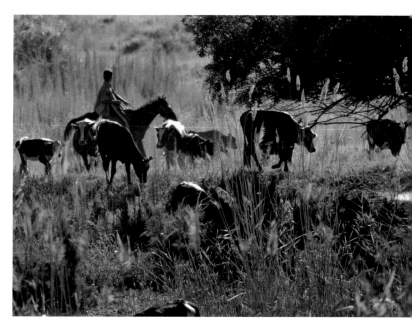

▼ **Detail of cattle grazing**
A close-up of the cow near the centre of the image shows that, even if the details were not softly focused, the film grain is already becoming apparent. Higher resolutions will only bring out more grain as the grain is around the size of the smallest details in the image – the average diameter is only a little less than the width of the grass stalks.

Broadly speaking:
- Images with large areas of even tone and indistinct details may be scanned at lower resolution to minimize file size.
- Images featuring fine detail should be scanned for an output resolution of 225 lpi (lines per inch).
- Images to be used in the highest-quality printing should be scanned for an output resolution of 300 lpi (or dpi) or greater.
- Line art or text should be scanned at the highest resolution available on the scanner. Note that in many flatbed scanners, the maximum resolution on one axis may be less than that of the other.

MAXIMUM RESOLUTION NEEDED

The highest resolution widely available for 35mm-format film is 4000 ppi. This is more than sufficient for top-quality prints of about 40 x 60cm (16 x 24in). Some machines can scan to 8000 ppi resolution, but that is hardly worthwhile for 35mm film, because the improvement in modulation transfer function is barely visible. Besides, to take advantage of it you must have perfect picture-making conditions: the highest-quality lens perfectly focused at optimum aperture, and the camera on a tripod with no movement in either the camera or subject. And very few optics can resolve better than 3500 lines over the 35mm format.

Note that as format becomes larger, the resolution requirement decreases. For example, if you need a 6000-pixel-long image for a large print, you need a resolution of 4000 ppi on 35mm film that is 38mm (1.5in) long, but a resolution of only 1200 ppi on film that is 127mm (5in) long.

in the length of the image (10 x 300). You therefore set the scanner to give you 3000 pixels along the length of your original: so if your negative is 36mm (1.5in) long, the resolution you need is 2000 ppi (points per inch). Modern scanner software will help you to make all the calculations you need – just enter the figures you know and it will work out the rest.

It is not necessary to work to exact figures. Scanners based on CCDs are best if used at resolutions that are whole number fractions of the highest resolution – if the highest resolution is 3600 ppi, then you can safely set 1800 ppi and obtain good results. But a setting such as 1700 ppi may give inferior results because of rounding errors caused by irregular fractions resulting from downsizing from 3600 to 1700 ppi.

There is a case for always scanning at the highest resolution the scanner is capable of, but that may result in files much larger than immediately needed.

TYPES OF SCANNER

While the essentials of scanning have not changed during the evolution of these machines, scanners have become smaller and smaller over the years (the first flatbed scanners took up entire studios), and their resolving powers have also steadily increased. The scanners that are currently available – even many entry-level models – are able to capture just about all the useful spatial information present in the original image. However, full dynamic information, which depends on the ability of the sensors to encode highly compressed tonalities at low light levels, remains the province of the more costly machines such as drum scanners or pseudo-drum scanners.

FLATBED SCANNERS

Flatbed scanners shine light onto the original while the sensor measures the reflected light. In some scanners the light is placed far from the sensor; in others, the light is placed right next to the sensor. The latter gives very compact machines.

You can use flatbed scanners to make a quick reference scan of a whole sheet of slides or negatives – just like a contact sheet, only paperless. Photographic prints can be scanned on any modern scanner. In fact, there is a case for preferring to scan a good-quality print over scanning the original negative. This is particularly the case if the negative is very unexposed

(thin) or over developed (thick) and if you do not possess an excellent film scanner.

Since the light is tightly focused onto the print and dust specks lie on the surface, specks will be captured sharply in the scan unless you carefully clean the original. Many modern scanners offer firmware features built into the scanner that will automatically recognize dust and remove specks from the scan.

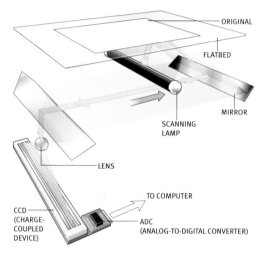

▲ Reflection scanner
This diagram shows the basic elements of a flatbed scanner set up to make reflection scans. The light path is somewhat convoluted, compared to the relatively straight path of film scanners: this contributes to the optical inefficiency of these designs. In some scanners, the light source is placed very close to the sensor, and both are placed very close to the object. In some designs the scanner moves along the object; in others only the mirror moves, sending the image to a stationary sensor.

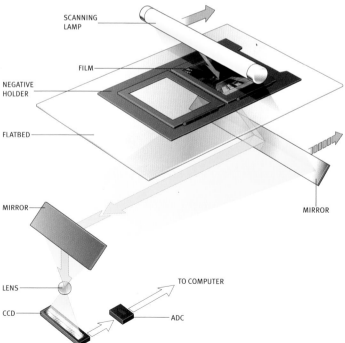

◄ Film scanner
This diagram shows the basic elements of a transmission or film scanner. The key difference between this and the reflection scanner is that the original is placed between the light source and the CCD array, so that the light transmitted by the film is measured. In flatbed-type designs, relay mirrors may be used to transfer the light from the original to the sensor. In other designs, the sensors may lie directly in the path of the light, which produces superior image quality.

While the depth of field of the scanner sensor is extremely limited, it usually sufficient to show up the slight crinkles of prints. The best results come from perfectly flat originals. However, take care that glossy originals do not cause the effect known as Newton's rings (bands of pale colour or light and dark).

Note that the resolution of the scanner may be given thus: 3000 x 1500 – that is, resolution in the two axes of the scan are different. This is because resolution along the length of the scanning sensor (usually across the length of the scan) is fixed by the number of sensors available. But resolution on the other axis is solely determined by how small a step between reading positions the mechanics can shift the sensor. If the smallest distance is 1/1000in, the resolution is 1000 ppi; but if the distance is a tiny 1/3000in, the resolution is 3000 ppi.

FILM SCANNERS

Film scanners are essentially flatbed scanners, but they use a light source that shines directly at the sensor. The film is placed in between to interrupt the light, so that the transmitted light is measured by the sensor. The main technical problem with film scanners is the need to untangle high tonal compressions to give smooth tonal gradations.

With colour negatives, scanners must be able to separate tonalities that are extremely compressed in the shadows. Density is normally very low, so transmission is high: the scanner sensors work with relatively bright light. In addition, colour negative materials carry an orange mask that must be neutralized in order to obtain life-like colours.

In contrast, the problem with colour transparencies is their high densities, so the scanner must be able to discriminate subtleties with low transmission – low light. Scanners need to work over an extremely large dynamic range (*see* page 288) and at high bit depths to be able to work with both types of materials. As a result of the design features required, film scanners produce much better-quality scans than flatbed scanners converted to scan film.

DRUM SCANNERS

These offer almost mythical qualities of performance in the eyes of digital photographers: they stretch the object around a cylinder, which spins rapidly under a highly focused light. They use photo-multiplier tubes that are highly sensitive and linear to capture the data. In addition to being able to vary the sampling rate or resolution, the actual aperture of the sample can be set, too: this enables grain in film to be rendered as sharp, or soft, as required. While drum scanners can produce faultless image quality, they are fickle to use, extremely delicate to set up, and consume costly materials. In short, they need great skill to operate. New low-cost but high-quality services have sprung up in countries such as India.

PSEUDO-DRUM SCANNERS

A type of scanner that sits halfway between flatbed and drum scanners is the Imacon Flextight, which stretches the film or print over a part of a cylinder. This helps keep the scanner focused on the original and is capable of very good results with high resolution and good shadow detail.

▼ **Kyrgyz girl**
This scan is taken from a colour transparency that was exposed for the face of the girl lit from a window, with almost featureless shadows beyond. In fact, there are features visible in the transparency, but the scanner was not able to penetrate the high density of the shadows.

▼ **Close-up of adjusted scan**
This shows what is revealed if we open up the shadows. The noise from the scanner is very visible and is seen here as irregular dark and light stripes. This reflects the varying performance of individual sensors. Notice that noise is far greater in the shadows than in the midtones of the girl's face.

SCANNER FEATURES

Obtaining the best results out of your scanner entails knowing how to make best use of its features. This is due in part to the specifications, and in part to the actual performance of the scanner. The default settings on your scanner are designed to suit the majority of photographers, but that may not cover your style of photography.

MULTIPLE-PASS SCANNING

Scanners may offer multiple- or multi-scan capabilities, also known as signal averaging or over-sampling. This means that the final scan is made by averaging the results of two, four, or more scans superimposed one on another. Each time the scanner adds the data together, this tends to cause noise, which varies from one to scan to another and cancel each other out.

For dense negatives or high-contrast, high-density transparencies such as Fuji Velvia, use multi-pass scanning. If your scanner driver does not offer multiple scanning, some third-party software such as SilverFast or VueScan may support your scanner and provide multiple scanning.

Multiple scanning takes a lot longer than usual – not only because the scans have to be made several times, but also because of the increased computing overheads. However, the benefits to the image outweigh this short-term problem.

DMAX

The maximum film density, or Dmax, specification of a scanner indicates the greatest density from which the scanner can obtain a reading that is usefully greater than the noise level. It is not an entirely objective measure, but higher figures generally indicate a higher performance, particularly with colour transparency materials.

For professional quality you need a Dmax of at least 3.8. A higher Dmax figure also leads to a greater dynamic range – this measures the span from lightness to darkness that a scanner can distinguish. It is equal to the maximum density, less the minimum density, that can be read – usually about 0.3–0.6. If the minimum recordable density is 0.5 and the maximum density is 4.0, the dynamic range is 4–0.5 = 3.5. Ideally we look for scanners promising both high maximum density – at least 4 – and wide dynamic range – at least 3.7. However, to obtain the full benefit of high Dmax and large dynamic range, the scanner should work with 48-bit colour.

SCANNING IN 48-BIT

A number of modern scanners will scan into 16 bits per channel, 48-bit space (some into 36-bit space or 12 bits per channel). This is necessary in order to code for the highly compressed information in film. While some scanners will output 48-bit files, others only output 24-bit files. If you have a choice, retain the scan in 48-bit. This is well worth working with, despite the overheads in terms of much longer scan times and larger files.

Once you have obtained the scan, ensure you carry out colour and tonal corrections while still in 48-bit. After making tonal corrections, you will need to turn the image into 24-bit for final use.

▲ **Average scan**
This is a transparency that is very difficult to scan in a single pass: the original was deliberately underexposed in the midtones in order to hold highlight detail. Here they are held, but at the cost of the shadows, which lack detail. Compare this to the image that was scanned with multiple passes and 48-bit on page 102.

▶ **Excessive dust removal**
In its attempt to clean up an old transparency, the dust-removal process has been remarkably successful, but at the cost of losing a great deal of detail. Seen here at over 200 per cent magnification, the edge of the landscape looks unnaturally sharp and free of grain, which is an artifact of dust removal.

▲ Out-of-focus grain
A high-magnification view taken from the edge of a transparency shows that grain has disappeared. If the film is not perfectly flat, slight buckling throws it out of focus, so grain appears unnaturally smooth.

▲ Sharp grain
The grain on a scan of film should look like this throughout the image area: distinct but not too sharp. The grain characteristics add to the texture and quality of the image and distinguish a film scan from the oversmooth look of high-resolution digital images.

DEALING WITH MOIRÉ

The regular pattern of scanning may interfere with patterns in the object. The usual culprit is printed material where the raster of half-tone dots can clash with the fine scan raster. Technically, the best remedy is to scan at a much higher resolution than you need and downsize later. Another trick is to try placing the original at an angle for scanning and correct the rotation afterwards. Start with an angle of about 15° or 30°. This goes against the advice to avoid rotation, but the angle and the losses due to interpolation contribute to suppressing moiré. In fact, reducing moiré has the side-effect of damaging fine detail.

DUST REMOVAL

A number of film scanners use infrared light – which is scattered by dust but not by the dye clouds of film – to detect dust specks prior to a mask-based removal of them by duplicating pixel data contiguous to the defects into the defects. But silver grains scatter infrared very well, so dust removal based on infrared works less well with black-and-white film, apart from those developed by C-41 process, such as Ilford XP2 or Kodak T400 CN. Some systems will work unreliably

with Kodak Kodachrome film. Dust-removal systems increase scan times but save you work in the long run. However, transparencies with numerous dust specks will suffer loss of detail when specks are removed.

FILM LENGTH

It is obvious the scanner should accept the film formats you use. What is not so obvious is what you have to do to get the film into the scanner. Some insist that you cut your film strips up into short sections before they will fit – if normally you have three 6 x 6cm (2.4 x 2.4in) shots on a length of film, you may have to cut the strip to two shots to fit. This is maddening if you also want to print the same strip in the darkroom, so check this detail carefully before you purchase.

INTERPOLATED RESOLUTION

The maximum input resolution of a scanner is a lead selling point. Formerly, fabulous figures such as 4800 ppi were promised, but these were interpolated and not the true optical resolution. It is a deception similar to digital zoom in cameras. The practice has receded, but there is another to beware of: the maximum resolution quoted may be limited to a small area or smaller formats. A scanner promising 3048 ppi will cover only a narrow strip in the centre of its A4 scan area; the maximum resolution for the full area is 2000 ppi. Usually this is not a problem, since larger formats do not need very high resolution.

AUTO-SHARPENING

One of the choices presented by scanners is whether to allow it to perform sharpening or whether to do the work yourself in Photoshop. Sharpening in the instrument that is acquiring the image for you may take longer than not, but the equipment may give better results than Photoshop can.

The best approach is to see if you can discover any difference. Try scanning an image without sharpening and then with different levels of sharpening performed by the scanner. Then compare the results with an unworked image that has been sharpened in image-manipulation software. Remember, scanner-sharpened images will also show up the dust and dirt very nicely, unless dust-removal techniques were used.

FORMAT CHOICE

Medium-format film scanners cost much more than 35mm scanners but are generally made to higher standards and can last a very long time. For 35mm, aim for scan resolutions of around 4000 ppi with a Dmax of at least 3.8. For medium format, scan resolutions of around 3000 ppi are ample. Choose a scanner that has dust-removal technology – you can always turn it off if you don't want it on. It is also advisable to buy scanners that offer multi-pass or multiple scanning.

SCANNING WORKFLOW

The task of converting film-based originals into digital files is not the most creative and satisfying. But there are methods you can adopt to minimize the time and effort spent on scanning. The basis of any attempt to reduce the workload is, however, good planning. Ideally, you need access to film and flatbed scanners – not only to handle different material, but also for different tasks.

SCANNER SET-UP

Although modern scanners deliver excellent results straight out of the box, you will benefit from calibrating your scanner. As with any other piece of equipment, it is important to get to know about the scanner's characteristics to improve efficiency.

▼ **Ektachrome scan**
A scan from a Kodak Ektachrome 100 transparency shows its typical colour palette of excellent neutrality, bright blues, but a little weak on the reds, with slightly heavy shadows. You may choose to conform the scan to the original as closely as possible, or, as the photographer, you can freely interpret the scan.

Use a standard target such as the IT 8.7 – the print version for flatbed scanners, and a 35mm film version for film scanners. Make a scan using default settings and evaluate the result. You may choose to change the scanner settings to match the scan to the target (ensure your monitor is correctly calibrated). Alternatively, note the changes you need to make in your image-manipulation software, or use the scan to profile the scanner.

BATCH PROCESSING

When several originals are similar, you will want to apply the same levels of tone and colour correction to all of them equally. The technique of automatically applying the same settings to many images is called batch processing. There are two approaches to this. One is to apply settings in the scanner so that all images come out without needing further processing. This is an ideal-world scenario. Many scanners provide a way to save the various settings so they can be applied to multiple originals – thus, if you use Kodak as well as Agfa and Fuji films, you can set up

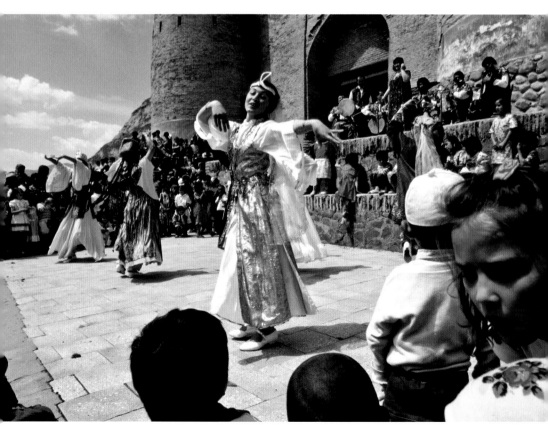

three different settings to suit the different films. The other technique is to leave the scanner on its default settings and batch process the scans using image-manipulation software.

However, for any batch processing to work, the input images need to be very similar, which means ideally they should have come from the same batch of film, been processed at the same time, and used on the same shoot. Unfortunately, legacy film is not as uniform as that. Nonetheless, it is likely that the scanner's default settings need some adjustment, and that, when applied to all scans, can save on image processing at a later stage.

SPEEDY SCANNING

If you need only thumbnail-sized images of transparencies, such as for use on the internet, you can lay several slides side-by-side on a flatbed scanner and scan them all at once. Then you need to crop the large file into the individual slides. Some scanners will automatically recognize the separate slides as individual items, or else you can first define separate scan areas over each slide, and the scanner will then make separate scans. Obviously, you will try to keep all portrait-format originals separate from landscape-format originals so you do not have to rotate some images and not others.

On the same principle, when you have a number of small, similar originals such as enprints to scan, lay them close together so that as many as possible fit onto your scanner's working area. Now scan them all as one image. This creates a large file with all the images together. You now need to select each one using the Rectangular Marquee tool with Feather set to zero pixels, and copy and paste each image into a new file. Remember that pasting in an image into a file in Photoshop creates a new layer, so it is necessary to flatten the image before saving.

Place your scans on the scanner carefully to avoid having to rotate them afterwards. Small rotations of less than 90° reduce sharpness and detail, due to the need to interpolate, even without changing file size.

AUTOFOCUS

In the rush to complete the scanning tasks, it is tempting to rely on the autofocus function offered by all scanners. With flatbed scanners, focusing is in fact fixed: the focus point is taken as the top surface of the glass. With film scanners, autofocusing is needed to adapt to the differences in the thickness of slide mounts. It is worthwhile comparing the results of autofocused scanning to those of scanning with manual focus – if that feature is offered by your scanner. You may be able to choose the point in the image to be focused on if you work manually, and results are usually sharper than with autofocus.

▲ **Kodachrome scan**
A scan from Kodak Kodachrome 64 film shows the greenish colour palette typical of the film, with olivey greens but strong reds, and excellent sharpness with fine grain. Because of the limited and biased colour range in the film, subsequent colour adjustment as a digital file is likewise limited.

▲ **Group scan**
Mounted transparencies can be scanned in groups on a flatbed scanner for quick results, which can then be selectively copied for use in small-sized reproductions. Note the veiling flare around the edges of the slide mounts: this is due to the light from the scanner. Its severity depends on the scanner design.

▲ **IT 8.7/1 target**
This widely used target contains a good range of colours, and the data file for each batch of targets – identified by the date in the lower left-hand box – can be downloaded from the manufacturer's website to be used for profiling the scan from your scanner.

ADVANCED SCANNING

As digital photography takes over more and more photographic output, the need for high-quality scanning has not decreased. If anything it remains vitally important as photographers seek the grain and tonal qualities that are suited to certain subjects. Experience with scanning has shown technicalities that were not at first apparent. Knowledge of these fundamental issues can help ensure top-quality scans. Finally, it is important to know how to supply files that are fit for function to ensure you do not cause yourself or your clients any unnecessary work.

RESOLUTION STRATEGIES

As discussed earlier, the easiest approach to resolution calculations is to remember that the currency is in pixels. Remember this is a virtual unit that has no size until it is made real or is output in some form. The workflow issue is exactly how many pixels you need.

Broadly speaking, images smaller than about 150 pixels long cannot show anything but the broadest structure of a picture. For web use, your images don't generally need to be longer than 720 pixels – which is also adequate for smaller prints, even half the average postcard size. For fair-quality prints and output to A4 size, you will work in the 2000–2500 pixel range. For good-quality prints, the numbers rise to image lengths of 3000–4800 pixels.

One strategy is that you should collect as many pixels as possible when you scan – scan to the highest resolution, thus creating the largest file size. The argument is that you can always downsize the file, but if you produce a small file from a scan, you will have to scan it again if you ever need a large file.

On the other hand, making large files takes much longer than small files, and of course, large files also increase overheads such as file storage space and time spent moving, opening, and saving them. However, this can be much less trouble and take less time than having to search for the original and scan it again.

SCANNING SILVER-GELATIN NEGATIVES

The scanning of silver-gelatin images – as opposed to scanning images formed from dye clouds – presents special problems. Black-and-white 35mm-format negatives scanned at high resolution of at least 2700 ppi may appear grainier than you had expected. At any rate, these scans are significantly grainier than a scan from comparable colour negative material. Attempts to scan at even higher resolutions may actually exacerbate the problem, not improve it.

Fundamentally, the difference is that the silver particles that make up the image scatter light, which means they change its direction. On the other hand, dye clouds of colour images absorb and filter light,

with little scattering. At the same time, the lighting in a film scanner is highly directional, which means it provides hard lighting.

The net result is similar to printing with a condenser enlarger (*see* page 298). Darkroom workers know that condenser enlargers give prints with sharper-edged grain and higher contrast than prints from a diffused-light-source enlarger. Now, add this to the high-resolution raster of a scan and you create an interference or aliasing between the film grain and the regular array of pixels.

Imagine a sharply defined grain: if it lies wholly within a pixel, it is accurately recorded. But if the grain covers half of one pixel and half of another, it will register on both pixels, filling both. Therefore, it appears to double in size (if less dense). The result of grain/raster interference is that many silver grains appear larger than they really are.

You can try to reduce grain/raster interference through slight defocusing. This classic work-around amounts to low-pass filtering. Set the scanner driver to manual focus, if possible, and focus just short of the optimum. This stops very fine detail from getting through and may seem counter-intuitive, but it may reduce graininess without too much harm to the main image features. You can avoid the problem by using chromogenic black-and-white films, such as Ilford XP2 or Kodak CN400.

SCANNING THE BLACK-AND-WHITE PRINT

There is a lot to be said for scanning a black-and-white print instead of the negative. Apart from grain/raster interactions, a large and well-made print – with well-executed burning and dodging – may extract more information when scanned at a low resolution, of, say, 500ppi (points per inch), on an inexpensive flatbed scanner than a high-resolution scan from a costly film scanner. The darkroom manipulations already applied to the print minimize post-scanning work. For the best results, make the largest print your scanner can take. This way you can use an average-quality flatbed scanner to obtain excellent results from film without having to buy an expensive film scanner.

FILES FIT FOR FUNCTION

You should ensure that the files you supply for output (whether to a third-party printer or yourself) are fit for function. This means the recipient should not need to work on the files – ideally your files do not need to be opened before they are used.

Your files should:

• Be printable at 100 per cent – that is, they are sized for the intended output size at a resolution compatible with the printer's specific requirements.

▲ ISO 400 film

The original image was recorded on Kodak Tri-X 35mm film developed in ID-11 at 1+1 dilution. This image is a scan, and close examination shows the grain is defined far more crisply than even the finest enlarging lens could deliver. The reason is that there is considerable light scatter in the enlarger and within the texture of the printing paper itself.

◄ ISO 400 grain

This close-up view of a scan from 35mm black-and-white film shows extremely sharp grain that would benefit from the application of a blurring filter. This would reduce grain without substantial harm to image detail, because most of the important information is larger than individual grains.

▼ Toned driftwood print

It is almost impossible to reproduce the subtle irregularities that occur in darkroom toning with image-manipulation software. Digital effects tend to be too regular, too perfectly applied. The real darkroom product is always a little irregular, not quite perfect. Fortunately, the flatbed scanner enables these darkroom treasures to be reproduced and enjoyed.

- Contain no more data than necessary. The resolution of the file should match the print media used. For glossy prints, use higher resolution; for prints on water-colour paper, use lower resolution.
- Be flattened to the Background layer and contain no extraneous elements such as layers, paths, or alpha channels.
- Be in a format compatible with systems in use. For mass printing, this is 24-bit RGB TIFF uncompressed, but JPEG files may be accepted.
- Be named consistently with codes for the job. Names should also be "legal" for the operating system – avoid use of punctuation marks such as "/", "*", and ":". Use dash (-) or undescore (_) to separate words if needed.
- Comply with colour-managed workflows. In professional work, all images should carry a suitable working-space profile, such as Adobe (1998) RGB or ProPhoto RGB.
- Not be sharpened unless the client has asked for sharpening, and not be over-sharpened if they have.

IMAGE MANAGEMENT

In the process of being liberated by digital photography, photographers have found they are inundating themselves with thousands of images. Many come from their digital cameras, some from scanning, yet others may be downloaded from the internet, and more from give-away CDs and DVDs in books and magazines. To make the best use of the images, you must be able to find them quickly and easily and keep track of them all without having to rummage through dozens of CDs or folders. The problem of image management has given rise to a new family of powerful software applications that are transforming the way photographers work.

STRATEGIES FOR EFFICIENCY

The most important decision is to get organized before your files get out of control and you lose important images in a hard-disk crash. It may seem unnecessary to catalogue a collection of a thousand images, but at least it is easy to do, and in the process you will learn about how to adapt software and systems to your needs. If you start when you really need to – with a manageable collection – you save yourself a more daunting task later.

SAVE TO FOLDERS

Before you save an image, think about where you will keep it. Don't save files into the first location offered by the software – it is almost always the wrong place. Create a folder specific to the occasion and save the files there – operating systems offer a high-level folder called "Pictures". To be really organized, create folders before you need to download your images. Before you leave for a holiday, create a new folder for each day or location that you'll be visiting, for example. It is better to have too many folders than numerous images all over the system.

PRACTICAL FILE NAMES

Always try to use helpful file names. Also, plan ahead: you know today what you mean when you call a file "Cape Babe" but years later, you're sure to find "Blonde – Noordhoek Beach – Cape Town" more helpful. Many digital asset-management applications allow you to change the names of your camera files so that unhelpful names such as IMG001.jpg can be changed to Cape001.jpg, for example. Also, use cross-platform-compatible names, which means avoiding the use of using any punctuation marks apart from the full stop (.).

NOT TOO MANY ITEMS PER FOLDER

Avoid storing too many items into the same level in a folder. Just like the paper equivalent, too many items in one place makes it difficult to find anything. Any set with more than a few hundred images should consist of sub-folders. It can be easier to find items

▲ Adobe Bridge
Adobe Bridge is a sophisticated file browser that helps you locate and work with files. It is capable of many useful tasks, such as downloading images from a camera, coordinating batch processing for renaming files, and using Photoshop to create contact sheets.

▶ Bridge metadata
In today's world, the metadata – the caption, location, etc – embedded in an image is a substantial part of the image's value. In Bridge, selecting an image displays not only a preview of the image but also all the embedded metadata.

▼ Camera Bits Photo Mechanic
Photo Mechanic is a very fast working and compact file browser for basic TIFF and JPEG files, which can quickly preview images, zoom and display image histograms, and compare images, but it has a limited ability to apply any image changes.

◄ **Adobe Lightroom**
Adobe Lightroom is a richly featured management tool that works with libraries of images to apply image processing or development, create slideshows, prepare for print, and create web pages. However, it must import images before it can work with them and is therefore not as quick to work as file-browser-type applications.

if you group related images to lower-level folders within a larger folder. Photographers returning from a wedding or other commission can have 2000 or more images, so metadata is used to keep large numbers of images organized.

LINK SCANS TO FILM FILING

Photographers do not need to be told to file their transparencies and negatives in numerical/date order, sequentially numbered. When you make scans from the same roll of film, it makes sense to append the film reference to the scan, plus some description, such as "2033/5 red landscape". This means film number 2033, frame #5 of the landscape.

LIST BY DATE MODIFIED

If you arrange files by the date they were modified, the first file offered will be the one most recently worked on. That is easier than rummaging among files listed alphabetically.

ADD CAPTION INFORMATION

The majority of image-manipulation software and all image-database applications allow you to add textual information or metadata. Add reminders of the steps taken to achieve the final effect, keywords that will enable easy picture management, and copyright data. Files now recognize a standard format – the value of this exercise will grow in years to come.

IMAGE DATABASES

An essential software application for the digital photographer, an image database enables you to link textual information with images. All image-management software enables you to change names and add keywords and caption information, as well as allowing you to email pictures, send to ftp (file transfer protocol) servers, print contact sheets, create simple slideshows, and burn discs.

Camera Bits PhotoMechanic is a favourite with photojournalists, thanks to its small footprint and quick operation. FotoWare FotoStation is similar in scope. More powerful than these is Extensis Portfolio (Mac OS and Windows), which can create web pages and serve to them. Some, such as Apple Aperture (Mac OS X only), Adobe Lightroom, and ACDSee (both Windows and Mac) are also raw converters and provide tools for you to make essential photographic adjustments such as tone and colour balance. Apple Aperture adds other functionality, such as designing simple web pages, printing books, and creating slide shows (*see also* page 318).

BACK-UP

While it is a given that backing up your image files is mandatory, the exact strategy to follow is not clear. Currently there are four ways, and it may be necessary to combine two or more to ensure full peace of mind.

The simplest, and one that provides the most rapid access, is to copy the files to at least two hard-disks, with one held off-site. However, hard-disks have a limited life, and if all your drives are about the same age, they may fail around the same time. Other local back-up is to copy files onto DVD, Blu-ray Disc, or other high-density discs, but these may have a limited life-span too. You may also back up to a remote redundant array – a network of many hard-disks that all carry the same information – such as a photo-sharing site or professional online site designed for photography, such as PhotoShelter. For the ultimate back-up – but a highly costly solution – some photographers are resorting to film, using film writers to turn digital images into large-format transparency film.

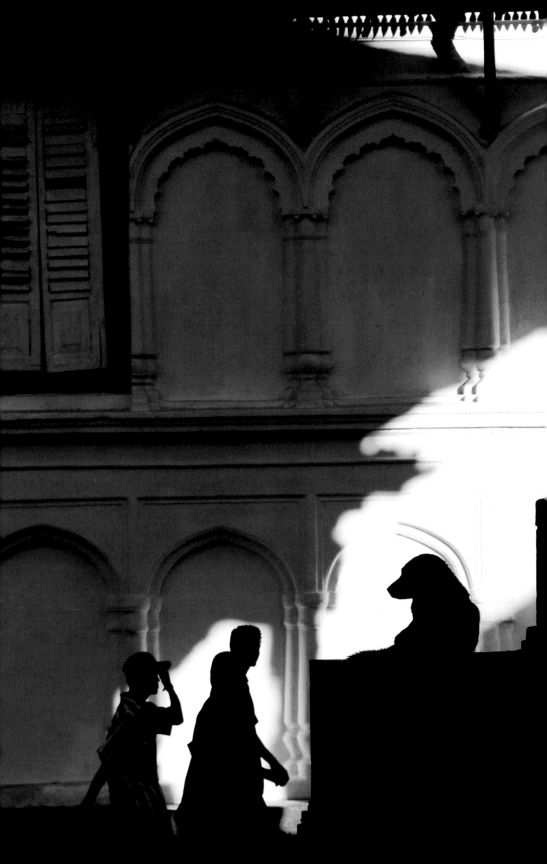

Outputting the image

PRINCIPLES OF ENLARGEMENT

DARKROOM EQUIPMENT

BLACK-AND-WHITE PRINTING

VARIABLE-CONTRAST PRINTING AND TONING

COLOUR PRINTING METHODS

DIGITAL OUTPUT

DIGITAL PRINTING

ARCHIVAL ISSUES

PRESENTING YOUR IMAGES

DISPLAYING YOUR IMAGES

PICTURES ON THE WEB

PRINCIPLES OF ENLARGEMENT

In film-based photography, enlargement is the process of making a print that is larger than the negative by using an enlarger. This projects an image of the negative onto paper, which is itself negative-working, thus reversing the negative tones of the film into a positive print. You can also scan the negative, then make a large print using a digital printer; essentially this too is enlargement, albeit one that uses a hybrid of analogue and digital processes. Note that image enlargement should not be confused with increasing the size of an image file.

FILM ENLARGEMENT

There are two main ways to enlarge a negative. The most familiar uses an enlarger and is a purely analogue process. The other, used in mini-labs and industrial-scale printing, is part-digital in nature in that many modern machines print by scanning the negative, then use laser beams to "write" the image onto printing paper.

The classic analogue enlarger used in darkrooms is essentially a projector for the film. A source provides light that shines through the negative onto a lens that focuses the image onto the baseboard; here, an enlarging easel holds the printing paper. The enlarger head is set on a column or other arrangement, which allows it to move up and down to change enlargement. The head consists of the light source, film carrier, and enlarging lens.

CALLIER EFFECT

Negatives printed through condenser-head enlargers are rendered at a higher contrast than the same ones printed through diffuser heads through the Callier Effect. This shows that light scattering is greater with directional light than with diffused light. In fact, the scattering of the directionally tight light of the condenser by the silver grains increases with a greater density of silver. With proportionally less light reaching the paper from denser regions of the negative, the result is a higher-contrast image. The effect increases with stopping down, as the smaller aperture cuts out peripheral rays, but it has no effect on images formed from dye clouds such as colour negative or chromogenic black-and-white film.

ENLARGER TYPES

The light source will be one of three types. The point source uses a special small bulb and is reserved for specialist, high-contrast printing. The condenser type uses large lenses (matched to the format being enlarged) that gather and focus light from a relatively weak lamp onto the negative. This gives normal-contrast results with the appearance of good sharpness; contrast also rises when the lens is stopped down. The diffuser type uses bright, low-voltage lamps in a white-lined box that lights the negative via an

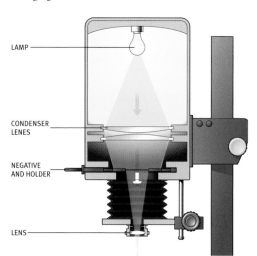

LAMP

CONDENSER LENES

NEGATIVE AND HOLDER

LENS

▲ **Condenser-enlarger cutaway**
This diagram shows the use of a large, low-powered bulb, which shines onto a pair of condenser lenses matched to the enlarging lens. The condenser lenses collect and focus the light through any filters present and onto the negative. The light reaching the negative is in a tight bundle of rays, which helps raise contrast.

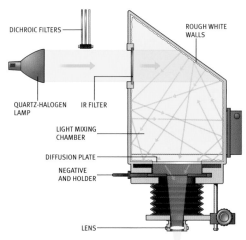

DICHROIC FILTERS

ROUGH WHITE WALLS

QUARTZ-HALOGEN LAMP

IR FILTER

LIGHT MIXING CHAMBER

DIFFUSION PLATE

NEGATIVE AND HOLDER

LENS

▲ **Diffuser-enlarger cutaway**
This diagram shows a typical colour enlarger that can also be used for black-and-white printing. A very bright lamp shines into a mixing box. The light path may be interrupted by colour filters. The light in the light-mixing chamber bounces around and is further diffused by the diffusion plate before reaching the film.

opalescent panel. This arrangement scatters the light to create a diffused beam through the negative, giving results that are lower in contrast than those from condenser enlargers. Silver grain may appear a little less sharp than that seen from condenser enlargers, but dust is suppressed compared with that seen from condenser enlargers. In practice, many condenser heads rely on some diffusion, and some diffuser heads use a little condenser effect.

Enlarger heads may be equipped with built-in filters for colour balancing colour prints, variable contrast filters for black-and-white papers, and may include a red filter for observing the image on the printing paper when it is in place. Built-in filters are more convenient to use and preserve image quality better than filters that fit under the lens.

ENLARGER COMPONENTS

The film carrier fits between the light source and the enlarging lens: these are designed to hold the film flat and to define the frame. The majority of carriers define a frame slightly smaller than the nominal negative size, but you can have them filed out if you wish to print a black border. While carriers are designed not to scratch film, it is advisable always to open up the negative carrier if you wish to enlarge another frame from the same strip of film.

The enlarging lens is specially designed for the subject/image distances normal in the darkroom and to give even sharpness across the image height, with minimal distortion: the majority of enlarging lenses are quasi-symmetrical optical constructions.

The normal focal length for a format is the same as that used in the camera – for example, 50mm for 35mm format, 80mm for 6 x 6cm. Longer focal lengths – for example, 63mm or even 80mm, for 50mm format – may be used for improved image quality and to increase exposure times with very bright sources. However, the longer focal lengths require a much greater working distance between the lens and baseboard.

Wide-angle lenses, such as 40mm for 50mm format, can be used to reduce working distances (the height of the enlarger head) and decrease exposure times. Non-standard focal length lenses may not work with condenser heads, as these are matched to standard lenses, but can be used freely with diffuser types.

The focusing mechanisms on enlargers can be manually controlled or focus automatically using a system of cams and linked levers. If manual focusing is used, it is essential to use a grain magnifier focusing aid; this gives you a highly magnified image of the grain on the baseboard, so when the grain is in sharp focus in the magnifier, it will also be sharply in focus on the paper.

▲ **Medium-format negative**
The most satisfying black-and-white prints are made from medium-format and larger negatives. The enlargement process tends to blur and soften the grain structure of film, allowing the tonality to be expressed. The more grains available, the smoother the transitions of tonality.

▶ **35mm-format negative**
The 35mm-format negative is ideal for capturing candid or street photography: the grain acts as a low-pass filter, which blocks out and obscures the fine detail present in the scene, thus forcing the viewer to look at the image as a coherent whole.

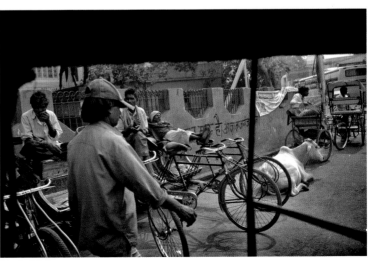

DARKROOM EQUIPMENT

The advantage of working with a black-and-white darkroom is that it uses largely 19th-century technology, so all the components are low-tech and relatively robust. Furthermore, creating a darkroom now can be an extremely low-cost exercise as many items are available very cheaply. Yet the laboratory will be fully capable of producing results far superior to even costly and advanced digital processes. The main downside is that just about every step uses wet chemicals, is labour intensive, and is time consuming to do.

PHYSICAL ARRANGEMENTS

The basic requirement is for a light-tight, well-ventilated room with electrical supply and preferably running water. Designate a dry bench – to keep paper and negatives that are being printed, and to make enlargements. It may also be where you put the enlarger. Then designate a wet bench – preferably unconnected to the dry bench but not more than a step or two away – for processing the exposed paper. The wet bench should be long enough to accommodate three rectangular dishes for the developer, stop, and fix. And it should be large enough to take the biggest size of paper you are likely to use. Finally, you need a print-washing area. If you are tight for space, this could be in a separate room, such as an adjoining bathroom.

LIGHTING ARRANGEMENT

In addition to normal room lighting, you must set up a safelight. This produces a deep orange light that allows you to see as you move around the darkroom but does not expose normal printing papers, so you can walk around and handle all your materials easily. A small inspection light or miniature light-box by the enlarger is useful for identifying and setting up negatives. But do not use orange light for developing film: a safe light for panchromatic film is an LED source, which produces a very dim green glow of a precisely regulated wavelength.

CHOOSING YOUR ENLARGER

There has never been a better time in the history of photography to purchase an enlarger. The rise of digital photography has put many darkrooms out of business, so equipment is extremely cheap to purchase – some photographers may even be giving it away. Items such as enlargers are extremely durable and very likely to be excellent second-hand buys. Furthermore, it remains as true today as a hundred years ago that few things are more rewarding in photography than making your own prints.

For normal printing with silver-based films, use a condenser enlarger, although dust does show up sharply. Alternatively, use a diffuser enlarger; but because this prints very slightly softer in contrast, you may need to increase film development time to boost negative contrast. Diffuser sources are best for colour printing but become hot and produce so much light that exposure with black-and-white materials with prints smaller than A4 may be very short, which may make it difficult to burn and dodge.

ENLARGING LENS

Optics for enlargers feature low levels of distortion, even coverage from edge to edge, and high performance limited to close-up distances. Unlike camera lenses, their lens apertures are manually controlled, so you have to open them to full aperture to arrange and focus, then stop down for exposure. Enlarging lenses should be focused at full aperture, then stopped down by one to two stops to improve image quality and increase depth of field (the subject being imaged is the film), which helps absorb errors from slightly curved film.

Lenses in the Schneider Componon, Rodenstock Rodagon, and Nikon series can be relied upon to give excellent results. Their close-range performance makes them excellent when used with bellows extensions for close-up photography.

◀ **Boy at ferry window**
In an era that is predominantly digital, the silver-gelatin print made in a darkroom has become marginalized, but the quality of the image – its tonality, grain, and physical presence – is still beyond the means of digital cameras. Silver-gelatin prints offer an immediacy and tactile qualities that are unique.

TIMER

An electronic timer controlling the enlarger is needed to ensure consistent print exposure. Timers will turn the enlarger on manually to allow focusing and will also time the exposures – turning on the bulb on command, then turning it off after the set time has elapsed. While the majority of timers set the time directly, the best for advanced work are those that can vary the set exposure times by stops or fractions of stops. For example, to burn in for 2 stops on a basic 10-second exposure, the timer sets 40 seconds.

ENLARGING EASEL

An easel to hold the printing paper on the enlarger baseboard is essential: it serves both to secure the paper and to keep it flat, so the image is evenly sharp. It also serves to mask off the borders to give neat edges to the print. The most flexible designs use four adjustable blades to accommodate different-sized papers and provide different widths of margin. However, two-bladed designs are the easiest to use and adjust. You can use a large easel to cover all sizes, but smaller prints are more easily made on small easels.

▶ Enlarger
This mounts the enlarging head so it can move up and down on a column. Modern enlargers offer a stable, high-power light source with automatic or manual focusing. By using wide-angle lenses, such as the 40mm lens for 35mm format shown (*see* right), you can create large prints without a very high column.

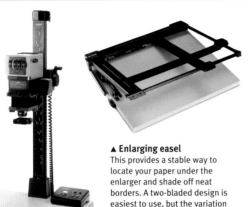

▼ Negative carrier
This holds the film – which may, of course, be a transparency – between the light source and the lens. It may be constructed as a hinged metal frame or carry one or more glass plates to hold the film flat.

▲ Enlarging easel
This provides a stable way to locate your paper under the enlarger and shade off neat borders. A two-bladed design is easiest to use, but the variation in border widths may be limited.

▼ Burn and dodge tools
Two L-shape cards can be used to give varying sizes of aperture for burning. To create a dodging tool, simply glue a piece of cardboard to a fine wire so that a shadow is cast by the card but not by the wire.

▼ Enlarging lens
A high-quality enlarging lens such as those from Schneider or Rodenstock is central to producing sharp prints. The model shown here has a lever for stopping down and opening the aperture to a preset value.

▲ Enlarger timer
This is essential to ensure repeatable printing results. Some timers can calculate times based on stops, or fractions of stops for a set time.

▶ Dishes
Dedicate a developing dish to a specific task, so one used to develop prints is never used for stop or fix. Colour-coding the dishes – white for development, red for stop, and grey for fix – helps keep functions separate.

◀ Safelight
Safelights can be domestic bulbs filtered with a deep-orange filter or LEDs tuned to deliver visible light that does not expose sensitive materials. A safelight is essential for efficient darkroom work.

BLACK-AND-WHITE PRINTING

The procedure for making enlargements is simple, flexible, yet easy to master. The key to success, as well as maximum enjoyment of darkroom work, is to prepare with care and to work as consistently as possible from one session to the next. A final point of good practice is to make notes as you work: jot down the exposure, contrast grade, and burning times for each print, and note the developer you use and any special circumstances. This becomes, in time, an invaluable resource for honing your darkroom skills.

SELECT FRAMES

Before you enter the darkroom, it is good practice to select the frames you wish to print, since there will be more space to work and better light. Write down references to each negative by its roll number and frame number. In the dark it is much easier to identify a frame by its number than by trying to find it among other similar images. And remember not to write with red-coloured ink: this will be nearly invisible under the safelight; use black or blue-black instead.

EVALUATING THE NEGATIVE

It is helpful to evaluate the negative (again, before entering the darkroom) to decide on the contrast grade of paper that will best suit. We match contrast grade of paper to compensate for negative contrast in order to make a print with a full range of tones.

High-contrast (or hard) negatives show a mix of mostly dense and nearly clear areas in the negative, with few midtone areas: shapes and detail are easy to see. Low-contrast (or soft) negatives show mostly grey tones, with few black or clear areas, and details may be difficult to make out. Having evaluated the negative, you can set the variable-contrast paper to the appropriate grade or choose a suitable grade of paper.
• **Normal** (Grade 2–3) paper for correctly exposed and normally developed negatives recording average luminance range.
• **Soft** (Grade 0–2) for high-contrast (hard) negatives.
• **Hard** (Grade 3–5) for low-contrast (soft) negatives.

MAKING UP CHEMICALS

You should make up solutions accurately and carefully following instructions. You should wear rubber gloves to protect your hands from chemicals (although the majority are not corrosive or poisonous except in large quantities), and wear a rubber or plastic apron. If you are mixing up powdered components, use a dust mask or face mask.

Measure concentrated quantities and the volume of diluting water as accurately as possible. You need to make up fresh developer for each session, but stop and fix baths can be used several times and stored for a few days between darkroom sessions. Try to work with the developer at 20°C (68°F): some people like to condition or soften the developer by processing a dummy sheet or two before the first proper test strip.

SETTING UP THE ENLARGER

Set the easel to the size of print you wish to make, but remember to allow at least 12mm (½in) border all round for the easel to hold the paper. Take out the negative carrier from the enlarger, and place the selected frame of your film upside-down with the shiny (non-emulsion) side up into the carrier.

Open the enlarging lens aperture to maximum, turn on the safelight, then turn off the main lights.

Turn on the enlarger, and you can now observe the projected image of the negative: it is likely to appear unsharp. Focus it by adjusting the lens control by eye: if the resulting image is smaller than the easel frame, raise the enlarger head; if it is smaller, lower the enlarger head. When you move the enlarging head, the image will appear to get smaller if you raise it and larger when you lower it, but will return to its true size once focused.

Adjust the enlarging head and focus until the projected image is the size you require. Ensure the image is just larger than the borders of the frame to make a neat print. Place a focus finder in the centre of the image, and adjust focus carefully until the grain is seen to be sharp. Stop the lens down 1 or 2 stops. Turn off the enlarger lamp.

CONTACT PRINTING

In contact printing, the film is placed flat onto the printing paper to make an image that is the same size as the film. It does not need an enlarger, although normally an enlarger is used to project an evenly illuminated beam of light to make the exposure. Contact prints are also called proofs because they provide a quick record of the images on a roll of film. You can use contact printers that hold individual strips of negatives or, if you use transparent sleeves to store your negatives, you can just place the sleeve with its negatives on printing paper, and hold them flat with a sheet of glass. If you have a scanner, it may be easier to scan the negatives to make a reference image. Unfortunately a set of 35mm or 6 x 6cm negatives is larger than A4, so you will need to scan in two portions and join the images together if you only have an A4 scanner.

PRINT EXPOSURE

As with exposing film, a crucial step is determining the correct exposure to produce the print. This depends on fixed factors such as the light output from the enlarger and other factors under your control:

• Scale of enlargement;
• Effective aperture of lens;
• Average density of negative;
• Speed of printing paper;
• Development;
• Contrast grade of printing paper.

The easiest way to determine exposure is to make a test strip. First ensure the correct contrast grade is set. Next, give a sample of printing paper a series of exposures: the first one exposes the entire strip for a short time, then you cover a strip (about 2cm/1in in width) and give another exposure before covering a further 2cm (1in), and so on. You then process the test strip to judge which exposure gives the best result.

The easiest timing method is to set, say, 5 seconds on the timer and make exposures in increments of 5 seconds, so the cumulative times for each strip are 5, 10, 15, 20, 25 seconds. Such a method gives you less and less information along the test strip: the difference between 5 seconds and 10 seconds is 1 stop, but the difference between 20 seconds and 25 is less than $\frac{1}{3}$ stop.

A superior method is to make test strips using this sequence of times: 5, 7, 10, 14, 20, 28, 40, seconds: this sequence gives you roughly equal steps that are about $\frac{1}{2}$ stop apart. Set the timer at 3 seconds and expose; cover a bit, set the timer to 2 seconds and expose; cover a bit more, repeat, then set 3 seconds again and expose and so on as follows:

SET	3	2	2	3	4	6	8	12	16
You get	*3*	*5*	*7*	*10*	*14*	*20*	*28*	*40*	*56*

With this method you should never need to make more than one test strip per print. Exposure times in the range 10–20 seconds give you sufficient time to burn or dodge but are also not inconveniently long.

CONTROLLING EXPOSURE WITH TIME

Note that we vary exposure time, rather than changing lens aperture, in black-and-white printing because it is easy to control with a precision and repeatability that aperture stops cannot equal. In addition, because of the photometry of condenser enlargers, stopping down a lens does not decrease the light coming through as the change in aperture would indicate. In contrast, your main control over exposure in colour printing is lens aperture. This is because colour balance shifts with changes in exposure time, which should therefore be kept constant.

▲ **Test strips**
Making test strips is not only essential for determining print exposure, it is also the best way to learn about the tonal characteristics of your paper and developer combination.

DEVELOP THE TEST STRIP

With the test strip exposed, it is time to develop it. Slip the test strip, emulsion down, into the developer and follow the developer's instructions – for PE (polyethylene-coated) papers, develop for 60 seconds; for baryta-coated or fibre-based (FB) papers, develop for 2–3 minutes. After full development is reached, lift the paper out, let it drip for a few seconds, then carry over to the stop bath.

STOP AND FIX

The stop bath stops the action of alkaline developer by being strongly acidic, thus conditioning it for the fix, which is also acidic. Fix removes undeveloped silver from the paper. Leave in the bath with light agitation for 1–3 minutes, according to the type of fix used.

EVALUATING THE TEST STRIP

Turn on the main light and examine the test strip: locate the section that shows the best image – that is, where the midtones are correctly exposed. Shadows may be missing detail, so you will need to dodge during the exposure to bring out shadow detail. Highlights may be too light, so you will need to burn in areas that are too light. Work out the exposure time from your sequence of timings for the test strip. This is your basic exposure for the print.

It may be evident that there is a mismatch between the contrast of the paper and that of the negative: the test strip may look too contrasty or too flat. If that is the case, make a new test strip using the correct contrast grade. Note that rate of agitation affects the

density and, marginally, the contrast of a print. Test strips that are smaller than a large piece of paper receive much more agitation than the final print, so you may have to allow for this.

When you evaluate the test strip, also look at the rendering of high and low tones. Will you need to give extra exposure to the high tones (burn in) or reduce exposure in the low tones (dodge)? If so, you can use the test strip to evaluate the degree of burning and dodging you will need.

MAKING THE PRINT

Prepare to print by writing lightly on the back, near the edge, a note of the frame number and basic exposure details: grade, aperture, time. Use a fine permanent marker for PE- (polyethylene)-coated papers or a soft pencil for FB (fibre-based) paper. This gives you invaluable reference for later printing

sessions. Set the enlarger timer to the time suggested by the test strip. Place the paper under the easel. If you wish to double-check the focus, swing in the red filter and open the lens aperture to examine the image under a focus magnifier.

For the print exposure, turn off the lamp, swing out the filter (if used), and stop down the lens to the same aperture as that used for making the test strip. Use very soft actions. Now set the timer and allow at least 5 seconds before exposing – this allows vibrations to die down – then expose with the timer.

Careful preparation before you make a print will help ensure your first full-size print will be close to the final print. You make a "flat" first print – one with no burn or dodge. Alternatively, if you are experienced, you can apply some burn and dodge manipulations on the first print as needed, fully expecting to refine it with subsequent prints.

▲ **1. Insert the negative**
Remove the film carrier from the enlarger. Place the negative emulsion down, rotated 180° from right-reading, and centred on the aperture in the negative carrier. Close the carrier and do not try to slide the film while in the carrier. Replace the film carrier.

▲ **2. Focus the image**
Turn the lens aperture ring to open to maximum aperture for the brightest image. Adjust the height of the enlarger head – higher to make a larger print, lower to project a smaller image for a smaller print – and focus roughly by eye.

▲ **3. Centre the image**
Arrange the baseboard to contain the image or crop to the desired extent. Check the borders will print neatly, or if you do not want borders, check that no part of the paper is shaded or picks up the edge of the film carrier.

▲ **4. Focus the grain**
With the lens aperture wide open, focus the image on the baseboard, viewing the image with a grain magnifier placed on a sheet of dummy printing paper to set the height. Note that the magnifier is placed near the centre of the image.

▲ **5. Stop down**
Turn off the enlarger light and stop the lens down to working aperture – 2 whole stops (which may be four clicks) from full aperture. This optimizes lens performance and increases depth of field to allow for slight curvature in the film.

▲ **6. Make a test strip**
Insert a sheet of paper and fully expose the whole sheet for 3 seconds. Cover all but a small strip with black card, expose for 2 seconds. Slide the card incrementally to expose another strip. *See* page 303 for the sequence.

▲ 7. Develop and evaluate
Develop the test strip, taking care not to give it more agitation than the full-size print will receive. Stop and briefly fix and rinse for 30 seconds, and view under a good light. Decide which strip gives the best result, and work out the exposure time.

▲ 8. Make the print
Set the enlarger timer to the time determined from the test strip. Insert a new sheet of paper, taking care not to disturb the position of the baseboard. Swing the red filter and turn on the enlarger to check focus again, if needed.

▲ 9. Expose the print
Swing the red filter away if you used it, and wait at least 10 seconds for the enlarger to settle down and be perfectly still. Expose using the enlarger timer, burning and dodging as necessary – using hands or with masks or dodging tools.

▲ 10. Develop
Slide the exposed paper, emulsion down, into the developer and agitate constantly with an irregular but gentle rocking motion for 30 seconds, then 10 seconds for every 60 seconds. Do not snatch the print early to compensate for overexposure.

▲ 11. Use the stop bath
Lift the print out of the developer dish by its corner and allow the developer to drain off. Slide the print into the stop bath. Agitate constantly for about 30 seconds for small prints, 60 seconds for prints A3 or larger. Lift up by the corner and drain as before.

▲ 12. Fix
Slide the print face down into the fixer. Agitate constantly but gently for 1–3 minutes according to instructions. Do not leave the print longer in the fixer than necessary, as you only prolong the wash cycle.

▲ 13. Wash
Wash the print in clean running water until the fixer is removed: PE papers for 3 minutes; for FB papers, up to one hour. Follow your paper and chemical manufacturers' instructions. Water should be constantly refreshed at a moderate rate.

▲ 14. Hang to dry
At the end of the wash, hang the prints by their edges to dry. Use a squeegee to remove excess water. With PE papers, prints can be hung individually or rested on supports. With FB papers, prints must be hung in pairs, pinned back to back.

PRINT OR SCAN?

The image quality of a print from a normally exposed and developed black-and-white negative is roughly comparable to a print of the same size from a high-quality scan. However, with a low-density, low-contrast negative, image manipulation may produce superior results from a scan compared with a darkroom print from the same negative. On the other hand, a darkroom print made from dense and contrasty negatives is likely to give superior midtone results compared to a scan from the same negative.

VARIABLE-CONTRAST PRINTING AND TONING

Given negatives of varying contrasts, it is necessary to use papers of compensating contrast. This is the precursor of modern techniques of tone-mapping, in which a wide luminance range is compressed into the relatively narrow tone range of a digital image. With printing paper, there are two strategies for varying the contrast grade. In one, the contrast grade is fixed in the paper at the time of manufacture: this can give the highest-quality results but calls for very careful film processing to ensure consistent film gamma. The other method, and by far the most widely used, is to create papers whose contrast can be varied at the time of printing.

VARIABLE CONTRAST

The contrast of fixed-grade papers can be varied within narrow limits – a little more than half a grade – by choice of developer. However, the grade of variable-contrast (VC) papers can be varied over the entire range, from 0 to 5, simply by changing the colour of the enlarging light: in green light, contrast is low; in blue light, contrast is high. Simply change the colour of the enlarger light by using filters or changing settings in the enlarger head.

Variable-contrast papers work by mixing two emulsions together: one is low in speed and sensitized to green light; the other is high speed and sensitized to blue – that is, each emulsion has a different characteristic curve according to the colour of light. Therefore, changing the colour of the light changes the relative contributions from the slow and fast emulsions, which in turn changes the combined gamma. This method is an improvement on the earlier technique of using green-sensitive low-contrast and blue-sensitive high-contrast emulsions, since it ensures even image colour throughout the contrast range and also uses the full available density.

SPLIT-CONTRAST PRINTING

Using VC papers it is possible to apply different contrast grades to different parts of the print. Typically, shadow areas or foregrounds in landscapes need higher contrast than the bright areas such as skies. The technique calls for two test strips to be made: one at Grade 4 or 5 covering the low-contrast areas in the print; then another at Grade 0 or 1 for the high-contrast areas. Once you have chosen the respective exposure times, you need to expose the entire print at Grade 4 or 5 first. This gives a high-contrast exposure to compensate for the dark, low-contrast areas. These dark areas usually call for the shorter exposure time, so the exposure has little or no visible effect on the high-contrast areas. Next, shade off the dark areas and expose only the bright areas using a Grade 0 or 1 setting.

PRINT IMAGE TONE

Black-and-white prints are never truly black or white: the "black" is often a dark grey with some hint of colour, while the white is usually off-white and sometimes visibly creamy or yellowy. Two main factors control the image tone; the first is the type of paper and its halide composition. Generally speaking, bromide papers with less silver chloride than a chlorobromide paper produce colder or more neutral tones. Papers called chlorobromide use more chloride than bromide, tend to be slower in speed, and yield warmer image tones. Slower papers respond more

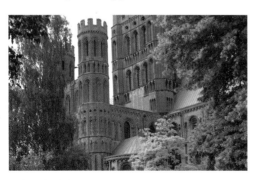

▲ **Ely Cathedral**
This image is equivalent to a straight print from a negative made with a yellow-green filter. Tones in the trees are well separated but made rather similar to the tones of the cathedral, so overall the mood is rather gloomy and overcast.

▲ **Ely Cathedral in sepia**
Sepia toning of prints not only changes the print hue to pale yellowy or reddish browns, there is also an overall drop in the maximum density that opens the shadows and improves darker details. This lifts the mood of the print.

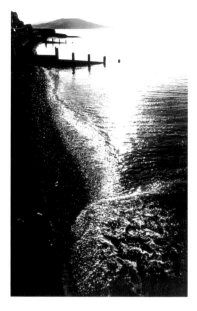

◄ **Grade 0 test strip**
A test strip is made for high-contrast sea and sky using Grade 0, the softest. Even so, it is apparent that small differences in exposure make a big difference to the density of the print, which is typical of high-contrast subjects.

◄ **Grade 5 test strip**
The gamma of the print is wound up to Grade 5 to extract as much detail as possible from the shadows. This shows that it is possible to retrieve some information from the shadows if we print with the highest contrast and dodge a little.

▲ **Dorset seaside**
This view straight into a low sun and its reflection on the sea offers extremely high luminance range. In an attempt to control the highlights, the foreground was allowed to go almost completely dark. Even so, a straight print, as that shown, holds no details in the shadows or the highlights.

readily to image-tone manipulations produced by developer modifications.

The developer is the second factor contributing to image tone, because its behaviour determines the size of grain and because dispersion varies with grain size. This in turn controls the image tone. The majority of image-tone effects can be controlled with the bromide and restrainer concentration and by the type of developing agent.

TONING

Toning is used primarily to change or enhance the image colour of processed prints. Toning can also improve the print's longevity. Toning chemically converts the black-and-white silver image to a metallic compound or substitute metal – both relatively more inert than metallic silver.

Selenium toner produces a richer range of tones in the shadow areas, giving cool chocolate-brown hues with warm-tone papers and very little or no change with cold-tone papers. A 1:20 dilution is used for print protection. The warm brown toners of sepia and similar toners are very popular. Digital cameras can even produce images with sepia effects. These toners convert the silver image to silver sulphide. Other toners, such as gold salts, enable black-and-white papers to cover a surprisingly wide range of colours.

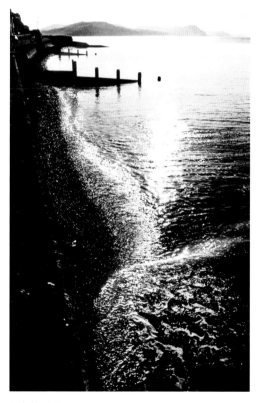

▲ **Final print**
The final print shows fair detail in the highlight regions, although the large grain has degraded sharpness in the sky and distant hills. There is a little foreground detail, but the most important feature is a continuity of tonal texture in the water.

COLOUR PRINTING METHODS

The integral or composite method uses material in which the colour components are incorporated or are ready to link with dyes during processing. The assembly method builds up the colour from separate elements that are brought together at the surface of the print. Modern ink-jet technologies are essentially assembly methods: separate ink colours are laid onto the paper. In contrast, the majority of silver-based technologies are integral, using printing papers that consist of superimposed layers incorporating dye couplers, which link with dyes during processing or contain actual dyes. Integral methods themselves fall into two main approaches: printing from a negative to positive (*see also* pages 112–13), or from positive to positive (*see also* pages 110–11).

NEG–POS

The vast majority of colour prints are made from negatives that are printed onto negative-working paper. The paper reverses the reversed colour of the negatives, as well as the reversed tones, into a positive record. In fact, the paper also uncompresses the highly compressed image held in the negative. While virtually all colour prints are made automatically in high-street printing machines, it is relatively easy to make prints in a home darkroom. And the results can be dramatically superior to high-street prints. In colour printing, two inter-related controls are required (after focusing): the exposure and colour balance. Colour balance is adjusted by changing the filter settings in the enlarger head, which changes the colour of the enlarging light. In the amateur darkroom, a change in exposure may cause a shift in colour balance, and a change in filter settings will cause a change in exposure.

COLOUR CORRECTIONS

When making prints from colour negatives, these are the directions of adjustments to help arrive at the correct filter settings. Decrease filter densities (settings) in preference to increasing densities.

IF THE PRINT IS	SET	OR SET
Too red	less C	more M+Y
Too green	less M	more C+Y
Too blue	less Y	more C+M
Too yellow	less C+M	more Y
Too magenta	less C+Y	more M
Too cyan	less M+Y	more C

COLOUR CORRECTION

The tricky part of neg–pos printing is learning how to correct colours, because the negative working calls for counter-intuitive adjustments.

If a print is too red, you need to increase the amount of red in the enlarging light: add magenta and yellow, or subtract cyan. Or if a print appears too magenta, you will need to increase the magenta setting, or decrease the yellow and cyan to compensate. Good practice is to try to reduce a filter setting rather than increase another setting – this ensures that exposures are as short as possible. Do not dial in all three colours at once, as one of the colours will be redundant and cause unnecessary loss of light. If a print is too light, you need to increase exposure; decrease exposure if it is too dark.

When you print a colour negative, you will need to calibrate its colour and determine the exposure. Set up

◀ Ring-around
From the basic filter pack, which gives the central image, we make various prints with differing settings. In the 1 o'clock position there is a yellow cast from cyan plus magenta; at 3 o'clock there is a red cast from increasing cyan; at 5 o'clock there is magenta from increasing cyan plus yellow; at 7 o'clock there is blue from increasing yellow; at 9 o'clock there is cyan from increasing yellow and magenta; at 11 o'clock there is green from increasing yellow and cyan. An ideal print may lie between the central print and the slightly blue print, so we need to reduce yellow by an amount half that used to make the ring around.

the enlarger for the print size required, focus and stop down to working aperture, and set filters as recommended by the enlarger or paper manufacturer: this is your default filter pack. Now you need to make a test strip using the aperture control. Then make a test strip for colour, making a series of exposures with differing filter settings (*see* opposite).

RING-AROUND

The above process creates the "ring-around", in which you ring all the various changes or combinations of filters: cyan and magenta, cyan and yellow, magenta and yellow, magenta and cyan, then yellow, cyan, and magenta by themselves. In practice, you may leave out the cyan filters. From the ring-around, you can choose the filter settings (also called filter pack) that give the best colour. You may need to repeat the process with smaller variations to home in on the perfect settings. Note that you may have to determine new settings for subsequent frames, even if they are on the same film. You may also need settings to compensate for changes in size of print, exposure times, change of paper, or change of enlarger or enlarger bulb.

PROCESSING

The standard process for making prints from colour negative is Kodak RA-4. Chemistries made by other manufacturers have different names, but the processes are identical. The first black-and-white developer step is similar to that of C-41, the negative film process, but

the contrast is higher. In the final step, the bleach and fix baths are combined, creating the "blix" step, which speeds up processing. Processing can be carried out in small tanks in a home laboratory, which can give superior results to professional hand-printing.

POS–POS

Prints made from positive materials such as colour transparency are positive-to-positive working. As such, because all normal photographic processes are negative-working, we need a reversal step to turn the native negative image in the print into a positive one. One process, the Kodak Type R-3, puts a dye-coupler paper through colour processing with a chemical-reversing step after the first development: the principle is very similar to processing a colour transparency in the first place. The alternative method, Ilfochrome Classic (better known by its old name of Cibachrome), uses relatively stable azo dyes incorporated into the print, which were selectively removed during processing. Cibachrome gives markedly sharp results with extremely good archival qualities. With the increasing use of digital printing, pos–pos processes are rapidly falling into disuse.

DIGITAL OUTPUT

In common with film-based, or wholly analogue, systems, digital colour reproduction is based on using a limited set of colours to simulate a much larger range of different colours. However, the fundamentals are entirely different. With film-based colour, the recording and reproduction take place over the entire image more or less within an instant.

With digital colour, the image is built up in what is essentially a scanning action. Colours chosen from a limited range of hues are laid down or used in a regular array of dots of ink: although recent technologies randomize the regularity, the underlying array or grid remains. The varying densities of colours simulate a wide range of hues.

DITHERING

Dithering is a family of different techniques used to create the illusion of many colours employing a small set of colours. This can vary from the three colours used in digital cameras and monitors, to the eight or more inks used in modern ink-jet printers. The colours that are not available directly from the separation palette are simulated by the mixture or diffusion of varying strengths of palette colours.

This exploits the human eye's perception of spots of colour that are too small to be distinguished to be a mixture or blending of the hues – appearing to have one uniform colour. The technique was actually known to Roman artisans, who used dithering in that ancient precursor of the digital image, the mosaic. Where dithered images use only a few colours, or the dither pattern is relatively large, the eye can distinguish irregularities in the colours that appear as a characteristic graininess or speckling.

Dithering has to be irregular or somewhat random. Otherwise, non-photographic patterns result.

◄ **Half-tone cell**
This shows 16 half-tone cells, each made up of 16 addressable dots. As more and more dots are filled with ink, the half-tone cell becomes darker. There are only 17 steps possible with unequal steps: 6 per cent coverage to 12 per cent coverage is a 100 per cent increase, but 94 per cent to 100 per cent is only a 6.4 per cent increase.

Essentially, what must be simulated is the random way in which silver-based film reproduces tones and colours. Without that randomness, extremely high device resolutions are needed for satisfactory output quality.

HALF-TONE CELL

The fundamental concept in modern printing is the half-tone cell. This is a defined grouping of printer-addressable points that can be filled with ink dots in various ways to simulate a greyscale ramp from white to full black (or full ink density), or any coloured ink from paper white to that colour's full density.

The assumption is that at any printer-addressable point on the paper – a place in two-dimensional space where a spot of ink can be placed – the choice is limited to either placing a dot of ink or not. From this comes the notion of the half-tone: either on or not. If we collect a number of addressable

▲ **Dithering and resolution**
This shows the use of two colours to create a third. If the dither pattern is large, we see two separate colours. As the dither pattern becomes smaller, depending on viewing distance and resolution, the two colours merge to form a third.

				10 LINES PER INCH
Y 40 PER CENT	Y 30 PER CENT	Y 20 PER CENT	Y 10 PER CENT	
				150 LINES PER INCH

▲ **Resolution and smoothness**
This diagram compares the visual appearance of varying densities of yellow on cyan at different resolutions. At a very coarse resolution, the dots are visible and there is no dithering effect whether at 40 per cent Y or 10 per cent. Note that each density uses the same number of dots, but at lower densities the dots are smaller. At a high resolution, again, each square is populated by the same number of dots, but they are so small we don't see separate yellow or cyan dots, but greens: dithering creates the third colour.

▼ **Colour table**
This shows the 80 colours used to create
the indexed-colour version. Obviously
a few more would make for a smoother
image, and one with more subtlety of
tone, but with care, even the 80 colours
can be reduced in number.

▲ Landscape – original
The original image was made on a colour
transparency and recorded in a very large
colour gamut, but the actual number of
colours used is surprisingly small.

▲ Indexed colour
This is the same image reduced to only
80 different colours. You have to examine
closely to find discernible differences
between this and the full-colour original.

points together, it is obvious that if
we fill each point with ink, we have
a dense or black assemblage. And
if we apply no ink to any point, we
have a white assemblage – an area
with no ink. The collection of points
is the half-tone cell. Each extra point
filled with ink is another greyscale
step towards black or a single colour
at full strength.

The number of steps equals the
number of points in the half-tone
cell, plus one for white. From a
normal distance, the small dots
merge to appear a shade of whatever
ink we apply. For smooth-looking
transitions, we need in excess of 100
steps. Therefore, each half-tone cell
must measure around 10-dot x 10-
dot. Better is a half-tone cell of
14-dot x 14-dot, giving nearly 200
greyscale steps. Note that the cell
is filled in a random manner: if not,
cells with equal populations of dots
will form patterns.

A printer, then, with a resolution
of 2400 dpi must devote most of its
resources to creating half-tone cells.
With 10-dot x 10-dot cells, the
output resolution drops to the
equivalent about 240 lpi (lines per

inch); with 14-dot x 14-dot cells, the
resolution is a mere 170 lpi.

The crucial result, which has the
force of mathematical law, is that
the more greyscales you reproduce
from a given device, the lower
the output resolution can be.
Conversely, if you want high detail
resolution, you must sacrifice
greyscale resolution. However,
remember that good-quality
magazine printing has a resolution
of between "only" 133 lpi and 150 lpi
– and its quality is visually superior

to that of ink-jet printers of
much greater resolution. This is
because magazine printing has
more than 100 greyscale steps for
each of four colours.

Since greyscale variation is
represented by differing numbers or
populations of dots, we call this a
frequency-modulation method of
greyscale reproduction – detail is
recorded by varying frequency.
This is also known as stochastic
screening and is processor-intensive
to compute.

In contrast, mass-printing
processes rely on changing the size
of dots in fixed arrays: greyscale
reproduction in this case is
amplitude modulation – detail is
recorded by varying ink density.
Modern ink-jet printers employ a
mix of FM and AM to obtain the
best of both worlds, as experience
has shown that midtones are
best recorded with stochastic
screening, but extreme tones record
perfectly well with AM screening
(which reduces computing load).

THE CONCEPT OF SIZE IN DIGITAL PHOTOGRAPHY

- **File size** is a measure of the memory or space taken up by an image file
 on the storage device. The file size may be slightly smaller than the space
 occupied on disk because of the way data is stored in discreet sectors.
 If the file size is much larger than you expect for the size of image, such
 as twice the size, then it may be a 16-bit per channel image.
- **Image size** is the size of the image once it is opened. It is what is
 displayed at the lower left-hand corner of a Photoshop window of a file if
 you set it to display "Document sizes". This will be the same as the file
 size only if there has been no compression.
- **Output size** is the physical two-dimensional size of the image when it is
 seen either on screen or in hard copy, such as printed on a magazine page.
 File and image size use the same units – bytes (or multiples such as
 megabytes) – but output size is in physical dimensions such as millimetres.

DIGITAL PRINTING

The key to successful printing lies in managing your expectations. A perfect print is one that conveys your artistic message with good details and good colour accuracy without unwanted effects. If you insist on absolute fidelity of the print to screen, film, or other image, you are likely to be disappointed. Normal images obtained from a modern digital camera usually print with satisfactory results on a modern printer, without modification. At its best, modern printing using eight-ink printers or better can be an extremely satisfying and tremendously good value-for-money way to create beautiful, long-lasting prints.

PRE-FLIGHTING

The experienced digital photographer will pre-flight an image file – check every detail – with care before hitting the "Print" button. The fundamental premise is that your workflow is colour managed – you have profiled your monitor and printer, and your files have profiles embedded (*see* page 224).

▼ **Printing even tone**
Printer quality is most tested by areas of even tones with smoothly changing gradations. If your printer renders the smooth tones of sky with bands of colour instead of smooth transitions, try adding a little noise into image: the noise will be invisible but can improve print quality.

- Use the Levels histogram to clip black output by 5–12 levels, and clip white output by 5–10 levels (follow your lab or agency guidelines if in doubt).
- Take one last quick look at the image at 100 per cent for specks and defects. Flatten the file if it has layers – a simple file prints more quickly.
- Check you have saved the file and backed it up if necessary, particularly if you are sending a portable hard-disk drive away.
- Is the output size correct, and will it fit on the paper you are using? Is the file's resolution sufficient for the results you wish for? Avoid setting magnification to anything but 100 per cent as enlargement or reduction increases printing time.
- Are printer settings for quality, paper, dithering, etc correct? Are the colour-management settings correct?

While not part of pre-flighting, it is good practice to note all the settings used – especially any that are different from usual. Note which type of paper you use. Also note the file name of the image on the back of the print – then you do not need to rely on memory if, years later, you wish to print it again.

GUIDE PRINTS

If you are sending files to be printed off-site – for a journal, magazine, or book – it is helpful to include guide prints made with the actual digital files from

your own printer. Then you can ensure that the print is how you wish the image to look. However, ensure the printer knows the prints are for colour reference only. Unless your printer is profiled and certified for the printing process, it should not be taken as a contract proof – for which an absolute match is required.

If you are creating guide prints for mass printing, such as offset lithography, your guide print will more accurately reflect what is possible to achieve on an offset press if it is cross-rendered. This is the use of an intermediate colour space to constrain the larger colour space available to ink-jet prints to the smaller colour space available to offset presses. In the print dialogue, choose the CMYK proof space as the source or input space. Choose Absolute Colorimetric as the rendering intent to limit a desktop printer's colour gamut to that of the printer's.

WORKING COLOUR SPACE

Modern printers use eight or more different inks, and the coloured ones are variants of the subtractive primaries: cyan, magenta, or yellow. But that does not mean that the printer drivers work in CMYK; some do and some do not. Unless you have been specifically instructed, it is best to send RGB files to a printer – any printer. Sending CMYK files will unnecessarily limit the colour gamut available to the printer and produce dull prints.

BLACK-AND-WHITE PRINTING

The obvious method of printing a black-and-white image is to use black ink. A single run with this method will show that the results are very disappointing, offering low maximum density, translating blacks into dull grey. There is poor tonal resolution and a lack of detail.

One solution is to use all the coloured inks available to the printer. This is component or subtractive printing. As the inks combine subtractively to create the impression of hue, adding the secondary colours creates a black that is more dense than any single black ink could be. One might expect equal amounts of colour to create a neutral monochrome, but the visual or perceptual strengths of colours vary – cyan is much deeper and stronger than yellow, for instance. In order to obtain truly neutral colours, the software must balance the separation colours with great care. Unfortunately, a complication arises from the varying absorption of inks by papers, as a result of which, a combination of colours producing neutral grey on one paper may not produce neutrals on another paper.

One response to these problems is to use black and grey inks with delicate tints. This mimics the printing-press technique of duotone printing: tinted inks – very dark grey inks with hints of green or blue or red – are

▲ **Black-only greyscale**
On the monitor screen, this greyscale image is indistinguishable from the RGB image because the image is displayed using all three RGB colours. When printed with only one ink, as reproduced here, the image is visibly inferior to that printed with CMYK inks.

▲ **Full-colour greyscale**
This image is printed with all four CMYK inks, with the K or black plate carrying a high-contrast image that anchors the blacks. Compared to the black-only image, this is tonally rich with good resolution both of details and of gradation but is slightly tinted.

◄ **Levels output**
This shows typical settings for outputs: black should be increased by 5–12 units, and white reduced by 5–10 units. This may cause the on-screen image to look pale and weak, but the printed result should be fine.

effective at creating black-and-white prints whose visual qualities resemble those made from silver-gelatin processes.

Modern ink-jet prints made with black and grey ink sets produce prints that are not quite a match to the best darkroom prints for smoothness of tone. But ink-jet prints made from a high-resolution scan can be sharper than any darkroom print from the film original. And the ink-jet print can look significantly sharper – appear to resolve more detail – if a little sharpening is first applied to the scan.

ARCHIVAL ISSUES

The issue of the longevity of records, photographic or not, is not new. Yet while some are preoccupied with ensuring their photographs survive for a century or more, invaluable records such as the film-based libraries of newspapers and broadcasting stations are being destroyed all over the world for lack of space and finance. The problems of longevity of images fall into three separate areas: physical reliability, software compatibility, and security. The first two areas are of concern to all photographers; the last is primarily a concern of professional photographers and institutional collections.

PHYSICAL RELIABILITY

The key to archival planning is to remember that future problems are usually the result of earlier decisions, so these should be made with care and with as much reliability built-in as possible. Fundamentally, the reliability of any medium of recording rests on its physical integrity over time. Paper-based material may rot or decay through internal processes, the dyes used in some CDs may be attacked by bacteria, the pigments of an ink-jet print may be stable but the receiving coat may peel, and the bearings of a hard-disk drive cannot last forever.

With this in mind, the present strategy is to build in as much contingency as can be afforded. You may store files on multiple hard-disks, on DVDs or high-density discs or digital tape, as well as making reference prints.

ARCHIVAL KEEPING CONDITIONS

For archival keeping of paper- and film-based materials, optimum storage conditions are:
- Materials in contact with the photograph should have an alpha cellulose content of 87 per cent or better, free of particles and chemicals.
- Materials should be neutral pH7, buffered and dry.

- Storage materials such as boxes should be neutral to slightly alkali – that is, pH7–9.5 buffered to the equivalent of 2 per cent calcium carbonate.
- Storage temperature between 10–15°C (50–59°F).
- Low relative humidity (at storage temperature) of 30 per cent to 40 per cent.
- Dark – with no exposure to visible light, and preferably to minimal ionizing radiation, too.

SOFTWARE COMPATIBILITY

With digital files, in addition to ensuring physical integrity, you have to be sure the files can be opened by software. As applications evolve and formats fall out of use, software support for some formats may disappear before the recording media has decayed. It may be necessary to ensure that, along with the files, you store the applications that are able to open them – particularly in the case of proprietary raw camera formats, some of which can be opened only with the manufacturer's own raw converter.

SECURITY

For professional photographers, it is as important to ensure easy access to images and for other assigned users to access them as it is to ensure their safe keeping. You may store your images on a computer that acts as a server and can be connected to by a registered outside computer to download images. More conveniently you can subscribe to picture-sharing services such as Digital Railroad, PhotoShelter, and others that handle the traffic for you.

DIGITAL MEDIA

In the past there were many downsides to backing up data: storage was very costly and transfer rates were low. But now there is no excuse at all. You can save to inexpensive but very fast external hard-disks through

TYPES OF STORAGE

Aluminium boxes
Boxes from Pina Zangaro offer the ultimate in archival solutions for the photographer. The double-hinge design enables the lid to lie flat on the table, allowing easy access to the prints.

Archival slide storage
This system from University Products uses archivally safe materials in a compact storage system with metal reinforced corners, which emphasizes high density of storage over ease of access.

Clamshell portfolio box
These from University Products are typical of designs that offer safe storage thanks to use of archival board and sturdy construction. They open out flat to provide a good area for display.

▲ **Mausoleum**
The ceiling of a restored mausoleum in Uzbekistan is rapidly decaying due to damp and poor restoration. A giclée print of a photograph may be the best way to preserve a record of the exquisite decorations of this World Heritage Site.

FireWire (IEEE 1394) cables. Hard-disks of around 500GB capacity generally offer the best value measured at cost per GB. And archiving on DVD or high-density optical discs such as Blu-ray Disc or HD-DVD is truly inexpensive.

The weakest link in back-up is usually the operator: purchase back-up software that can be set to work when you are not at work – overnight is best. It is prudent risk-management to store your archives at a different location from your computer.

GICLÉE PRINTS

After a hesitant start, the best of modern ink-jet prints can offer colour prints whose longevity and keeping qualities are significant superior to any film-based materials with the exception of Ilfochrome Classic (Cibachrome). In black-and-white printing, ink-jet prints can nearly match silver-gelatin prints for keeping qualities, although darkroom prints made with platinum salts may remain superior. The key requirement is that the ink-jet printer uses pigment-based inks – those using coloured particles instead of dye-based inks, and those using staining liquids. In addition, the base must, of course, be archival in quality, such as 100 per cent cotton rag.

The keeping qualities of the best ink-jet prints are such that, together with the high resolutions attainable, giclée prints are accepted by many authorities as the best currently available way to archive copies of historic material.

PRESENTING YOUR IMAGES

The arrival of digital photography has brought many ways to present your images. On one hand, very large prints can demonstrate a photographer's ability to produce high-quality images, but their bulk renders presentation a clumsy exercise needing a lot of space, and their weight limits portability. In contrast, images can be shown easily on a laptop, which can hold literally thousands of images in a package the size and weight of a book. And even if large files are displayed and a client wants to check the image quality, it is a simple matter of zooming in to a detail and examining histograms. The central issue is that you should present your work in a style that is appropriate to the client and to the work.

PRESENTATION METHODS
Current practice accepts digital images of relatively small size – low resolution, or lo-res – as a first submission. If interest is expressed to view more work, then your potential clients may be specific about their preferred mode of presentation.

Art galleries and collectors may ask for large prints, which may be window-matted (mounted within a board frame) or dry-mounted.

Publishers of books, magazines, and journals may be satisfied with a viewing on a laptop. Some will ask to see prints – usually between A4 and A3 in size – or wish to see original colour transparencies. Increasingly, high-resolution image files, either from scans or from digital cameras, are acceptable. Clients responsible for high-quality publications will ask for 50MB RGB files or larger. Newspapers, websites, and other publishers may accept smaller files.

PRINT PORTFOLIOS
A portfolio of unprotected, unmounted prints remains the easiest way to show your images to anyone. You need only enough light to read by, you do not need to

> ### CORRECT VIEWING DISTANCE
> When making prints from colour negatives, the viewing distance for a print is said to be correct if it recreates the perspective seen at the time the picture was taken. For wide-angle lenses, the correct viewing distance is close to the print, for a long lens, the distance is greater. The correct viewing is the degree of enlargement multiplied by the focal length. The basis for the wide-angle and telephoto effects arise from our tendency to view prints of the same size from the same distance, irrespective of the focal length of lens used, which is generally at the incorrect perspective.

power up a device, and you do not need to worry about high ambient-light levels obscuring any electronic displays – in fact, you welcome bright light. There is no delay in viewing, and there are no buttons that can be pressed accidentally.

The cons of a print portfolio are not only its bulk, but that prints soon look worn and tattered after only a few viewings. You can protect prints within acetate sleeves, but this adds bulk and a highly reflective surface between the print and viewer. In addition, print portfolios are time-consuming to produce – whether in the darkroom or on ink-jet printer – and are inflexible to change while on the road: either you must carry a stack of spare prints, or you return to base to restock.

DRY-MOUNTING
An excellent way to present fibre-based black-and-white prints is to use dry mounting. This is a technique of securing a print trimmed to bleed onto archival board using dry-mount tissue, usually made of shellac, which is melted under heat to produce its bonding effect. It not only secures the print to the board with an archival

▲ **Trim the tissue and tack**
Trim the dry-mount tissue to larger than the print size and tack it to the back of the print at one point with the iron.

▲ **Trim the print and tissue**
Carefully trim the print and tissue together to bleed – to just within the picture area – with a very sharp edge or guillotine.

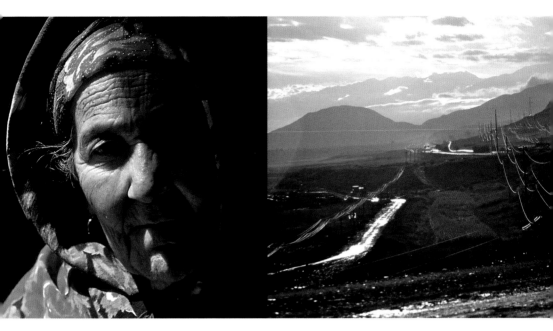

barrier, it flattens the print. Polyethylene (PE or RC) papers are best mounted with acrylic adhesives.

The procedure is: first cut a piece of dry-mount tissue to slightly larger than the required final-print size. Place the print face down and line up the dry-mount tissue to cover the trimmed size. Using a hot tacking iron, gently press the tissue near the centre to stick to the print.

Turn the print over and carefully trim to just within the edge (to bleed). The tissue should be exactly the same size as the print.

Now locate the print with its attached dry-mount tissue on the board in its final position. Holding the print in position, lift up a corner (not attached to the dry-mount tissue), and, using the tacking iron, secure a corner of the dry-mount tissue to the board. It is important not to make the mistake of tacking more

▲ Image pairs
The convention is to show single prints. But pairs of contrasted images can be visually effective because the juxtapositions create tensions between subject types, spatial suggestions, scale, and tone. With digital printing, it is easy to create image pairs.

than one corner to the board, since this can cause uneven spread of the tissue under pressure.

Cover the print and its dry-mount tissue attached with a release paper – it is coated so that it will not stick to the print. Sandwich the print with its release paper between two perfectly clean and dry archival boards. Place into a dry-mount press that has been preheated, and squeeze for the recommended time – usually 30–60 seconds. Too short and too long a time under heat will produce an unreliable seal. Remove and allow to cool.

▲ Tack the tissue to the board
Locate the print and attached tissue on the board for its final presentation position, and tack the tissue to the board.

▲ Dry-mount
Place the sandwich of release paper, protective boards, and print/tissue on its board in a pre-heated press and compress.

DISPLAYING YOUR IMAGES

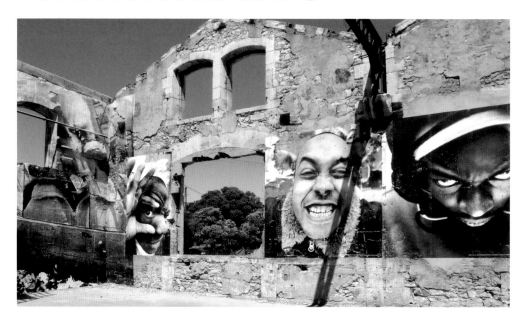

Showing a portfolio of work, whether as prints or on a laptop, is essentially a one-to-one exercise. There is far more satisfaction, if not also a threatening sense of exposure, to display photographs to many people at once. While showing your photographs on the web (*see* pages 320–1) has the potential to reach millions within days, photographers report more reward from mounting an exhibition or projecting images to an audience.

EXHIBITING

The key to a successful exhibition is in planning. Decide what you want to show and why. Is it just to share your work with friends and family, or in the hope of selling to the public or building your reputation? The answers to these questions determine criteria for how you select pictures to show and how much to show, as well as helping you decide on the quality of the presentation required. Then decide when to show and how much you can afford to spend.

If you do not already have all the pictures you wish to show, ensure you have time to build up a set of the strongest images. It is easy to find exhibition venues, but many are booked up at least six months in advance. Unless your reputation precedes you, gallery directors will want to see samples of your work before they allow you to book their venue.

Remember that any space – even in the open – can be an exhibition venue: the corridors of City Hall, railway stations, and bus stops have all been used for successful shows.

▲ **Large prints**
Digital technology enables giant prints to be made by a mosaic of smaller sheets, which are assembled into larger ones. Here, stuck onto the walls of a disused railway yard, the images dramatically transform the space at Les Rencontres d'Arles, France.

WORKING WITH THE SPACE

Once you have a space to show in, get to know it well. Work out the lines of sight from the entrance to help determine where your strongest pictures should go. Get to know the lighting; place your best (and your darkest) prints where lighting is good. Lighter prints can be placed where light is weak, and sometimes a large print can make up for a poorly lit position. Take pictures of the space, and use your computer to superimpose your exhibition pictures on the "wall" to see how they will look. All this helps you to plan the sequencing and size of pictures around the characteristics and geography of the exhibition space.

When preparing the selection of images, it is invaluable to make average-sized prints and hang them on a spare wall so you can look at them at any time. This makes it easy to rearrange the sequence, and it will be easier to spot the weaker images.

HANGING THE PRINTS

Prints should be presented to help the visitor fully enjoy the images. This means that the prints should be at a comfortable eye level, correctly hung, and arranged neatly. If you are taller than average, prints

at a height that is perfect for you may be inconvenient for others. On the other hand, an exhibition held in northern Europe will have an eye line that is higher than one held in south-east Asia. Determine the eye line according to the size of the prints and average visitor: the centres of all pictures should be on a line that is 1.4–1.7m (4ft 6in–5ft 6in) above ground.

LIGHT BOX

Transparent images lit from behind by a light box are big, heavy, and need ready access to a power point, but they work superbly in any space: simply turn off the ambient lighting. While large light boxes and transparency prints (either film-based or digital) are very costly, they are also exceedingly impressive to view and command high prices.

PROJECTORS

While an exhibition of prints is static and relies on the visitor to move around the show, projected shows allow the photographer to set the pace and to add features such as text, music, or sound to the show, resulting in a more dynamic experience. There are

two technologies: the analogue or film-based, and the digital-based. The film projector offers superior image quality but the technology is clumsy – requiring an elaborate set-up – and the programming of dissolves and synchronization with music is very cumbersome. The majority of film projectors take 35mm slides, but some accept 6 x 6cm transparencies.

In contrast, all but extremely costly high-definition digital projectors project a relatively poor image. To compensate, programming effects such as dissolves and transitions, or synchronization with music and words, is extremely easy. Furthermore, modern projectors easily correct for keystone distortion, so that the image is square even when the projector is pointing upwards.

There are three types of digital projector available. The majority use LCD filters, which are moderately light-efficient and offer good colours. Others use DLP (digital light processing), which produces finer images with good contrast but lower colour saturation than LCD. Finally, the newest is LCOS (liquid crystal on silicon), which offers high contrast and sharpness with excellent colour.

▲ **Exhibition in church**
An exhibition such as this, from Les Rencontres d'Arles, France, which fully exploits the space and lighting of the space, can transform a disused church into a rich visual experience with delightful juxtapositions.

PROJECTION CONDITIONS

This table gives the approximate projection distance in metres for different projected image widths for three focal lengths of projector lens for 35mm transparencies projected in landscape format.

PROJECTED WIDTH (m)	FOCAL LENGTH		
	70mm	100mm	150mm
1	2.2	3.9	4.8
2	4.3	6.3	9.3
3	6.3	9.4	13.7
4	8.4	12.4	18.2
6	12.5	18.5	27.1
8	16.6	24.6	36.1
10	20.7	30.7	45

▲ **Installation**
Prints do not always have to be framed behind glass. Here portraits appropriated from Chinese cemetery headstones are presented as loose prints lit by red light. This is an installation from Les Rencontres d'Arles, France.

PICTURES ON THE WEB

At the time of writing, over one billion images can be viewed on the internet on just two websites – one website claims to host 600 million images. And this does not include the images that feature incidentally as illustrations on web pages providing general information and services. A search of the term "photo" returns 200 million images, and "image" returns 350 million images and 4.5 billion web pages. An image posted on a picture-sharing site can be seen by thousands all over the world within hours. The chief method of consuming images is through the web.

STRATEGIES

As a result of photo-sharing websites, the best known of which include Flickr, Fotki, and Webshots, connected amateur photographers enjoy a wider audience than a successful professional who does not have a website. Joining these sites is free or very inexpensive, and you can share hundreds of images.

At the same time, you join a large community of photographers and are able to share comments, information, and have discussions about photography. Many will have special interests similar to yours, be it wildlife, stamp collections, or fountain-pen photography – so you can share tips and techniques too. As a showcase, these sites can be very helpful: agencies and publications search photo-sharing sites as a source of images that normal picture sources cannot provide, or in search of talent.

It is important that once you have joined a site to show your pictures that you tell everyone about the availability of the images.

WEBSITE CHOICES

It is more or less obligatory for photographers to have their own website, preferably one in their name, such as www.tomang.com, on which they display their images, provide background information and news about their work, and a way to make contact. Remember that until an image is visible, it has no commercial value – whatever its intrinsic value.

Since the cost of having your website can be low, and because numerous software applications – iView, FotoStation, Photoshop, Portfolio, Aperture, Lightroom – can automatically create complete websites, there is no excuse for a photographer not to have one. However, with a little extra cost in time and effort, you can create a website with a more personalized design using special software. Modern

◄ Tom Ang website
Keep your personal website up to date. Low-resolution images on this website that were initially acceptable because they loaded quickly could now be improved upon, especially since there would be no significant increase in upload times.

▲ Digital Railroad
This site is designed to serve photographers and agencies by providing an interface that allows design, editing, and management of individual pages and images together with a secure online service for licensing images – technically the most difficult thing for an individual photographer to implement.

▲ Automated construction
A website can be created within minutes by software such as Adobe Photoshop, given a little preparation by way of providing caption information and organizing images into a folder. The range of templates is limited but designed by experts.

This screenshot shows a two-up view of the original image on the left and the web-optimized image on the right. The original 720-pixel-wide file size has been compressed from 1010KB to a mere 15KB, but at a cost of severe artifacting. The darker image on the right simulates the appearance on a Windows monitor. Shifted from its usual position the drop-down menu shows the choice of settings for calculating the download times and preview colours.

web-authoring software is easy to use, and even inexpensive software can design small business websites on which you can sell images.

By spending more, you can host your work on a website that also helps sell it. This is done in two main ways: they provide the online selling infrastructure, and are also active in publicizing the website. These sites also provide a safe storage for your files and will accept much larger file sizes than photo-sharing sites. Typical services that offer a professional level of facilities with the ability to customize the interface and contents and manage accounts include Digital Railroad, and PhotoShelter. Services such as Zenfolio and Phanfare are less expensive to maintain because they are designed for amateur users.

Once you have a site where your images are shown, then you need to market it: tell potential clients that the images are available and can be viewed. For this you can create blogs, send emails, and learn how to optimize your site for search engines.

MONITOR STANDARDS

Despite the worldwide use of computer monitors, even now there are two standards that prevail. The small but significant minority are those who adhere to the Mac standard, and all others to that for PC. Essentially, Mac-profiled monitors look brighter and less contrasty than PC monitors. An image perfectly balanced for Windows will look too light on Apple screens, and images optimized for Apple screens look a little too dark on Windows monitors. In general, the differences are not too damaging.

OPTIMIZING WEB IMAGES

The strategy is to ensure the speediest file upload while not compromising on image quality. As the bandwidth available has grown, and the quality of monitors has improved, images that were once acceptable now appear too coarse and low-quality. But there is no noticeable improvement in download times because even fairly large, uncompressed

WHY 72 DPI?

By convention, images intended for use on a monitor projector are set to a resolution of 72dpi. Given a monitor whose resolution is in fact 72dpi, a line that is 72 pixels long at 72 dpi output resolution will display as 25mm (1in) long. But at other resolutions the line cannot be 25mm (1in) long. In fact, most modern monitors work at higher resolutions – around 110 dpi. Given the range of monitor sizes in use (from 25cm/10in to 76cm/30in) and resolutions (from 720 to 2560 pixels) in almost any combination, it is not possible to set an output resolution that guarantees a target size for a displayed image. For web pages, you need measure images only by pixels.

images will be drawn quickly. A conservative guideline is that an entire page should take no longer than 10 seconds to load, or your visitor is likely to click away.

The easiest way to optimize images for the web is to use specialist software such as Adobe Image Ready or the "Save for Web" option in Photoshop. You can preview the appearance of the image to either Apple or Windows settings of monitor gamma, and you can see the upload time displayed as you adjust compression and evaluate image quality. Generally, it is not necessary to use quality settings higher than "High" or 5 for web use.

WEB-SAFE COLOURS

GIF files are based on the so-called web-safe colours – a set of 216 colours that could be guaranteed to be reproduced on colour monitors in the early days of the internet. They are all the colours where the R, G, or B values are either 0 or a multiple of 51. Nowadays, virtually all monitors are capable of displaying millions of colours. As a result, there is very little reason for photographers to limit themselves to web-safe colours.

References

DIAGNOSING FILM AND PROCESSING DEFECTS

COMPENDIUM OF FILTER EFFECTS

PICTURE EDITING

COPYRIGHT FAQ

GLOSSARY

WEBSITES AND FURTHER READING

INDEX

ACKNOWLEDGMENTS

DIAGNOSING FILM AND PROCESSING DEFECTS

The following is a guide to identifying problems with your negatives, along with suggestions for how to correct the problem and how to avoid repeating them in future. The most common problems in black-and-white photography are inaccurate exposure and the attempt to compensate by using a non-standard development regime. If you expose accurately and develop consistently, following the processing instructions and making up your solution with care and precision, you will have few problems when working with film. However, only experience will show you that small variations in the way you agitate or changes in the ambient conditions can have a marked effect on your films.

1. PROCESSING PROBLEMS

IMAGE	DEFECT	DIAGNOSIS	CORRECTION
	Thin, flat negative Light shows through easily, and you can see through even the densest areas. As a result, prints come out dark and very low in contrast, with no details in the shadows and grey highlights.	The original exposure was too low for the film, and the development was also insufficient. If development had been sufficient, highlights at least may have adequate density and overall contrast may be adequate.	Difficult to correct. Toning the negative may improve contrast, but it is not possible to reconstruct lost detail. In future, expose fully and develop carefully. In particular, ensure there is sufficient agitation and temperature is accurate.
	Thin negative While midtones hold little detail, highlights, such as the bright area behind the figures (dense areas in the negative) appear correct.	The original exposure was less than optimum, but the film's development was correct for the film speed.	Print with harder-than-normal paper, and try to hold back the shadow areas, or scan and increase contrast overall – but shadow detail may be lost. In future, expose more fully.
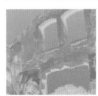	**Flat negative** The negative looks flat (low-contrast) with little tonal variation anywhere. Overall rather low in density, but highlights do appear sufficiently dense.	The original exposure was correct, but the film was under developed for its speed, so that density could not build up in midtones.	Print with a harder-than-normal paper – or this negative may scan well. The low overall density favours scanners, but you will need to adjust Levels or Curves to improve midtone contrast. In future, increase development slightly.
	Contrasty negative The negative appears very contrasty, with very dense highlight areas and blank shadow areas, while midtone areas are heavy.	The original exposure was too low for the film, and the development was also insufficient. If development had been sufficient, highlights may have adequate density and overall contrast may be acceptable.	Difficult to correct. Toning the negative may improve contrast, but it is not possible to reconstruct lost detail. In future, expose fully and develop carefully. In particular, ensure there is sufficient agitation and temperature is accurate.
	Heavy negative Overall, the negative looks dense with fair contrast, yet the shadow areas appear lacking in details.	The original exposure was too low, so shadow details were not recorded, followed by over development, which raised overall densities but could not recover shadow information.	Print on normal grade paper for a longer exposure than usual, but expect the print to appear rather grainy. Scanning is unlikely to produce better results unless a drum scan is made. In future, ensure there is sufficient exposure for shadow areas.

IMAGE	DEFECT	DIAGNOSIS	CORRECTION
	Flat, heavy negative The negative looks dense overall but low in contrast, so prints will lack contrast and liveliness.	This is a common fault as it results from overexposure followed by under development. The good density comes from ample exposure, but contrast is low because there was insufficient development for a good midtone range.	Print with harder-than-normal grade of paper, or scans may give good results if the negative is not too dense for the scanner. Use a film scanner if possible. In future, expose and develop as accurately as possible.
	Very dense negative The negative is very dense, so while details are easily seen in shadow areas, highlights are very dark and cannot be seen through.	The film has not only been overexposed, it has then been over developed, resulting in high density in the highlights, as well as high gamma (contrast).	Extremely difficult to print satisfactorily, and next to impossible to scan with normal scanners. Try using the softest-grade paper, and expect very long exposure times and very grainy images. Always avoid over development at all costs.
	Surge marking Patches of higher density near one or other edge of the film correspond with the positions of the sprocket holes. This causes uneven printing of what should be even areas of density – for example, in the sky.	These are caused by developer surging quickly through the sprocket holes during development: the developer is in turbulent flow past the holes, which causes over-agitation, resulting in increased density.	This cannot be easily corrected in the darkroom, though mild cases may be dealt with by careful burning. When scanned, heavy surge marks may be corrected, again with careful burning, or possibly by selection and applying Levels control.
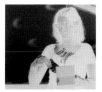	**Water marks** There are small, irregular, crescent-shaped marks on the negative: against the light they can be seen on the shiny (non-emulsion) side of the film. They print as pale crescent shapes in a print.	These are caused by droplets of hard (lime-bearing) water left on the film that concentrates and deposits the lime on drying.	Easily wiped off if on the film side: breathe gently on the film, then use a microfibre lens cloth to wipe off. Severe cases can be treated by rewashing the film, then using a distilled-water final bath. Avoid by using the cleanest-water final bath.
	X-ray marks There are shadows across the developed film – curves or straight lines – found irregularly on the roll of film, usually concentrated towards one end of the roll.	These bands of extra density are caused by exposure to X-rays used in airport hold-luggage security scanners. They are most likely to occur in high-speed and exposed films.	Difficult to correct. Avoid by packing all undeveloped film in hand luggage, where X-rays are known not to harm film. Never leave film in luggage for the cargo hold. Best to avoid flying with undeveloped film at all.
	Air bubbles Small dots are visible on the negative as low density against higher-density background; some have a lighter centre. On a print, they are seen as dark dots, particularly visible in images with sky in them.	These small dots are caused by air bubbles trapped when developer was poured into a tank. They slowed access of developer to the film, causing a reduction in density. They are more prevalent in some developers than others.	Very difficult to correct using darkroom techniques, but easily corrected digitally using Heal tools. Ensure all air bubbles are dislodged from the film by banging the tank after developer is poured in, or wet the film before pouring the developer in.
	Fixer fault A pale yellow or cream patch of irregular shape, usually elongated along the film's axis. It causes a slight loss of density in the print.	Inadequate fixing or a weak fixer solution has left some silver undissolved and remaining on the film. Invisible at first, but reaction with sulphur in the air renders the silver visible.	Returning the film to fix may prevent the problem from becoming worse, but it may be too late to completely remove the density. Fixer bath is inexpensive; there is no reason to used old solutions.

2. PRINTING AND OUTPUT PROBLEMS

IMAGE	DEFECT	DIAGNOSIS	CORRECTION
	Unsharp print Print comes out unsharp, or parts are unsharp, despite the most careful focusing before putting enlarging paper in place and taking care not to disturb settings.	When the enlarger is turned on, the negative is heated on the near side faster than on the far side. The negative expands unevenly and may "pop" if it is unable to move. If you focus on this, when it cools, it returns to position and falls out of focus.	After you focus normally, place the printing paper in position, and hold a red filter over the enlarging lens. Turn on the enlarger for 15 seconds, turn it off, remove filter, and immediately start the exposure.
	Partially unsharp print One side of a print is sharp (near the cat), while other parts of the print (to the cat's left) are unsharp. Yet the image on film is perfectly sharp overall.	The negative carrier, lens carrier, or enlarger baseboard is square on to another. The most common cause is the negative carrier or the lens carrier not being correctly fitted.	If the fault is the baseboard, raise the baseboard on one side using a narrow wedge. It is possible to correct a problem with the lens or negative carrier by adjusting the baseboard, but the adjustment is different for every change of enlarger height.
	Hairs Fine white or grey lines appear on the print, varying from quite sharp to very sharp.	A hair or fibre has fallen on the negative or print and cast a shadow, which causes a white line on the print. If on the negative, it may not be very sharp; if on the print, it is likely to be pin-sharp.	Remove the negative and attempt to clean. If the hair is stuck on the negative on the emulsion side, you may need to rewash the film. If on the print, reprint. Ensure you do not wear woollen clothes when printing.
	Uneven enlarger light The corners of the print are very dark, while the centre appears too bright.	This is usually caused by a mismatch between enlarging lens and condenser, or a mismatch of enlarging lens's coverage and format. If it is a diffuser enlarger, the mismatch may be between the enlarging lens and film format.	If using a condenser enlarger, check you have fitted the correct lenses into the condenser unit (between the lamp and the negative carrier). Use a lens whose focal length is at least that of the normal focal length of the format.
	Uneven patches Uneven, lighter-density patches are visible on several prints from different negatives that show no density corresponding to the patches.	The most likely cause is a light source with dust or other marks. Possibly the light bulb is not properly aligned.	Clean the light source, particularly surfaces closest to the film – the bottom condenser or diffuser surface, for example. Check the light bulb is located in its holder and in its proper position.
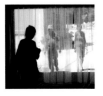	**Ink pooling** With an ink-jet printer, the ink appears to lie on the surface, sometimes collecting into pools or large droplets.	You are using incorrect paper or the wrong side of the correct paper: the ink is unable to soak in and dry out.	Use paper recommended for your printer. Use the correct side of the paper by observing instructions on the packaging. The ink may have been transferred onto other parts of the printer, so clean it with a cleaning sheet or a spare sheet of paper.
	Faulty colours Printer gives poor colours irrespective of the image printed or the paper used, with consistent bias towards some colours and not others.	The printer is faulty: you may not have installed all cartridges correctly, or one or more of the ink cartridges are faulty. Or your monitor may be poorly calibrated.	Reinstall all ink cartridges, and run cleaning programs (from the printer utility program) before making new prints. Check your monitor settings, and calibrate if possible.

3. DIAGNOSING/CORRECTING DIGITAL DEFECTS

IMAGE	DEFECT	DIAGNOSIS	CORRECTION
	JPEG artifacts Images seen at high magnification show blocks of uneven and varying colour that do not belong to the image and that destroy detail.	The blocks are the JPEG kernels in which colour differences within the blocks are smaller than colour differences between blocks. This causes blocks to be differentiated from each other. It is caused by using too high a compression.	Specialist software may be used to blur JPEG artifacts and reduce their impact, but it is not possible to remove entirely without blurring image detail because the artifacts are caused by lost data.
	Aliasing Lines at an angle appear jagged or saw-toothed: this is called aliasing. As a result, details are lost and unsharp when magnified.	The resolution of the scan or capture by digital camera is insufficient for the magnification of the images you are viewing. If the magnification is much higher than you would use the image for, reduce it to the required size and review.	If the resolution is still insufficient, increase the resolution of the scanner or digital camera; or increase the file size if the consequent blurring of detail is acceptable.
	Newton's rings Multicoloured rings or fringes around a central dark area occur in scans; there may be more than one set, or a few could merge together.	The defect is caused by light interference known as Newton's rings. The original and the glass nearly touch but are slightly separated in places.	Scan again, remounting the original. If using film, avoid using glass holders. If a print, raise the print using a frame of thin card, or press down as evenly as possible. A film of moisture on the glass may exacerbate the problem, dry the glass.
	Moiré A pattern of dark fringes appears over the scan or on a digital camera image where the original has a fine pattern, a knitted garment, roof tiles, or fences, for example. It may also occur with scans of mass-printed images.	There has been a clash between the pattern in the image and the regular array of the monitor itself. It can disappear when the screen resolution changes.	Screen moiré is an artifact of viewing that does not affect the actual image, only the viewing of it. No correction is required.
	Scanner judder Scans show uneven lines, or detail appears to be divided into steps or is out of alignment with neighbouring detail. Visible only at high magnification.	There was movement of the scanned material during scanning, or the scanner head is jittering – moving unevenly.	May be invisible at normal print sizes, so no correction strictly required. Otherwise, try rescanning, and try a different resolution.
	Scanner noise Shadow areas in scanned or digital images appear peppered with dark and light spots. Some may be arranged in lines or bands.	This defect is caused by noise in the system, as a result of the scanner having to work with a dense original, the setting of a high sensitivity in the digital camera, or a long exposure running into several seconds.	With digital camera images, software reduction of noise may be successful. With scanners, try making two scans – one optimized for the shadows, one for the high tones – then combine in software (*see* page 255).
	File error Images appear half-drawn, with bands of colour, or they show a question mark or similar warning when you attempt to review them on a camera or open them on the computer.	The file is partially defective, so software was able to read some of it but was unable to parse the rest, giving an incomplete or irregular image. May be caused by removing a card while the camera is accessing it, which is not recommended.	Back up all files on the same medium as those that are defective, whether giving problems or not. Use file-recovery software to rebuild the files. Avoid by never removing a card when any lights are on, meaning an action is in operation.

COMPENDIUM OF FILTER EFFECTS

To beginners in digital photography, the sheer variety of filter special effects is exciting, bewildering, and confusing. Some people try all the filters, usually with very mixed results. Others are scared off and never use them. While many effects are garish, some produce completely pointless results. However, it is useful to be aware of what effects are available, since all of them are are fundamentally tools in search of a problem. As you gain experience, you will discover certain types of images work better with some filters than with others. Remember that the application of a filter is not the end of the process, but the beginning or an intermediate step towards the final image. Where you apply a simple filter effect, the result is almost always greatly improved with a further adjustment of tone and colour using Hue/Saturation, Levels, or Curves. There are different ways to classify and name filter effects: those shown here are from Adobe Photoshop.

▲ Sample 1
Images with strong shape and clear outlines work well with artistic and brush effects, as well as with lighting effects.

▲ Sample 2
Images with complicated outlines or textures work well with distortion filters, since the loss of shape is acceptable.

▲ Sample 3
Images with abstract shapes and simple outlines work well with a very wide range of filter effects.

FILTER EFFECTS BY CLASS

ART MATERIALS

▲ Poster Edges
This posterizes the image to simple tones and emphasizes the edges to produce an effect like that from felt-tip pens.

▲ Watercolor
Depending on settings, the Watercolor filter can be a subtle softening of outlines or produce accentuated effects.

▲ Colored Pencil
On strongly graphic or finely detailed subjects, the Colored Pencil filter can create attractive textures with soft colour.

ARTISTIC AND BRUSH

▲ Sumi-e
This imitation of Japanese brush technique is rather crude, but the graphic quality is useful for accentuating shapes.

▲ Ink Outlines
This simulation of pen-and-ink technique can be effective on monochrome images with clear and simple outlines.

▲ Ink Outlines (Alt)
When applied to an already abstract composition, ink-and-brush effects make the image even more abstract.

ARTISTIC AND BRUSH *(continued)*

▲ Conté Crayon
Many art effects imitate not only the art tool but the typical paper or substrate that it is applied on, such as laid paper, here.

▲ Water Paper
Some filters imitate the effect of the image lying on a substrate, as here, as if paper has been soaked in water.

▲ Stamp
An image transferred to a rubber stamp may look like this. You can vary the roughness and texture.

DISTORT

▲ Ocean Ripple
Distort filters move pixels around without strong changes in the tonal or colour qualities of the image.

▲ Diffuse Glow
This filter operates like a Blur and Distort filter in one and has the additional effect of lightening the tone.

▲ Liquify
Unlike other filters, you apply this one manually, so the effects can be as subtle or, as here, extreme as you like.

▲ Polar Coordinates
This filter reads the usual Cartesian coordinates (x and y) of pixels as polar coordinates to create the distortion.

▲ Twirl
You can adjust the strength and direction of this distortion to suit. It works best with the simplest outlines.

▲ Spherize (Vertical)
This filter maps the pixels as if they lay on a sphere that is flattened out. It can correct wide-angle projection errors.

▲ ZigZag
This filter is very useful when compositing images with water as it quickly creates what looks like a ripple in the reflection.

▲ Radial Blur
This filter is much used to create a sense of movement and frenetic activity. It works best when part of the image is sharp.

▲ Box Blur
While many blurs are omnidirectional, some orient themselves along certain axes. This is imitated by this filter.

PIXELATE

▲ Color Halftone
Pixelate filters break up the image into picture elements. This breaks the image up into four-colour printing rosettes.

▲ Pointillize
Similar to an Art Effect filter, this imitates Pointillist techniques of building up the image from regular-sized dots.

▲ Crystallize
Unlike other Pixelate filters, Crystallize does not introduce gaps between the picture elements.

STYLIZE

▲ Extrude
Typical of many Stylize filters, Extrude combines several effects: distortion with tonal effects and pixellation.

▲ Solarize
This filter imitates a darkroom effect with partial tonal and colour reversals, but with little distortion.

▲ Glowing Edges
Tonal and colour reversals combined with Finding Edges and Blur result in a powerful package of effects.

▲ Find Edges
Ideal for producing immediately graphic effects, this filter simplifies tone and colour by emphasizing edges.

▲ Emboss
This filter works by duplicating and offsetting the image, combined with tonal and high-pass effects.

▲ Trace Contour
An elaboration on the Find Edges filter, but producing more varied effects. Shown is the result of applying the filter twice.

TEXTURE

▲ Stained Glass
Similar in appearance to a pixellation effect, the results of this filter are best when it is used on a posterized imaged.

▲ Craquelure
Imitating the cracking pattern of old oil paintings, this filter is also useful for producing leather-like textures.

▲ Patchwork
This filter is useful if you already have a patchwork pattern and wish to create a texture over it.

RENDER

▲ Difference Clouds
You can achieve the same effect by apply the Clouds filter on a duplicate layer then blending to Difference, but this is easier.

▲ Lighting Effects
Triple Spotlight is one of the numerous effects obtainable from what is one of the most complicated of filters.

▲ Fibers
The Fibers filter, together with Clouds, is meant to be used in combination with a blend mode: here Lighten was used.

NOISE

▲ Add Noise (Chromatic)
Adding a small amount of noise can solve some printing problems. This shows a simulation of chroma noise.

▲ Add Noise (Monochromatic)
This filter shows a simulation of the appearance of luminance noise, but it would be less in brighter areas.

▲ Noise Ninja
This is a sophisticated plug-in that analyses the image and adapts noise reduction according to image detail.

OTHER

▲ Offset
This filter offsets part of the image to one side while wrapping the edge of the image to fill the format.

▲ High Pass
This filter lets through high-frequency data or fine detail but blocks coarse detail. It is useful for sharpening.

▲ Custom
Unusual tonal effects are possible from designing your own filter, just by entering a few numbers into a grid.

SPECIALIST

▲ DxO FilmPack
DxO provides excellent image-processing software, including special effects and distortion controls for raw and other formats.

▲ Knoll Light Factory
Using simple controls, a very wide range of lens-flare effects can be simulated with convincing results.

▲ Alien Skin Exposure
One of the most useful plug-ins, Alien Skin Exposure offers one-click darkroom effects such as Sepia Mid Band Split.

PICTURE EDITING

Picture editing is usually regarded as the task of selecting the best image from a selection of images, but it is much more. First you need to define "best". An image that works well for a spread inside a publication may not be good for a cover, and what is suitable for one specialist magazine may be unsuitable for a public exhibition. Furthermore, the selection itself is only part of a longer process to ensure the right picture with the right information reaches the end user. Picture editing comprises four principal phases: defining the aim, sourcing the images, assembling and editing the images, and, finally, their preparation and production.

AIM

The aim of picture editing may be to compile family pictures from a holiday, so selection is based not on fine photography but coverage of the places visited, events, parties, and friends. In contrast, if the aim is to enter a competition for nature photography, the selection process rejects technically poor images: those with poor lighting or bad composition. Once you define the aim, you also define the "best" pictures.

SOURCE

For many photographers, their own work is the source. But if you need a particular picture, you have a choice: go out and take the picture yourself, or obtain it from somewhere else – a picture agency or picture-sharing site, for example. You may also find useful some of the royalty-free images given away by photography magazines and offered by websites run by the photographic industry.

SELECT

The selection process is the third step in the picture-editing process. Here you use your skill and judgment to find superb images. This may take place in two stages, particularly if you have a lot of images to review. The clean-out aims to weed out all images that are definitely not suitable – those that fail the minimum standards (see page 334). Then we move to the primary edit, during which we check the suitable images against a personal look-up table of non-technical factors.

For example, for some, the image must capture a significant moment; for others, the image must demonstrate fine composition or must demand to be looked at again and again. What is uppermost in an editor's mind may vary according to the aim: whether looking for a cover picture or a link picture, or simply for a filler where copy falls short. Where there is doubt, you may make first, second, or even more selects, grading images by how much you like them.

All modern image-management software makes it easy to mark images with ratings or colour codes that help you to structure your choices from large numbers of images. When working with transparencies, it is routine to make piles that correspond to first, second, and third choices.

The selection process may also be devoted to the more complicated task of choosing a series of images that work, or narrate, together. The aim is to produce a set that informs the viewer in a way single images or a disordered sequence would fail to. It is the photographic equivalent of telling a story coherently with a beginning, middle, and end.

PRODUCE

Finding a wonderful picture is not the end of the work – it is just the beginning. Now the picture needs to be prepared for production.

Competent picture editing ensures the image is fit for its function: this ensures it is the correct size for printing or sufficient for potential use, that it is fully captioned with complete metadata, it is colour-managed so that what was seen by the picture editor is still what will be seen by the viewer or reader, and that the image complies with appropriate editorial and ethical standards.

◄ Flickr page
Although the images are only about 100 pixels wide, and there are 30 images, it is easy to spot the group that is visually the most interesting, with strong colours and interesting lighting. With practice, a picture editor will see this group (five related night shots) almost as soon as the page appears. But if they were looking for a specific building, then the process would take longer as some pictures need to be scrutinized at larger sizes.

COMMON IMAGE FAULTS

One of the basic functions of picture editing is to weed out images with technical faults. Many faults are not obvious at first glance but require you to examine the image at 100 per cent or more. If the content of an image is outstandingly newsworthy, then technical defects are of lesser importance, but where quality counts, as in advertising or fashion, there is zero tolerance for image defects.

▲ **Over-sharpening**
Avoid images that have been over-sharpened, showing haloes and unnatural image boundaries.

▲ **Posterization**
Avoid images where manipulation has caused smooth tonal transitions to separate out into bands of colour.

▲ **Focus problem**
Avoid images where the focus is uncertain, even if the fault is not obvious at first glance.

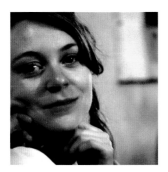

▲ **Noisy image**
Avoid images where an excessively high-sensitivity film or setting has been used, resulting in high levels of noise or grain.

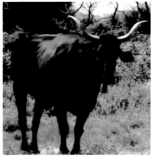

▲ **Blocked shadows**
Avoid images where an exposure for highlights has caused shadows to be devoid of detail.

▲ **Burnt-out highlights**
Avoid images in which overexposure in bright conditions has caused the highlights to be devoid of detail.

▲ **Dust spots**
Avoid images where the photographer has failed to remove spots caused by dust lying on the sensor.

▲ **Camera shake**
Images viewed at small size may mask softness due to camera or subject movement. Avoid blurred images.

▲ **Colour fringes**
Colour fringes at subject outlines should not be easily visible – they indicate poor imaging or lens quality.

METADATA

An increasingly important part of the image file is the metadata – information about the image, rather than the image data itself. It is analogous to the label on the back of a photographic print, which is where you would put essential information. The same needs to be embedded in the image file. The data should include the following:

• Your name and copyright notice.
• Contact details including email and website if available.
• Caption information – the title of the image; the location, date, and time it was taken; the names of anyone featured prominently.
• Keywords describing the content and location; also the context or news story, relation to culture or customs, and associated concepts such as effort, skill, beauty.
• Other details, such as availability of model release, restrictions on use – not for advertising, for example.

Adding this information to a single image is tedious enough, but to do so to hundreds of images calls for special software.

Fortunately, digital asset-management software such as Adobe Lightroom, Apple Aperture, FotoWare FotoStation, Extensis Portfolio, or iView MediaPro can add a great deal of information to images automatically. These software programs enter data that is compliant with the IPTC (International Press Telecommunications Council) specifications – *see* www.iptc.org for details.

Another layer of metadata is provided by the EXIF data. These provide information about the camera and lens used, as well as details of the camera and lens settings, such as shutter, aperture, ISO, and whether flash was fired or not. Crucially, the data also provides serial numbers of the camera and information about the date and time of the photography. This data is increasingly important for verification purposes.

PICTURE QUALITY

The basic requirements for picture quality are well known to all visually literate people. Constant exposure to images – the typical urban dweller in developed economies sees over a thousand images every day – has trained everyone to be highly critical of the images they view. To meet basic standards, the picture must be sharp: details are clearly defined, with no fuzziness in important parts. Exposure should be accurate: neither too dark, nor too light. Colour should be true-to-life, and neutral colours, such as greys or whites, should be neutral. Finally, contrast should be accurate – neither bright nor dark areas being too different or too similar.

MINIMUM STANDARDS

The following is a list of technical tests for professional-quality images – it is very rigorous.

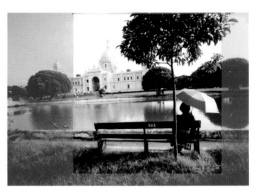

▲ **Cropping flexibility**
While the image is best used in its entirety, it allows a square crop as well as a wide, long crop. The second crop corrects the horizon. The test of the suitability of any crop is that it produces an image that appears complete and balanced in itself.

While many of the world's great images fail this test, it provides a useful benchmark for evaluation.

• Exposure should be correct or appropriate for the task: midtones in the subject reproduce as midtones in the image.
• Sharpness should be high where image should be sharp.
• No motion or subject blur, unless appropriate to image content.
• Details should be resolved to good contrast.
• Focus should be accurate.
• No colour fringing should be easily visible.
• Depth of field should be adequate for the task or appropriate to the image content.
• Contrast should be appropriate to the image content.
• Highlights should be clear but with some detail; shadows should be dense with some detail.
• Tonal gradations should be smooth, not posterized.
• Flare or veiling glare should be absent or minimal.
• Grain or noise should be low.
• Colour rendering should look natural, and balance should be neutral.
• Colours should be rich, not posterized.

- Images should be spotless, without blemishes or artifacts.
- Camera should be oriented correctly and accurately to the horizon or the subject.
- No distortion should be visible.
- File, print, or film size should be adequate for reproduction.
- Copyright, attribution, model release, and other release noted on photograph or embedded in the file.

OTHER FACTORS

Depending on picture use, the following often need to be taken into account.

- **Date/time markers:** If time of day or year is important, the picture may need natural markers such as sunlight, flowers, or leaves. Cars, buildings, advertisements, and fashions can give an idea of the date or period in which a picture was taken.
- **Effects of scale:** The effect and effectiveness of some images are linked to the final viewing size.
- **Identifiable persons:** Depending on use or accompanying text, people in a photograph may object to their depiction and possibly take legal action.
- **Personal security:** People should not have their personal security threatened by a published photograph, such as if they are a witness to a crime.
- **Sequencing:** Photographs that may not stand on their own may need to be linked with others to form a sequence.
- **Censorship:** Pictures used in international publications should stay within the censorship and cultural limits of the most restrictive country to be distributed to.
- **National security:** Unless there is a public-interest argument, published photographs should not threaten national security or open the photographer to action by security services.

BEING COMMISSIONED

The real test of your skill is when others edit or select your pictures that they have commissioned or paid you to obtain. Understanding the process of briefing and commissioning photography is a vital part of picture editing.

The commission is essentially the contract made between those who need a photograph – agency, publisher, or private client – and the photographer. It sets out what needs to be photographed (which will be detailed in the briefing), when the images are required to be delivered, how much the fee will be, and whether expenses are included or not. The contract should also explicitly set out the image and usage rights acquired by the commissioner – for example, images are exclusive to the commissioner for one year in the European Community only. It should also explicitly state that copyright remains with the photographer.

The brief or briefing is a set of instructions that the photographer is expected to follow in order to complete the commission. The main purpose is to communicate the picture editor's requirements clearly: the commissioner must be confident the photographer will deliver what's required. It is a responsibility of the photographer to ensure the instructions are clearly understood and that they feel capable of delivering the images.

People commissioning pictures have their own personal way of delivering a brief, depending on their experience and personality. Some are articulate and wordy to the point of causing boredom. Others expect a few gestures and muttered words to suffice. But the best is a trusting relationship between commissioner and photographer built on successfully completed previous commissions.

BRIEFING CHECK-LIST

If you are given a briefing for a job, ensure that the following basic set of questions have been answered before you start work:

- Am I clear about the aim of the photography (together with the feature article or programme)?
- What level of quality is wanted?
- What can go wrong?
- Do I have all contact details and key facts in writing?
- Have I made any unwarranted assumptions?
- Is the client expecting too much for the time or money?
- Can I do it in the time?
- Do I need assistants on location and other help?
- Will I be art-directed during the shoot?
- Do I need permits or letters of permission, and if so, will these be provided?

NON-TECHNICAL FACTORS

A picture that shows one or more of these characteristics is more likely to be selected.

- It depicts the subject in a revelatory, thought-provoking, or emotive way.
- It tells a story; its content is narrative.
- The location is exotic, or an inventive perspective has been taken on a well-known one.
- The lighting is dramatic, arresting, or sets the mood.
- Faces in the image carry an expression appropriate to the occasion.
- Its colours are bright or unusual, or colour and tone contrasts are strong.
- Its composition is strong and dynamic, firmly leading the eye into the centre of action or interest.
- Image composition and shape allows for cropping if necessary to fit space or layout.
- It is evocative, with a strong emotional charge due to a combination of some of the above characteristics.

COPYRIGHT FAQ

his section provides brief and general answers to frequently asked questions about copyright. The law is changing rapidly and varies in detail between countries that are signatories to different bilateral or international treaties or arrangements. For initial advice, contact local professional photographic organizations or trade unions. You should always obtain expert advice from specialist lawyers or attorneys prior to taking any legal action, and that includes any agreements that you enter into or letters that you write. In particular, be aware that threatening to sue or take legal action against a party may, in itself, be an act that others could take action against.

DO I HAVE TO DECLARE THAT I OWN COPYRIGHT BY STAMPING A PRINT OR SIGNING A FORM?

In the majority of countries, copyright subsists in the work – that is, it comes into being at the same time as the work is created. Copyright and the protection given to copyright works is not conditional upon any formality such as registration, deposit, or notice. It helps, however, to assert your ownership of copyright clearly – at least "© MY NAME" – on the back of a print (even an ink-jet print), within any image displayed on a website, or embedded in the metadata.

DO I HAVE TO REGISTER TO GET COPYRIGHT PROTECTION?

No, you do not. Copyright in works of art, including writings, photographs, and digital images, arises as the work is created. In over 140 countries in the world, no formality is needed to receive legal protection. In some countries, registering a work as your copyright may give you certain advantages, such as seeking compensation or other remedies for any proven infringement, or being able to claim for costs of pursuing a case.

CAN I PRESERVE THE COPYRIGHT OF MY IMAGES ON THE WEB?

In general, you do not lose copyright when you place images on the web, but you may lose control of them because you cannot control who accesses your website. If a service provider demands that you assign copyright to it as part of its terms of service, it is advisable to decline and take your business elsewhere. You may find that although you lose copyright, you are still responsible for the image should someone make a claim against you if they take offence to your images. Some measure of protection can be obtained by ensuring you place only small files on the web so they cannot be used in publication. Alternatively, you can use a watermark or a signature, which also reduces the value of any theft.

IS IT WRONG TO SCAN FROM BOOKS AND MAGAZINES?

You are copying copyright material when you scan from published sources, and to do so is a breach of copyright in most countries. However, in many countries you are allowed certain exceptions that allow otherwise infringing acts to be acceptable – for example, if you do it for the purposes of study, research, criticism or review, or to provide copy for hard-of-seeing (these exceptions vary greatly from country to country). But if you use the scans as a basis for derivative works, such as to provide an element for a composite image, then you breach copyright on two counts: copying, and modifying without permission. And if you do not acknowledge the source of the element in your image, you may be in breach another element of copyright protection.

SURELY IT IS ALL RIGHT TO COPY JUST A SMALL PART OF AN IMAGE, SUCH AS THE SKY OR OTHER SMALL DETAIL?

Most copyright laws allow "incidental" or "accidental" copying. If you take an insignificant part of an image, perhaps no one will object, but it's arguable that by choosing that part of the image you are giving significance to the selection – if so, it could be argued that you are in breach, since the copying can no longer be said to be accidental. If it makes no difference where you obtain a bit of sky, then take it from your own images or a free source.

IF I SELL A PRINT, CAN THE BUYER REPRODUCE THE IMAGE?

No. You've only sold the physical item – the print. You grant no rights apart from the basic property right of owning the piece of paper and an implied right to display it for the buyer's personal, private enjoyment. The buyer can keep the print and display privately but should not copy, alter, publish, exhibit, broadcast, or otherwise make use of that image without your express permission.

WHAT ARE "ROYALTY-FREE" IMAGES?

Images that you pay a fee for to obtain an unlimited licence to use them. Subsequently you do not have to pay any extra even if you use them commercially. With some suppliers, certain categories of commercial use such as advertising or packaging may attract further payments. Royalty-free images are usually downloaded from a website but may be supplied on CD. Royalty-free images may be offered at very low rates – low enough for almost anyone to afford. You may use the images for as long as you like, but you cannot transfer or sell the licence to others, not even in the event of your death.

WHAT IS THE CREATIVE COMMONS?

This is a type of licence that is designed to allow a flexible range of protections and freedoms for authors, artists, and educators. The intention is to allow dissemination of intellectual property while protecting the creators from abuse and exploitation. Works can be used, provided the author is credited, that the use is not for commercial purposes, and that no derivative works are made. This allows a widespread sharing of creative and other works without loss to the copyright owners by those who otherwise would not be able to benefit from the works. It is in widespread use in the photo-sharing community. See www.creativecommons.org.

HOW CAN IMAGES BE COMPLETELY FREE?

Free images on the internet are an inexpensive way for companies to attract you to visit their site, thereby increasing the traffic. It is also an inexpensive way to offer "value-added" content. You may download these images for your own use, but if you wish to make money from them, you are expected and trusted to pay. But the fee is usually relatively small, so you are encouraged not to cheat.

WHAT IS A WATERMARK?

It is information, such as a copyright notice or your name and address, that is incorporated into an image file. The watermark is usually visible but may be designed to be invisible. In either case, watermarks are designed so they cannot be removed without a great deal of image manipulation or damaging the image itself.

DOES SOMEONE OWN COPYRIGHT IF THEY PAY FOR THE FILM OR HIRE OF EQUIPMENT?

No, with very few exceptions. In some countries, if you are employed as a photographer, your employer retains copyright, while in others, the photographer retains copyright. In some it is not possible for a business entity such as a company to own copyright, and your work is therefore always "for hire" and you retain copyright by default. At any rate, whatever the basic position, it can be overridden by a local contract made between the photographer and another party prior to the work being done. It is important that such agreements are made in writing. Photographers are best advised to make an explicit agreement with the client that copyright is retained by the photographer but that the client obtains rights, regulated by a licence to be agreed, over the picture in return for the commission.

IS IT OKAY TO SELL COPYRIGHT?

If you assign copyright to someone or a business in exchange for a fee (where local legislation allows), you are selling or assigning the copyright to the other party. That means you wave goodbye to ownership of the images, so ensure you obtain a very good price. In the film-based era, the sale was a practical expedient, since no copy was ever as good as the original, so owning copyright meant owning the original. In the digital era, physical ownership has lost the primacy of the individual quality and is no longer the reason for copyright ownership. If possible, it is better to offer a broad, or even an unlimited, licence to use the images. Then, if the business becomes bankrupt or disappears, you still own the image. But if you had sold the copyright, you would have to buy it back or your rights to the image may disappear as part of the assets taken down by the liquidation of the company.

WHAT IS A LICENCE?

This is an agreement you offer to a party in return for a fee that allows it to use your images for certain uses, for a specified time, and in specified countries or territories, possibly under certain conditions, such as that credit must be given or the identity of people must be concealed. It is almost always possible to provide everything a client wants without assigning copyright. This can be done by allowing flexibility in use of an image by the way the licence is agreed.

IF I MANIPULATE SOMEONE ELSE'S IMAGE, DO I OWN THE COPYRIGHT IN THE NEW IMAGE?

No. You were infringing copyright by making the copy. Altering the image is a further breach of copyright because you may not create a derivative work without permission. If your work is sufficiently different from the original, you may now own copyright in it, but your right to use the new work will be constrained by the fact that it is derived from someone's copyright work. You should obtain their permission or licence before you can show or trade with your work.

WHAT IS A MODEL RELEASE?

A model release is a memorandum of an agreement between the photographer and a model that allows the photographer to freely use any images taken of the model. This agreement protects the photographer from any action a model may make, such as to seek additional fees for an image that proves commercially highly valuable. It also protects the model from abuse of the image, since restrictions may be placed on the photographer, such as not to use the images on pornographic websites. The model must be of legal age to enter into a contract, so minors should have model releases signed by a guardian. Increasingly, model releases are required for any image featuring a recognizable person. While not legally an element of copyright, model releases are an important element of rights-managed images.

GLOSSARY

8-bit Bit is short for "binary digit", the basic unit of the binary language. An 8-bit microprocessor works with data that is 8 bits, or 1 byte, long.

24-bit Measure of the size or resolution of data with which a computer, program, or component works.

32x speed Thirty-two-speed: reads data off a CD-ROM at 32 times basic rate (150 KB/seconds).

6500 White-balance standard corresponding to normal daylight: appears warm compared with 9300.

9300 White-balance standard that is close to daylight, used mainly for visual displays, as its higher blue content gives better colour reproduction in normal indoor lighting conditions.

A

Additive colour Combining or blending two or more coloured lights to simulate or give the sensation of another colour. Any colours can be combined.

Adjacency effects Chemical reactions taking place at dark/light boundaries. Active developers in shadow regions drift over to increase development in the brighter areas.

Aliasing The appearance of steps or jaggies in an edge or curve of a digital image due to sampling rates lower than the frequency of the detail.

Ambient light Existing light, but not light specifically added for the purpose of the photograph, such as sunlight or light from a chandelier.

Analogue A non-digital effect; a representation or record that is proportional to some other physical property or change, such as amount of light.

Anti-aliasing The process of smoothing away the stair-stepping appearance in an image.

Aperture The setting that controls the amount of light entering the lens of the camera. An *f*/number indicates the size of the opening.

Attachment File that is sent with an email. This could be an image or a Word document. Equivalent to an enclosure accompanying a letter.

Autofocus A system whereby the lens is automatically adjusted by the camera to bring the subject into sharp focus.

B

Background Bottom layer of an image – the base.

Back-up Make and store copies of computer files.

Bicubic interpolation Type of interpolation in which the value of a new pixel is calculated from the values of its eight nearest neighbours.

Bilinear interpolation Type of interpolation in which the value of a new pixel is calculated from the values of four of its nearest neighbours: left, right, top, and bottom. It gives a result that is blurred and soft and one that requires less processing.

Bitmap A one-bit image, such as black and white, with no shades of grey.

Bitmapped An image formed by a grid of pixels. The computer assigns a value to each pixel ranging from 1 bit of information (simply black or white) to as many as 24 bits per pixel for full-colour images.

Black An area that has no colour or hue due to absorption of most or all light.

Black crush Tonal compression of shadow detail to produce black.

Bleed (1) Photograph or line that runs off the page when printed. (2) Spread of ink into fibres of support material: the effect causes dot gain. (3) In computer graphics, it is the diffused spread of one colour from one object to another within close proximity.

Blow-out Excessive light that leads to loss of highlight detail.

Bluetooth A standard for high-speed wireless connections between devices such as mobile phones and keyboards, and for networking.

BMP Bit MaP: file format native to Windows.

Bracketing To take several photos of the same image at slightly different exposure settings. This is to ensure at least one picture has the correct exposure.

Brightness (1) Quality of visual perception that varies with amount or intensity of light that a given element in the visual field or optical component appears to send out or transmit, such as a sunny day or powerful lamp. (2) A brilliance of colour, related to hue or colour saturation. (3) Also in reference to reproduction of colour.

Browse To look through a collection of images or web pages, for example.

Brush Image-editing tool used to apply effects such as colour, blur, burn, dodge, etc.

Burning (1) Darkroom technique in which additional exposure to light is given to selected areas of print to alter the local contrast and density of a print. (2) Digital image-manipulation technique that mimics darkroom burning technique.

Byte A unit of digital information used for measuring the memory capacity of a digital storage device. One byte = 8 bits.

C

C Cyan: secondary colour made by combining the two primary colours red and blue. The cyan separation is used in the four- and six-colour printing processes.

Calibration Process of matching characteristics or behaviour of a device to a standard.

Camera exposure Quantity of light reaching the film or sensor; depends on the aperture of the lens and the length of shutter time or exposure to light.

CCD Charge-Coupled Device. A type of semi-conductor image sensor used by the majority of digital cameras.

Channel Set of data used by image-manipulation software to define colour or mask.

CIE Commission Internationale de l'Eclairage. Model based on human perception of colour.

Circle of confusion The size of image blur that is indistinguishable from a sharp point.

Clone To copy parts of an image onto another part or other image.

CMOS Complementary Metal Oxide Semiconductor. Type of sensor used by digital cameras and mobile-phone cameras.

CMYK Cyan, Magenta, Yellow, Key: the colours of inks used to create a sense of a range of colour in four-colour printing.

Cold colours Subjective term referring to blues and cyans. They are less acceptable than warm colours and are often regarded as needing to be corrected.

Colorize To add colour to a greyscale image without changing the original lightness values.

ColorSync Proprietary colour-management software system to help ensure that colours seen on screen match those to be reproduced either on screen or in print.

Colour Quality of visual perception characterized by hue, saturation, and lightness. It is perceived as an attribute of things seen.

Colour cast Tint or hint of colour evenly covering an image.

Colour gamut A range of colours able to be produced by a device such as a computer screen or image-reproduction system such as a printer.

Colour management Process of controlling the output of all devices in a production chain to ensure the colours of the results are accurate.

Colour profile The way one device, such as a screen, scanner, or printer, handles colour is defined by the differences between its own set of colours and that of the profile connection space.

Colour space Defines a range of colours that can be reproduced by a given output device or seen by the human eye under certain conditions. It is commonly assigned to manage the colour capture and reproduction of each photo image.

Colour temperature The colour of light produced by a theoretical "black body" object that is heated to a certain temperature using a scale marked in degrees Kelvin (K). Lighting can vary in colour temperature between 2000 degrees Kelvin (warm) and 9500 degrees Kelvin (cold).

Compositing (1) Picture-processing technique that combines one or more images with a basic image. (2) Process of reducing the size of a digital file by changing the way the data is coded.

Contrast (1) Of ambient light: the measure of the brightness range found in a scene. (2) Of light source or quality of light: where there is a difference in brightness between the deepest shadows and the brightest highlights. (3) Of film: the rate at which density builds up with increasing exposure over the mid-portion of the characteristic curve of film/development combination. (4) Of printing paper: where high-contrast paper is Grade 4 or 5. (5) Of colour: where colours positioned opposite each other on the colour wheel are regarded as contrasting – for example, blue and yellow, and green and red.

Crop (1) To use part of an image for improving composition or fitting an image to available space or format. (2) To scan only the part of the image that is required.

Curves Control for adjusting tonality and colour in a digital image.

D

Definition Subjective assessment of clarity and quality of the detail visible in an image.

Defringe To remove the edge pixels of a selection.

Delete (1) To remove a whole item or selected area, such as a letter or a block of words. (2) To remove a file from the current directory.

Depth of field Measure of a zone or distance over which any object in front of the lens will appear acceptably sharp. It lies in front of and behind the plane of best focus. That is, the nearest and furthest parts of the subject that can be rendered sharp at a given focusing setting. Depth of field relies on the aperture used, the distance at which the lens is focused, and the real focal length of the lens.

Direct vision finder Type of viewfinder in which the subject is observed directly – through a hole or optical device, but not via a reflection in a mirror.

Display A device that provides temporary visual representation of data, such as a monitor screen, LCD projector, or the information panel on a camera.

Dodging (1) Darkroom technique in which the amount of light is reduced on selected areas of a print that would otherwise print too dark. (2) Digital image-manipulation technique that mimics darkroom dodging.

Dot gain Dot gain is caused by a wide range of printing and reproduction issues that darken images. It affects the full tint range, so images darken and lose contrast and shadow detail.

Download To copy files from a memory card, camera, or the internet to a computer.

Dpi Dots per inch: a measure of resolution of output device as the number of dots or points that can be addressed or printed by the device.

Driver Software used by a computer to control or drive a peripheral device such as a scanner, printer, or removable media drive.

Drop shadow Graphic effect in which an object appears to float above a surface, leaving a fuzzy shadow below it and offset to one side.

DSC Abbreviation for Digital Stills Camera.

DSLR Abbreviation for Digital Single-Lens Reflex camera.

Duotone (1) Photomechanical printing process using two inks to increase the tonal range. (2) Mode of working in image-manipulation software that simulates image printing with two inks.

DVD Digital Versatile Disc: storage medium, of which there are many variants.

Dye sublimation Process of creating photographs using a printing technique based on the rapid heating of dry colorants, which are converted into a diffused gas when heat is applied. This is absorbed and solidified by a special coating on the paper.

E

Electronic viewfinder (EVF) An LCD screen viewed under an eyepiece and showing the view through a camera lens.

Enhancement Change in one or more qualities of an image to improve the visual appearance, such as an increase in the colour saturation, sharpness, and so on.

EXIF EXchangeable Image File format: standard for storing interchange information on image files, especially those using JPEG compression.

Exposure Process of allowing light to reach light-sensitive material to create an image.

F

Feathering The blurring of a border or boundary line by reducing the sharpness or acutance of that change.

File format The way in which a software program stores data that is determined by the structure and organization of the data-specific codes. Formats may be generic and shared by different software, or native to a specific application.

Fill in (1) To illuminate shadows cast by the principal light by using another light source or reflector to bounce light from main source into shadows. (2) To cover an area with colour – as achieved by the Bucket tool in Photoshop.

Filter (1) An optical accessory for a camera that is used to cut out certain wavelengths of light or frequencies of data and let others pass in order to cause visual effects on the film or sensor. (2) Part of image-manipulation software written to apply special effects simulating those of photographic filters. (3) Software that converts one file format to another. (4) Program or part of an application used to remove or screen data, such as that used by email.

Filter pack Set of filters placed in a colour enlarger or the settings of dial-in filters.

FireWire Standard for rapid communication between computers and devices.

Fix (1) Chemical solution that is used in darkroom development where the silver halides are converted into soluble salt. It is used after developing the photograph and before washing; it removes the remaining light-sensitive halides, so fixing the developed image. (2) To spray fixative onto a photo, painting, or drawing to make a protective layer.

Flash (1) To provide illumination with a very brief burst of light. (2) Equipment used to provide brief burst or flash of light. (3) Type of electronic memory used in digital cameras.

Flatten To combine multiple layers and other elements of a digitally manipulated or composite image into one background layer.

f/number Setting of the lens diaphragm, indicating the size of the aperture relative to the focal length of the lens. This determines the amount of light transmitted by lens. Also known as an f/stop.

Focal length Distance between a sharp image and the lens, where it is focused on an object at infinity.

Focus (1) To make an image look sharp by bringing the film or projection plane into coincidence with the focal plane of optical system. (2) The rear principal focal point. (3) The point or area on which, for example, a viewer's attention is fixed or compositional elements visually converge.

Font A set of typed forms of a particular face and size.

Frame rate The number of exposures, per second, that a camera can produce.

G

Gamma In relation to monitors, it is a measure of the correction to the colour signal prior to its projection on screen. A high gamma gives a darker overall screen image.

GIF Graphic Interchange Format: a compressed file format designed for use over the internet.

Greyscale Measure of a number of steps between black and white that can be recorded by a system. A greyscale of two steps permits recording or reproduction of just black and white. The Zone System uses 10 divisions. For normal reproduction, a greyscale of at least 256 steps, including black and white, is required.

H

Hard copy Visible form of a computer file printed more or less permanently onto a support such as paper or film.

HDR High Dynamic Range: an HDR image is created by blending two differing exposures of the same scene in order to compress the dynamic range into one image.

Highlight The portion of the image that records the brightest parts of the subject.

Histogram Statistical, graphical representation showing the relative numbers of a variable over a range of values. It is an indication of the pixels allocated to each level.

Hot-pluggable Connector or interface that can be disconnected or connected while the computer and machine are powered – USB or FireWire.

Hue Name of the visual perception of colour.

I

IEEE 1394 Fast external bus standard that is the same as FireWire. It provides for rapid communication between computers and devices. Supports data transfer rates of 400MB/second or 800MB/second.

Infinity A long way away, so that rays reaching the lens are effectively parallel, not diverging.

Ink-jet Printing technology based on the controlled squirting of extremely tiny drops of ink onto paper.

Interpolate (1) Resize a digital image by inserting pixels into an existing file when a bitmapped image is enlarged. (2) To give an apparent, but not real, increase to the resolution, such as in scanned images.

ISO International Organization for Standardization. Most exposure indices or film speeds today are described by the ISO system, which uses the same numeric values as the old ASA system – ISO 100, 400, 800, etc. The slower the film, the lower the number. So ISO 100 is slow film, and ISO 800 or ISO 1600 is fast film. Digital cameras have sensitivity adjustments that are calibrated to be essentially equivalent to ISO film speed.

J

Jaggies Appearance of stair-stepping artifacts. *See* Aliasing.

JPEG Joint Photographic Experts Group: a data-compression technique that can reduce files sizes to 75 per cent with nearly invisible loss of quality or to as little as 10 per cent of the original, with visible loss of quality.

K

K (1) Binary thousand – 1024 bytes is abbreviated to KB. (2) Key colour or black in the CMYK process. (3) Degrees Kelvin, which measures colour temperature.

Keyboard shortcut Keystroke that executes a command.

Key tone The principal or most important tone in an image, usually the midtone between white and black.

L

Laser printer A digital printer.

Layer An image that is allowed to sit upon another. The original image can be protected as the background layer while alterations are made to the copy layer.

Layer mode Picture-processing or image-manipulation technique that determines the way in which a layer in a multi-layer image combines or interacts with the layer below.

LCD Liquid Crystal Display: a type of display using materials that block light.

Legacy work Photographs made on film or paper.

Levels Shades of lightness or brightness that are assigned to pixels. Histograms are used as a guide to the corrections that need to be made.

Load To copy enough of the application software into the computer to be able to run the application.

Lossless compression Computing routine that reduces the size of a digital file without reducing the information in the file, such as LZW.

Lossy compression Computing routine that reduces the size of a digital file but also loses information or data, such as JPEG.

Lpi Lines per inch: measure of resolution or fineness of photomechanical reproduction.

M

Mac Apple Macintosh computer. Also the operating system used on Apple computers.

Marquee The selection tool used in image-manipulation and graphics software.

Mask Technique used to obscure selectively or hold back parts of an image while allowing other parts to show.

Megapixel More than a million pixels. A measure used in the description of digital cameras in terms of sensor resolutions.

Metadata Information relating to an image but not part of the image itself.

Moiré A repetitive pattern of alternating light and dark bands or colours caused by interference between two or more superimposed arrays or patterns that differ in phase, orientation, or frequency.

Monochrome Photograph or image made up of black, white, and greys. Also a general term for all types of black-and-white photography.

Multi-grade Printing paper whose contrast grade can be varied by changing the colour of the exposing light.

N

Nearest neighbour Type of interpolation in which the value of the new pixel is copied from the nearest pixel.

Noise Unwanted signals or disturbances in a system that tend to reduce the amount of information being recorded or transmitted. It is the spurious differences between pixels.

O

Opacity Measure of how much can be "seen" through a layer.

Operating system The software program that coordinates the computer.

Optical viewfinder A type of viewfinder that shows the subject directly through an optical system rather than via a monitor screen. Common on digital cameras.

Out of gamut Colours from one colour system that cannot be seen or reproduced in another.

Output Hard-copy print-out of a digital file, such as an ink-jet or laser print.

P

Paint To apply colour, texture, or effect with a digital "brush" or using the colour itself.

Palette (1) A set of tools and shapes shown in drawing programs. They are in a small window that is active, together with other palettes. (2) A selection of colours for painting or filling in that floats on the screen in graphics and image applications ready for the paintbrush to "pick up" colour. (3) Range of colours reproduced by a film.

PC An abbreviation of personal computer.

Peripheral Any device connected to a computer – printer, monitor, scanner, modem.

Photograph Record made with a camera or other device from which a visible image may be obtained.

Photomontage Photographic image made from the combination of several images.

PICT The graphic-file format used on Mac OS. It is normally limited to 72dpi because it is designed to be used for screen images.

Pixel An abbreviation of "picture element". It is the smallest element capable of resolving detail in a light-sensitive device or of displaying detail on a monitor screen. Digital images are composed of thousands or millions of pixels. These are not visible because the eye merges these differently coloured spots into areas of continuous tones and additively formed colours.

Pixellated Appearance of a digital image whose individual pixels are clearly discernible.

Plug-in Application software that works in conjunction with a host program into which it is "plugged". It operates as if part of the program itself.

Posterization Representation of an image using a relatively very small number of different tones or colours that result in a banded appearance and flat areas of colour.

Ppi Points per inch: the number of points that are seen or resolved by a scanning device per linear inch.

Prescan In image acquisition, it is a quick view of the object to be scanned, taken at a low resolution for cropping.

Prime lens Fixed focal length lens, as opposed to a zoom lens.

Push-processing Giving extra development to film to compensate for under-exposure.

R

RAM Random Access Memory: component of the computer in which information can be stored or rapidly accessed.

Rangefinder An optical device or aid to focusing.

Raw Raw files are digital images with minimal processing. Raw files must be processed before use but can give the best image quality the camera is capable of.

Read To access or take information from a storage device such as a hard-disk, CD-ROM, or USB memory stick.

Resampling The addition or removal of pixels from an image by sampling or examining the existing pixels and making the necessary calculations.

Resizing Changing the resolution or file size of an image.

Retro-focus Inverted telephoto-type lens using groups in front with negative power and positive rear groups, so that the space between the rear of the lens and the focal plane is greater than the focal length.

RGB Red, Green, and Blue: a model that defines colours in terms of relative amounts of red, green, and blue components. These are the three colours employed by computer monitors, digital cameras, and scanners to display or record images.

S

Sabattier effect Partial reversal of tones in a print caused by exposure to light during development.

Scanner A device that converts photographs, pictures, and text from analogue to digital files.

Scanning The process of turning an original into a digital facsimile.

Scrolling The process of moving to a different portion of a file that is too large for the whole to fit onto a monitor screen.

Shutter lag The time between pressing a shutter button fully and the shutter run or exposure being made. A lag of 75 milliseconds is just perceptible and acceptable for professional use.

Shutter time The duration of exposure of film or sensor to light.

Soft-proofing Using the monitor screen of either a computer or digital camera to proof or confirm the quality of an image.

Stair-stepping Jagged, rough, or step-like reproduction of a line or boundary that was originally smooth.

System requirement A specification defining the minimum configuration of equipment and version of the operating system needed to open and run a software application or device.

T

Telephoto lens Optical construction that enables the physical length of the lens to be less than the focal length. It makes objects appear larger than they would to the human eye.

Thumbnail A low-resolution, small version of an image, which is used to make it easier to view many images on a computer screen at once.

TIFF A widely used format that supports up to 24-bit colour per pixel. Tags are used to store image information.

Tint (1) Colour reproducible with process colours; a process colour. (2) An overall, usually light, colouring that tends to affect areas with density but not clear areas.

Tone A tint of colour or shade of grey.

Tone mapping Image-manipulation technique for compressing a high-dynamic-range image to fit the limited dynamic range of print or display.

Transparency (1) Film in which the image is seen by illuminating it from behind. (2) The degree to which the background can be seen through a pixel of a different colour in the foreground.

Transparency adaptor Accessory light source that enables a scanner to scan transparencies.

TWAIN Toolkit Without An Important Name: standardized software "bridge" used by computers to control scanners via drivers.

Two-bath Any film- or paper-processing technique using two separate steps for development.

U W Z

Undo To reverse an editing or similar action within a software application.

Unsharp mask Image-processing technique that has the effect of improving the sharpness of image.

Upload To send files from a computer to a network or the internet.

USB Universal Serial Bus: standard port design for connecting peripheral devices such as a digital camera, printer, storage device, etc to a computer. USB 2.0 is faster than USB.

Warm colours A subjective term referring to hues such as reds, oranges, and yellows.

White balance This is a calibration of the white point of an illumination, where it is matched to a set standard. Most digital cameras have an automatic white-balance system that tries to correct the recorded colours so that the whites (and all other colours) appear "normal" to the human eye.

Write To save data to a storage medium such as a memory stick, DVD, CD, etc.

Zoom A type of lens that can change its focal length (field of view) without changing the focus.

WEBSITES AND FURTHER READING

WEBSITES

American Museum of Photography
www.photographymuseum.com
Treasure trove of great images collected thematically with informative historical notes. Like any good museum, well worth the occasional visit.

Bob Atkins Photography
www.bobatkins.com
Mixed bag of reviews, technical articles, and numerous links. Generally high-quality information and many interesting discussions. Worth dipping into.

Colors magazine
www.colorsmagazine.com
Superlative collection of powerful, emotive imagery of great editorial intelligence. Must visit.

Creative Pro
www.creativepro.com
One of the best sources for news, techniques, and issues relating to image manipulation, digital photography, design and graphics, as well as software and hardware reviews. Highly recommended.

Depth of field calculator
www.dofmaster.com
This website offers easy-to-use online calculators for depth-of-field and hyperfocal-distance calculations as well as free downloadable depth-of-field calculator software for Windows, Palm, and iPhone.

Digital Camera Resource
www.dcresource.com
Site dedicated to thorough reviews of consumer cameras featuring useful comparison charts – enormous number of cameras covered. Excellent resource for checking out current or out-of-date cameras before buying.

DIWA (Digital Imaging Websites Association)
www.diwa-awards.com/
Compilation of camera reviews carried out by 13 (at time of writing) digital photography sites all over the world, following common formats and shared procedures.

Edmund Optics
www.edmundoptics.com
Primarily a corporate site for an optics supplier, but it is informed with clear FAQs and articles on optics, as well as an excellent list of links. For those interested in applied photography and optics.

Ephotozine
www.ephotozine.com
General digital photography website with serious content and useful news, reviews, and help pages.

EXIFutils
www.hugsan.com/exifutils
Application for editing, correcting, and altering EXIF and IPTC data saved in image files by digital cameras.

Foto8
www.foto8.com
Website of the eponymous magazine, which is the leading showcase for contemporary photojournalism and documentary photography. Deserves bookmarking for any photography lover.

The Getty
www.getty.edu
Authoritative references on digital collections, including excellent book-length introduction to digital imaging – highly educational, and not only to museum people. While you are there, browse the collection of marvellous photos and artwork.

ICC Profiles
www.color.org/iccprofile.html
Clear and authoritative explanations of everything you need to know about colour profiles, their applications, and details of software programs that comply with the specifications. Essential for advanced understanding but highly technical.

Imatest test software
www.imatest.com
Used to test all major aspects of lens performance in digital cameras: widely used in industry. Worth using the evaluation runs on your camera. Windows only.

Informit
www.informit.com/articles
Extracts in article form from a wide range of information-technology books, with hundreds for design and creative media, including digital photography and Photoshop, and many offering the highest quality content.

International League of Conservation Photographers (ILCP)
www.ilcp.com
Portal to some of the finest wildlife and conservation photography on the planet, with links to individual photographers' websites showing images, and listing workshops and books.

IPTC Metadata for XMP

www.iptc.org/iptc4xmp
The International Press Telecommunications Council standards for image metadata: all the technical documentation, tutorials, and samples.

Jack's Photographic and Chemistry Site

www.jackspcs.com
Concise information on chemicals, with formulary for developers, toners, etc, as well as links.

Norman Koren

www.normankoren.com
Dedicated to the technically inclined photographer, this site offers much to ponder on: from printing to scanning and digital photography, with good links.

LetsGoDigital

www.letsgodigital.org
Extensive news and reviews of equipment, as well as a regularly updated picture gallery.

The Luminous Landscape

www.luminous-landscape.com
High quality of varied content, with some substantial essays on a wide range of photographic topics and detailed, considered reviews. Worth a leisurely visit.

Max Lyons

www.tawbaware.com/maxlyons/calc.htm
Handy calculators for depth of field, angle of view, etc. Part of an informative, well-illustrated site covering technical matters. Tawbaware offers a number of utilities for digital photography.

Photoshop News

www.photoshopnews.com
Much more than a portal for news about Photoshop, this is a heavy-weight site offering high-quality material on a wide range of issues relating to the Photoshop user covering not only the software but technical market as well as legal issues, news, and recommended links.

Photoshop Support

www.photoshopsupport.com
A valuable beginner's resource that offers innumerable tutorials, free resources such as brushes, fonts, actions and so on. With links to software such as plug-ins, video training, and extracts from Photoshop books. Also supports other software such as Lightroom, Dreamweaver and Aperture.

Plugins World

www.pluginsworld.com
Comprehensive and constantly updated listings of plug-ins for Photoshop and other software.

Popular Photography

www.popphoto.com
Home of the venerable and much-respected photography magazine, as well as of *American Photo*. Excellent for news, features, and reviews.

Retro Photographic

www.retrophotographic.com
The technical section of this commercial outpost of darkroom practice offers a valuable compendium of data sheets and processing guides.

RH Designs

www.rhdesigns.co.uk
Home of advanced enlarger timers, densitometers, and other darkroom aids for high-quality printing, with technical information as well as digital supplies such as papers and inks.

Schneider Kreuznach

www.schneiderkreuznach.com
The know-how section contains valuable and authoritative (technical but approachable) essays on a variety of topics including lens coatings and lens design. A very good resource on filters for photography.

Schorsch

www.schorsch.com
A corporate lighting-design website with a useful knowledge base offering information for anyone interested in light and lighting.

Steve's DigiCams

www.steves-digicams.com
Well-known site with extensive information covering a wide range of subjects, numerous reviews, technical features, and news. Well worth bookmarking.

Travel Photographer's Network

www.travelphotographers.net
Specialist site offering illustrated travel features, equipment reviews, and technical advice aimed at travel photographers, with image and discussion forums.

Universal Photographic Digital Imaging Guidelines

www.updig.org/guidelines/
Set of guidelines for best practice in the creation, supply, and transmission of digital image files. Particularly useful on strategies for achieving best practice with different types of workflow. Essential reading.

BOOKS

Ang, Tom
Advanced Digital Photography (2nd edition)
Mitchell Beazley, London, 9781845332563
Takes readers beyond the basics to look at advanced
techniques and the fundamental background to image
manipulation and digital photography, together with
"power techniques" difficult to find elsewhere.

Ang, Tom
Digital Photographer's Handbook (3rd edition)
Dorling Kindersley, London, 9781405316613
Broad-based compendium of techniques for digital
photography featuring sections for troubleshooting;
one of the most comprehensive on the subject but in
need of updating.

Ang, Tom
Digital Photography Masterclass
Dorling Kindersley, London, 9781405315562
Further photographic and image manipulation
techniques and discussion for experienced
photographers, with workshop examples, critiques
of submitted photos, portfolios, and interviews with
young professionals.

Berns, Roy
Principles of Color Technology
John Wiley & Sons, New York, 9780471194590
Up to date, fully illustrated with excellent diagrams,
clearly written, and authoritative, this is the book to
start with if you really want to understand modern
colour without going into the fullest details.

Burian, Peter and Caputo, Robert
National Geographic Photography Field Guide
National Geographic Society, Washington DC,
9780792256762
Concise, clear guide to practical photography, packed
with excellent instruction and first-rate advice written
in clear language with inspiring examples – enlivened
by interviews.

Burkholder, Dan
Making Digital Negatives for Contact Printing
Bladed Iris Press, Carrollton, Texas, 9780964963832
Step-by-step guide on the subject – essential for the
advanced darkroom worker.

Caplin, Steve
How to Cheat in Photoshop CS3:
The Art of Creating Photorealistic Montages
Focal Press, Oxford, 9780240520629
Classic text giving clear instructions for elaborate
techniques that lay the foundations to enable you to
work out how to achieve a wider range of effects.

Cotton, Bob and Oliver, Richard
The Cyberspace Lexicon
Phaidon, London, 9780714832678
Numerous illustrations and hyperactive layout make
for a restless read, but it is a veritable visual source in
itself. Well worth dipping into, and it's hard not to
learn something new.

Freeman, Michael
Pro Digital Photographer's Handbook
Lark Books, Asheville, North Carolina,
9781579906320
Sound and accurate advice from this learned veteran,
covering many aspects of digital camera and software
use. Recommended.

Galer, Mark and Horvat, Les
Digital Imaging
Focal Press, Oxford, 9780240519715
Uneven in quality and coverage, but much
useful information written in clear language.
Worth a browse.

Hicks, Roger and Schultz, Frances
Quality in Photography
David & Charles, Newton Abbott,
9780715321485
Valuable approach to photography, concentrating on
technical aspects, somewhat to the detriment of the
visual quality of some of the photography – but many
useful tips and helpful advice offered.

Kelby, Scott
The Adobe Photoshop Lightroom Book for
Digital Photographers
Peachpit Press, Berkeley, 9780321492166
Thorough and clear introduction to the best and
most efficient ways to use Adobe Lightroom, which
is rapidly becoming an essential item in a digital
photographer's computer.

Kelby, Scott
The Photoshop Channels Book
Peachpit Press, Berkeley, 9780321269065
It is interesting that Adobe Photoshop is so complex
one can write an entire book on just one feature. And
the fact that it can be so useful and crammed full of
practical information is amazing. Invaluable for the
advanced worker.

Kieran, Michael
Photoshop Color Correction
Peachpit Press, Berkeley,
9780321124012
Excellent, thorough, and authoritative coverage of
colour correction and management – invaluable even
for non-Photoshop users.

Krogh, Peter
The DAM Book: Digital Asset Management for Photographers
O'Reilly Media, 9780596100186
Comprehensive coverage of an important field, covering workflows, archiving, and use of suitable software, but dominated by coverage of Adobe Bridge.

Langford, Michael
Basic Photography
Focal Press, Oxford, 9780240515922
Patchy and lacking in authority on digital matters, but the rest of the book covering analogue photography and processes, as well as the fundamentals, is peerless and thorough. Highly recommended for selective reading.

London, Barbara, Stone, Jim, and Upton, John
Photography
Pearson Education, New Jersey, 9780131896093
Comprehensive basic but voluminous introduction to photography – perhaps the best modern treatment, but a little thin on digital photography. Fully illustrated.

Luna, Orlando and Long, Ben
Aperture 2
Peachpit Press, Berkeley, 9780321539939
Model of how to write and produce an instructional manual, which should have been sold with the software itself. Excellent introduction to Apple Aperture.

Margulis, Dan
Photoshop LAB Color
Peachpit Press, Berkeley, 9780321356789
Insightful and invaluably deep treatise on colour correction. While it is a little long-winded, you will learn much and your technique will improve. A must-read, and essential for the advanced worker.

Margulis, Dan
Professional Photoshop: The Classic Guide to Colour Correction
Peachpit Press, Berkeley, 9780764536953
Deservedly a classic on image manipulation, full of insight on key topics such as tone and colour correction, colour spaces, sharpening, resolution, and blends. Must-have.

Mitchell, William
The Reconfigured Eye
MIT Press, Cambridge, Massachusetts, 9780262132862
Although it is in need of some updating, this presents an art-critical approach to image manipulation with useful discussion on the impact of digital technologies on art, photography, and the nature of representation.

Ray, Sidney F
Photographic Imaging and Electronic Photography
Focal Press, Oxford, 9780240513935
More encyclopedia than dictionary: it is strong where entries can be more leisurely, but shorter definitions are often illuminating only to technophiles.

Ray, Sidney F
Photographic Technology and Image Science
Focal Press, Oxford, 9780240513898
Good on the photographic technology, but not so hot on the imaging sciences. Lengthier entries are good, but the shorter definitions presume technical knowledge or demand a lot of digging around.

Rodney, Andrew
Colour Management for Photographers
Focal Press, Oxford, 9780240806495
Comprehensive and thorough treatment of colour management without the colour science but much on practicalities, mainly relating to Photoshop. Invaluable for the advanced photographer.

Saxby, Graham
The Science of Imaging
Institute of Physics, London, 9780750307345
With many sections pertinent to photography, this is the best modern, all-round introduction to the science of photography.

Steinmueller, Uwe and Gulbins, Juergen
Fine Art Printing for Photographers: Exhibition Quality Prints with Inkjet Printers (2nd edition)
Rocky Nook, 9781933952314
Sound presentation of colour management needed for producing high-quality ink-jet prints. Written by leading experts in the field. Worth a browse.

Stroebel, Leslie and Todd, Hollis N
Dictionary of Contemporary Photography
Morgan & Morgan, Inc, New York, 9780871000651
Safe, sound, and solid as ever from these authors: clear definitions, and excellent coverage, but hampered by its lack of depth on digital matters.

White, Ron and Downs, Timothy Edward
How Digital Photography Works
Que, Indianapolis, 9780789736307
A fully illustrated guide that does exactly what it says in the title: clearly drawn illustrations show every aspect of digital camera operation, as well as image manipulation, although it baulks at some of the more tricky optics. Recommended.

INDEX

Illustrations are indicated in *italics*

A

actinicity 53, 194–5
actuators 165
Adams, Ansel 50
Adobe software, Camera Raw 240–1, *241*; DNG 241;
 Lightroom 295, *295*; RGB 21, *21*, 90, 222
aerial photography 176
Agfa film 290
amateur photography 24
angle of view 136–8, 146–8, *147*, 160, 174, 177
aperture 41, 48, *49*, 72, 79, 80, 84–91, *88*, 121, 133,
 136–7, 139, 145, 155, 164, 165, 303; effects 88–9;
 f/ number 88; ring 139
Apple Aperture software 240, *240*, *253*, 262, 295
APS film format 115
architectural photography 70, 100–1, *101*, 140, 141, 172
artifact correction 19, *19*
astigmatism 89, 151, *151*, 162, 165
Autochrome film 110
autofocus 72, 74–7, *74–5*, *77*, 91, 134, 137, 138, 158,
 164, 291; one-shot 74, 91, 134; servo 74–5, 91, 134

B

backgrounds 185
back-up 20, 246, 295, 314–15
Bayer array/pattern 126, 238
Bessa 65
black point compensation 223, *223*
bokeh 89, *89*
brightness 26, 46–7, *46*, 180; inverse square law 47,
 47, 181
burning and dodging 256–9, *256–9*, *271*, *273*

C

Callier effect 298, *298*
Camera Bits PhotoMechanic software 295
camera construction 62–3
cameras 58–101; *camera obscura* 62; digital 61, 90–3,
 147, 176–7, 249; DSLR 66, 128–9, 145, 147, 153,
 160, 164; medium-format 70–1, *70*, 96, *99*, *100*;
 monorail *100*, 153; pinhole 63, *63*; point-and-
 shoot *61*, 123, 129, 138, 164; SLR 66–7, *66*, 70–1,
 70, 96, 104, 138, 164; viewfinder 64–5, *64*, 96, 137,
 electronic *68*, 69
Canon cameras *62*, 142, 146, 155, 159, 160, 238
Carpentier, Jules 171
catadioptric image *41*, 89
Cibachrome 309, 315
circle of confusion 85
cloning 264–5, *265*
close-up photography 66, 70, 134, 140, *140*, 152–3, 165

cold conditions, working in 177
colour 16, 52–7, 108–13, 126, *127*, 182, 200–25;
 accuracy 16, *17*, 108; balance 21, 54, 55, 111, 112,
 208–9, 214–15, 260–1, 263, 269, 275, 276, 308,
 white balance 21, 54, 92, *92*, 108–9, 209, point 209;
 conversion 169, 207, 222–3, 261–3, black point
 compensation 223, *223*; digital 108, 109, 126–7,
 216–25; gamut 202, *203*, *206*, 220; management
 220–1, 224–5; palette 54–5, 104, 210–11, 216–17,
 216–17; recording *27*, 54–5, 126–7, 208–9;
 rendering index (CRI) 182; saturation 90, *90*,
 206–7, 223, 260, 261, 263, *273*; settings 21, 222–3;
 space 21, 90, 260; spectrum 52–3, *52–3*; symbolism
 204–5; wheel 205
coma 151, *151*, 160, 165
commercial photography 23, *25*, 100
composition 30–5, *34–5*, 204–5, 268, 269
compression/decompression 18–19, 89, 90, *155*, 245;
 JPEG 245
contrast 44–5, *44–5*, 108, 111, 206, 210–11, 255–7;
 compensating 255
conversion 222–3, 240–1, 261–3, *262–3*; batch 241
converters 160–1, 240–1, 262–3
copyright 336
cropping 145, 242, *249*
curves 21, 234–5, 275, 276; characteristic 234–5, *235*;
control 254–5, 260, 274
cyanotype 276, *277*

D

darkroom effects 274–7; equipment 300–1
defects, printing/output 326–7; processing 324–5
demosaicking 126, 239, *239*
depth of field 28–30, 41, 72, 84–6, *84–7*, 91, 129, *129*,
 137, 141, 146, *153*, 155, 171; bit 56–7, *56–7*, 284
developer 228–9, 232–3
development 107, 228–33; black-and-white film 230–3
diffraction 41, 87–9, 128, 165
diffusers/deflectors *188*, 189
digital principles 18–19, *18–19*
distortion 41, 141, 142, 146, 150, *150*, 165, 248–9
dithering 310, *310*
dropper tools 253, *253*, 260
dry-mounting 316–17, *317*
dust removal 289
DX coding *48*
dye clouds 104, 292

E

easel, enlarging 301, *301*, 302
Ebony camera *100*
editing 332–5
Ektachrome film 224

enlarger, condenser 292, 298, *298*, 300; diffuser 298–300, *298*

enlarging *20*, 49, 85, 250, 298–9; Callier effect 298, *298*; equipment 300–1

Epson camera 99

equipment 98–101, *99*, *100*

evaluating negative 302

exhibiting 318

exposure 44–5, 48–51, *49–51*, 55, 78–83, 86, *93*, 105, 107, 110, 112–13, 118–21, 153, 159, 192, 194, 206, 235, 255; auto 79, 91, *93*, 125; bracketing 192; compensation 55, 118, 153; control 124–5; flash 194, *195*; metering 48, *48*, 94, *94*, 118–21, *119*, 153, 185, 192, 194; print 303; zone system 50–1, *51*

Extensis Portfolio software 295

eye 26–7, *26*

F

feathering 266

field curvature 150, *150*, 165

files 20, 239–41, 244–5, 250–1, 292–3; JPEG 240, 244–5; TIFF 239, 240, 245

film 48, 104–17; black and white 106–7, 230–1; colour 110–13, *110–11*, 236–7; density 288; fast 107, 110, 112, 124; formats 114–17, 289; medium/roll 116, to slow 107, 111, 112; miniature 114–15, ultra 114; sensitometry 234–5; transparency 104, 110–11, *110–11*, 236–7, 275, *275*, 309

film carrier 299

filters 53, 55, 80, 109, 123, 132, 135, 160, 166–9, 278–81, 299; colour conversion/compensation 169; effects 328–31; light-adjusting 166–7; polarizing 168; special effects 168–9; Spherize 249

flare 133, *133*, 142, 183

flash 38–9, *47*, 90, 183, 184, 194–9, *195–9*; guide number 198, 199; portable 196–9; ring 193

focal length 128–9, 136, 138, 139, 141, 145–9, 152, 154–5, 158, 161, 164, 299

focussing 28, 72–7, *76–7*, 91, 126, 132, 139, 164; auto *see* autofocus; close-up 134, 153; manual 72–3, *72–3*, 76, 83, 86, 91, 132, 164, 299; predictive 77

fog 107, *107*, 111, 112

forensic/medical photography 22–3, *23*

FotoWare FotoStation software 295

framing 33, *33*, 67, 242

Fuji camera 174; film 108, 224, 290

G

gamma 108, 220, 228, 235, 269

goboes 189

golden ratio/section 31

gradients 126, 257, 280; filters 166–7

grain 16, 19, 104, 107, 108, 111, 112, 228, 235, 292, 299

guide prints 312–13

H

half-tone cell 310–11, *310*

Hasselblad camera 70, 98, *100*, 132, 133; XPan 115, 174

healing 265, *265*

highlights, specular 45, *45*, 51, 54, 110, 134, 255

HMI lamps 39, 184, *185*

holds, camera 96

hot conditions, working in 177

I

Ilfochrome Classic 309

Ilford film 107, 292

illuminance 47; inverse square law 47, *47*, 181

image databases 295

image digitizing 282–95

image formation 32–3, 40, *40*, 145, 239

image levels 252–3

image management 294–5

image quality 16–17, 41, 57, 87, 124, 162–3, 239; clarity 162–3; colour accuracy 16; dynamic range 16, *17*; proportions 242–3; sharpness 16, 84, 89, 104, 269; shape 32–2, *32*, 248–9; tonality 16, 254–5

image workflow 246–7

imaging 14–15; chains 14–15; digital 14–15, 18–19, *18–19*

industrial photography 22, *23*

infrared 52, *52*, 76

interpolation, bicubic 251; bilinear 251; nearest neighbour 126, 251

intertextuality 29

J

journalism 99, 107, 149, 172

K

Kodak film 114, 115, 224, 236, 262, 290–2, 309

L

landscape photography 69, 70, *71*, 92, 96, 104, 141, 149, 155, 172

Lasso tool 267

layers 257, 263, *267*, 268–70, *271–3*

Leica cameras 64, 132, 149, 163; Elmarit 138, 152; Summicron 149; Summilux 146, 155

lens aberrations 19, 87, 89, 140, 150–1, *150–1*, 158, 160, 165; chromatic 151, *151*; spherical 150, *150*

lens cleaning 135

lens construction 132, *132*

lenses 60, 66, 87, 124, 129, 130–77; aperture 85–7, 136–7; catadioptric 41, 89; enlarging 300, *301*; fisheye 146, *146*; macro 152–3, *152*; medium to long 154–5, *154*; normal 148–9, *148*; prime 142, 155; shift-tilt 160, *160–1*, 170, 172; soft focus 160, *161*; specialist 160–1, *160*; telephoto 158, 176; very long 66, 134, 158–9, *158*; wide-angle 66, 72, 128, 134, 136, 141, 146–7, *146*, 154, 299; zoom 92, *93*,

98, 124, 128, 133, 137–43, *138–42*, 154, 199, 249
lens formulae 144–5
lens handling 134–5
lens hood 134, *134*, 142, 149, 144
lens mount 132
lens specifications 136–7
light 36–57, 102–29, 178–99; adaptation 26–8;
 brightness 26, 46–7, *46*, 166, 180; colour (CRI) 182;
 density 166–7; direction 43, 180, 269; evaluation
 95; fall-off 151, *151*, 167; inverse square law 47, *47*,
 181; metering 48, *48*, 94, *94–5*, 118–21, 182–3, 194,
 TTL 120, 166; modifiers 188–9; power spectrum
 194, *195*; quality 42–3, 180; shape/shapers 181, *188*,
 189; source 38–9, 182–5, *186–7*
light box 319
light tents 193
lighting, bounce 197; equipment 184–5, *185*, 188–9;
 set-ups 190–3, *190–3*
lightness 46–5, *47*
Linhof camera 174
lith printing 276
long-distance photography 177
low light, working in 55, 124–5, 137, 146, 149, 155
luminaires 184
luminance range 44–5, 110
LUT 95

M
Magic Wand tool 267, 276, 280
magnification 72, 92, 128, 134, 139, 145, 152–4,
 160, 177
magnifying loupe 111
Mamiya camera 98, 133
masks 267, 279
memory card 90, 176, 239
metamerism 202, *203*
minimum object distance 137, 139
Minolta 160
Minox film format 114, *115*
modulation transfer function 162–3, 285
moiré 104, 123, *123*, 289
movements, camera 170–1, *172–3*, 175; Scheimpflug
 Rule *171*, 177
multiple prism effect 169

N
nature photography *98*, 99, *143*
Nikon cameras *60*, 149, 159, 160, 300; Nikkor 146, 152,
 155; Nikonos 176
Noblex camera 174
noise 16, *17*, *49*, 80, 104, *105*, 122, 124, *125*, 128, 269;
 reduction processes 80
Normlicht Kombi *221*

O
outputting 296–321

P
Panasonic camera *62*
panning 80
panoramic photography *114*, 174–5, 243; shift 175,
 175; stitch 174–5; swing 174
parallax 174
patching 265, *265*
perspective/position 30–1, *31*
phase detection 77
Phase One software 240, *241*
photometry, basic 46–7
PhotoShelter 295, 314
Photoshop software 222, 248, 249, 251, 255,
 257, 262, 263, 265, 267, 268, 274, 276, 279,
 280, 289
pixel aspect ratio 249
Polaroid camera 238
portrait photography 70, *71*, 72, 87, *87*, 89, 96, 98, *98*,
 104, 155, 160, 171, 185
posterization 89
preferences 90
pre-flighting 312
presentation 316–21
printing, 302–9, *304–5*, 312–13; black and white
 302–3, 313, 315; colour 308–9, neg-pos 308,
 pos-pos 309, *309*, processing 309; contact 203;
 digital 312–13; variable contrast 306–7
processing 12–13, 18–21, 92, 226–81, 309; colour
 236–42; cross- 274–5, *275*; in-camera 238–9;
 negative 236, *237*; "pull-" 50; "push-" 50, 237; raw
 240–1; reversal 236–7, *237*
professional photography 24–5, *25*
profiles 224
progressive frame 104
projectors 319
ProPhoto 21, 223, 293
proportions 31

Q
quantization 238, 284

R
rangefinders 72, 76, 80, 134, 164
reciprocity 48, *49*, 80
record making 22
reflection *40*, 41, 43, *43*, 45, *88*, 183
reflectors 188–9, *188*
refraction 40–1, *41*
rendering, colour 222–3
resolution 90, 107, 142, 152, 162–3, 250, 284–5,
 289, 292, 311; modulation transfer function
 162–3, 285
Rodenstock Imagon camera 160; Rodagon 300
Rolleiflex-type cameras 70, 82, 98, 116, 133
rotations 170, 243
rule of thirds 31, *31*

S

Sabattier effect 274, *275*
sampling 18–19, *18*, 284
scanning 21, 104, 224, 284–93, 298; advanced 292–3; Dmax 288; drum 287; film 286–7; flatbed 286; multiple-pass 288; workflow 290–1
Scheimpflug Rule 171, *171*, 177
Schneider cameras 149; Apo-Symmar 152; Componon 300; Tele-Xenar 155
scientific photography 22, *22*
screen 70; CRT 81, 203; LCD 65, 69, 81, 125, 203
seeing 26–9; dimensions 28–9
Seitz camera 174
selections 266, 276
sensitivity *27*, 90, 91, 94, 124, 234–5
sensitometry 234–5
sensors 41, 48, 66, 82–3, 104–5, 114, 118, 122–3, 126, *126*, 128–9, 136, 137, 147, 165, 234, 238; CCD/CMOS 122–3, *123*; formats 128–9; full frame/interline 123
settings, digital 21, 90–3, 222–3; black point compensation 223
shadow 43, 51, 110, 182, *183*, 214–15, 255
shake, camera 78, 91, 142, 158, 159, 165, 176
sharpening 278–81, *278–81*, 289
shutter 82–3, 91, 123, 133, 199; focal-plane 82, *83*, 104; inter-lens 82, *82*; sensor 82–3
shutter lag 83, *83*, 91
shutter time 48, 78–81, 86, 91, 121, 124, 159, 165; long 80–1; short 78–9, 176
Sigma camera 142, 159
Sinar camera *100*
size 311
soft proofing 224, *225*
solarization 274
Sony camera *63*, 126
spectrum, electromagnetic 52–3, *52–3*
speed, film/sensor 48, *49*
split-toning 276, *277*
sports photography 92, 99
spotting scopes 177
stabilizing camera/image 96–7, *96–7*, 142, 158–9, 165
still life 89, 104, 149, 155
stopping down 87, 146, 165, 298
storage 314–15
street photography *155*
structuring space 33
studio 184–5; equipment *185*
studio photography 101
sub-atomic photography *22*
sunlight 38
surroundings 183–5
surveillance 22, *23*
swirling 81

T

Talbot, Henry Fox 62
Tamron camera 155
teleconverters 80, 99, 160–1
template 22
test strips 303–4, *303*
timer 301, *301*
tonality/toning 16, *16*, 107, 108, 254–5, 257, 307
tone mapping 104, 255, 306
travel photography 69, 98, *99*, 141, *143*, 154, 155
triangulation 76, *76*
tripods 97, *97*, 163, 174
tungsten halogen light 39, 169, 184
TV screens 81, *81*
twilight effect 125, *125*

U

ultraviolet 52–3, *53*
underwater photography 176–7
uses of photography 22–5

V

viewfinder 69, 96, 134
vignetting *133*, *135*, 142, *143*
visual perception 28–9

W

Weber-Fechner Law 28
websites 320–1
wedding photography *84–5*, 100, *113*
Widelux camera 174
workflow 20–1, 246–7, 290–1
working distance 165, 181; minimum 137, 139

Z

Zeiss cameras 64, 65; Biogon 147; Distogon 146; Hologon 147; Planar 149, 155; Softar 160
Zhao Youquin 62
zone system 50–1, *51*
zoom 92, *93*, 98, 124, 128, 133, 137–43, *138–42*, 154, 199, 249; ratio/streaking 139; wide-angle 140–1

ACKNOWLEDGMENTS

My first thanks go to Jeremy Williams, who has had to work comprehensively to ensure the contents are fine-looking. To Michele Byam, who nursed this book through its early gestation, my warm thanks. To Patrick Mulrey, many thanks for his virtuoso illustrations showing his firm grasp of the technicalities. And to the team at Mitchell Beazley: thank you for seeing the book through to fruition. Finally, to Wendy, my warmest thanks are due not only for her stewardship of all my work and her continuing love and support, but I am also delighted to thank her for her many excellent photographic contributions.

TOM ANG

CREDITS

Cameras used in the preparation of this book included: Leica M6, Rollei Rolleiflex 6008i, Canon EOS 1N, Canon EOS 1Ds, Canon EOS 1Ds Mk II, Canon EOS D30, Canon EOS 10D, Sony Alpha A100, Ricoh Caplio GX8, Nikon D2X, Nikon D50, Nikon D100, Olympus C-70, Panasonic Lumix DMC-FZ30, Panasonic Lumix DMC-LZ3, Fujifilm FinePix S5600, Pentax Optio S5N, Sony Cyber-shot F828, Sony Cyber-shot P200, Hasselblad H1D, Kodak DCS SLR/n, Nikon Coolpix 5400.

All images © TOM ANG except those listed.
Thanks to: CERN for permission to use the bubble event image © CERN on page 22; © US Geological Survey/Department of the Interior/USGS/Landsat 7 December 18 2002 for the image of Lake Chad on page 24; Cicely Ang for "Implied Space", on page 32; Carel Struycken, www.sphericalpanoramas.com, for the spherical panoramas, page 175; Norman Koren, www.imatest.com for the Imatest analysis on page 216; © Wendy Gray on pages 4BR, 16M, 31T, 33ML, 34–5, 53MR, 55BR, 77ML, 98BL, 105TL, 121T, 127, 129BL, 130–1, 133MR, 133ML, 135MR, 140, 141T, 154, 155T, 155M, 159MR, 159B, 166–7, 207, 215L, 242, 243, 244B, 246, 247, 249, 267, 312.

Technical diagrams and illustrations © Patrick Mulrey.

Pictures of equipment were obtained from manufacturers' websites and press materials and are copyright of their respective owners, which are hereby acknowledged.